Warman's®

North American Indian Artifacts

Identification and Price Guide

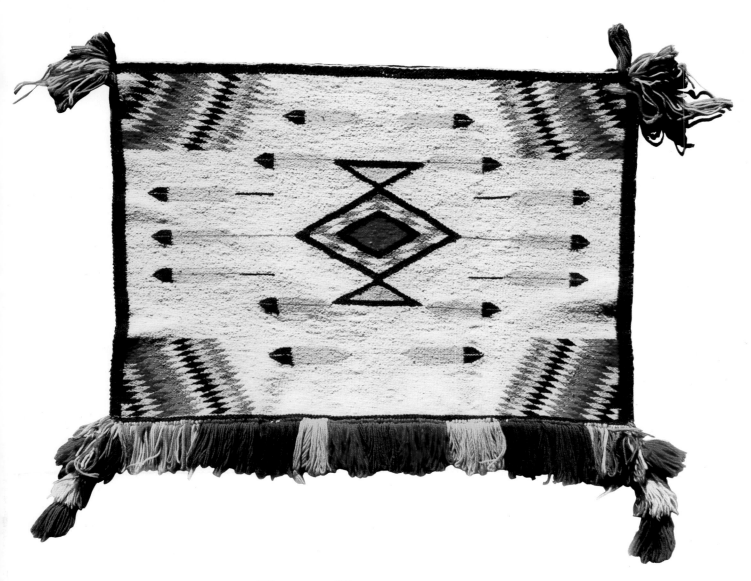

Russell E. Lewis

©2006 Krause Publications

Published by

An Imprint of F+W Publications

700 East State Street • Iola, WI 54990-0001
715-445-2214 • 888-457-2873

Our toll-free number to place an order or obtain
a free catalog is (800) 258-0929.

Library of Congress Catalog Number: 2006927362

ISBN 13: 978-0-89689-421-1

ISBN 10: 0-89689-421-5

Designed by Sandy Kent

Edited by Dan Brownell

Printed in China

DEDICATION ⬚ This book is dedicated to the memory of all of those who have gone before us in this beautiful place we now call North America. By definition, that includes all Native Americans, but it also includes those explorers and pioneers who at times understood those cultures and people and helped document their history and culture for those of us to follow. I offer this book to the Native American community with the same kindness and fellowship as was symbolized by them when offering one of those early explorers the pipe in friendship and peace. ⬚

Acknowledgments

I would like to thank the owners and staff at Allard Auctions, Inc., especially Steve Allard, president of Allard Auctions, Inc.; Cowan's Auctions, Inc., especially Danica Farnand, director of its American Indian Division; James D. Julia, Inc., especially Judy Labbe of its Firearms Division; and Skinner, Inc., especially Anne M. Trodella of its Public Relations Department.

Each of these auction houses and people contributed freely of their time, numerous images, and prices-realized to make this book a reality. I cannot overstate what a joy it was to work with these four people and their four major auction houses, and I would encourage all of my readers to consider any of them if ever in need of a professional auction house capable of accurately researching an item and producing a professional catalog documenting all items for sale.

I would also like to thank the research staff at the above auction houses for their hard work in identifying items shown in this book as to region, culture, and type of item. Many readers may not know that large auction houses employ experts with professional training in anthropology and ethnography to detail items for sale such as shown in this book. Without their research in developing their auction catalogs, this job would have been far too monumental for me to complete in a reasonable time. So, again, thank you to my colleagues for making these important contributions.

Finally, most of us do not have the luxury of writing books as I do, and I would likely not have this luxury but for the most wonderful wife in the universe. So, as with all of my books, I dedicate this work also to my wife, Wendy, and wish to acknowledge her constant support in my efforts. On this particular book, she was also somewhat of a taskmaster in that the subject matter is also important to her, and she insisted that it be "the best book done to date." I only hope I have lived up to that standard and certainly have tried my best to give this great topic a decent treatment in words and photos. I hope you enjoy reading it at least half as much as I did writing it!

Contents

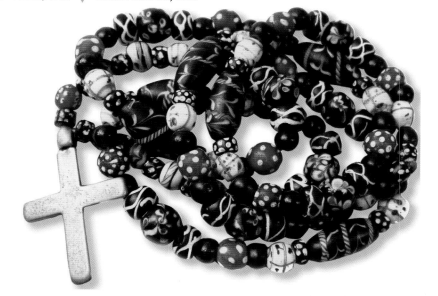

Preface

This book covers collectible items commonly referred to as American Indian artifacts. Our interest in Native American material cultural artifacts has been long-lived, as was the Indian's interest in many of our material cultural items from an early period. During recent years, it has become commonplace to have major sales of these artifacts by at least four major auction houses, in addition to the private trading, local auctions, and Internet sales of these items. The goal of this book is to assign these items to recognizable categories and show recent sales by using photos of the actual items sold and their pricing.

Many volumes could be written on the moral and ethical issues related to the sale of material cultural artifacts of Native American societies; however, I shall leave that debate for the scholarly fraternity of anthropology and archaeology. As a former field archaeologist for over a dozen years, I used to abhor the "pot-hunting" and "pot-hunters" involved in the destruction of valuable archaeological resources, and I still do. However, as a lawyer with knowledge of the private property rights of individuals, I also respect the fact that many of the artifacts being traded are simply in the marketplace as a result of a individual wanting to profit from his or her legitimate ownership of an interesting item. Even museums often release artifacts to generate money to preserve and acquire other artifacts for their collections.

I do not condone any illegal trading of items; however, I certainly am enough of a realist to know that the interest in these beautiful and creative items expands far beyond that of the academic community and that people have a right to know the values of the items in their possession or in their collections. It is to this end that I am writing this book, given my expertise in historical archeology of North America and my knowledge of Native American societies gained as a professional anthropologist.

Many of my colleagues may cringe at a professional writing a price guide on artifacts of this nature, yet I know each one of them would like to know the value of other material cultural artifacts inherited in their family or purchased some time in the past. In other words, if it is proper to be concerned with the value of a Ben Schmidt duck decoy, then I believe it is equally proper to be concerned with a projectile point, gun flint, or peace medal from Native American cultures.

Anthropologists have written millions of words on American Indian cultures and societies and have standardized various regions of the country when discussing these cultures. I am not going to attempt to reinvent the wheel by creating new categories but shall follow standard regional definitions such as the Great Plains, the Inter-Mountain West, and the Great Lakes regions. This will allow the new collector the ability to learn all that is wanted about societies within an interest area by referring to standard works on Native Americans and discovering all the wonderful sources covering that area. This would include many books of a scholarly nature and some of a more pictorial or popular nature.

I have personally worked primarily in what is known as the Woodland period of the Great Lakes throughout Michigan, Indiana, and parts of Illinois. I consider myself the most "expert" on the historical archaeological period of the mid-1700s to the mid-1800s. Sites excavated have included major sites from this time period with artifact contributions made to the Smithsonian and the State Museum of Indiana from a Miami Indian village site burned Christmas Eve, 1812. Indiana has loaned some of these same items to the Field Museum of Chicago.

My very first site was an historical site along the Grand River, and this hooked me on the material culture of Europe traded to the American Indians of the time. Thus, since this beginning back in 1968, I have been primarily concerned with how Native American societies traded with the Dutch, French, and English traders and how they accepted or rejected certain cultural items offered to them in trade.

Just as Native Americans were interested in our material culture, we have also been fascinated with their material culture from the beginning of our contact with their societies. The majority of these valuable items are in repositories of museums, universities, and colleges, but many items that were traded to private citizens are now being sold to collectors of Native American material culture.

In addition, as a farmer, I also know that many of us on farms have, since childhood, been looking for arrowheads while plowing, disking, or dragging our fields in preparation for planting. For instance, I found my first projectile point—actually a spear point and not an arrowhead—as a young child on our farm in western Michigan. Many more were added to the family's meager collection over the years. This is the way most artifacts being traded were originally acquired and not by individuals improperly invading sites. However, sadly to say, I also realize some of the items traded are the result of activities that I personally and professionally do not condone.

Native American artifacts are now acquired by collectors in the same fashion as any material cultural item. Individuals interested in antiques and collectibles find their items at farm auction sales (an especially good place for farm family collections to be dispersed), yard sales, estate sales, and specialized auctions such as those featured in this book, and from private collectors trading or selling items. The most wonderful of all new sources is the Internet, especially online auction sales. There is no shortage of possibilities in finding items; it is merely deciding where to place one's energy and investment in adding to one's collection.

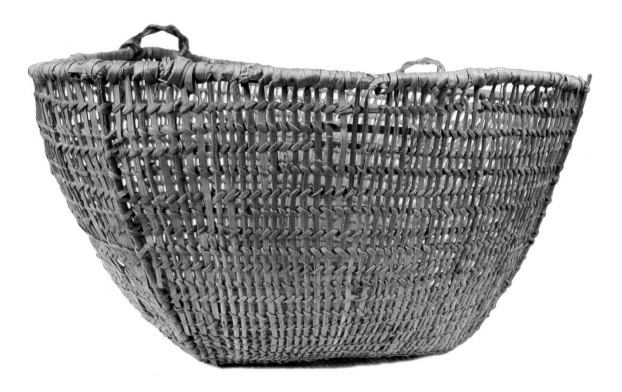

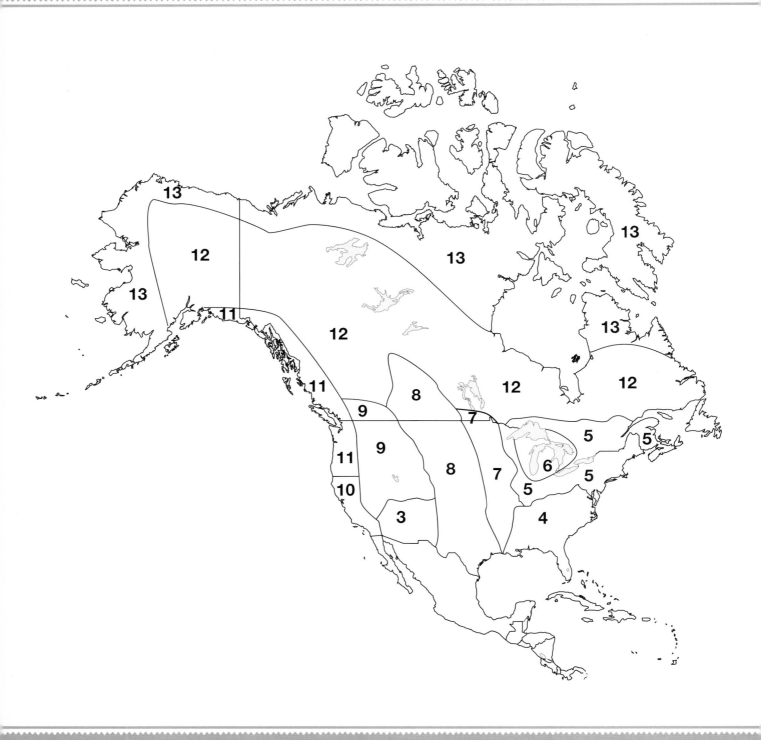

North American Indian Populations by Region

Map Key
Key Matches Chapters in Book

3 = Southwest
4 = Southeastern Woodlands
5 = Northeastern Woodlands
6 = The Great Lakes
7 = The Prairies
8 = The Plains

9 = The Plateau
10 = California
11 = NW Coastal
12 = Subarctic
13 = Arctic

1

Finding Native American Artifacts

nlike many other material cultural items from European and American societies with which collectors are familiar, Native American artifacts are much more difficult to locate for a variety of reasons including the following:

1. Scarcity of items.
2. Legal protection of items being traded.
3. A more vigorous collecting of said artifacts by numerous international, national, state, regional and local museums and historical societies.
4. Frailties of the items themselves, as most were made of organic materials.
5. A more limited distribution network through legitimate secondary sales.

Let's briefly examine each of these five factors.

Scarcity of Items

There is no need to attempt to construct history in this brief introduction to collecting, but it still must at least be recalled. The first European contacts of major significance (I will leave earlier explorers to someone else) was of course in three major points in what is now considered the Americas:

a. The West Indies and eventually the Southeast Coastal region
b. The Eastern Woodlands in the Northeast
c. The Southwest.

In each of these regions, the Europeans' early contact left significant cultural footprints, and in the Northeast, did the greatest immediate cultural damage leading to a large scale decay of traditional societies and destruction of significant amounts of material culture, in addition to carrying out relocation and ultimately causing cultural disintegration.

I am not covering the West Indies per se in this volume, but this area's traditional culture was also largely decimated in the early years of the European migration and discovery periods. Fewer imprints were initially made in the Southeastern United States, as the occupation was primarily exploratory in nature and not long-lived until a much later period. Thus, traditional cultures and their material culture survived more than in the Northeast.

The Southwest had a similar experience to the Southeastern United States, with the exception that missionaries influenced the area much earlier, and some significant agricultural practices were borrowed from the Europeans that had a major impact on native cultural practices, namely the raising of sheep and the harvesting of wool. The wool later led to one of the most significant and recognizable of all Southwestern artifacts, the beautiful woven blankets.

Later, the introduction of horses created another cultural revolution coming in from the Southwest and changing Plains culture forever as well. One major difference between the Southwest and artifact survival compared to other regions (except parts of the Intermountain and California regions) is the climate. Due to the arid climate, artifacts had a greater tendency to survive into the current period. In addition, the pottery techniques of the region were more developed and highly honed compared to many regions, which contributed to the larger numbers of these fragile pieces surviving into today's society.

Legal Protection of Native Artifacts

I began my career in archaeology and anthropology in 1968 as a student at a major university by participating in my first "dig." Within three years, I was leading digs throughout the Midwest and Great Lakes regions each summer for about a dozen years. In 1968

there were few, if any, laws in most states to protect the cultural heritage of our native societies. Along with the Red Power movement, and the Civil Rights movement in general, came a better understanding of the importance of these sites and the related artifacts by all parties concerned, including state and national legislators. Now we have artifact preservation laws in nearly every state or territorial jurisdiction and at the federal level.

As a professional in the field, to me this is a good thing. However, it certainly has changed the difficulty level of finding artifacts on the "open market," as their legal status has indeed changed from items freely traded to items controlled by a variety of laws.

Vigorous Collecting of Artifacts

Native American material culture has not only fascinated newcomers to America but it has also captivated peoples the world over. This intense interest has been translated to large scale early and ongoing collecting of Native American artifacts worldwide by scholarly bodies including museums, ethnographic societies, and universities. I have been fortunate enough to travel throughout Europe, and one of my early surprises as a scholar was the extensive holdings of Native American artifacts in even the smallest regional museums in many countries. I vividly recall one I visited in rural Holland that shocked me concerning the completeness of its collection, most of which was, of course, stored out of sight of the average museum attendee. Collections such as this are actually commonplace throughout the world, and this has led to a scarcity of these items being traded.

Frailty of Items

Many of the material cultural items used by Native Americans—with the exception of stone tools and weapons—were very frail due to the organic nature of the objects. Of course, there were exceptions, such as the copper items made in the northern region of the Great Lakes in what is now Michigan's Upper Peninsula, stone tools and weapons, obsidian points found from both pre-historic and historic periods, certain early trade items made of iron and later steel, glass beads, other trade items, etc. But, for the most part, items of reed, cloth, bark, low fire ceramics and other organic materials cannot be expected to survive the test of time, especially in the areas east of the Mississippi River where the ravages of heat, cold, and moisture quickly ruin such items if not protected from the weather. Again, the arid regions of the Southwest have the advantage for preserving cultural heritage, due to the climate and lack of population pressure until relatively recent times.

Limited Distribution of Items

The preceding four factors have led to a relatively small group of major auction houses handling the vast majority of items that do come up for sale in the legitimate market, the only one with which I am concerned. This book would not have been possible without the great cooperation of the four auction houses referred to in my acknowledgments, and most items would not be sold unless passing through their doors. It is difficult indeed to go to the usual online sources such as eBay or Yahoo auction sites and find items that are both authentic and legitimately for sale. It does happen, but it is rare compared to artifacts from American society or even 17th century European society.

Summary

In sum, it is far more difficult to find these items than most, for at least the five reasons discussed above. However, it is still possible to find some types of Native American items through the traditional sources of online auctions, auction houses in local communities, antique stores and malls, flea markets, trading meetings, estate sales, and similar venues. Add to this the recent articles available at "Pow Wows," and one still has an opportunity to add to a collection. The most likely items to find in the above ways would be items made of stone, chert, flint, obsidian, and copper. Most organic materials will not have survived the rigors of a marketplace unless they were recently released from some estate or collection and their value was unknown to the previous owner.

Another problem, of course, with finding items on the "open market" is the great possibility of intentional fraud on the part of the seller. I know how to make a flint projectile point, as do most who have worked in the field of American archaeology for any period of time. I even know how to make points from a particular region or cultural type. Of course, I would never sell one of these, but many would be happy to sell a point made in his/her garage for a decent price. So, caveat emptor—let the buyer beware—doubly applies to transactions involving Native American pieces.

That is the beauty of buying from one of the auction houses previously mentioned; often provenance in not only given, but significant documentation is frequently available proving the item's origin and legitimacy. When paying hundreds of dollars for an item, this is no small thing. I also have a potter friend who can turn out Woodland-type pots with ease and know of more than one basket maker who can duplicate many "native" baskets. Therefore, this problem is a real one and one of which the collector must be aware. Remember the old saying: "To be forewarned is to be forearmed."

I will end this discussion on fraud on a more humorous note. My wife and I were recently watching an interesting program on the History Channel about modern looting of major archaeological sites around the world. A solution that a former colleague of mine devised came to mind. He was excavating a major Hopewellian site here in the Great Lakes that was located within an urban area. This led to many visitors due to press coverage of the events and the obvious nature of the large mounds that the locals all knew about (and could see from a freeway).

Many of these visitors wanted a souvenir from the site and would prod around attempting to find a fragment of pottery or some other item that, of course, was valuable to building a knowledge base about the culture. Therefore, in an effort to thwart both looting and innocent interruptions, my colleague came up with the idea of offering a basket of "mound rocks" for onlookers to take. He simply went to the riverbed each morning and filled a small basket of rocks and put up a sign on a tree that said: "Mound Rocks, please take just one". People were happy, as they could leave with a piece of "cultural heritage" from a local dig. One lady was caught trying to leave with two "mound rocks" and had to put one back!

What my wife and I were discussing is the possibility of one of these "mound rocks" now coming down to the third generation from the time when this happened and ending up on eBay as Hopewellian Mound Rocks! What started as a prank to trick the onlookers of a major site may turn out to be an innocent hoax on some current buyer. So, the point is simple; not all frauds are intentional. There are many items that are fake, or at least not of the origin believed by their owners, due to the role of folklore, mythology, and traditional stories that are not based in fact. Therefore, if you are offered a "mound rock" you may want to forego that opportunity!

> Remember the old saying: "To be forewarned is to be forearmed."

2

Regional Cultural Variations

gain, this is not meant to be a text on Native American societies or cultures; it is, rather, a pricing guide on their artifacts commonly traded in today's society through legitimate sources and outlets. Many of my readers will already have a vast and thorough knowledge of Indian culture, history, and societies. However, for the newcomer to this field of collecting, at least a few words are in order to help understand the organization of this book.

Scholars do not agree on anything. I say this with the authority of a scholar with 36 years teaching and research experience at the university level. However, there is a general scheme of geographical areas concerning Native American cultures with which most of us at least partially agree. The problem is that Native American culture was far more complex than European descendants realized and the ethnocentrism of those descendents became an impediment to understanding how vastly different a group could be within the same general geographical region.

Native American society actually consisted of hundreds of linguistic groupings and concomitant cultural groupings. However, the normally recognized regions will suit our needs, and the major auction houses use these regions to organize goods for sale. Therefore, we should follow that tradition in my opinion. I only ask the reader to recognize that, in reality, it is far more complex than breaking North America up into a dozen cultural regions. I would also suggest buying any major current textbook on Native American society to have a more complete understanding of the cultural, social, and linguistic complexity of native peoples in North America.

One more word is in order about my selections. I have purposely not included Central or South American artifacts for a couple of reasons. It is my belief that most North Americans are far more interested in learning more about our own cultural heritage, which was held by Native Americans of our lands, and I know far more about the ethnography of North America than I do of Central and South America.

I also feel, after visiting many of the famous sites in Central America, that there is much more opportunity for fraud, looting, and other nefarious activities related to cultural artifacts and thus want to stay away from discussing them. Many wonderful artifacts are to be found from both Central and South America, and the auction houses mentioned above sometimes also offer them for sale with some provenance to establish authenticity, with the greatest amount of items coming from what is today Mexico. However, I shall leave a book on said items to another author and another time.

So, with the above in mind, I have organized this book according to some broad geographical regions well recognized in both anthropological circles and the collecting fields and then divide each region further into material cultural type, such as pottery, basketry, clothing, etc. I have begun with the Southwest due to the early contacts by Europeans and, more importantly, due to the large part the region has played in offering items of interest to collectors.

Some regions, such as the Southwest, have hundreds of items shown in this book due to the number of items available for trade and sale and the demand by collectors for said items. Other regions, such as the Northeast Woodlands will have far fewer items shown due to their fragility, scarcity, and general lack of availability in the marketplace. The book has relatively few "prehistoric" items for reasons related to their legal status and scarcity.

> **It is my belief that most North Americans are far more interested in learning more about our own cultural heritage.**

In addition, the book has few items related to stone and projectile points, as these texts have been well done by many others and are available as both scholarly and collecting guides elsewhere. This book concentrates on pieces that were sold at public auction within the past two years to give both a sense of what is available to collect and the actual pricing of these items.

The regions used in this book are, in order of presentation, Southwest, Southeastern Woodlands, Northeastern Woodlands, Great Lakes, Prairie, Plains, Plateau (Intermountain West), California, Northwest Pacific Coastal, Subarctic, and Arctic. Obviously this could be refined to include major river valleys and prehistoric periods, but I am not doing so in this reference book on artifacts.

If an artifact type is restricted to a particular sub-cultural region or time period, it is so noted, e.g. Ohio River Valley Hopewellian period, etc. In addition, it becomes very difficult to pigeon-hole certain cultural groups such as the Apache, who became far more mobile with the introduction of the horse and in essence were Southwestern, becoming at times Southern Plains and even to a degree Plateau. Thus, my placement in one particular region may not agree with that of yours or a particular auction house; it will, however, at least serve as a point of reference for locating items from a particular culture.

The categories used in this book for material cultural items are quite standard and include such categories as pottery; basketry; clothing; woven goods such as blankets in the Southwest; ceremonial items; weaponry; utilitarian items of stone, copper, iron, and steel; American artifacts given to groups, such as peace medals; American and European trade goods including beads, artwork, and

This book concentrates on pieces that were sold at public auction within the past two years to give both a sense of what is available to collect and the actual pricing of these items.

so on. Not all categories are represented in all regions, but if an item is known to have been recently traded from a region in any particular category, it is included. The categories are presented alphabetically.

Following in this chapter, I introduce the reader to the types of items by category, using images that sometimes contain items from multiple cultural regions that will serve as a good beginning essay on the wide array of items available to the collector of Native American items and also give a flavor of the regional cultural differences among our native peoples and their material culture.

Then the book is divided into separate chapters for each cultural region and the items recently sold from a particular society within that region, or the item is from that particular region even if the specific culture cannot be identified with any certainty.

Provenance of items is mentioned when appropriate. When exact provenance is not known, please keep in mind that each of the auction houses from which items have been selected have professional anthropologists and historians who have examined these items for their authenticity and cultural traits and have based their decisions on many years of experience working in this field. I have not usurped their authority or opinion as to a particular item in any case. I may add a bit of caution here or there and at times place a society in a different region, but that is only a matter of my professional opinion based on my own experience and should not detract from an item's description as presented.

Again, my thanks are extended to the staff, owners, and researchers at Allard Auctions, Cowan Auctions, James D. Julia Auctions, and Skinner Auctions for all of their service and the contributions of thousands of images for this work and the use of catalog descriptions and realized prices to make this the most current and up-to-date book on Native American artifacts.

I have now completed over 15 books dealing with collectible and antique items related to material culture, and I can state with certainty that I have never met nicer people with whom to work in my entire writing career. These folks gave freely of their images and information and asked little or nothing in return. It is wonderful to have such cooperative people willing to help inform the collecting world by sharing their knowledge and experience so freely, and I frankly cannot thank them enough, other than again say: Thank You!

Artistic Items

This category will be used in which to place items that were known to be produced primarily for what we would deem artistic purposes and will have few listings compared to most categories. However, that does not mean artistic items are limited in number, as most items created by Native Americans have artistic attributes, such as is found in the intricate designs and cultural messages incorporated in the bead work of the Plains. We could place most Southwestern pottery and blankets here as well. However, those items will have separate categories. I have also included in this category some art produced by non-natives.

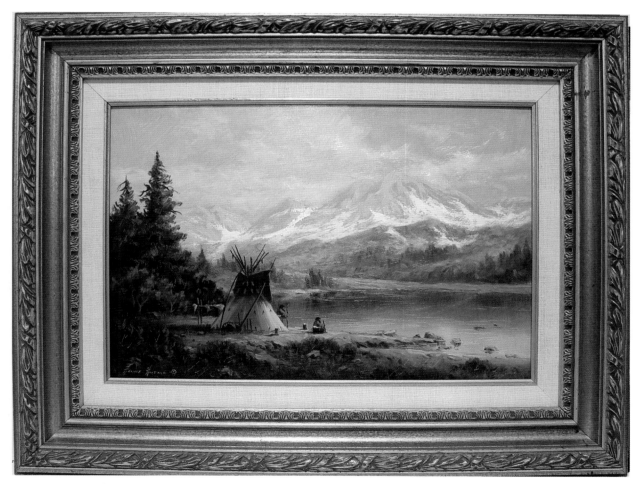

Heinie Hartwig (1937-) Original Acrylic. Beautiful encampment scene of a single tipi on Masonite, signed acrylic, 12" x 18" image, 20" x 27" framed. Allard 3-11-05 **$650.00.**

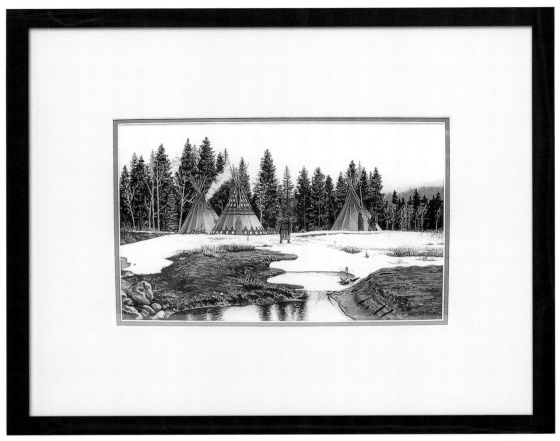

Paul Surber (1942-) Original Gouache. This encampment scene with three tipis is on Masonite with a 7" x 11" image and is 15" x 18" framed, circa 1990s. Allard 3-11-05 **$400.00**

Pony Express Original Painting, early 1900s. Unsigned original oil painting on board of a Pony Express rider or scout on the Plains, paper attached to the back reads "Painted by N.D. Hunt", image 9 3/4" x 16 1/4", framed 15" x 21 3/4". Allard 8-14-05 **$1,200.00.**

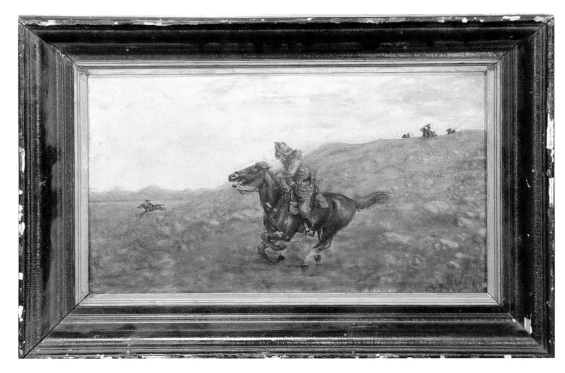

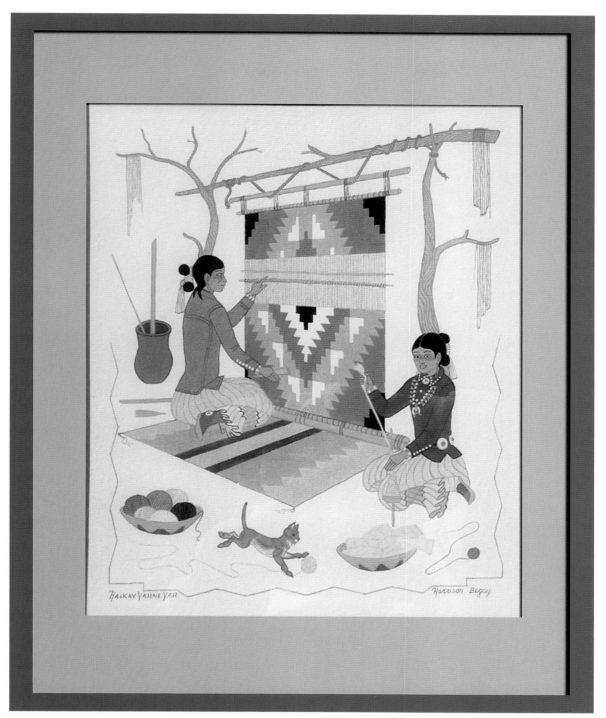

Harrison Begay (1917-) Original Art, circa 1970s. Original watercolor reservation scene entitled "Weaving the Rug and Spinning Yarn" by this well-known Navajo artist, image 12" x 14", framed 18" x 16". Allard 3-11-05 **$550.00.**

Ledger Drawing, age unknown. Cheyenne style drawing depicting two chiefs on a purple horse, found in Oklahoma, 8 1/2" x 13 1/2". Allard 3-12-05 **$150.00.**

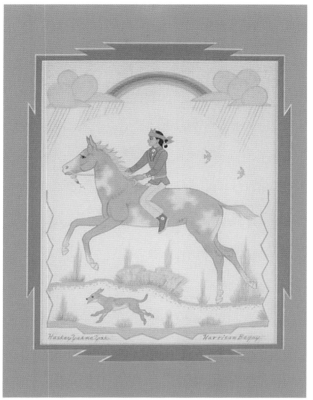

Harrison Begay Original Acrylic, 1960s. Signed original, 10" x 14" image, framed 17 1/2" x 21 1/2". Allard 8-14-05 **$600.00.**

Harrison Begay Original Acrylic, 1960s. Signed original, 10" x 13" image, framed 18" x 22". Allard 8-14-05 **$275.00.**

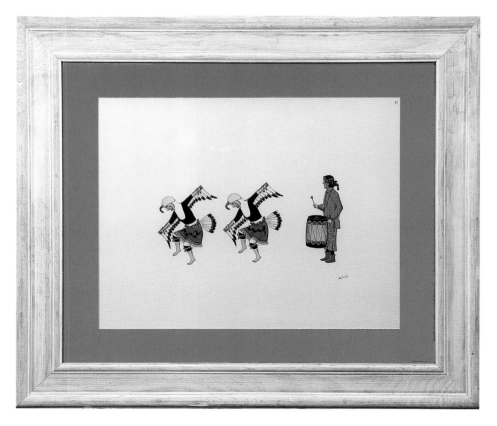

Awa Tsireh (1898-1955) 1932 Silkscreen. Matted, framed and signed silkscreen entitled "Eagle Dancers", 15" x 19" image, 25 1/2" x 29 1/2" framed. Allard 3-11-05 **$130.00.**

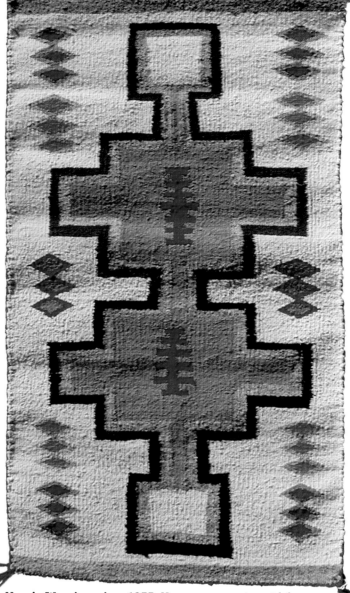

Navajo Weaving, circa 1955. Home spun weaving with large geometric symbols on a white background, 24" x 42". Allard 3-11-05 **$170.00.**

Red Mesa Navajo Weaving, circa 1955. Classic Red Mesa area style with black border on white background, 34" x 51". Allard 3-11-05 **$550.00.**

Frederick Remington "The Cheyenne", circa early 1900s. Original Alumaclad bronze by Remington, 42" x 64" x 16". Allard 8-13-05 **$650.00.**

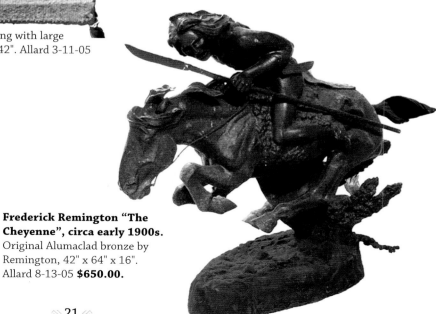

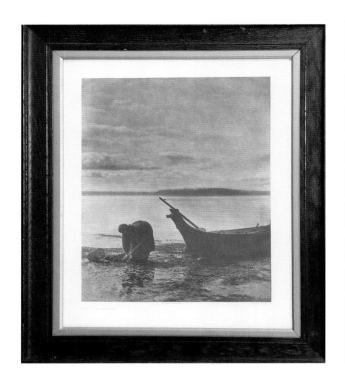

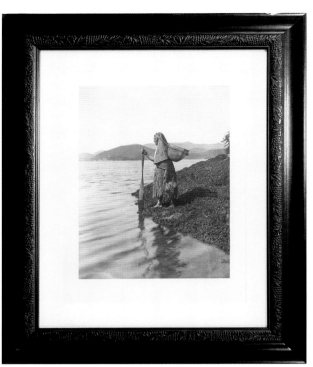

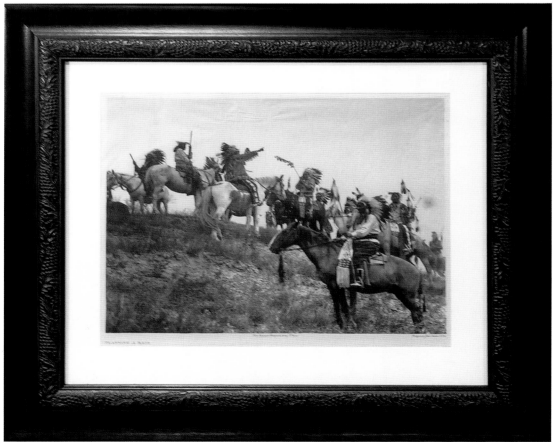

Three Curtis Photogravures, circa 1900. Two NW Coastal and one Sioux photos by Curtis, two NW are circa 1900 and Sioux is 1907. Allard 3-13-05 **$225.00-325.00 each.**

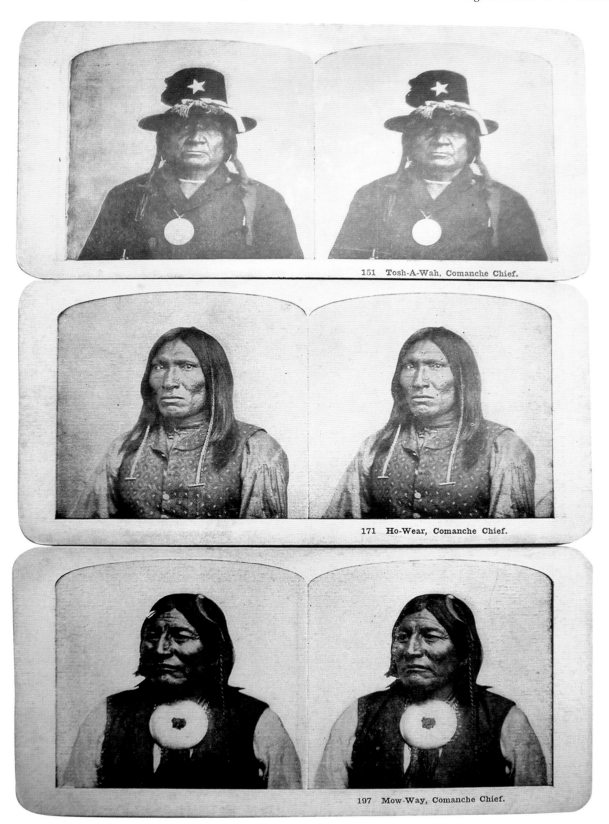

151 Tosh-A-Wah, Comanche Chief.

171 Ho-Wear, Comanche Chief.

197 Mow-Way, Comanche Chief.

Three Stereoptic Cards, circa late 1800s. Note, some of these cards of rare groups bring thousands of dollars on occasion. Allard 3-12-05 **$100.00.**

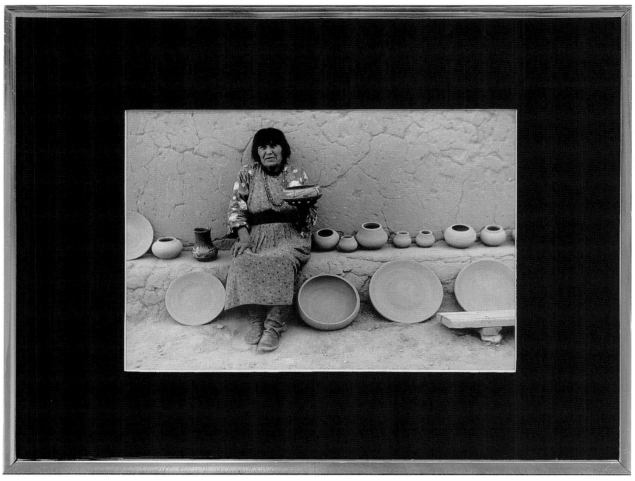

Original Photograph of Maria, Southwest Potter, mid/late 1900s. A beautiful original black and white photograph of the Southwest's most famed potter, see her examples following and in Chapter Three, 6 3/4" x 9 1/2", framed 12" x 15". Allard 3-13-05 **$500.00.**

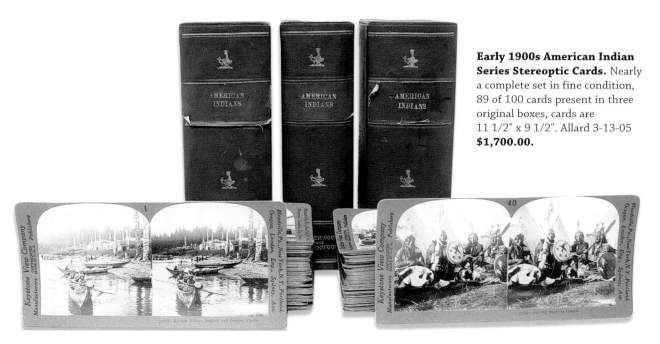

Early 1900s American Indian Series Stereoptic Cards. Nearly a complete set in fine condition, 89 of 100 cards present in three original boxes, cards are 11 1/2" x 9 1/2". Allard 3-13-05 **$1,700.00.**

Basketry

These items are items of a woven nature in the form of baskets, bowls, jars, ollas, pots, fish creels, and other basket-type items. It was an art form used for utilitarian purposes in nearly each cultural region, with it being more important in some than others. The inclusions will attempt to illustrate this difference.

It also had great cultural variations in terms of technique and materials used. The early reed duck decoys found in the Southwest are just one example of the wide variation of the types of items manufactured with natural materials using these techniques.

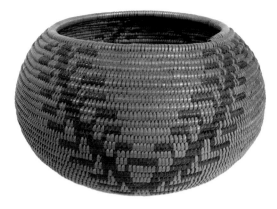

Pomo Basket Bowl, early 1900s. Fine weave basket bowl, classic topknot chevron motif, 3" high x 5" diameter. Allard 8-13-05 **$1,600.00.**

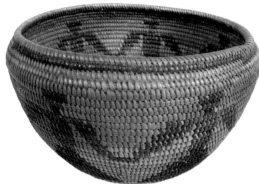

Pomo (?) Basket, early 1900s. With human friendship figures in black and dark red, 3 3/4" high x 6" diameter. Allard 8-13-05 **$1,100.00.**

BELOW: **Three Apache Basketry Bowls.**

Left: Circa 1900 coiled basketry bowl with abstract motifs and some stitch loss at rim, flared form, 3" high x 14" diameter. Provenance: Wistariahurst Museum. Skinner 9-10-05 **$822.50.**

Center: Early 20th C. bulbous form with male and female figures, positive and negative dogs and geometric designs, 6" high x 7 3/4" diameter. Provenance: Wistariahurst Museum. Skinner 9-10-05 **$11,750.00.**

Right: Circa 1900 pictorial coiled basketry bowl with seven-petal center and four-petal checkerboard, four quadrupeds and eight small triangular motifs, 2 1/2" high x 11" diameter. Skinner 9-10-05 **$940.00.**

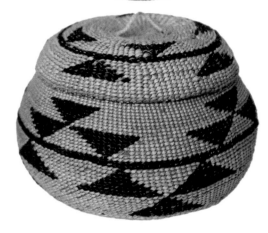

Hupa Treasure Basket, early 1900s. Lidded treasure basket in excellent shape, 4" x 5". Allard 3-12-05 **$550.00.**

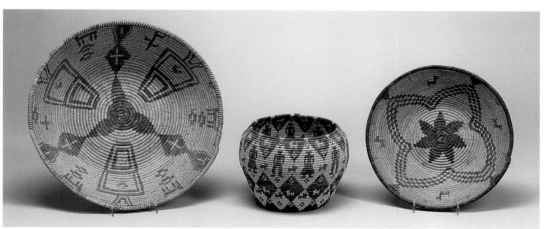

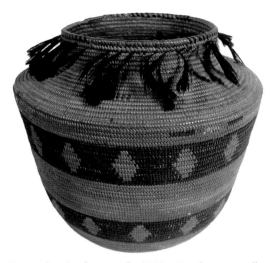

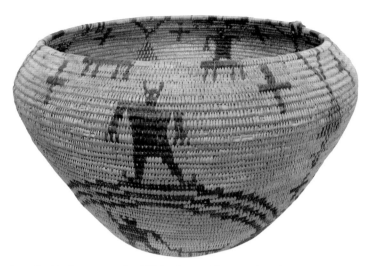

Panamint Basket, early 1900s. Finely woven olla with two rows of rattlesnake designs and original rim feathering, 5 1/4" high x 5 1/2" diameter. Allard 8-13-05 **$1,700.00.**

Apache Basketry, early 1900s. Rare wide-mouth style woven basketry vessel with human figures, crosses and other designs, 8 1/2" x 13". Allard 8-13-05 **$1,800.00**

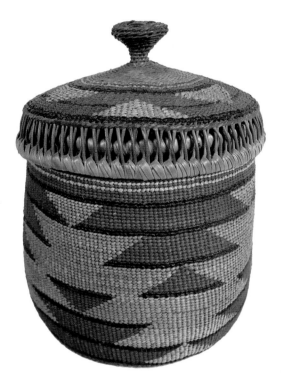

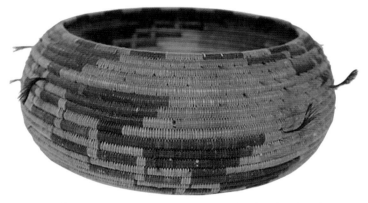

Pomo Basketry, circa 1900. Fine weave feather bowl with only a few original feathers remaining, 4" x 7". Allard 8-14-05 **$1,100.00.**

Hupa Basket, early 1900s. Very fine lidded vessel with openwork galleries, top knot handle and geometric motifs, 7" high x 5 1/2" diameter. Allard 8-13-05 **$1,000.00.**

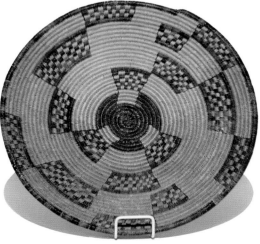

Yavapai Basketry, circa early 1900s. Boxed checks and whirlwind pattern, excellent condition, 14" x 2 1/2". Allard 8-14-05 **$3,000.00.**

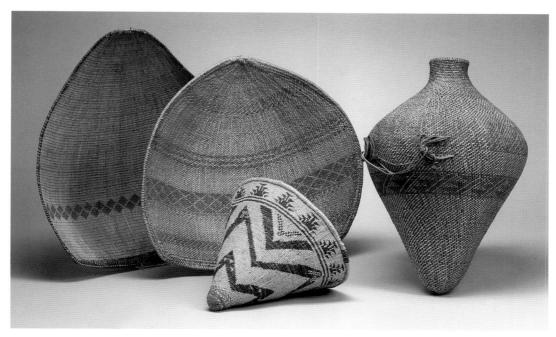

Four Twined or Basketry Items.

 Left: California twined harvest basket, possibly Yokuts, diamond motif, some minor edge loss, 23 1/2" long x 22" wide. Skinner 9-10-05 **$528.75.**

 Second item: California twined winnowing tray, Yokuts, late 19th C. Concave fan shape with geometric designs, 22" long x 21" wide. Provenance: Wistariahurst Museum. Skinner 9-10-05 **$735.00.**

 Front Center: Northern California twined burden basket, circa early 20th C., conical form with chevrons and quail feather designs, 12" high x 13 1/2" diameter. Provenance: Wistariahurst Museum. Skinner 9-10-05 **$1,116.25.**

 Right: Southwest twined basketry bottle, Paiute circa 1900, tapered form with two fiber lugs and two bands of geometric designs and some minor stitch loss, 22" high x 15" diameter. Provenance: Wistariahurst Museum. Skinner 9-10-05 **$2,350.00.**

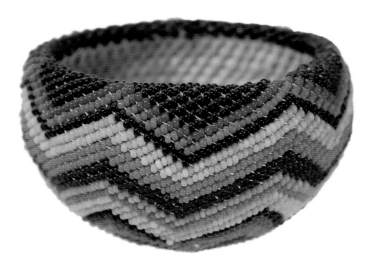

Paiute Beaded Basket, mid-1900s. Single rod woven basket with traditional fully beaded exterior designs, excellent condition, 2 1/2" high x 4" diameter. Allard 3-11-05 **$250.00.**

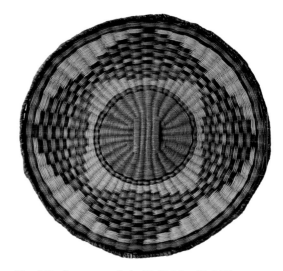

Hopi Basketry, early/mid 1900s. 13 1/2" diameter. Provenance: Thunderbird Museum collection. Allard 3-12-05 **$275.00.**

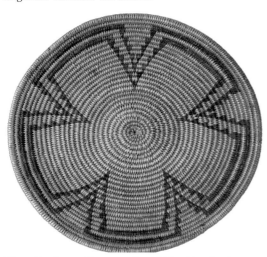

Pima Basketry Tray, early 1900s. Fine basketry tray with squash blossom design, excellent condition, 10" diameter. Allard 3-12-05 **$250.00.**

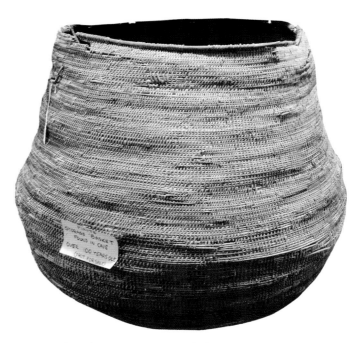

Paiute Basket, late 1800s. One of the largest woven storage baskets extant, well used with some repairable damage, 24" high x 33" diameter. Provenance: Hon-Dah Museum, Tombstone, Arizona. Allard 8-13-05 **$1,300.00.**

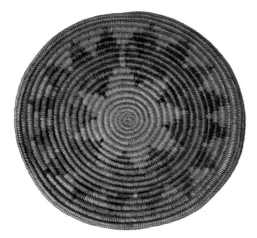

Navajo Wedding Basket, early/mid-1900s. 15 1/2" diameter. Allard 3-11-05 **$200.00.**

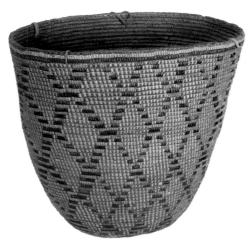

Lilooet Basket, early 1900s. Fine weave, large hard-sided basketry vessel with exterior geometric designs, 14 3/4" x 13 1/4" x 16". Allard 8-13-05 **$1,000.00.**

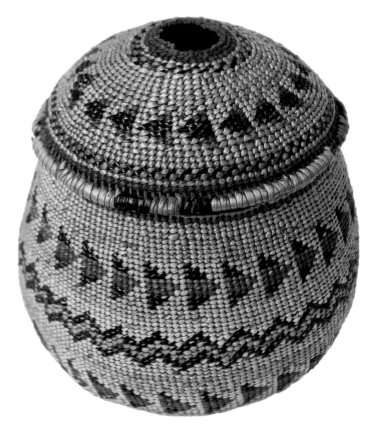

Yurok Basket, early 1900s. Lidded polychrome yarn basket, 6" x 7". Allard 3-11-05 **$600.00.**

Ceremonial and Utilitarian Items

Originally I had intended to have two categories for these listings, but the reality is that many items had a cross-over purpose and at times were ceremonial and functional or utilitarian, e.g. Plains shields being used in dance ceremonies and for warfare, or Woodland war clubs being used in warfare or to signify that the bearer was on "men's business" when carrying the club.

Also, some items such as what many scholars and collectors initially thought were ceremonial may have also been merely functional, such as "burial moccasins" with full sole beading that were actually worn and used according to many observers, historical photographs, and the wear shown on the bottom of said moccasins.

There are even some items referred to by most as ceremonial that may have indeed been merely functional items according to some researchers, such as the amulets with two holes in them that anyone who has ever worked with pottery knows can also be used to smooth pots on a wheel. Of course, Native Americans did not use a wheel but these "ceremonial" items might have been used related to the craft of pottery nonetheless. I am sure my inclusion of items in this category will cause some to dispute my choices, but again, decisions have to be made to help categorize items, and that is all I have done here.

Crow Dance Roach, early 1900s. Porcupine hair roach with red accents, 10" long. Allard 8-13-05 **$650.00.**

Hopi Gourd Rattle, mid-1900s. 14" long rattle in Mudhead form. Allard 8-13-05 **$225.00.**

Hopi Drum, circa early 1900s. Carved cottonwood drum with stretched rawhide, 6 1/2" diameter. Allard 8-13-05 **$300.00.**

Hopi Meal Rake, early 1900s. Rare hand-carved and painted cottonwood root grain rake/scoop with cloud and rain designs, 7 1/2" wide, 5 1/2" high with 12" handle. Allard 8-13-05 **$375.00.**

Rare Plains Parfleche Box, early 1900s. Painted and shaped into box form fringed rawhide parfleche, painted with American flags and other motifs, 10" x 15" x 8". Allard 8-13-05 **$2,500.00.**

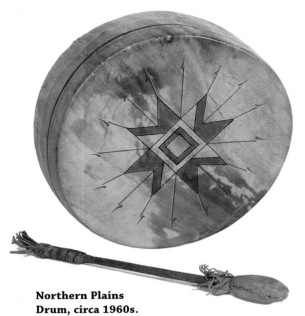

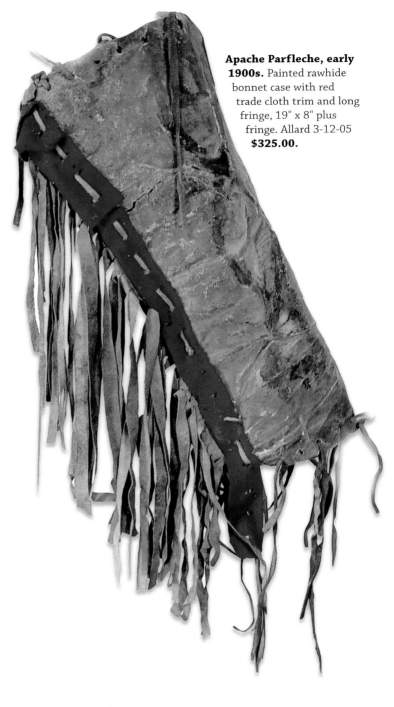

Apache Parfleche, early 1900s. Painted rawhide bonnet case with red trade cloth trim and long fringe, 19" x 8" plus fringe. Allard 3-12-05 **$325.00.**

Northern Plains Drum, circa 1960s. Rawhide gaming drum with stretched rawhide, handle on back, geometric design and drumstick, 4" thick x 11 1/2" diameter. Allard 8-13-05 **$200.00.**

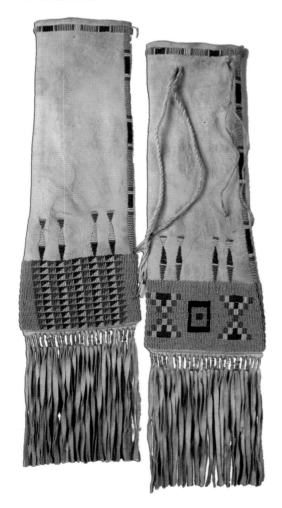

Arapaho Pipebag, early/mid 1900s. Pristine example of a sinew sewn, native tanned buckskin pipebag, beaded on both sides and terminated with quilled fringe, 6" x 23" long. Provenance: formerly property of Niagara Falls Museum. Allard 3-11-05 **$3,250.00.**

Three Peyote Religion Items, mid-1900s. One traditional feather dance fan, one beaded gourd rattle, and one dance wand with wrist loop and tin cones, all from the Southern Plains Region. Allard 8-13-05 **$375.00.**

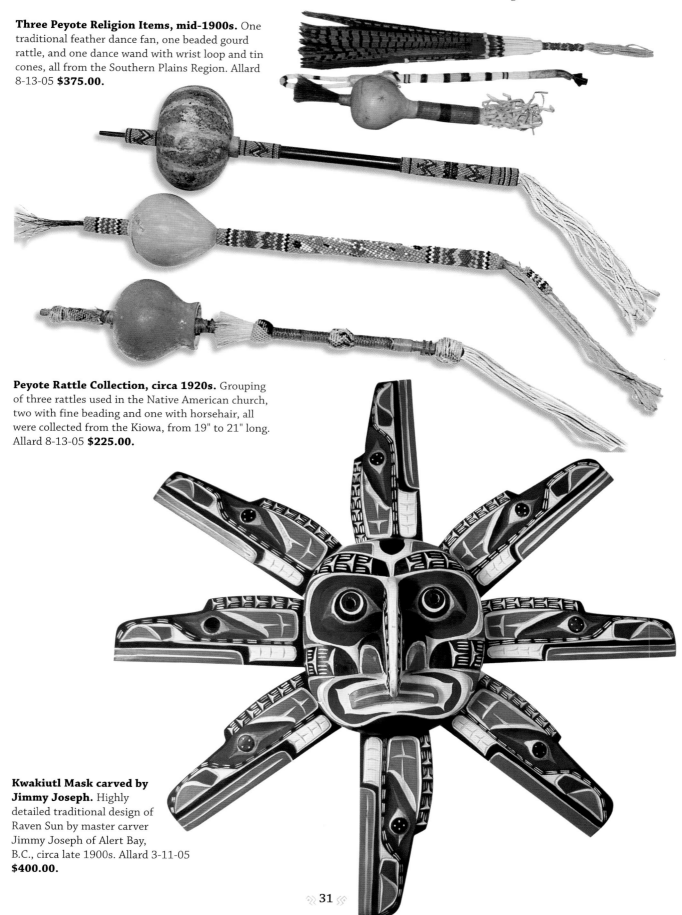

Peyote Rattle Collection, circa 1920s. Grouping of three rattles used in the Native American church, two with fine beading and one with horsehair, all were collected from the Kiowa, from 19" to 21" long. Allard 8-13-05 **$225.00.**

Kwakiutl Mask carved by Jimmy Joseph. Highly detailed traditional design of Raven Sun by master carver Jimmy Joseph of Alert Bay, B.C., circa late 1900s. Allard 3-11-05 **$400.00.**

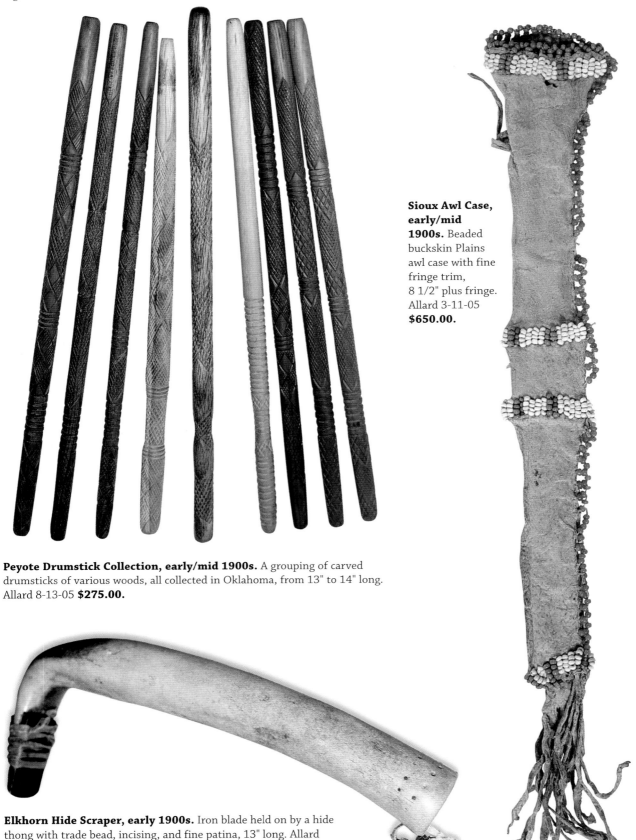

Sioux Awl Case, early/mid 1900s. Beaded buckskin Plains awl case with fine fringe trim, 8 1/2" plus fringe. Allard 3-11-05 **$650.00.**

Peyote Drumstick Collection, early/mid 1900s. A grouping of carved drumsticks of various woods, all collected in Oklahoma, from 13" to 14" long. Allard 8-13-05 **$275.00.**

Elkhorn Hide Scraper, early 1900s. Iron blade held on by a hide thong with trade bead, incising, and fine patina, 13" long. Allard 3-11-05 **$325.00.**

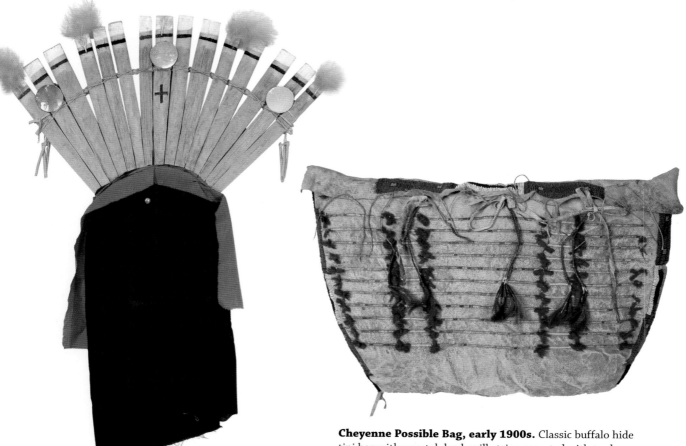

Apache Headdress, mid-1900s. Ceremonial Devil Dancer's headdress of carved wooden slats and black and red cotton cloth cowl, 23 1/2" x 31". Allard 8-13-05 **$375.00.**

Cheyenne Possible Bag, early 1900s. Classic buffalo hide tipi bag with vegetal dyed quill strips accented with trade wool tufts, sinew sewn beaded panels and tin cones with horse hair, 15" x 23". Allard 3-12-05 **$2,750.00.**

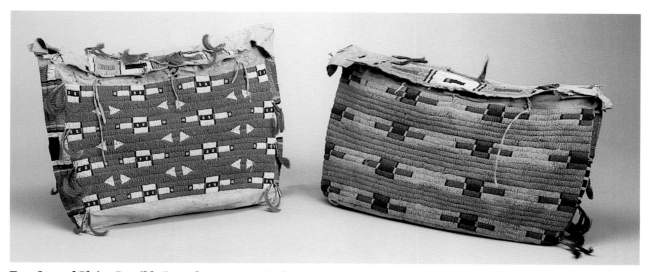

Two Central Plains Possible Bags, last quarter 19th C.
　　Left: 19 1/2" example of a Cheyenne possible (or tipi) bag made of buffalo hide trimmed in red dyed horsehair and cone danglers. Skinner 1-29-05 **$4,113.00.**
　　Right: Another Cheyenne bag made of hide and trimmed in horsehair with danglers, 22 1/2" long. Skinner 1-29-05 **$5,288.00.**

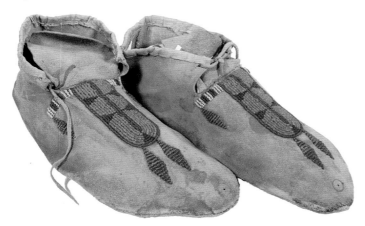

Beaded Moccasins, circa 1920. Sinew sewn, lazy stitch beaded moccasins with hard rawhide soles, cloth-trimmed uppers and some yellow ocher staining, 9" long. Allard 8-13-05 **$650.00.**

Beaded Moccasins, Likely Plateau, early 1900s. Sinew sewn, beaded moccasins with traditional white outlined floral designs, buckskin ties, and cloth trimmed uppers, 9 1/2" long. Allard 8-13-05 **$550.00.**

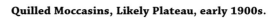

Clothing

This category includes obvious clothing and pouches, purses, belts, buffalo robes, moccasins, and other items of dress or utilitarian use related to daily activities that best fit under clothing.

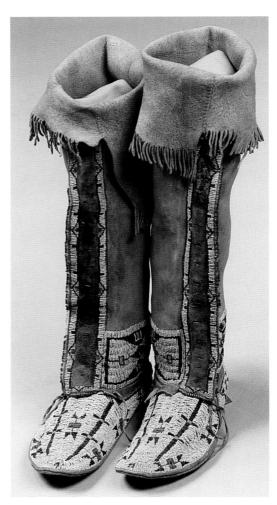

Southern Plains Arapaho Beaded High-Top Woman's Moccasins, circa last quarter 19th C. Stained yellow and green with fringe at top and fully beaded lowers and partially beaded uppers, some bead loss, 23" high. Provenance: Collected during the 1889 Oklahoma Land Rush by Fred H. Reed, and descended in his family. Skinner 1-29-05 **$11,163.00.**

Quilled Moccasins, Likely Plateau, early 1900s. Sinew sewn on elk or buffalo hide moccasins with fully quilled "Chevron" uppers and cotton cloth trim (may have been added later), 10 1/2" long. Allard 8-13-05 **$1,500.00.**

Five Pairs of Moccasins

Top central: Plateau beaded hide moccasins, circa early 20th C., 9" long. Skinner 9-10-05 **$205.63.**

Central Left: Woodlands pictorial beaded hide moccasins, circa 1900, design made with metallic and period glass beads, not from this region. Skinner 9-10-05 **$183.75.**

Central Right: Eastern Plains (Dakota), circa third quarter of 19th C. Skinner 9-10-05 **$336.88.**

Lower Central: Two pairs of child's moccasins, Arapaho, circa 1900. Provenance Wistariahurst Museum; C. H. Strawbridge. Skinner 9-10-05 **$1,175.00.**

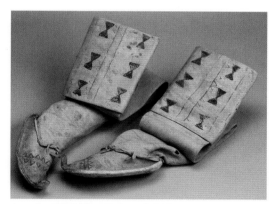

Apache High-Top Painted Hide Moccasins, circa last quarter 19th C. Long soft hide forms with rawhide soles and "cactus kicker" toes. Painted on the down-turned cuffs and vamps with black, yellow and red geometric motifs, 41" high. Provenance: The Charles and Blanche Derby collection. Skinner 1-29-05 **$5,288.00.**

Shoshone Moccasins, mid/late 1900s. Large white buckskin high top moccasins with saddle leather soles and beaded geometric designs, 10" x 11". Allard 3-11-05 **$120.00.**

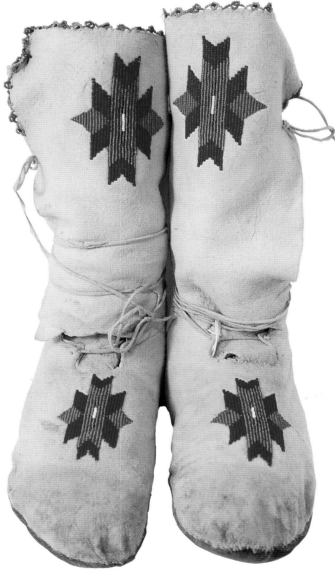

Three Beaded Pouches
　　Left: Southwest pictorial beaded pouch, Apache, circa late 19th C., 9". Skinner 9-10-05 **$1,997.50.**
　　Center: Southwest beaded pouch, circa 1900, Apache, 6". Skinner 9-10-05 **$1,175.00**
　　Right: Plateau pictorial beaded pouch made of commercial leather, 8", circa late 19th C. Skinner 9-10-05 **$822.50.**

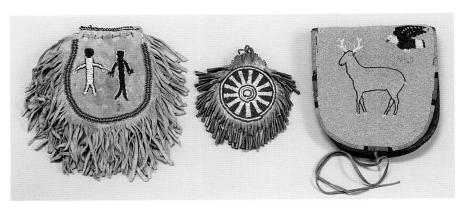

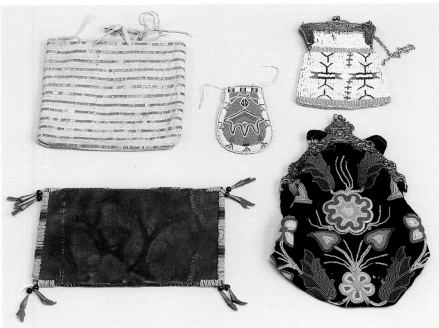

Five Bag/Pouch Examples, various cultures.
　　Top Left: Central Plains quilled hide bag, late 19th C., 7 1/2" x 8". Skinner 1-29-05 **$411.00.**
　　Bottom Left: Plains commercial leather beaded pouch, last quarter 19th C., 10" long. Skinner 1-29-05 **$558.00.**
　　Center: Plains beaded hide pouch, circa late 19th C., 4 5/8". Skinner 1-29-05 **$764.**
　　Top and Bottom Right: Two beaded handbags, top is a Central Plains example and lower is a Great Lakes example black velvet bag with a commercial clasp, largest is 10". Skinner 1-29-05 **$382.00.**

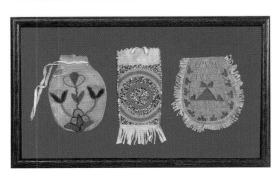

Three Beaded Pouches, Framed, early/mid 1900s. Plains, Plateau, and Woodlands, all beaded buckskin, bags are from 2 3/4" to 4" wide and 5" to 5 1/2" long. Allard 8-13-05 **$800.00.**

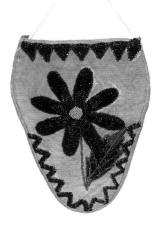

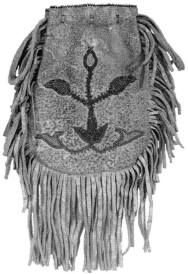

Two Plains Pouches, circa mid-1900s. 4" x 7" and 8 3/4" x 6". Allard 8-13-05 **$325.00.**

Five Plateau Examples of Pouches/Bags.

Top Left: Plateau pictorial beaded cloth pouch, first quarter 20th C., 9 1/2". Skinner 1-29-05 **$1,116.00.**

Top Center: Plateau beaded hide and cloth pouch, circa 1900, 13 1/2". Skinner 1-29-05 **$1,998.00.**

Top Right: Plateau beaded commercial leather and hide pouch, early 20th C., 8 1/2". Skinner 1-29-05 **$881.00.**

Bottom Left: Pictorial beaded saddlebag, circa 1900, single commercial leather saddlebag with hide covered flap, 12 1/2". Skinner 1-29-05 **$2,350.00.**

Bottom Right: Pictorial beaded hide bag, circa 1900, 11". Skinner 1-29-05 **$1,528.00.**

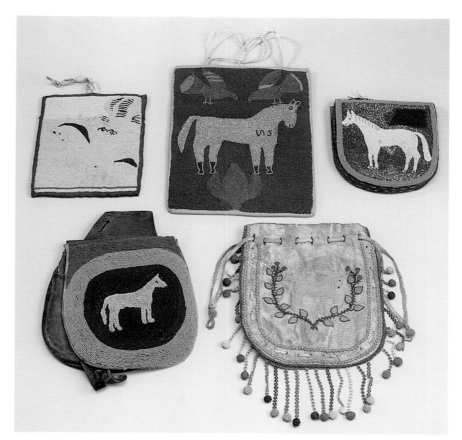

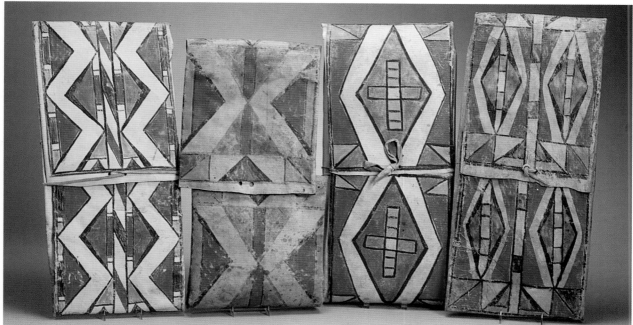

Four Plateau and Plains Parfleche Envelopes.

Left: Plateau polychrome parfleche envelope, circa early 20th C., 26 1/2". Skinner 1-29-05 **$1,293.00.**

Second from left: Northern Plains polychrome parfleche envelope, late 19th C., 25". Skinner 1-29-05 **$1,175.00.**

Third from left: Plateau polychrome parfleche envelope, late 19th C., 27". Skinner 1-29-05 **$2,115.00.**

Right: Northern Plains painted parfleche envelope, Crow, late 19th C., 28". Skinner 1-29-05 **$2,820.00.**

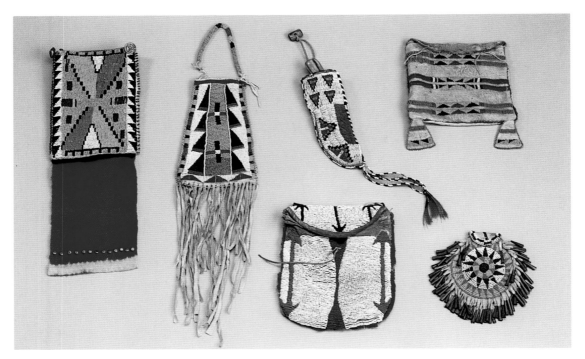

Six Bag/Pouch Examples, Various Cultures.
 Left: Assiniboine (?) Northern Plains, circa late 19th C., 15 1/2". Skinner 1-29-05 **$1,410.00.**
 Second from left: Crow Northern Plains, circa late 19th C., 18". Skinner 1-29-05 **$2,468.00.**
 Top Center: Central Plains, Cheyenne, hide knife sheath, last quarter 19th C., 13" long, and knife marked "Askhan & Mosforth Sheffield". Skinner 1-29-05 **$1,880.00.**
 Bottom Center: Northern Plains beaded hide pouch, third quarter 19th C. (bullet pouch?), 8". Skinner 1-29-05 **$999.00.**
 Top Right: Small Northern Plains beaded hide possible bag, Crow, last quarter 19th C., 8 1/4". Skinner 1-29-05 **$1,763.00.**
 Bottom Right: Southwest beaded hide pouch, Apache, last quarter 19th C. in sunburst pattern with tin cone danglers, 6". Skinner 1-29-05 **$1,410.00.**

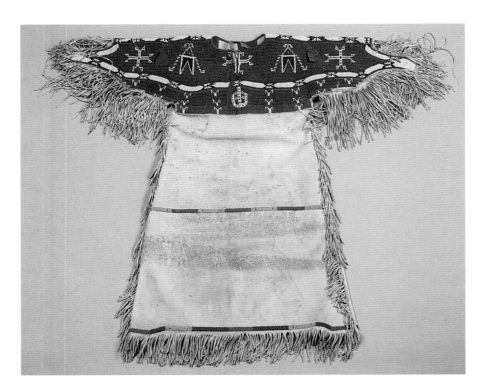

Central Plains Beaded Cloth and Hide Girl's Dress, Lakota Sioux, first quarter 20th C., 40" long. Yoke is fully beaded and reinforced with red and white striped canvas, which is possibly part of an American flag, fringed with additional bead trim on lower dress, some minor hide damage and bead loss. Skinner 1-29-05 **$3,819.00.**

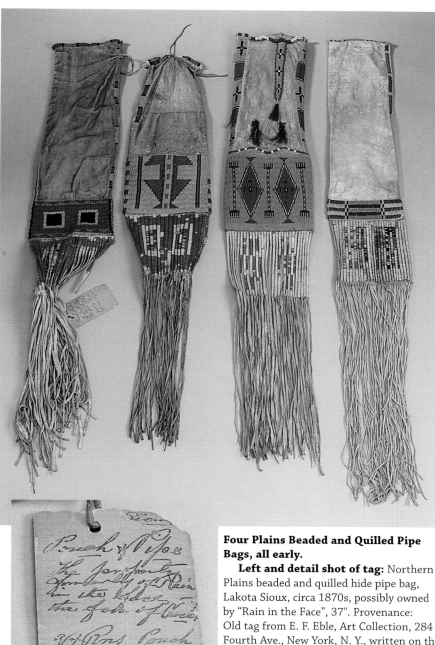

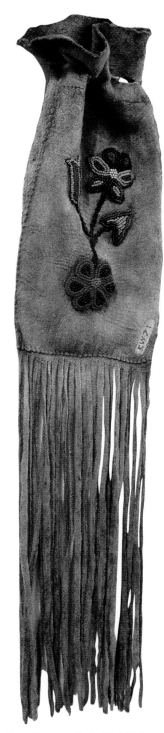

Four Plains Beaded and Quilled Pipe Bags, all early.

Left and detail shot of tag: Northern Plains beaded and quilled hide pipe bag, Lakota Sioux, circa 1870s, possibly owned by "Rain in the Face", 37". Provenance: Old tag from E. F. Eble, Art Collection, 284 Fourth Ave., New York, N. Y., written on the back "Sioux Pouch and Pipe. The property formerly of Rain in the face-the foe of Custer." Skinner 1-29-05 **$12,925.00.**

Second from left: Central Plains, Lakota Sioux, late 19th C., 33". Skinner 1-29-05 **$2,233.00.**

Third from left: Central Plains, Lakota Sioux, last quarter of 19th C., 36". Provenance: The Charles and Blanche Derby collection. Literature: *Eye of the Angel, Selections from the Derby Collection*, White Star Press, 1990. Exhibitions: George Walter Vincent Smith Museum, Springfield, Massachusetts, October 27, 1991-January 5, 1992. Skinner 1-29-05 **$19,975.00.**

Right: Central Plains, Lakota Sioux, third quarter 19th C., 39". Skinner 1-29-05 **$9,440.00.**

Cree Bag, early/mid-1900s.
Heavyweight moosehide ladies bag, thread sewn, with long fringe and contour beaded foliate designs, 26" x 5 1/2". Allard 3-11-05 **$325.00.**

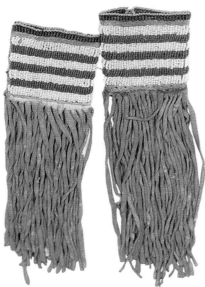

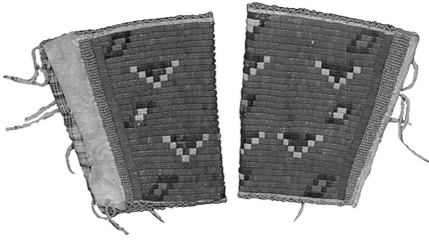

Plains Child's Cuffs, circa early 1900s. Quilled dance cuffs on thread sewn buckskin with tie closures, beaded trim and geometric designs, 6 1/2" x 5 3/4". Allard 8-14-05 **$800.00.**

Sioux Hair Ties, circa 1900s. Sinew sewn and lazy stitch beaded hair ties in white and red (whiteheart) beaded bands, blue accents and long fringe, 4 1/2" x 2" plus fringes. Allard 8-14-05 **$1,600.00.**

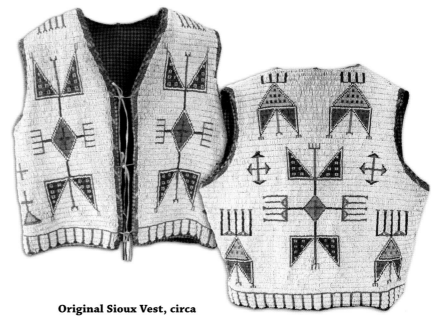

Original Sioux Vest, circa 1880s. Rare and original man's vest that is fully beaded and sinew sewn on buffalo hide in excellent condition, display stand included, 18" x 20". Allard 8-14-05 **$6,500.00.**

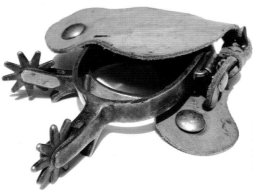

Plateau Gloves, circa 1940s. Buckskin gloves with beaded spider motif at wrist and ticked outline in black, 9" long. Allard 8-13-05 **$80.00.**

Crockett Spurs, circa 1930s. Leaf and diamond rocker work motif, hallmarked. Allard 8-13-05 **$325.00.**

Jewelry

Not every society will have extensive entries under jewelry, and we could show nothing else from the Southwest without boring our audience. It will not include items that were jewelry items made as trade goods, such as trade crosses or the trade beads, as they are placed in the Trade Goods category.

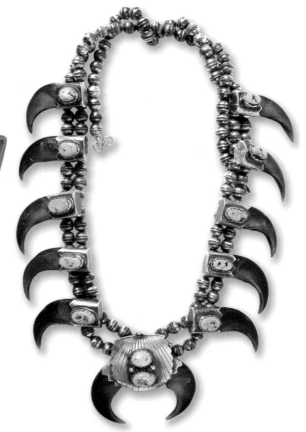

Navajo Concho Pin. Mid-1900s hand stamped repousse style Zuni/Navajo silver cluster pin with 31 individually cut turquoises, 2 1/2" x 2 1/4". Allard 3-11-05 **$120.00.**

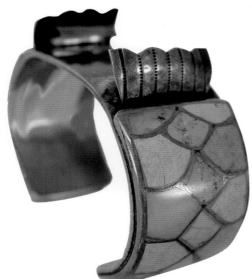

Zuni Watch Bracelet, circa 1960-70. Sterling watch bracelet with side panels of free-form turquoise inlay, unsigned, 5 1/2" x 1 1/2" with a 1 1/8" wide gap. Allard 3-11-05 **$100.00.**

Zuni Bolo Tie, circa 1960-70. Free form turquoise channel inlay on silver, 2" x 2". Allard 3-11-05 **$110.00.**

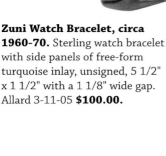

Navajo Necklace, circa 1970. Hand-wrought silver, turquoise and bear claw necklace, 28". Allard 8-13-05 **$1,100.00.**

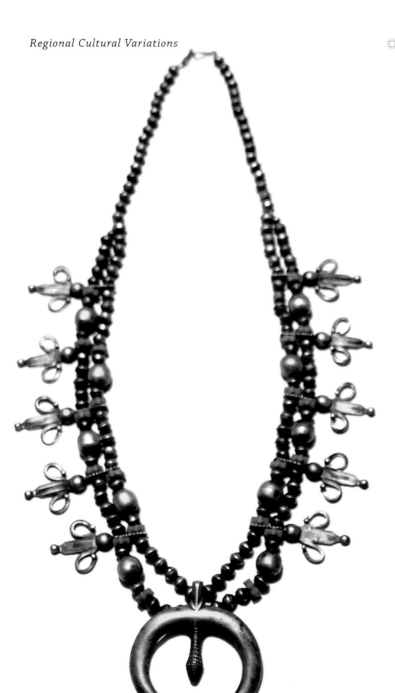

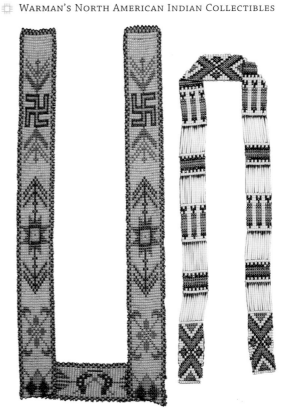

Two Apache Necklaces, circa 1915. Beaded necklaces with floral and fylfot motifs and one with geometric designs and porcupine quills, 26" and 22" long. Allard 3-11-05 **$60.00.**

Navajo Squash Blossom Necklace, circa 1920. Unusual and rare necklace with handmade beads and fleur de lies blossoms interspersed with floral glass Hubbell beads, 32" long. Provenance: Don Hoel. Allard 8-13-05 **$400.00.**

Southwest Gold/Turquoise Jewelry, late 1900s. Beautiful signed original necklace and earrings set with segments of inlaid and overlaid turquoise and coral on 14k gold, strung on hand honed beads, earrings 1 1/4" x 1" and necklace is 22" long. Allard 8-13-05 **$850.00.**

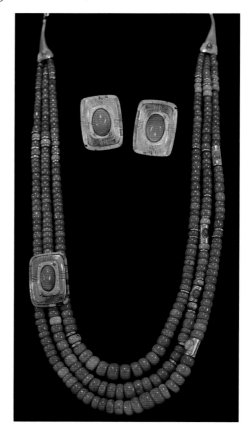

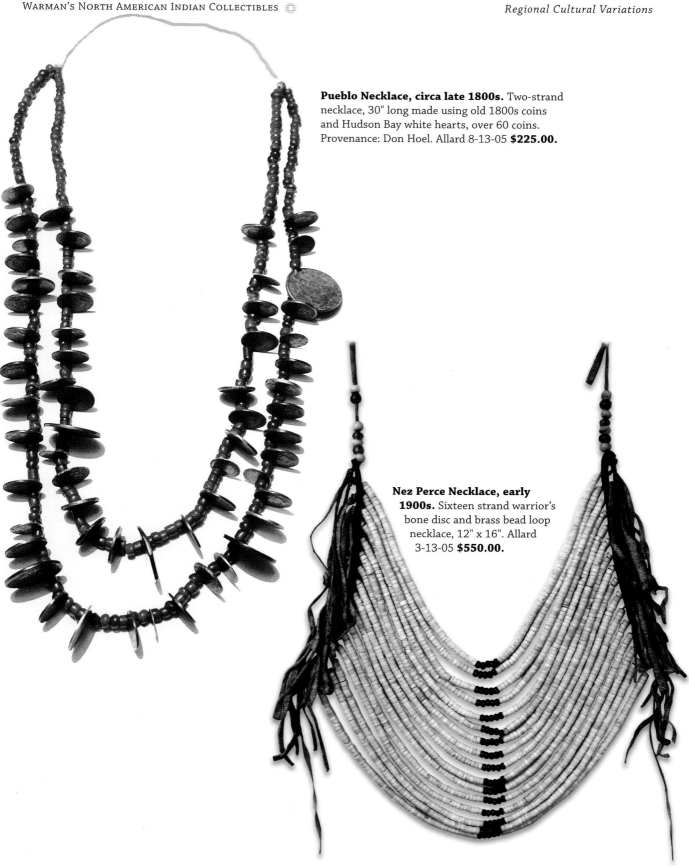

Pueblo Necklace, circa late 1800s. Two-strand necklace, 30" long made using old 1800s coins and Hudson Bay white hearts, over 60 coins. Provenance: Don Hoel. Allard 8-13-05 **$225.00.**

Nez Perce Necklace, early 1900s. Sixteen strand warrior's bone disc and brass bead loop necklace, 12" x 16". Allard 3-13-05 **$550.00.**

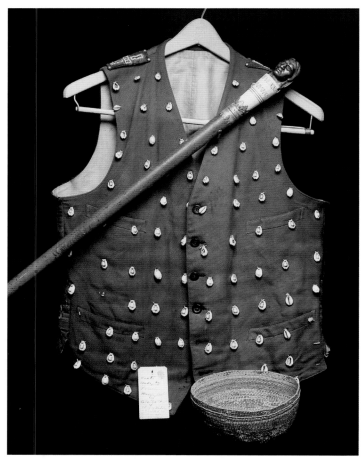

Miscellaneous

This category is reserved for items that I do not believe make a good fit for any other category I have selected or may be items related to Native American societies but not of their origin, such as a presentation cane given to an Indian Agent, or similar items.

Three items Belonging to Daniel Burns Dyer, U.S. Indian Agent, circa 1880-85. Agent for the Southern Cheyenne and Southern Arapaho tribes, Dyer collected items and donated them to Kansas City at the turn of the century. The items shown include a commercially manufactured vest with typical Plains style decorations, a decorative cane presented to him in 1885, and a basket hat typical of the Northern California tribes and being likely a Karuk female's hat. 7 1/2" diameter and 3 1/2" deep. Julia 10-05 **$3,622.50.**

Lewis & Clark Books, circa 1904. Rare set of two books by Olin Wheeler entitled *The Trail of Lewis & Clark* in excellent condition, volumes are 377 and 419 pages each. Allard 8-13-05 **$190.00.**

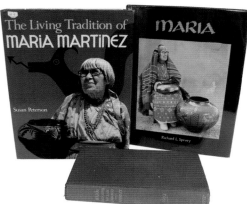

Maria Book Collection, various ages. Three books about Maria Martinez of San Ildefonso Blackware pottery fame: *Maria-The Pottery of San Ildefonso*; *The Living Tradition of Maria Martinez*; and, *Maria* by Richard Spivey. Books are respectively 136, 294 and 300 pages. Allard 8-13-05 **$90.00.**

Pouch made from Southern Plains Buckskin Dress Yoke. Formerly belonged to photographer Carl Moon, from whose collection most of the James D. Julia auction items originated that have been used in this book. This is early 20th C., as Carl changed the spelling of his name to Karl in 1917. Julia 10-05 **$460.00.**

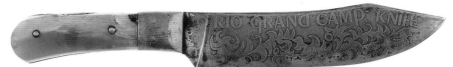

Presentation Rio Grande Camp Knife, 7" blade. Presented to the Superintendent of New Mexico Indian Affairs, A. Norton. This knife is shown on page 351 of Driebe's book about photographer Carl Moon's possessions. Julia 10-05 **$2,875.00.**

Antique Ethnology Books, circa 1900. Three volumes of *The Annual Report of the Bureau of Ethnology* covering various Native American related topics, 8" x 11 1/2". Allard 8-14-05 **$150.00.**

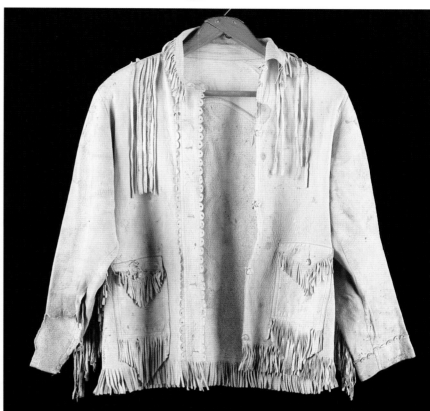

12" Gloves (gauntlets) of William F. Cody, and a Cree Scout Jacket. The gloves had provenance with letter documenting the gift of the item and the scout jacket is machine sewn in a small man's size, 27" long, shoulder to shoulder being 18". The gloves are likely Athabascan, which is properly placed in the Subarctic and the jacket is Cree, who extended from the northern Plains into the Subarctic. Julia 10-05 **$4,600.00.**

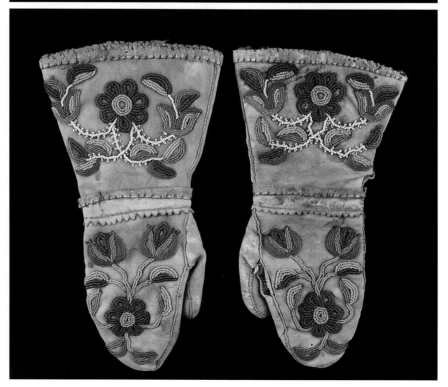

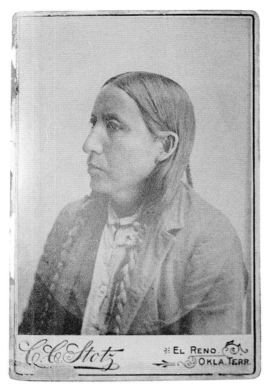

Photograph of Little Raven, Arapaho, 19th C.
Photograph of the Head Chief of the Sand Creek,
Little Raven, taken in 1864 according to the
inscription on the back by C. C. Stotz of El Reno,
Oklahoma, 4 1/2" x 6 1/2". Allard 3-11-05 **$190.00.**

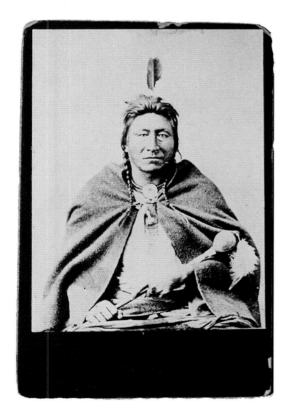

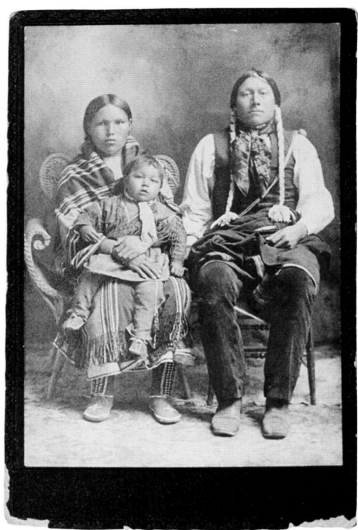

Photograph of Kiowa Bill and Family, 19th C. Photograph of
Kiowa Bill; his wife, Anegetah; and his child Kicking Eagle,
4 1/2" x 6 1/2". Allard 3-11-05 **$140.00.**

**Photograph of Chief Tommy
Hawk, 19th C.** Cabinet card of Chief
Tommy Hawk, by Welch, Mandan,
North Dakota, 4 1/2" x 6 1/2". Allard
3-11-05 **$250.00.**

Original Edward Curtis Signed Photograph Entitled "The Vanishing Race." Edward Curtis (American, 1868-1952) is one of the most famed of photographers documenting early Native American history through his work. This photo is signed with the original descriptive label placed on the back by Curtis, 5 1/2" x 7 1/2". Skinner 9-10-05 **$2,115.00.**

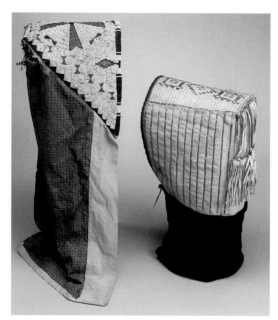

Two Cradle Covers, late 19th C.
Left: Central Plains, Cheyenne, triangular form with Morning Star pattern beaded over head, 34" long. Skinner 1-29-05 **$3,819.00.**
Right: Quilled Lakota Sioux example, 27". Skinner 1-29-05 **$2,703.00.**

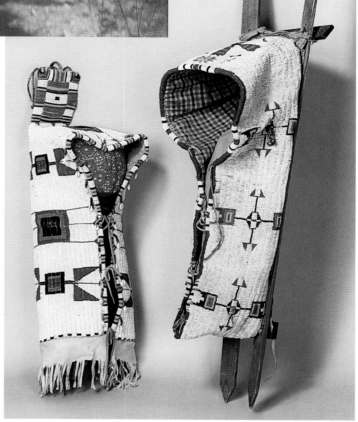

Two Plains Cradles.
Left: Lakota Sioux, last quarter 19th C. fully beaded hide cradle, soft hide form with rawhide tab at top, strings of bugle beads and cowries and brass hawk bells as additional decorations, 22" long. Skinner 1-29-05 **$7,050.00.**
Right: Central Plains, Cheyenne, circa 1900 canvas with cloth liner and rawhide insets, striped cloth backing, fully beaded with classic Cheyenne multicolored geometric designs on a white background, pointed wood slats have tacks on one tip, some bead loss and stiffness to rawhide, 46 1/2" long. Skinner 1-29-05 **$10,575.00.**

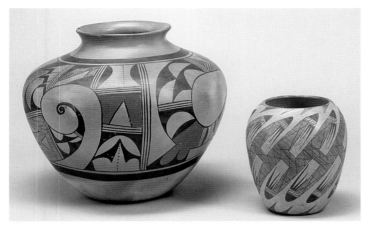

Two Southwest Pottery Items.
 Left: Hopi Olla, 20th C., 12 1/2" diameter, 10 1/2" high. Skinner 9-10-05 **$5,287.50.**
 Right: Hopi Jar, signed by Priscilla Namingha Nampeyo, 6 1/2" high, 5 3/4" diameter. Skinner 9-10-05 **$881.25.**

Pottery

This category includes items made from earthen materials and recognized as using the pottery-making process, whether historic or pre-historic, Southwestern or Middle Woodlands. As with some other categories, the Southwest will have the most examples of these items due to the prolific numbers from the region and the fact that the items have survived for reasons stated elsewhere in this book.

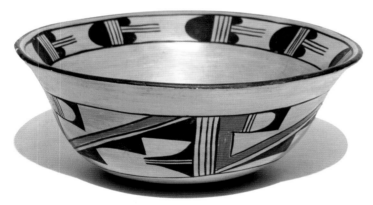

Garnet Pavatea, Hopi Bowl, circa 1950. Polychrome Hopi bowl with classic geometric motif and rim décor, 5 3/4" high x 11 1/4" diameter. Allard 8-14-05 **$850.00.**

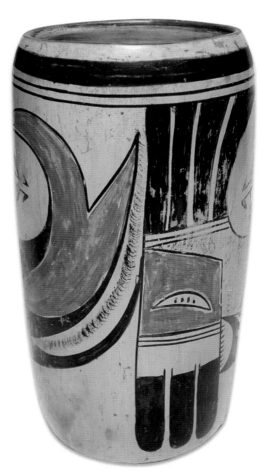

Hopi Jar with Parrot, circa 1930. Polychrome jar with parrot motif, good shape, 9 1/2" tall x 5" diameter. Allard 3-11-05 **$400.00.**

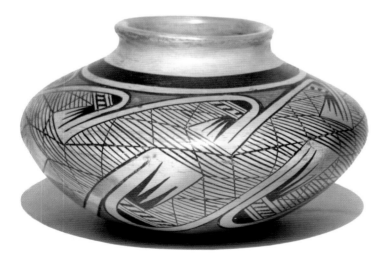

Fanny Nampeyo, Hopi Jar, circa 1950. Polychrome jar with bird motif and fine lines, excellent condition, 3 1/2" high x 5 3/4" diameter. Allard 8-14-05 **$750.00.**

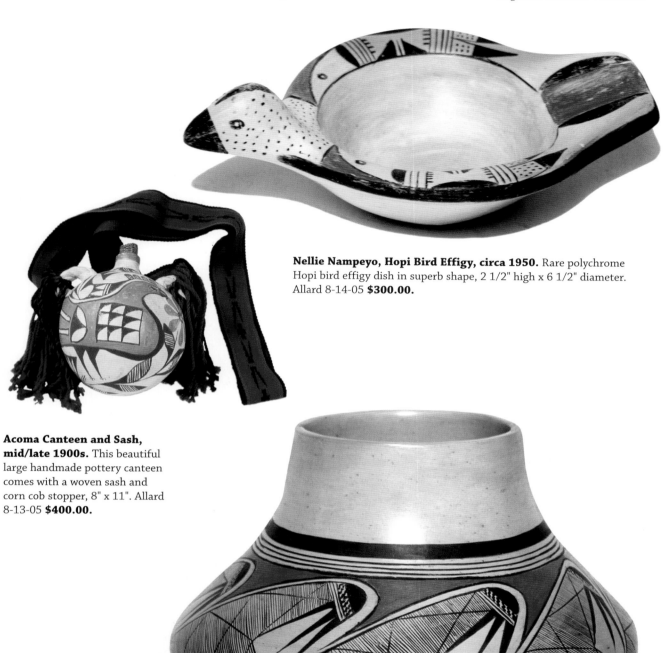

Nellie Nampeyo, Hopi Bird Effigy, circa 1950. Rare polychrome Hopi bird effigy dish in superb shape, 2 1/2" high x 6 1/2" diameter. Allard 8-14-05 **$300.00.**

Acoma Canteen and Sash, mid/late 1900s. This beautiful large handmade pottery canteen comes with a woven sash and corn cob stopper, 8" x 11". Allard 8-13-05 **$400.00.**

Dextra Quotskuyva Pottery, Hopi, circa 1974. Excellent Hopi olla design with Nampeyo-style fine line and bird motif, 8" x 8". Allard 8-14-05 **$3,750.00.**

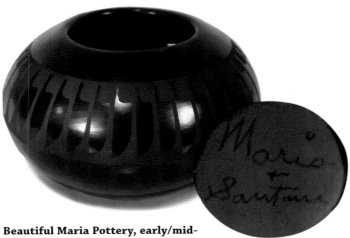

Beautiful Maria Pottery, early/mid-1900s. San Ildefonso Blackware vessel with encircling feather designs and signed "Maria & Santana", 3 1/4" high x 5" diameter. Allard 3-12-05 **$1,600.00.**

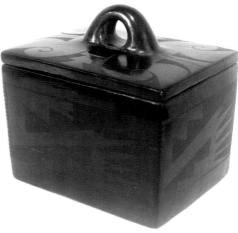

Maria Pottery, Southwestern, Circa 1940s. Very rare, San Ildefonso Blackware lidded pottery box with traditional designs and signed by "Marie", box is 5" x 4" x 5". Allard 8-13-05 **$7,000.00.**

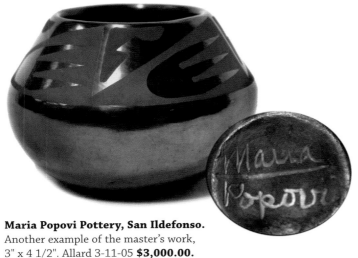

Maria Popovi Pottery, San Ildefonso. Another example of the master's work, 3" x 4 1/2". Allard 3-11-05 **$3,000.00.**

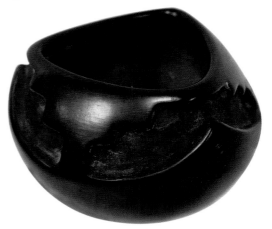

Santana and Adam Plate, San Ildefonso Pottery. Beautiful black plate with radiating feather design, signed, with a few small rim chips, 1 1/2" high x 9" diameter. Allard 3-11-05 **$1,200.00.**

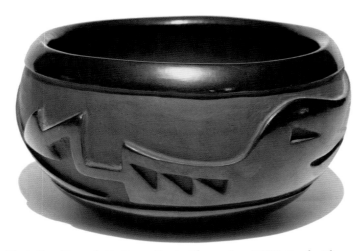

Christine Naranjo Pottery, Santa Clara, circa 1965. Bowl with deeply cut Avanyu motif, pristine condition, 4" high x 7 1/2" diameter. Allard 8-14-05 **$425.00.**

San Ildefonso Pottery Bowl, early/mid 1900s. Unsigned classic three sided deeply carved black bowl, 3 1/2" x 5". Allard 3-11-05 **$80.00.**

San Ildefonso Blue Corn Bowl, circa 1965.
Polished black feather designs on black matte
pottery, pristine shape, 3 1/4" high x 8 1/2"
diameter. Allard 8-14-05 **$3,250.00.**

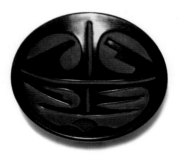

**Rose Gonzales Plate, San
Ildefonso, circa 1971.** Deeply
cut geometric forms highlight
this rare plate, 10 1/2" x 1 3/4".
Allard 8-14-05 **$1,500.00.**

RIGHT: **Grace Medicine Flower
& Camilio Tafoya Pottery,
Santa Clara, circa 1964.**
Beautiful little polychrome seed
jar with incised Avanyu and black
polished Yei motif, 2 3/4" high x
4 3/4" diameter. Allard 8-14-05
$1,700.00.

**Rare Candlesticks from
Santa Clara, circa 1950s.**
Polished black Santa Clara twist
candlesticks, signed Pablita,
7 1/2" x 6". Allard 8-14-05
$1,000.00.

RIGHT: **Zuni Pottery Bowl, circa
1910.** Classic geometric and fine line
motifs, 7" high x 10 3/4" diameter.
Allard 8-14-05 **$1,000.00.**

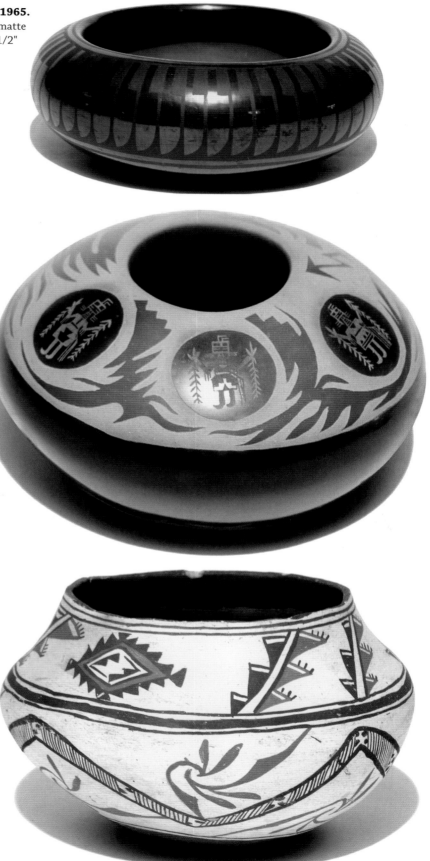

Prehistoric Items

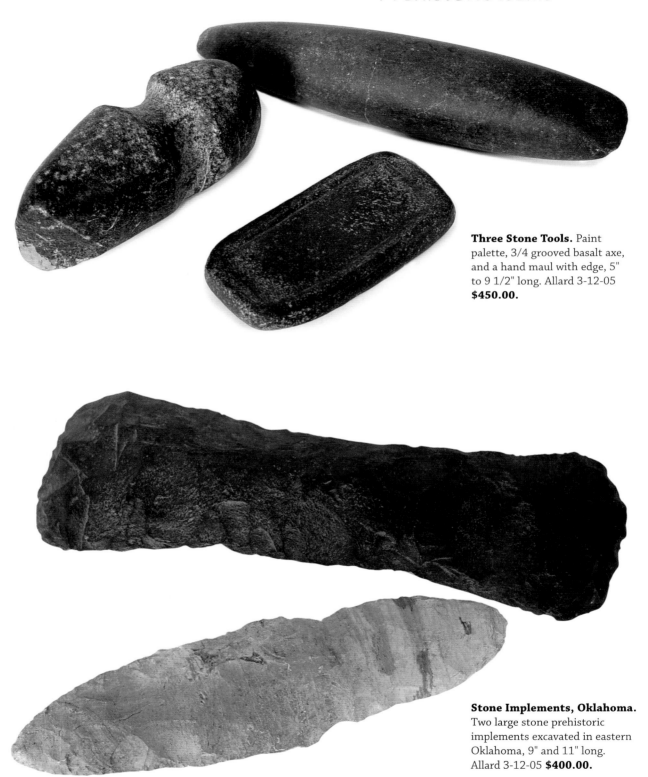

Three Stone Tools. Paint palette, 3/4 grooved basalt axe, and a hand maul with edge, 5" to 9 1/2" long. Allard 3-12-05 **$450.00.**

Stone Implements, Oklahoma. Two large stone prehistoric implements excavated in eastern Oklahoma, 9" and 11" long. Allard 3-12-05 **$400.00.**

Ho Ho Kam Pottery. Professionally restored flattened bowl/plate in classic red-on-buff design, professionally restored, 3" x 13". Allard 8-13-05 **$375.00.**

Anasazi Pottery Scoop. Rare small scoop, black-on-red with geometric designs, 1 3/4" x 3 1/2" x 5 1/2". Allard 8-13-05 **$475.00.**

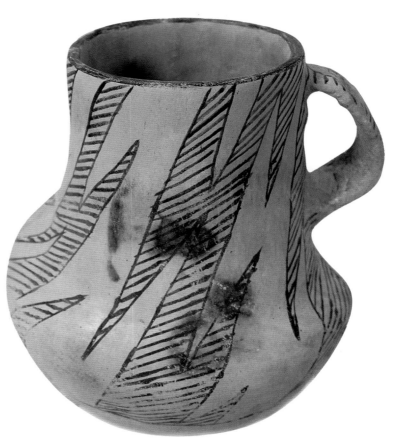

Anasazi Chaco Pitcher. Black-on-white lightning bolt design pitcher, professionally restored, 6 3/4" x 6". Allard 3-12-05 **$475.00.**

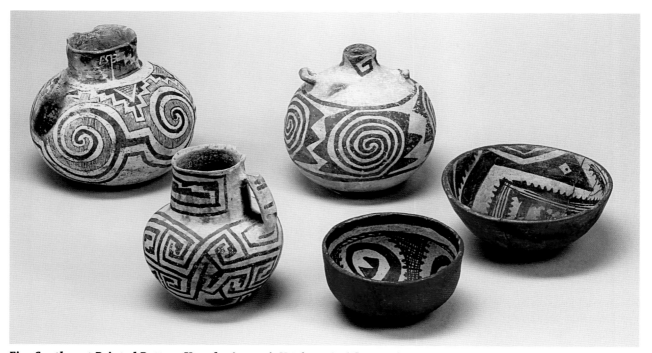

Five Southwest Painted Pottery Vessels, Anasazi. Height to 6 1/2", some damage. Provenance: Wistariahurst Museum. Skinner 9-10-05 **$1,997.50.**

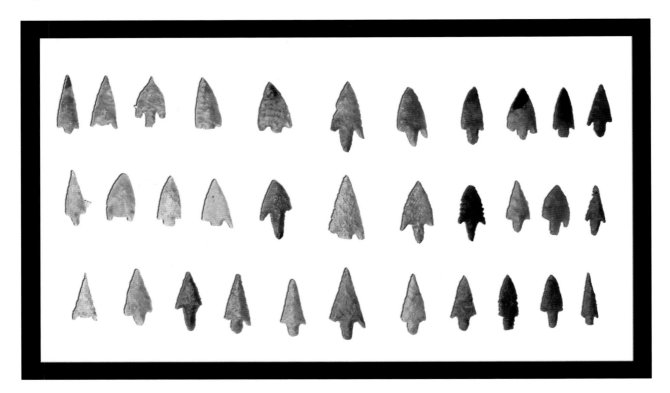

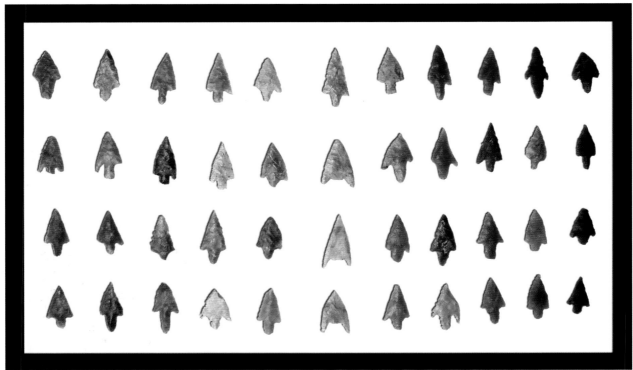

Two Washington/Oregon Point Collections. One with 33 points and one with 44 points, to 1" each. Allard 3-13-05 **$170.00 and $180.00 respectively.**

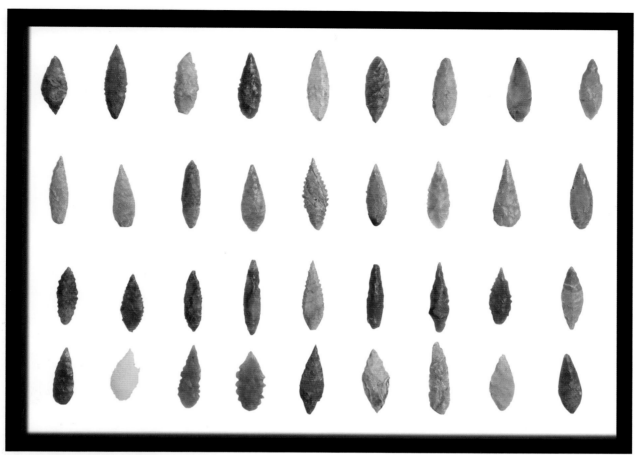

Columbia River Point Collection. Thirty-six chert and agate drill points from the Columbia River area. Allard 3-11-05 **$90.00.**

Nine Points from Hazen, North Dakota. 2 1/2" to 3 1/2" long. Provenance: formerly owned by the Thunderbird Museum, Hatfield, Wisconsin. Allard 3-11-05 **$700.00.**

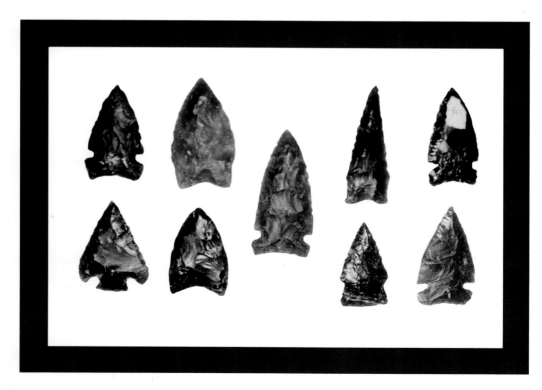

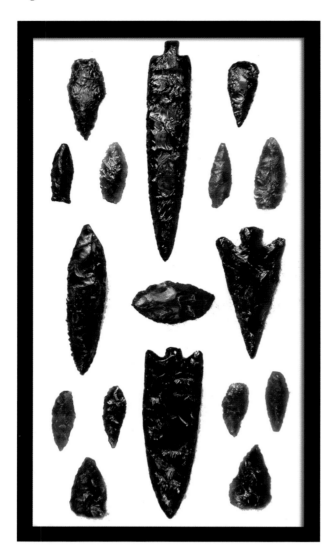

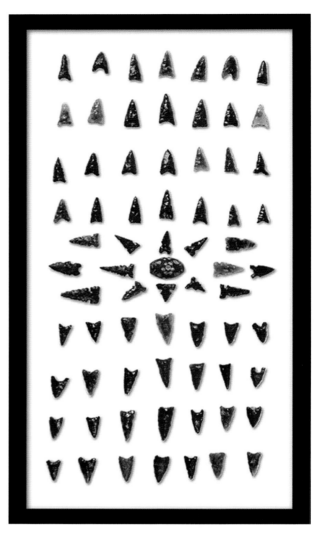

17 Klamath Points, various ages. Ceremonial and game points, 1 1/2" to 6" in length, framed. Allard 3-11-05 **$200.00.**

Klamath Lake Obsidian Points. Frame of 70 Klamath Lake obsidian bird and fish points, 1/2" to 1" long. Provenance: Chas. Hall collection. Allard 8-14-05 **$160.00.**

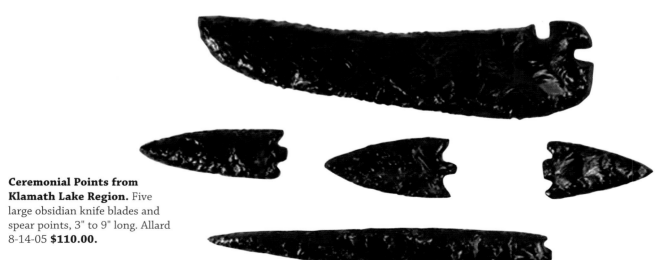

Ceremonial Points from Klamath Lake Region. Five large obsidian knife blades and spear points, 3" to 9" long. Allard 8-14-05 **$110.00.**

Ceremonial Spear Point from Elk River, Oklahoma. 9 1/2" point excavated by Mack Tussinger in 1921. Provenance: Oral Roberts University Museum. Allard 3-13-05 **$600.00.**

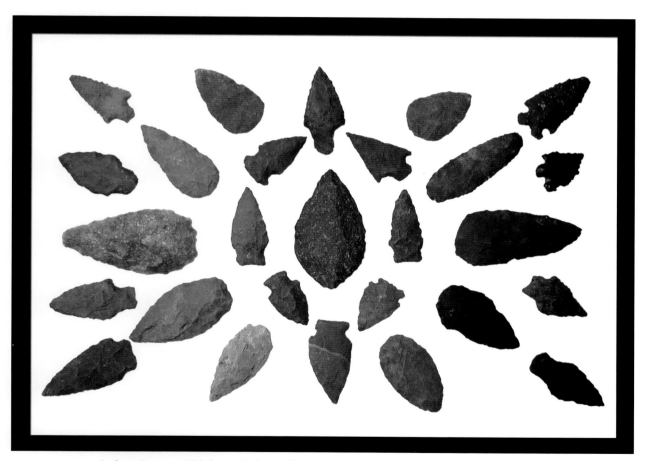

Lefore County, Oklahoma Point Collection. Twenty seven various points collected in the 1920s, 1" to 3" each. Allard 3-13-05 **$110.00.**

Southwest Female Clay Doll, Mojave, circa early 20th C. 7 1/4", horsehair hair, necklace, beaded ear drops. Provenance: Wistariahurst Museum; C. H. Strawbridge. Skinner 9-10-05 **$499.38.**

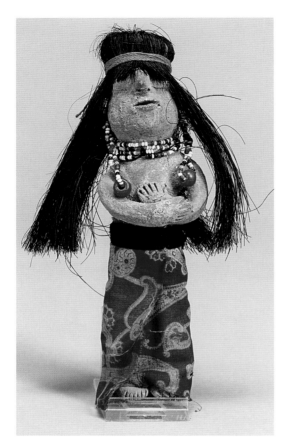

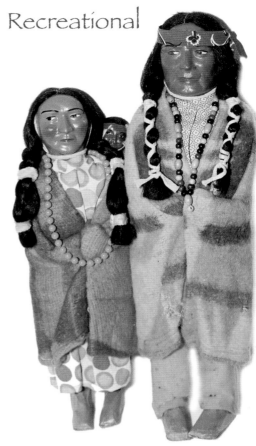

Recreational

Skookum Dolls, early 1900s. Male and female with papoose, excellent original condition, 13" and 15" tall. Allard 8-13-05 **$425.00.**

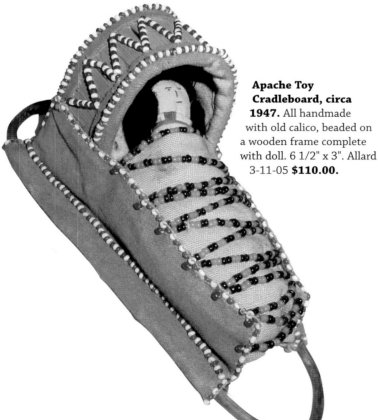

Apache Toy Cradleboard, circa 1947. All handmade with old calico, beaded on a wooden frame complete with doll. 6 1/2" x 3". Allard 3-11-05 **$110.00.**

Navajo Doll, early 1900s. Muslin bodied doll in full dress with old metal concho, earrings and blouse trimmed with a beaded necklace, 15" high. Allard 8-13-05 **$160.00.**

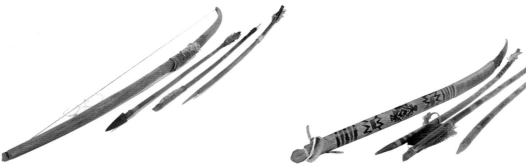

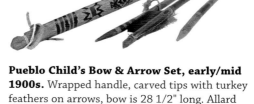

Early 1900s Bow & Arrow Set. Hand-carved with buckskin handle and three arrows with metal tips and turkey feather fins, 37" long bow. Allard 8-13-05 **$225.00.**

Pueblo Child's Bow & Arrow Set, early/mid 1900s. Wrapped handle, carved tips with turkey feathers on arrows, bow is 28 1/2" long. Allard 8-13-05 **$110.00.**

Navajo Tobacco Canteen of Silver, early 1900s. Hand-wrought silver canteen for tobacco with rocker motif of mountain sheep, 3". Allard 3-13-05 **$325.00.**

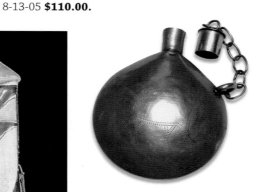

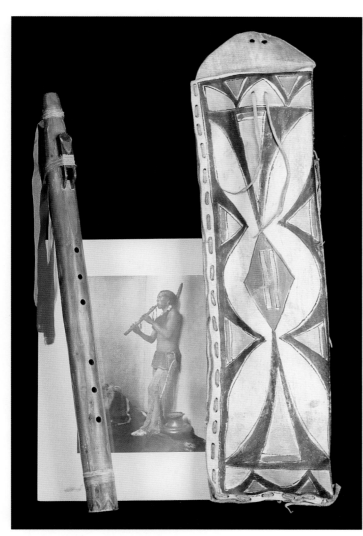

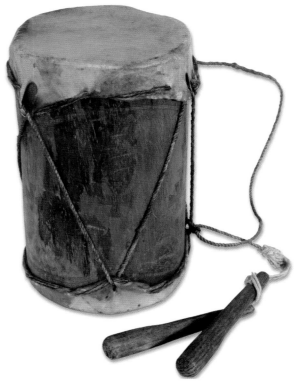

Sioux Flute, Painted Parfleche Case and Photograph, late 19th C. This interesting set of items shows a Sioux flute and holder typical of Plains culture, the parfleche is made of native tanned rawhide and beautifully decorated. This flute is shown in a photo dated 1914 from Taos, New Mexico with Geronimo Gomez, a Taos Indian man, playing the flute as documented in Driebe's 1997 book on the photographer Carl Moon at page 83. Julia 10-05 **$10,637.50.**

Arapaho Gaming Drum, circa early 1900s. Small old hand drum of cottonwood and stretched rawhide painted with symbols and two small beaters, 10" x 6". Allard 8-13-05 **$300.00.**

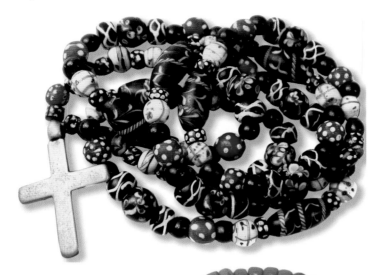

Trade Goods

This category includes numerous examples of items specifically used by Americans and Europeans to trade with the indigenous Americans, such as beads used by Lewis & Clark, trade crosses, etc.

Lewis & Clark Trade Beads. Polychrome trade beads with a silver cross, extra long strand, 44". Allard 3-11-05 **$250.00.**

Four Strands of Padre Glass Trade Beads. 25" long. Allard 3-13-05 **$60.00.**

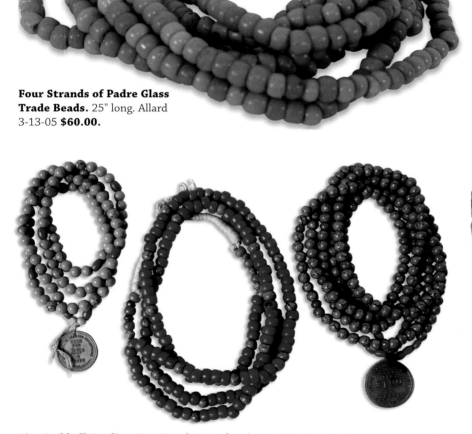

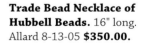

Trade Bead Necklace of Hubbell Beads. 16" long. Allard 8-13-05 **$350.00.**

Five Hubbell Trading Post Bead Strands, circa 1890. Historic faux turquoise and coral trade beads from the Hubbell Trading Post strung with old trading post tokens, 28" strands. Allard 8-14-05 **$325.00.**

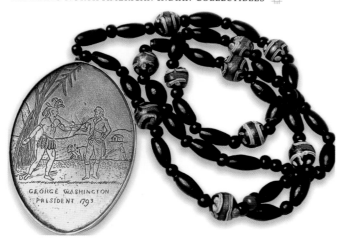

George Washington Peace Medal, 1793. Rare late 18th C. silver peace medal strung with early 19th C. polychrome trade beads, 2 1/2" x 3 3/4". Allard 3-11-05 **$170.00.**

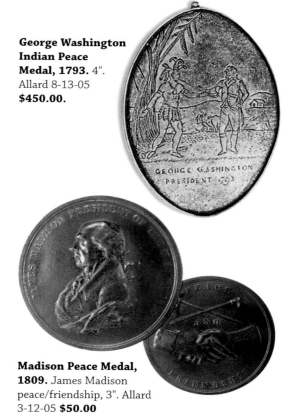

George Washington Indian Peace Medal, 1793. 4". Allard 8-13-05 **$450.00.**

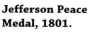
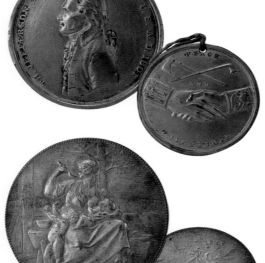

Jefferson Peace Medal, 1801. T. H. Jefferson solid silver peace/ friendship medal, 3". Allard 3-12-05 **$110.00.**

Madison Peace Medal, 1809. James Madison peace/friendship, 3". Allard 3-12-05 **$50.00**

French Peace Medal, 1874. Silver plated bronze medal from the French minister of the Interior. 2 3/4". Allard 3-12-05 **$60.00.**

Indian Peace Medals in American History

Francis Paul Prucha

Franklin Pierce Peace Medal, 1853. 3" diameter. Allard 3-13-05 **$200.00.**

Van Buren Peace Medal, 1837. Presidential Peace Medal dated 1837 in silver plated copper strung with cloth and beads, nice patina, 3". Allard 8-13-05 **$425.00.**

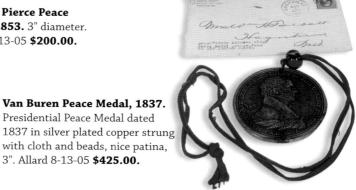

Hudson's Bay Four Point Trade Blanket. Green, woven in England with original tag, 85" x 70". Allard 8-13-05 **$80.00.**

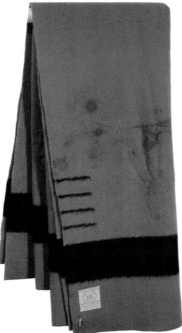
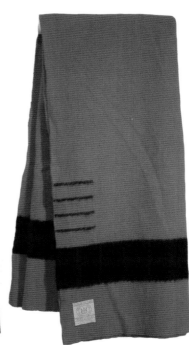

Hudson's Bay Four Point Trade Blanket. Red, woven in England with original tag, 84" x 68". Allard 8-13-05 **$150.00.**

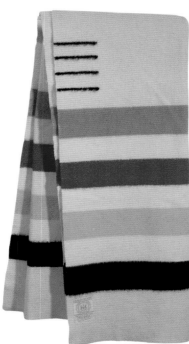

Pendleton Trade Blanket, early 1900s. Twelve element woolen trade blanket in excellent condition, original tag and binding intact, 58" x 84". Allard 3-12-05 **$400.00.**

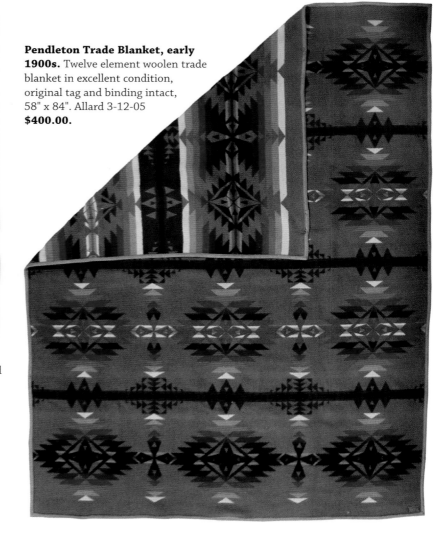

Hudson's Bay Four Point Trade Blanket. Multicolor, woven in England with original tag, 89" x 71". Allard 8-13-05 **$300.00.**

Weaponry

This category includes items used for daily use, such as knives, knife sheaths and holders, guns, bows, quivers, bow cases, arrows, war clubs, tomahawks, and other items that may have been used in either hunting or warfare. Some of these items, such as shields, may be shown under the Ceremonial category instead.

Apache Bow & Arrows, circa 1922. Boy's bow and three matching arrows, all painted, marked "Yuma, Ariz. Dec. 14th 1922" in paint on the bow. Bow is 24" and arrows are 17" long. Allard 8-13-05 **$275.00.**

Plains Child's Knife & Sheath, early 1900s. Sinew sewn and beaded buckskin sheath done with parfleche backing complete with child's sized matching belt. Sheath 6", belt 22". Allard 3-11-05 **$475.00.**

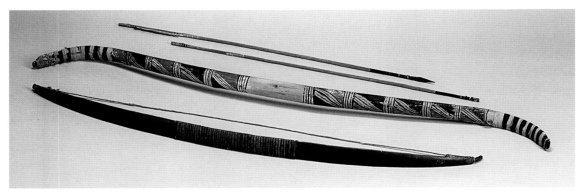

Bows and Arrows.

Lower: Native American sinew backed wooden bow, circa last half of 19th C. possibly Plains, rawhide wrapped handgrip and twisted sinew string, length of 39 1/2". Skinner 9-10-05 **$998.75.**

Upper: Southwest painted wood bow and arrows, Mojave, circa late 19th C. double curved bow painted on both sides, twisted sinew string, 45" long. Also the remnants of three arrows, two with metal points. Skinner 9-10-05 **$857.50.**

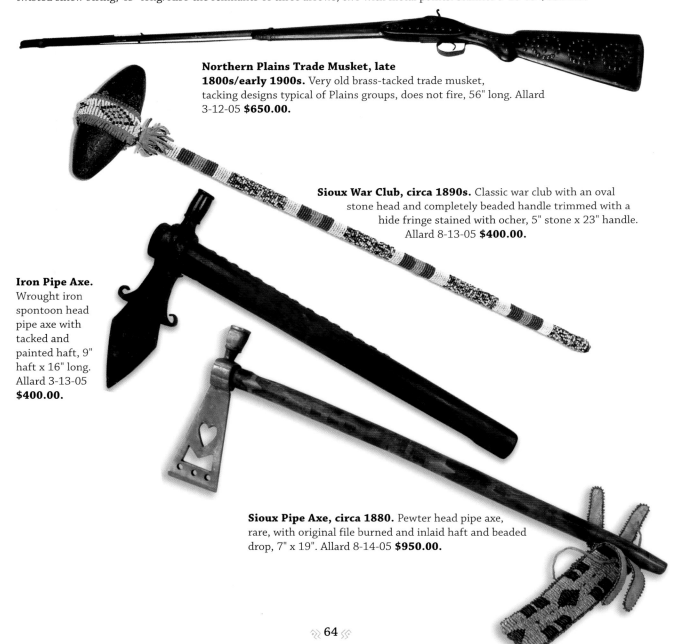

Northern Plains Trade Musket, late 1800s/early 1900s. Very old brass-tacked trade musket, tacking designs typical of Plains groups, does not fire, 56" long. Allard 3-12-05 **$650.00.**

Sioux War Club, circa 1890s. Classic war club with an oval stone head and completely beaded handle trimmed with a hide fringe stained with ocher, 5" stone x 23" handle. Allard 8-13-05 **$400.00.**

Iron Pipe Axe. Wrought iron spontoon head pipe axe with tacked and painted haft, 9" haft x 16" long. Allard 3-13-05 **$400.00.**

Sioux Pipe Axe, circa 1880. Pewter head pipe axe, rare, with original file burned and inlaid haft and beaded drop, 7" x 19". Allard 8-14-05 **$950.00.**

Woven Materials

The largest number of items in this category are the beautiful blankets from the Southwest, but other items that best fit under the category of woven materials will also be included.

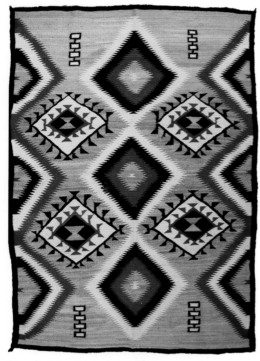

Navajo Weaving, circa 1930s. Hand loomed rug in Crystal pattern, 54" x 90". Allard 3-12-05 **$1,100.00.**

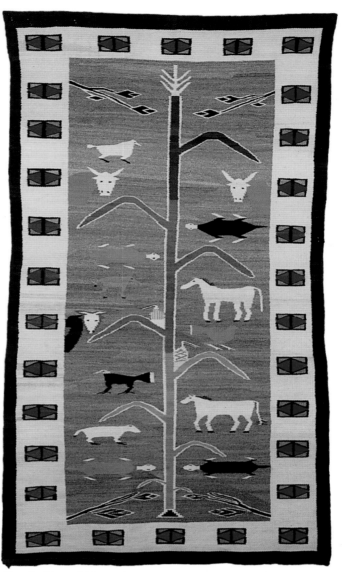

Navajo Pictorial Weaving, circa second quarter 20th C. Naturally and commercially dyed homespun wool with cornstalk motif surrounded by cows, lizards, and horses on variegated ground with geometric border, 81" x 47". Skinner 1-29-05 **$9,400.00.**

Navajo Weaving, late 19th C. Third phase of Chief's pattern, natural and commercially dyed homespun wool, some wool loss, fading and repairs, 73" x 59". Skinner 1-29-05 **$2,115.00.**

Navajo Germantown Weaving, last quarter 19th C. Tightly woven variant of the Chief's blanket pattern, 67" x 45 1/2". Skinner 1-29-05 **$21,150.00.**

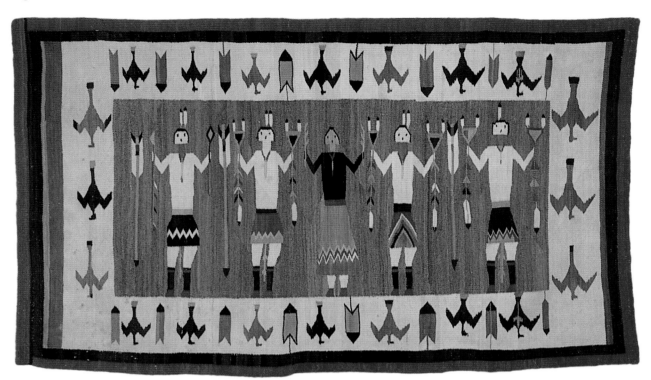

Navajo Pictorial Weaving, circa second quarter 20th C. Five multicolored Yei figures including a central female figure surrounded by bird and feather motifs in the border, minor stains, 70 1/2" x 42". Skinner 1-29-05 **$4,994.00.**

Navajo Weaving, early/mid 1900s. Hand woven transitional blanket with three "chief" style gray bands, 36" x 40". Allard 3-11-05 **$250.00.**

Navajo Weaving, mid-1900s. Colorful hand-spun all-wool rug with Valero stars and arrow geometric center, 39" x 58". Allard 3-11-05 **$225.00.**

Navajo Double Saddle Blanket. Commercially and naturally dyed homespun wool, stunning colors, 48" x 30". Skinner 1-29-05 **$4,700.00.**

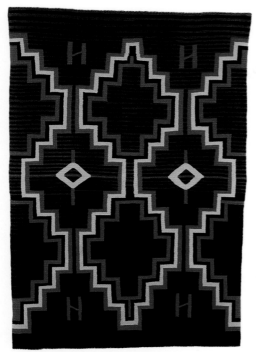

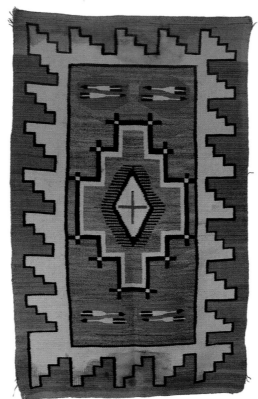

Navajo Weaving, circa 1940. Klagetoh rug with feather designs inside of a large central lozenge, 36 1/2" x 62". Allard 3-12-05 **$400.00.**

Navajo "Moki" style Germantown Weaving, circa last quarter 19th C. Tightly woven stepped diamond pattern over a variegated purple and black striped ground, 75" x 51". Skinner 1-29-05 **$10,575.00.**

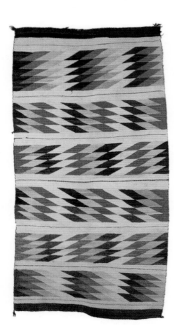

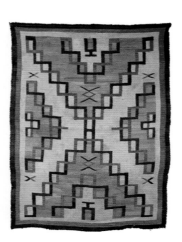

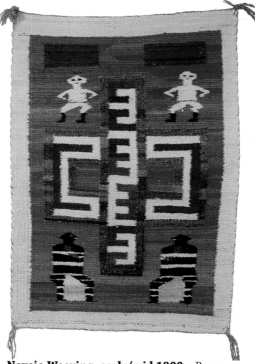

Navajo Weaving, early/mid 1900s. Older Crystal weaving with water birds, "x"s and geometric designs, 50" x 60". Allard 3-11-05 **$350.00.**

Navajo Weaving, early/mid 1900s. Traditional all-wool rug with serrated rhomboid designs in fine condition, 32" x 61". Allard 3-11-05 **$225.00.**

Navajo Weaving, early/mid 1900s. Rare homespun rug, all wool, with interesting human figures and geometric designs, 35" x 23". Allard 3-11-05 **$1,200.00.**

3

The Southwest

he Southwestern region has a vast and lengthy history of European contact and interest in the cultural items of the area. Likely the first item that pops into the mind of the average American concerning the region is the beautiful turquoise jewelry produced by many cultures in the Southwest. Second, one normally thinks of the woven blankets in the many beautiful colors reflecting the panorama of the desert environment. Finally, the pottery of the region is famous, and most of us who have travelled through the region have picked up some example of this pottery as a relic of our visit. This has been so for hundreds of years, giving this region a national and international reputation as a source for Native American artifacts.

Basketry was also an important indigenous trait, as was true in California as well. The arid climate has led to survival of some wonderful basketry examples dating from the early 18th C. and numerous examples from the 19th C.

The region also has a fairly well-known prehistoric period compared to what we know of many regions, due to the large concentration of archaeological excavations in the region, including such famous sites as Mesa Verde National Park. The Anasazi and other early cultures have left some artifacts intact, whereas it would be nearly impossible to find such items in non-arid climates.

Another interesting fact is that early contacts with the peoples of this region were often recorded in detail by the priests and other early missionaries, which gives us a little better understanding of the cultural evolution of the region.

One confusing aspect of the Southwest is what to do with certain groups, as time changed some far more than others. The best example would be the Apache, as it is with little doubt that we would first place them in the Southwest. However, unlike the Navajo and Hopi, the Apache soon adapted the horse to their use in migrating out onto the Plains and further into the Southern Plateau regions.

Thus, many artifacts of the Apache belong more properly to the Plains than to the Southwest, but then again, early basketry examples are best placed in the Southwest, as are some other items. I have included Apache artifacts in both regions depending primarily on the age and style of the item as I could best determine it from a catalog description and one photograph.

An interesting fact is that early contacts with the peoples of this region were often recorded in detail by the priests and other early missionaries, which gives us a little better understanding of the cultural evolution of the region.

Artistic Items

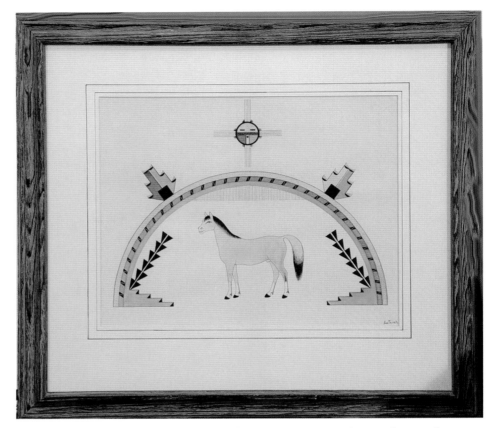

Alfonso Roybal (Awa-Tsireh) (1895-1955) Original Art. Signed pen and watercolor on paper showing a single horse and interesting symbols, image 10 1/4" x 13", framed 18" x 20". Allard 8-13-05 **$1,100.00.**

Traditional Hopi Kachina. Made of traditional cottonwood in classic colors, hand-carved 10 1/2" doll is placed here as an example of "Art" even though most are under Ceremonial Items below. It is without doubt that these important cultural icons served artistic purposes in addition to the ceremonial purposes in which they were involved. Allard 3-11-05 **$450.00.**

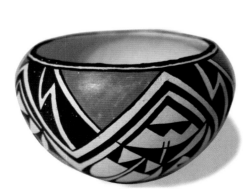

Lucy Lewis Pottery, circa 1970s-80s. Acoma master potter example from a fairly recent period, signed. 3" x 4 1/2". Allard 3-11-05 **$800.00.**

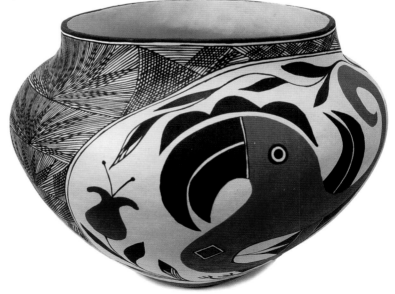

Traditional Acoma Olla Parrot Design, circa 1972. Again, shown here as an example even though the Pottery section following has most pottery because this piece was a recently made olla, signed "Darla Davis, Acoma, NM", 10" x 12". Allard 3-11-05 **$1,000.00.**

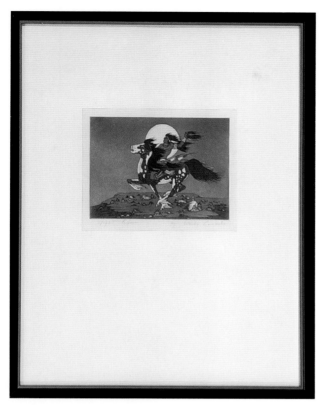

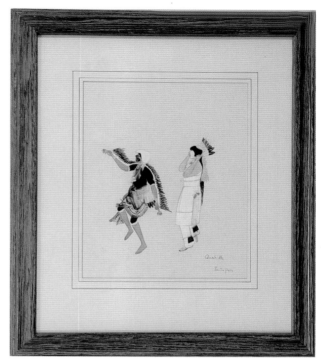

Tonita Pena (Quah Ah) (1895-1949) Original Art, early 1900s. Rare signed watercolor of two Pueblo dancers by noted San Ildefonso artist and female dancer, image 10" x 8 1/2", framed 17 3/4" x 15 3/4". Allard 8-13-05 **$900.00.**

Romando Vigil (Tse-Ye-Mu) (1902-1972) Original Art, early/mid 1900s. Original signed pen and watercolor of a single Pueblo dancer by this San Ildefonso artist, image 10 1/2" x 6 3/4", framed 16 3/4" x 12 3/4". Allard 8-13-05 **$400.00.**

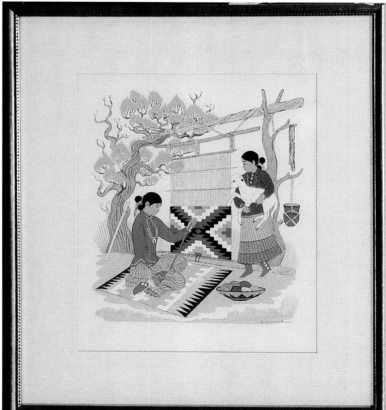

Harrison Begay Silkscreen, mid-1900s. Print of a mother and daughter weaving, Navajo, image 12" x 10", framed 17 3/4" x 15 1/2". Allard 8-14-05 **$300.00.**

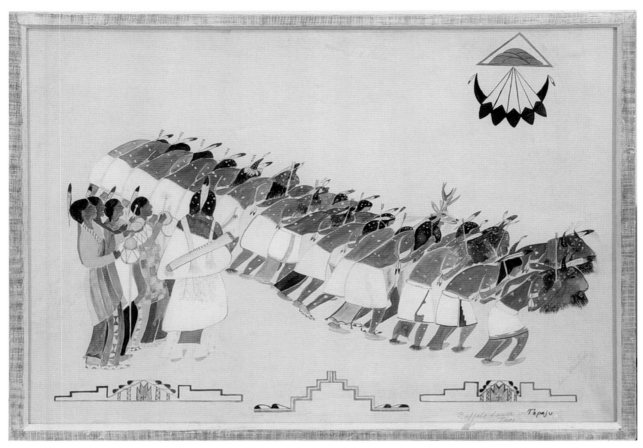

John Mirabel (Topaju) Original Art, early 1900s. signed original watercolor entitled "Buffalo Dance-Taos", image 16 3/4" x 22 1/2", framed 18 1/4" x 23 3/4". Allard 8-13-05 **$850.00.**

Percy Sandy (Kai-Sa) (1918-1974) Original Art, mid-1900s. Beautiful watercolor entitled "Deer Dance" by this noted Zuni artist, image 15 1/2" x 27", framed 17" x 29". Allard 8-13-05 **$650.00.**

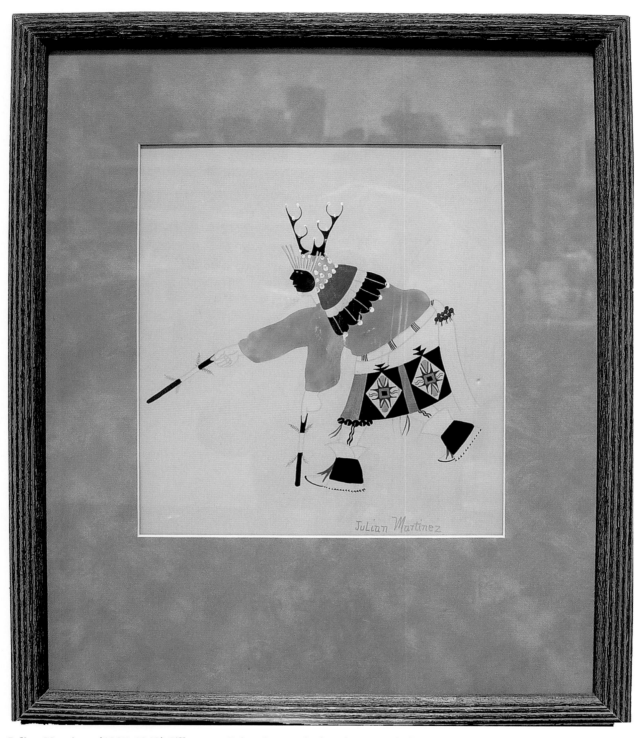

Julian Martinez (1897-1943) Silkscreen Print. Image of a deer dancer on dark ivory paper, image 10 1/2" x 9", framed 19" x 16". Allard 3-11-05 **$375.00.**

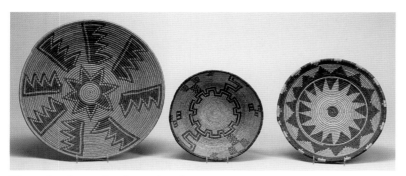

Basketry

Examples of basketry abound in the Southwest and Southern Plains due to the wonderful climatic conditions preserving this art form. Basketry examples are a bit less expensive than pottery due to the lack of fragility in comparative terms between the two.

Three Southwest Basketry Bowls.

Left: Southwest coiled basketry bowl, circa 1900, flared form with braided rim, eight-point star design, 3 1/2" high x 15 1/2" diameter. Provenance: Wistariahurst Museum. Skinner 9-10-05 **$1,645.00.**

Center: Apache, circa late 19th C., shallow form with checkered and fret designs, 2 1/2" high x 10" diameter. Skinner 9-10-05 **$646.25.**

Right: Havasupai coiled basketry bowl, circa first quarter 20th C., shallow form with geometric designs, 2 1/2" x 11 1/2" diameter. Provenance: Wistariahurst Museum. Skinner 9-10-05 **$1,057.50.**

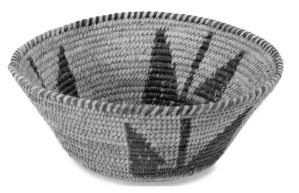

Papago Basket, circa 1970. Unique flat-bottomed bowl with geometric butterfly designs, 3 1/2" high x 6 1/2" diameter. Allard 3-11-05 **$110.00.**

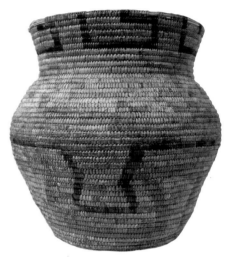

Papago Grain Storage Basket, circa 1900. Large polychrome basket used for grain storage, 14" x 15". Allard 8-14-05 **$350.00.**

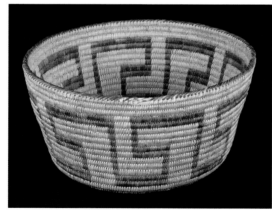

Papago (Tohono-Oodam) Basket, early 20th C. Made of willow and devil's claw over a grass foundation in a fret pattern, 12" diameter, 6" high. Julia 10-05 **$143.75.**

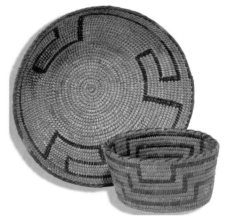

Pima Basket Pair, mid-1900s. Classic weave vessels in traditional Pima designs, both bowl shaped. The large one is 3 1/2" high x 11" diameter and the small one is 3 1/2" high x 6 1/2" diameter. Allard 3-11-05 **$170.00.**

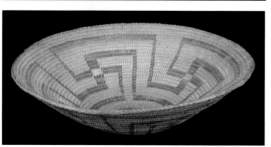

Pima Basketry Bowl, early 20th C. Made of willow and devil's claw over a grass foundation in a fret pattern, 12" diameter, 3 1/2" high. Julia 10-05. **$690.00.**

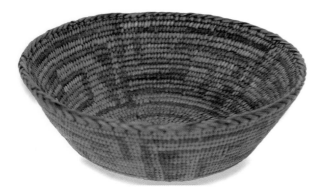

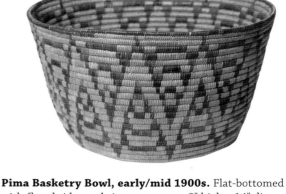

Pima Fine Weave Basket, early 1900s. Small fine weave bowl with flat bottom and key patterns, 2" high x 5 1/2" diameter. Allard 3-11-05 **$225.00.**

Pima Basketry Bowl, early/mid 1900s. Flat-bottomed with flared sides and zigzag patterns, 8" high x 14" diameter. Allard 3-11-05 **$850.00.**

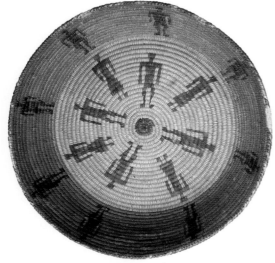

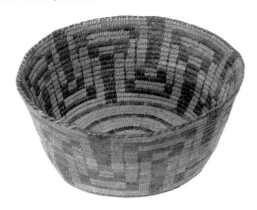

Pima Basket, early 1900s. Bowl with traditional Pima designs, a few missing rim stitches, 4" high x 9" diameter. Allard 3-11-05 **$300.00.**

Pima Basketry with Human Figures, early 1900s. Huge 6" high x 19" diameter basket in excellent condition. Allard 3-12-05 **$800.00.**

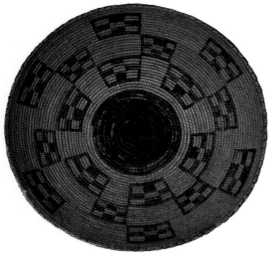

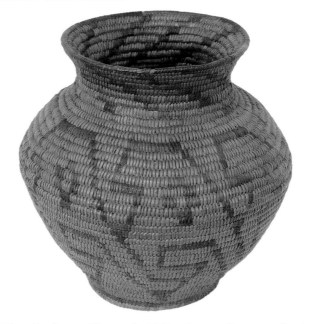

Pima Basketry Bowl, early 1900s. Large Pima bowl with cross and box designs, 5" high x 17" diameter. Allard 8-13-05 **$800.00.**

Pima Basketry Olla, early 1900s. Outstanding example of basketry in the olla form of pottery vessels in other cultures, flat bottom with geometric designs and crosses, 8 1/2" high x 8 1/2" diameter. Allard 3-11-05 **$850.00.**

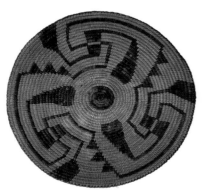

Pima Basketry Tray, early 1900s.
Older tray with cross, step and
whirlwind designs, 32 1/2" diameter.
Allard 8-13-05 **$700.00.**

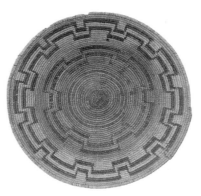

Apache Basketry Tray, early 1900s.
Red/brown geometric designs with
some stitch loss and a small rim tear,
3 3/4" high x 13 3/4" diameter. Allard
3-11-05 **$325.00.**

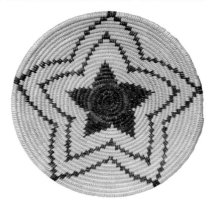

**Apache Basketry Plate, mid/late
1900s.** 9" diameter. Allard 3-11-05
$200.00.

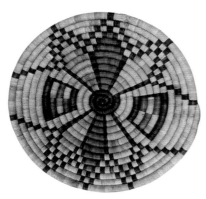

Hopi Basketry, mid-1900s.
Polychrome tray in butterfly pattern,
12" diameter. Allard 8-13-05 **$170.00.**

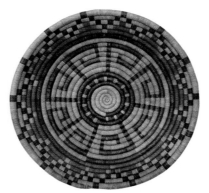

Hopi Basketry Bowl, circa 1940.
Fine weave traditional pattern full
geometric design coiled flat bowl
with key and other symbols, 14 1/2"
diameter. Allard 3-12-05 **$375.00.**

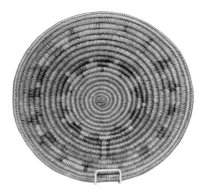

Navajo Basketry, early 1900s.
Wedding basket with braided rim and
stepped motif, 15" x 3 3/4". Allard
8-14-05 **$225.00.**

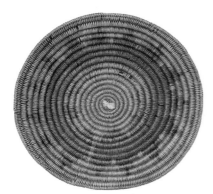

**Classic Navajo Wedding Basket,
circa mid-1900s.** Three color, 3" high
x 12 3/4" diameter. Allard 3-11-05
$50.00.

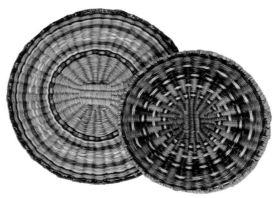

Hopi Basketry, early 1900s. Two polychrome
wicker trays, 8" and 10 1/2" diameter. Allard 8-13-05
$225.00.

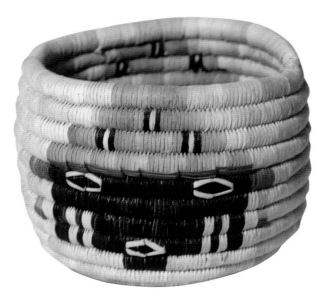

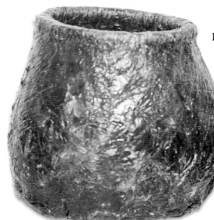

Early Apache Basket, 1890s. Woven coiled basket covered inside and out with hardened tree pitch, 9" x 9". Allard 3-11-05 **$110.00.**

Classic Hopi Basketry, mid-1900s. Coiled basketry bowl with traditional Kachina head designs, 4 1/2" high x 6" diameter. Allard 3-11-05 **$130.00.**

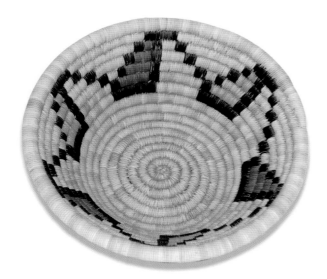

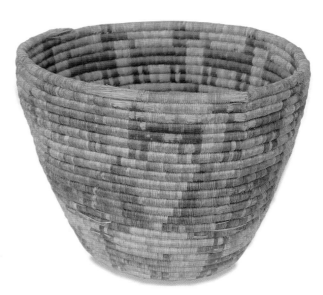

Hopi Basketry Bowl, circa 1940. Deep coiled bowl with rows of animal figures above and below a row of Kachina heads, polychrome, some wear, 11" x 13" x 13". Allard 3-12-05 **$500.00.**

Hopi Basketry, early 1900s. Coiled polychrome basketry bowl with stepped motif, 11" x 4 1/2". Allard 8-14-05 **$180.00.**

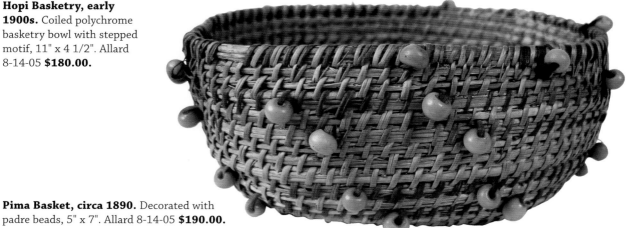

Pima Basket, circa 1890. Decorated with padre beads, 5" x 7". Allard 8-14-05 **$190.00.**

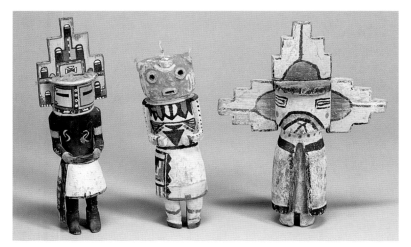

Three Hopi Kachina Dolls.
Left: Hopi, second quarter 20th C., Hemis Kachina with case mask and tablita, wearing a kilt and detailed sash, 11 1/2" high. Skinner 9-10-05 **$3,525.00.**
Center: Hopi, circa 1900, cottonwood "mudhead" case mask with painted clothing and a restored foot, 9 1/2". Provenance: Dr. W. C. Martin collection. Skinner 9-10-05 **$7,637.50.**
Right: Palhik Mana, Hopi, late 19th C., 11" Kachina wearing a manta, with case mask and tablita. Exhibitions: The Haffenreffer Museum of Anthropology. Skinner 9-10-05 **$6,462.50.**

Ceremonial and Utilitarian Items

Many tourists traveling through the Southwest have picked up a reproduction "Kachina Doll" as a keepsake. It is a shame that most Americans do not realize the important cultural and religious significance of the Kachinas to their native cultures. The Kachina was used in sacred ceremonies and was an integral part of the cultural heritage and an object highly regarded for its intrinsic value.

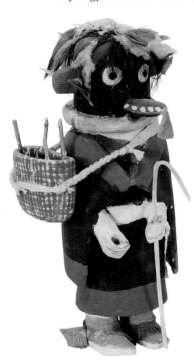

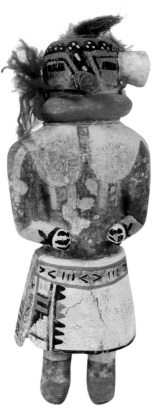

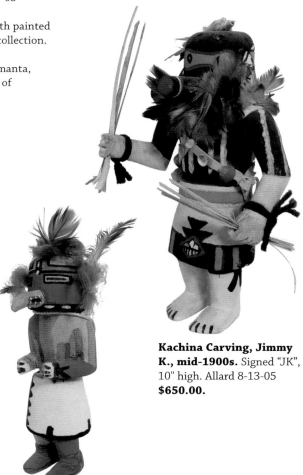

Master Carver Jimmy K. Kachina. Hand-carved and painted traditional cottonwood root doll marked by master carver James Kewonwytewa "J.K.", 10 1/2" tall. Allard 3-11-05 **$1,500.00.**

Early Hopi Kachina, circa early 1900s. Fox Dancer Kachina, 9" tall. Allard 8-13-05 **$1,200.00.**

Kachina Carving, Jimmy K. Kachina, mid-1900s. Master carver James Kewonwytewa signed "JK", 6 1/2". Allard 8-13-05 **$600.00.**

Kachina Carving, Jimmy K., mid-1900s. Signed "JK", 10" high. Allard 8-13-05 **$650.00.**

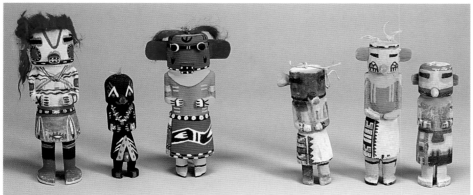

Six Hopi Kachina (Katcina) Dolls, circa early/mid 20th C.
 Left Three: Hopi, mid-20th C. all are wearing case masks and the small one in the center is a "Route 66" doll, one has a Hopi Village sticker, tallest is 8 1/2". Provenance: Wistariahurst Museum, C. H. Strawbridge. Skinner 9-10-05 **$587.50.**
 Right Three: Hopi, first half 20th C., all made of cottonwood and wearing large case masks, tallest is 8". Provenance: Wistariahurst Museum; C. H. Strawbridge. Skinner 9-10-05 **$1,880.00.**

Hopi Kachina, Possibly Star Kachina, early 20th C. Made of cottonwood root which is a common material used and a traditional material as well, 8 1/2" high. Julia 10-05 **$2,100.00.**

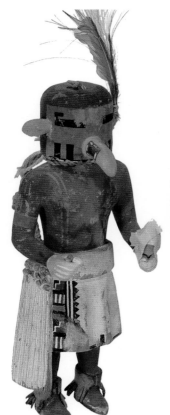

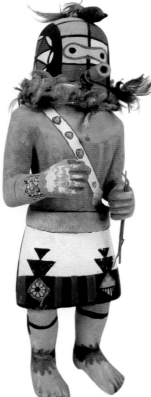

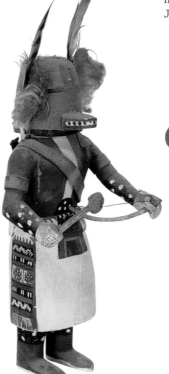

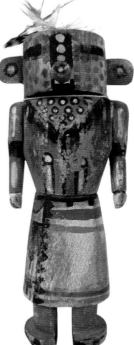

Hopi Kachina, early/mid 1900s. One dance rattle missing, hand-carved and painted, 11" tall. Allard 3-11-05 **$425.00.**

Early Hopi Kachina, circa early 1900s. Masked Duck Kachina, 10 1/4" tall. Allard 8-13-05 **$650.00.**

Hopi Kachina, early/mid 1900s. With bow, arrow and rattle, 9 1/4" tall. Allard 3-11-05 **$350.00.**

Early Hopi Kachina, circa early 1900s. 8" cottonwood root Kachina with feathers atop head. Allard 8-13-05 **$750.00.**

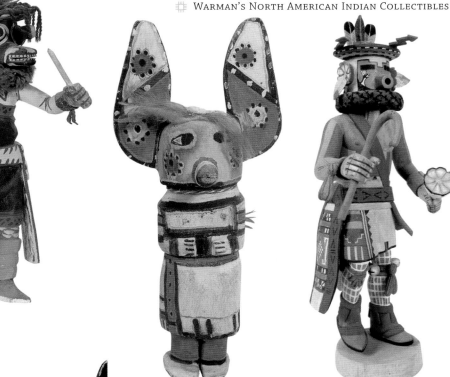

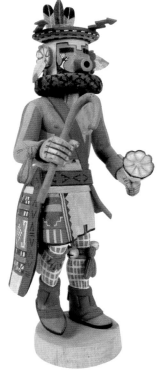

Kachina Carving, mid-1900s. Cottonwood doll with traditional carving and painting details, 12". Allard 3-11-05 **$350.00.**

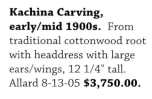

Kachina Carving, early/mid 1900s. From traditional cottonwood root with headdress with large ears/wings, 12 1/4" tall. Allard 8-13-05 **$3,750.00.**

Hopi Palolo Kong Kachina, circa 1970. Carved by Henry Shelton, Oraibi, Arizona, a National Living Treasure, now deceased. This is the water serpent Kachina, 13" high and a superb example. Allard 8-13-05 **$550.00.**

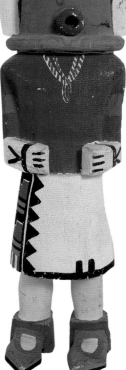

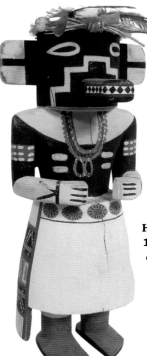

Kachina by Jimmy K., mid-1900s. Signed "JK", 19" high finely detailed "Aholi" (Chief's Lieutenant) Kachina doll by this master carver. Allard 8-13-05 **$3,000.00.**

Kachina Carving, mid-1900s. Feather ears and red body, 12 3/4" tall. Allard 8-13-05 **$225.00.**

Hopi Kachina Carving, mid-1900s. Black Lizard pattern carved from traditional cottonwood root also showing a Concho belt and nugget necklace, 8 1/2" high. Allard 8-13-05 **$450.00.**

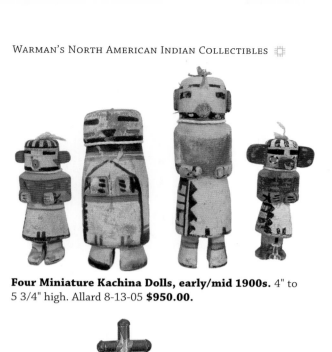

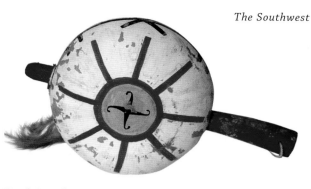

Hopi Gourd Rattle, mid-1900s. Classic old pigment painted gourd rattle with carved cottonwood handle, 10" x 4". Allard 3-11-05 **$130.00.**

Four Miniature Kachina Dolls, early/mid 1900s. 4" to 5 3/4" high. Allard 8-13-05 **$950.00.**

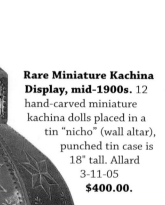

Rare Miniature Kachina Display, mid-1900s. 12 hand-carved miniature kachina dolls placed in a tin "nicho" (wall altar), punched tin case is 18" tall. Allard 3-11-05 **$400.00.**

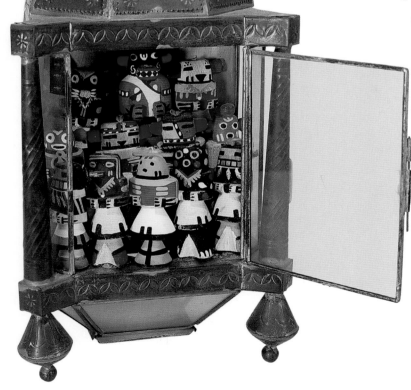

Hopi Hodta Doll, early/ mid 1900s. Hand painted, carved, and marked "Jerry Honawa, Hotevilla" (Rabbit Clan), 12" tall. Allard 3-11-05 **$475.00.**

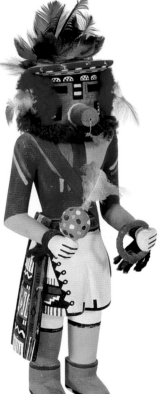

Hopi Kachina Carving, mid-1900s. 11 1/2". Allard 3-12-05 **$500.00.**

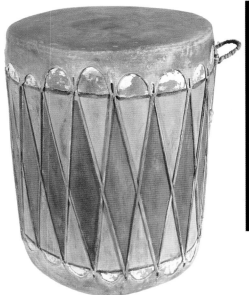

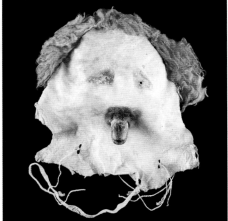

Navajo Mask, circa 1900. Possibly related to Yei-be-chai ceremony. Native tanned leather with angora across the top, painted with clay or kaolin, 17" high x 15" wide. Julia 10-05 **$1,610.00.**

Hopi Drum, mid-1900s. Cottonwood with stretched rawhide, beautiful 20" x 14" drum in traditional colors. Allard 8-13-05 **$850.00.**

Hopi Mask, early/mid-1900s. Early shape painted hide mask with fringe trim and some feather drops, 9" x 9" x 9". Allard 8-13-05 **$650.00.**

Hopi Tabletta, mid-1900s. Classic dance headdress hand-carved and painted, 19" x 13 1/2". Allard 3-12-05 **$550.00.**

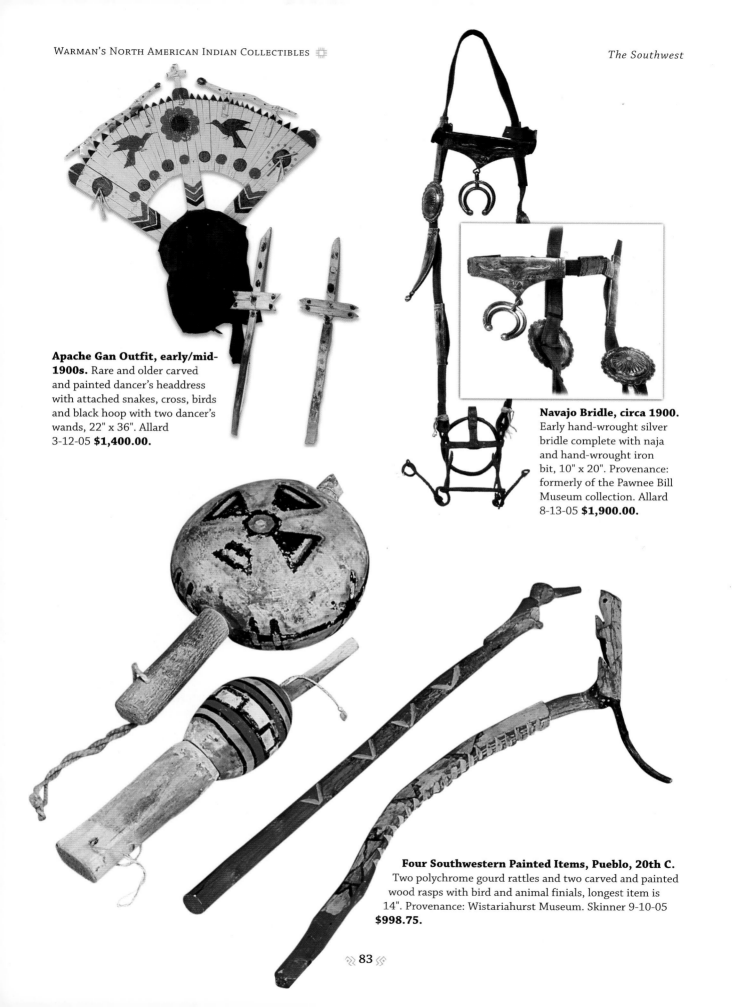

Apache Gan Outfit, early/mid-1900s. Rare and older carved and painted dancer's headdress with attached snakes, cross, birds and black hoop with two dancer's wands, 22" x 36". Allard 3-12-05 **$1,400.00.**

Navajo Bridle, circa 1900. Early hand-wrought silver bridle complete with naja and hand-wrought iron bit, 10" x 20". Provenance: formerly of the Pawnee Bill Museum collection. Allard 8-13-05 **$1,900.00.**

Four Southwestern Painted Items, Pueblo, 20th C. Two polychrome gourd rattles and two carved and painted wood rasps with bird and animal finials, longest item is 14". Provenance: Wistariahurst Museum. Skinner 9-10-05 **$998.75.**

Clothing

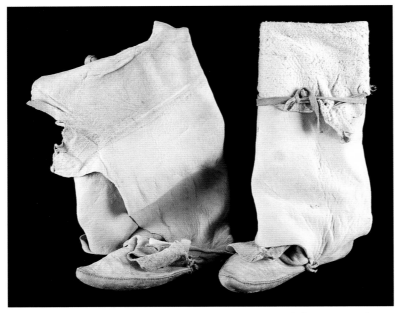

Pueblo Woman's Moccasins, circa 1900. Native tanned elk uppers with rawhide soles. Painted with yellow ocher and green, 29" high x 18" wide. Julia 10-05 **$575.00.**

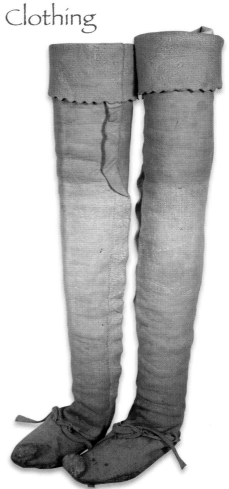

Apache White Mountain Moccasins, early 1900s. Full high top moccasins with toe tab in yellow ocher, 10" long x 30" high. Allard 8-13-05 **$475.00.**

Navajo Girl's Outfit. Traditional moccasins with silver buttons, cotton floral print skirt with a black velvet blouse. Blouse is decorated with fluted button and Conchas, repousse worked brooches with turquoise settings and silver and turquoise collar tabs, mounted on display, total length is 38". Skinner 1-29-05 **$2,350.00.**

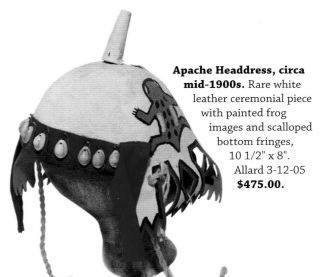

Apache Headdress, circa mid-1900s. Rare white leather ceremonial piece with painted frog images and scalloped bottom fringes, 10 1/2" x 8". Allard 3-12-05 **$475.00.**

Jewelry

I, for one among thousands if not millions, think of jewelry first when I think of the Southwest. I have a beautiful turquoise and silver ring purchased in Taos, New Mexico, in about 1983, and most who have visited the region make similar purchases, with such items as the "Squash Blossom" pendants being very famous.

This cultural tradition has changed relatively little over the past few hundred years, and it is now a hallmark of the region. Both living and deceased makers command high prices for examples of their work, and the items are sought by visitors the world over, creating high demand for precious gems turned into small works of art.

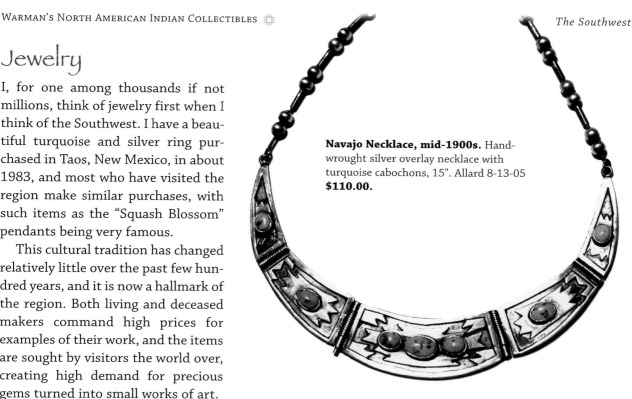

Navajo Necklace, mid-1900s. Hand-wrought silver overlay necklace with turquoise cabochons, 15". Allard 8-13-05 **$110.00.**

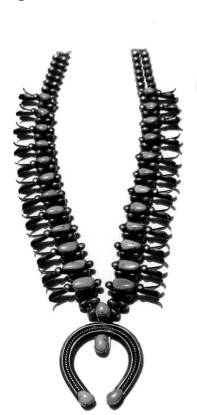

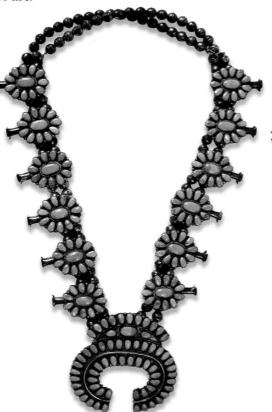

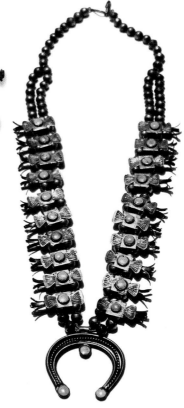

Navajo Necklace, circa 1930. Box bow design squash blossom with handmade beads and all natural oval turquoise stones, 32" long. Allard 8-13-05 **$475.00.**

Navajo Necklace, circa 1980. Hand-wrought silver and turquoise cluster necklace, 29" long. Allard 8-13-05 **$500.00.**

Navajo Squash Blossom, circa 1940. Another box bow design with handmade beads and natural turquoise but also hand stamping, 25" long. Allard 8-13-05 **$375.00.**

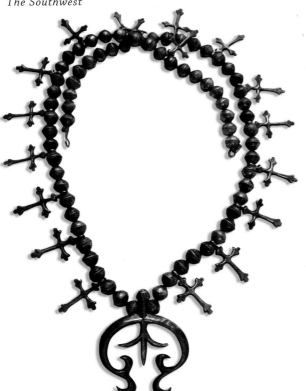

Pueblo Necklace, mid-1900s. Hand-wrought silver cross necklace made with cast crosses, naja and bench made beads, 28" long. Allard 3-11-05 **$400.00.**

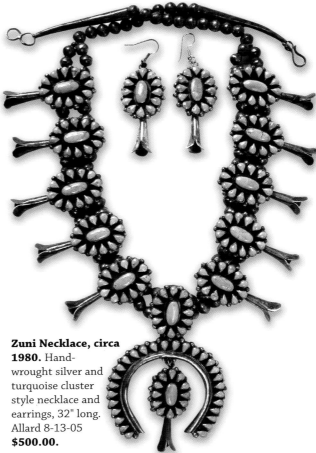

Zuni Necklace, circa 1980. Hand-wrought silver and turquoise cluster style necklace and earrings, 32" long. Allard 8-13-05 **$500.00.**

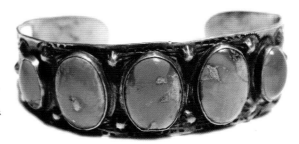

Navajo Bracelet, circa 1930s. Five oval cabochons all hand stamped with arrows. 5 5/8" x 3/4" wide with 1" gap. Allard 8-13-05 **$225.00.**

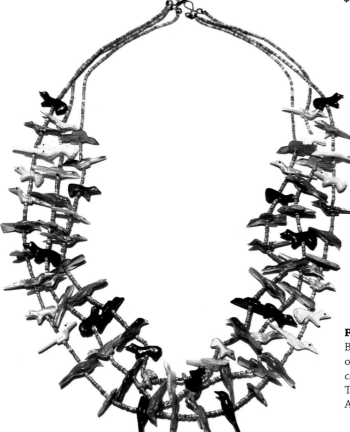

Fetish Necklace, mid-1900s. Bird and animal fetish necklace on fine shell heshi with 77 carved stone fetishes by Leekya, Tsikewa, and Quam, 30" long. Allard 8-13-05 **$1,500.00.**

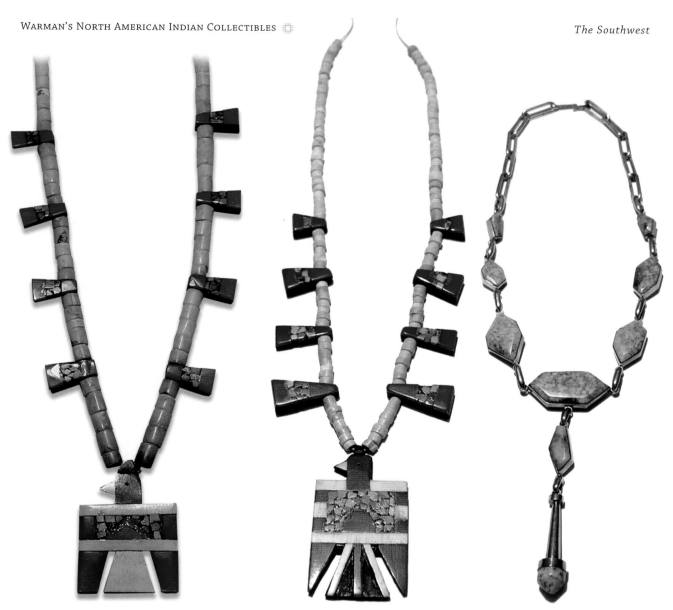

Santo Domingo Necklace, circa 1920s.
Thunderbird necklace of bone, turquoise and coral on Bakelite bone heshi, 28" long. Allard 3-11-05 **$225.00.**

Santo Domingo Necklace, circa 1920s.
Classic early necklace with chip inlay of turquoise in the Thunderbird design pendant and bone heshi, 24" long. Allard 8-13-05 **$250.00.**

Gilbert Damon Necklace, circa 1960. Silver segment necklace with faceted natural turquoise stones with drop and hand-forged chain, 24" long. Allard 8-13-05 **$325.00.**

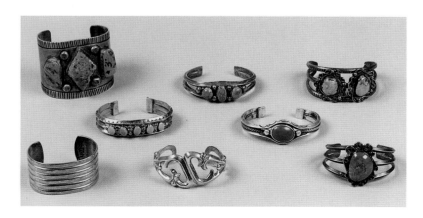

Eight Navajo Bracelets.
 Left: 20th C. Navajo examples, one sand-cast, a triple-band form with five ovular turquoise settings, a silver ribbed form and a heavy band with three large settings. Largest is 2 3/4". Provenance: Property of a major Western museum. Skinner 1-29-05 **$294.00.**
 Right: Four Navajo examples, two with one stone and two with multiple settings, various styles and periods, largest to 2 3/4". Skinner 1-29-05 **$411.00.**

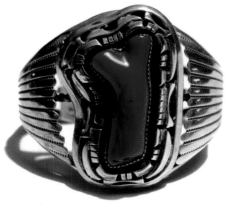

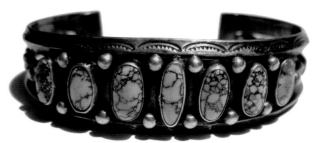

Navajo Bracelet, circa 1950. Silver bracelet with seven Burnham spider web turquoise cabochons and stamping, 4 1/2" x 7/8" wide with a 1 3/8" gap. Allard 8-13-05 **$600.00.**

Navajo Bracelet, circa 1950s. Branch coral in sterling triple bezel with feather motif, 6 1/4" plus 1 1/4" gap and 2 1/4" wide. Allard 8-13-05 **$1,100.00.**

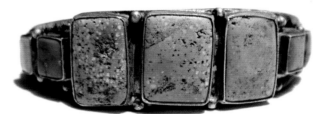

Navajo Bracelet, circa 1930s. Natural square turquoise cabochons set in two wire-spun bands. 6 1/4" x 7/8" wide, 1 1/8" gap. Allard 8-13-05 **$225.00.**

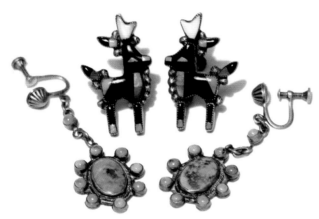

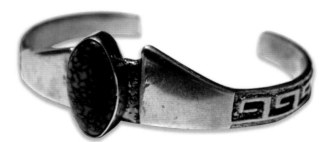

Zuni Earrings, mid-1900s. Two pair of earrings, one is Blue Gem petit point turquoise drop and the other with a deer design of stone-to-stone, 2" and 1 1/2". Allard 8-13-05 **$275.00.**

Hopi Bracelet, circa 1970s. Sterling with gold overlay set with a large oval Landers spider web turquoise cabochon, 5 1/2" x 3/4" wide with a 1 1/4" gap in bracelet. Allard 8-13-05 **$550.00.**

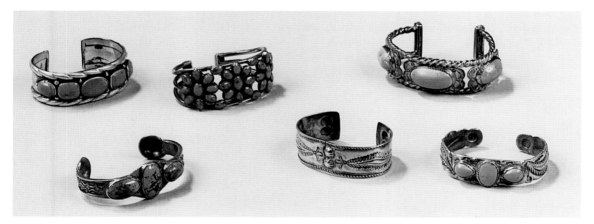

Six Southwest Bracelets.
 Left: Two Navajo turquoise bracelets and a Zuni cluster bracelet, largest is 3". Provenance: Property of a major Western museum. Skinner 1-29-05 **$823.00.**
 Right: Three Navajo bracelets of various ages, largest to 3 1/2". Provenance: Property of a major Western museum. Skinner 1-29-05 **$3,408.00.**

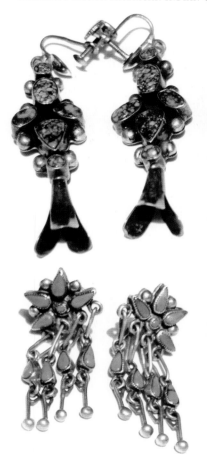

Zuni and Navajo Earrings, circa 1940s. 1 1/2" & 2 1/2". Allard 8-13-05 **$200.00.**

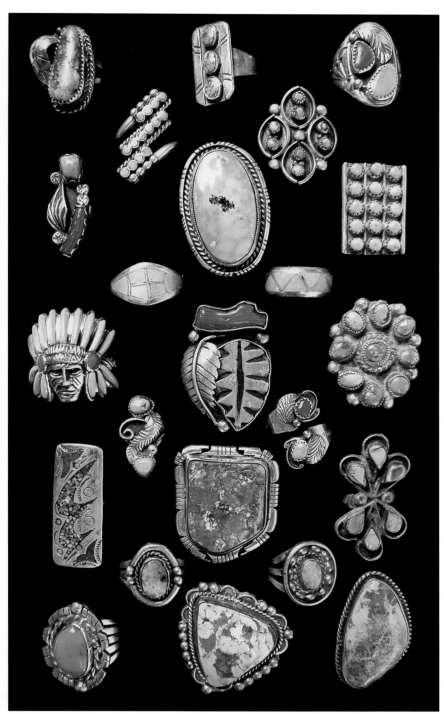

Navajo Rings, circa 1970s. Collection of 23 old pawn rings, hand-wrought silver, turquoise and coral rings, sizes 5-12. Allard 8-13-05 **$475.00.**

Zuni Pin, circa 1940s. Stone-to-stone Thunderbird pin of jet, turquoise, and shell with fine silver work, 2 1/4" x 2 1/8". Allard 8-13-05 **$180.00.**

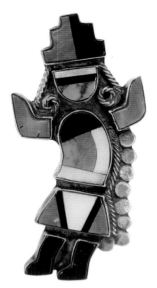

Hoyungwa Concho Belt, Hopi, late 1900s. Sterling overlay Concho belt with nine Conchos plus buckle in Navajo rug patterns hallmarked by husband and wife team Karen and Manuel, Concho size of 2 1/2" x 3" on a 36" belt. Allard 8-13-05 **$2,500.00**

Zuni Inlay Pin, circa 1940s. Channel inlay pin of turquoise, jet, coral, and mother of pearl on silver in the "Knife Wing God" design, 2 3/4". Allard 3-11-05 **$100.00.**

Hoyungwa Concho Belt, Hopi, late 1900s. Sterling overlay Concho belt with matching buckle with insect and Yei figures made by husband and wife team Karen and Manuel, Concho size of 2 1/4" x 3" on a 36" belt. Allard 8-13-05 **$3,500.00.**

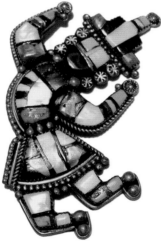

Zuni Pin, circa 1940. Stone-to-stone Rainbow God pin using jet, turquoise, spiny oyster, shell, etc. and it is hallmarked, 4" x 2 1/4". Allard 8-13-05 **$375.00.**

Navajo Silver Buttons, mid-1900s. 36 hand-stamped fluted silver buttons, 3/8" each. Allard 3-11-05 **$70.00.**

Navajo Belt, circa 1940s.
All-silver Concho link-belt hallmarked "United Indian Traders Assoc. #21-Pine Springs", 35" long. Allard 8-13-05 **$275.00.**

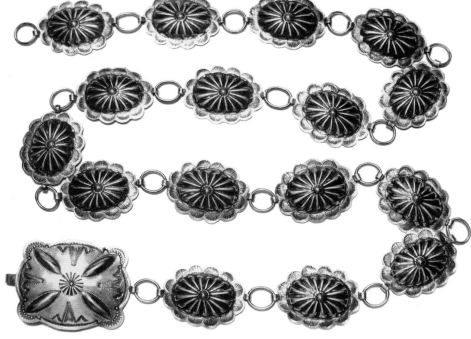

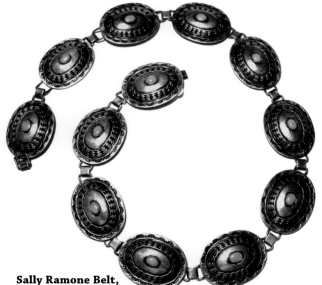

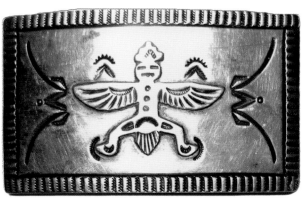

Navajo Buckle, circa 1930. All sterling buckle stamped with overlay thunderbird, 2" x 3". Allard 8-13-05 **$350.00.**

Sally Ramone Belt, circa 1960. Stamped silver Concho belt with turquoise stones, hallmarked, 31" long. Allard 8-13-05 **$350.00.**

Zuni Buckle, circa 1940. Stone-to-stone ranger buckle of jet, shell and spiny oyster with two keepers, 2 3/4". Allard 8-13-05 **$275.00.**

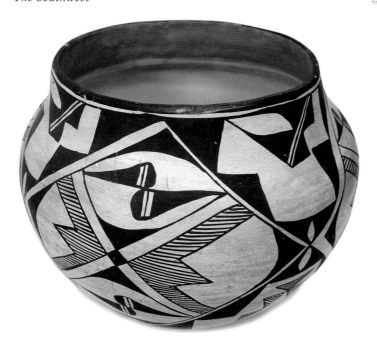

Classic Acoma Olla, early 1900s. Black designs on white slip with red bottom and inside, thin-walled, 7 1/2" high x 10" diameter. Allard 3-11-05 **$550.00.**

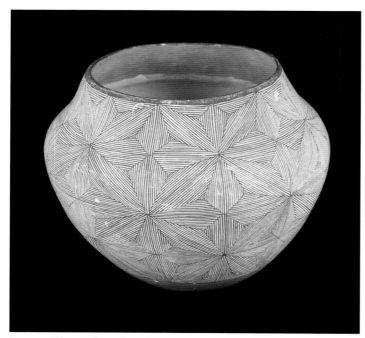

Acoma Olla, mid-20th C. (an Olla is simply a particular form of a pottery jar) made by Marie Miller of Acoma, New Mexico at Sky City, 7 1/4" high, diameter of 8 3/4". Julia 10-05 **$230.00.**

Pottery

Another major area of collecting interest from the Southwest includes the historic and prehistoric pottery from the region and its many and somewhat varied traditions. It is not uncommon for pieces to bring hundreds and even thousands of dollars, with some individual potter's pieces being in higher demand than the norm from the region. Following are numerous examples of the art and artisanship of the potter's trade found in the Southwest.

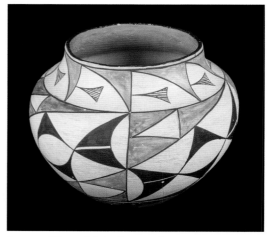

Acoma Olla, mid-20th C. Reflects an earlier Pueblo form and has the typical orange and black feather and rain motifs, 6 1/4" high, and 8" diameter. Julia 10-05 **$230.00.**

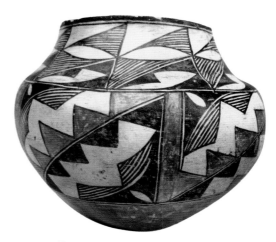

Acoma Olla, circa 1900. Shows use, no cracks, no damage or restoration, museum quality piece, 10" x 12". Allard 8-13-05 **$2,250.00.**

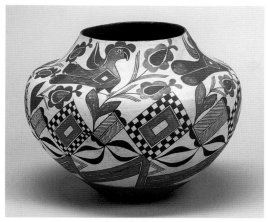

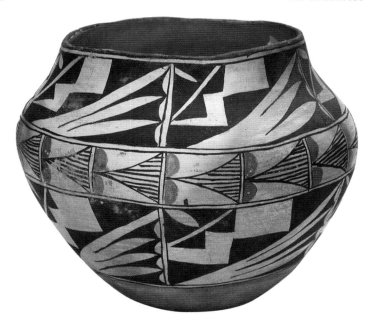

Acoma Polychrome Olla, circa 1900. Concave base, rounded shoulder and tapered neck with black, red/brown and orange geometric, foliate motifs and a stylized parrots on a cream-colored ground, 11" high x 13 1/2" diameter. Skinner 9-10-05 **$29,275.00.**

Acoma Polychrome Olla, mid-1900s. Classic geometric and curvilinear forms, 10" high x 12" diameter. Allard 3-11-05 **$600.00.**

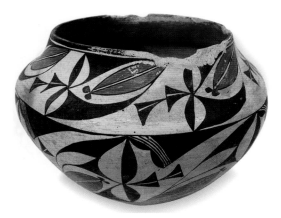

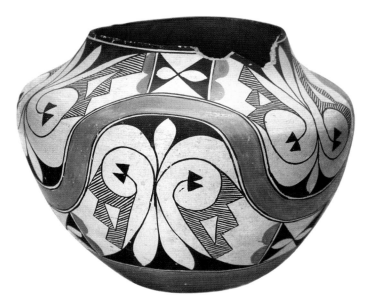

Acoma Polychrome Olla, circa 1900. Older, thin-walled olla with leaf and other motifs, some chipping and wear around the rim, 10" high x 12" diameter. Allard 3-11-05 **$375.00.**

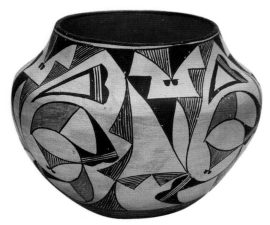

Acoma Polychrome Olla, mid-1900s. Some rim damage as shown, classic designs, 10" high x 11" diameter. Allard 3-11-05 **$350.00.**

Thin-Walled Acoma Olla, mid-1900s. Black and red designs on a white slip on a traditional style olla, 9" high x 10" diameter. Allard 3-11-05 **$500.00.**

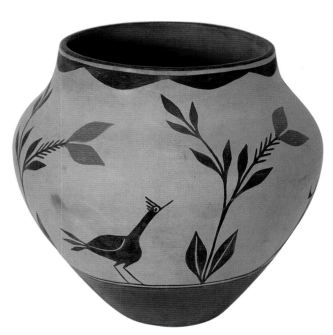

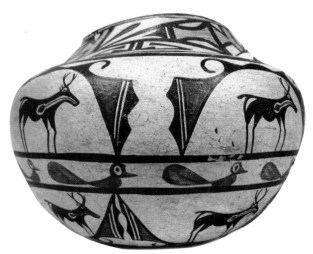

Zuni Olla, circa 1880. Shows use, no cracks, no damage or restoration, museum quality piece, 11" x 15". Allard 8-13-05 **$16,000.00.**

Zia Olla, mid/late 1900s. Beautiful and large polychrome pottery olla with traditional bird and foliate designs, 10" high x 11" diameter. Allard 3-12-05 **$600.00.**

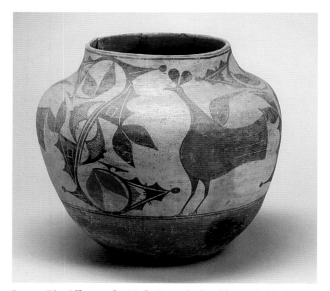

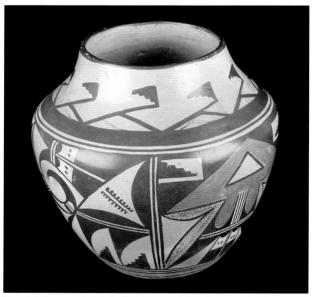

Hopi Olla, early 20th C. Motifs of clouds, rain, feathers and parrots with maker's symbols on bottom, 8" high, 8" diameter. Julia 10-05 **$450.00.**

Large Zia Olla, early 20th C. High shoulder with black and dark red abstract floral design and three large Zia birds, some damage to rim and surface wear, 15 1/2" high x 16 1/2" diameter. Skinner 9-10-05 **$11,162.50.**

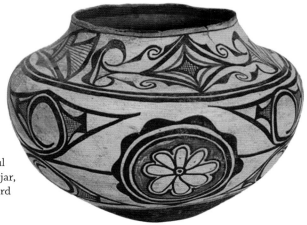

Zuni Olla, late 1800s. Beautiful designs on this old Zuni pottery jar, 10" high x 13 1/2" diameter. Allard 8-14-05 **$5,500.00.**

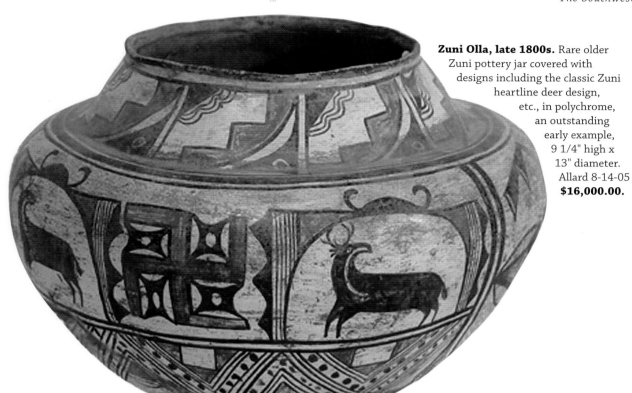

Zuni Olla, late 1800s. Rare older Zuni pottery jar covered with designs including the classic Zuni heartline deer design, etc., in polychrome, an outstanding early example, 9 1/4" high x 13" diameter. Allard 8-14-05 **$16,000.00.**

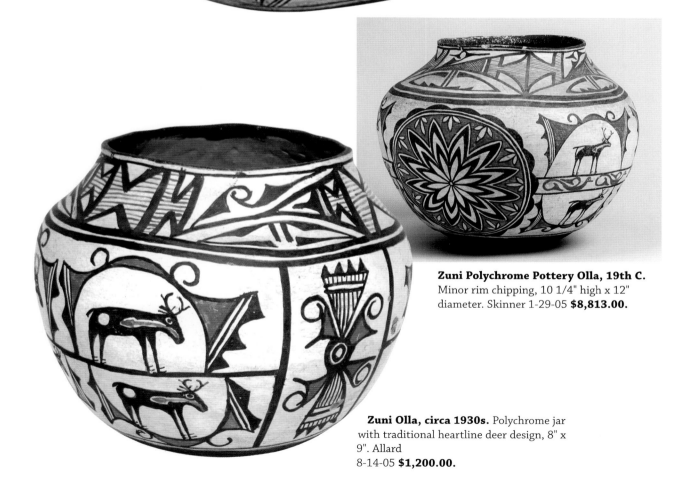

Zuni Polychrome Pottery Olla, 19th C. Minor rim chipping, 10 1/4" high x 12" diameter. Skinner 1-29-05 **$8,813.00.**

Zuni Olla, circa 1930s. Polychrome jar with traditional heartline deer design, 8" x 9". Allard 8-14-05 **$1,200.00.**

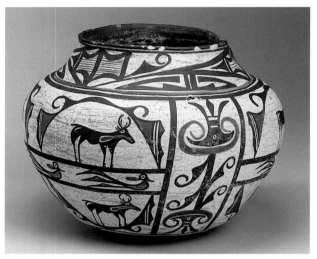

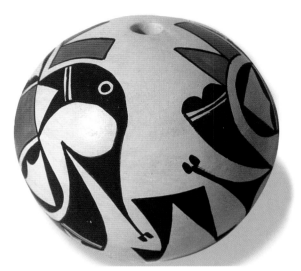

Zuni Polychrome Olla, 19th C. Great figural motifs an geometric designs, chips at rim and small hole in upper shoulder, 10 1/2" high x 12 1/2" diameter. Skinner 1-29-05 **$14,100.00.**

Acoma Seed Jar by Master Potter Lucy Lewis, circa 1970s-80s. 4" high x 5" diameter. Allard 3-11-05 **$550.00.**

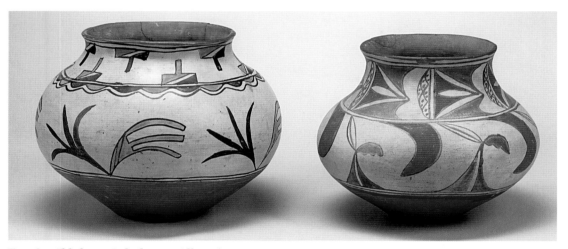

Two San Ildefonso Polychrome Ollas, circa 1900.

Left: 10" high x 12" diameter, part of rim broken and repaired. Provenance for both pieces is Wistariahurst Museum. Skinner 9-10-05 **$2,350.00.**

Right: The red has some fading and a piece was broken at the rim and repaired on this nice concave based piece, 9 1/2" high x 11" diameter. Skinner 9-10-05 **$1,997.50.**

Hopi Seed Jar, Possibly Nampeyo, late 19th C. Original with a stabilized hairline crack across the bottom, some shelf wear on bottom, 8 1/2" high x 13 1/2" diameter. Provenance: Collected circa 1912 by a couple working for the railroad and living in Winslow, Arizona. Present owner purchased item from their family. Skinner 1-29-05 **$27,025.00.**

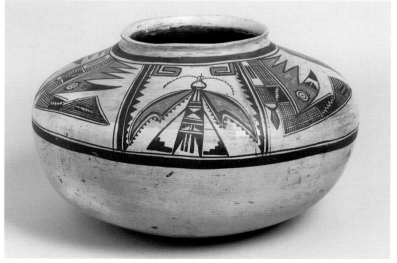

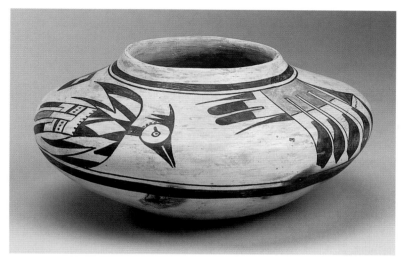

Acoma Pottery by Lucy M. Lewis. Signed, 2 1/4" x 4", circa 1970s. Allard 3-11-05 **$600.00.**

Hopi, Nampeyo, Pottery Seed Jar, late 19th C. Beautiful polychrome seed jar with great provenance indicating item purchased at Nampeyo and made by potter named Nampeyo C.E.M.-Keams, restored by Andrew Goldsmidt, break lines visible on the interior, 5 1/4" high x 11" diameter. Provenance: Collected by Charles Edward Mendenhall (1849-1937), or his son, Edward Simpson Mendenhall, and was descended in the family. An old playing card inside of the bowl indicated it was purchased in 1893 at Nampeyo. Skinner 1-29-05 **$7,638.00.**

Acoma Pottery by Lucy M. Lewis. Signed, 3" x 4 1/2", circa 1970s. Allard 3-11-05 **$700.00.**

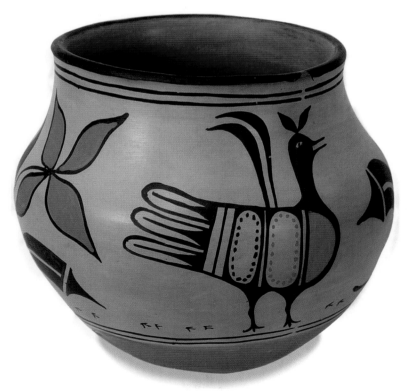

Acoma Pottery by Lucy M. Lewis. Signed, 5 1/2" x 4", circa 1970s. Allard 3-11-05 **$600.00**

Santana Melchor Signed Pottery, mid/late 1900s. Original pottery olla from Santo Domingo with black and red bird and foliate motifs on gray slip, 8" high x 9" diameter. Allard 3-12-05 **$425.00.**

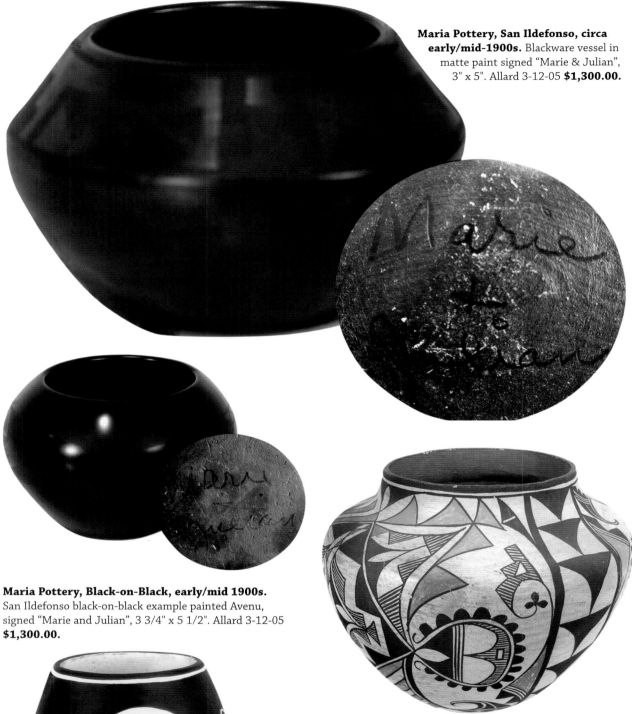

Maria Pottery, San Ildefonso, circa early/mid-1900s. Blackware vessel in matte paint signed "Marie & Julian", 3" x 5". Allard 3-12-05 **$1,300.00.**

Maria Pottery, Black-on-Black, early/mid 1900s. San Ildefonso black-on-black example painted Avenu, signed "Marie and Julian", 3 3/4" x 5 1/2". Allard 3-12-05 **$1,300.00.**

Acoma Pottery Vase, mid-1900s. Thin walled polychrome painted vase with geometric and curvilinear designs, 8 1/4" x 9 1/2". Allard 8-13-05 **$1,000.00.**

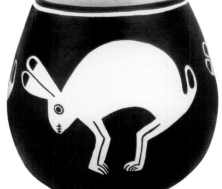

Acoma Pueblo Pottery Jar, 2005. A great negative rabbit design on this Acoma jar signed by Lucy Lewis' sister "Carmel Lewis" made in 2005, 5" x 5". Allard 8-14-05 **$275.00.**

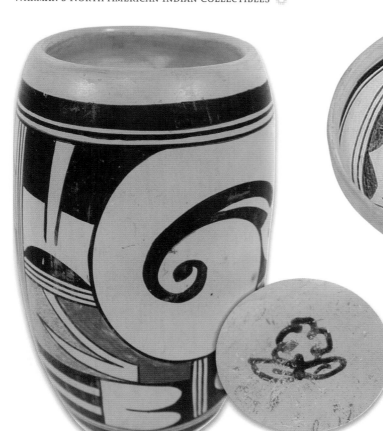

Hopi Cream Colored Bowl, circa early 1900s. Unusual Hopi bowl in cream color with indented rim and an interior polychrome design, 3 1/2" high x 8 1/2" diameter. Allard 8-14-05 **$650.00.**

Hopi Pottery Vase, mid-1900s. Traditional style upright vase with polychrome design and signed with a flower hallmark, 8 1/2" high x 5" diameter. Allard 8-14-05 **$400.00.**

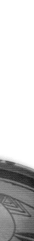

Hopi Redware Pottery Bowls, circa 1940. One bowl has two repaired hairline fractures, 3" x 9" each. Allard 8-14-05 **$1,200.00.**

Hopi Bowl, early 1900s. Rare and early black-on-buff pottery bowl with a stylized bird design on the interior, unsigned, 3" high x 9 1/2" diameter. Allard 8-14-05 **$325.00.**

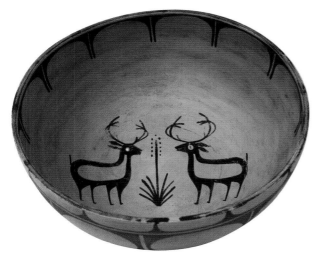

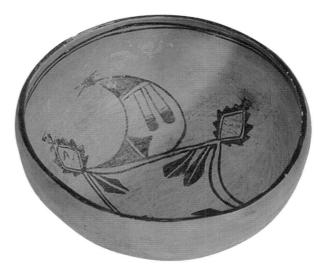

Santo Domingo Bowl, mid-1900s. Large old handmade pottery dough bowl with deer and Yucca design, very classic, 8" high x 17" diameter. Allard 8-13-05 **$650.00.**

Hopi Pottery Bowl, early 1900s. Large bowl intact with interior designs, 6" high x 12" diameter. Allard 8-14-05 **$650.00.**

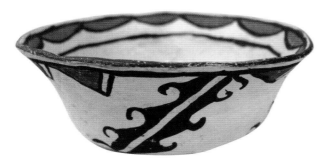

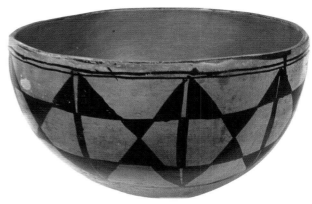

Zuni Pottery Bowl, circa 1890. Excellent historic Zuni bowl in as found excellent condition, 3" deep x 7" diameter. Allard 8-13-05 **$225.00.**

Santo Domingo Bowl, early 1900s. Large traditional black and white-on-red pottery dough bowl with geometric designs in classic style, 9" x 15 1/4". Allard 8-13-05 **$3,750.00.**

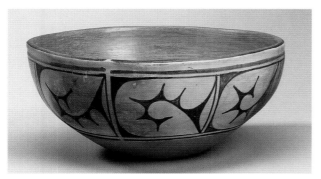

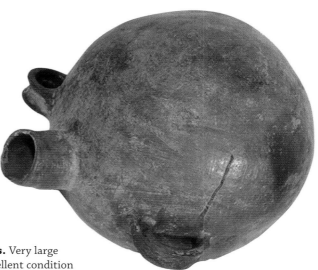

Santo Domingo Painted Pottery Dough Bowl, second quarter 20th C., 7" high x 15 1/4" diameter. Skinner 1-29-05 **$1,293.00.**

Pueblo Water Jar, late 1800s. Very large water jar, possibly Hopi, in excellent condition with original lugs and spout, 12" x 15" x 16 1/2". Allard 8-14-05 **$2,500.00.**

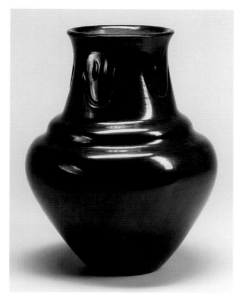

Large Southwest Polished Blackware Pottery Vase, Santa Clara, mid-20th C. "Margaret Tafoya, Santa Clara, New Mexico", ribbed shoulder, long neck with four bear paws and a flared rim, minor scratching, 16" high. Skinner 9-10-05 **$19,975.00.**

Zuni Kiva Bowl, late 1900s. Handmade Kiva bowl made by M. Homer, excellent condition, 12" diameter. Allard 8-13-05 **$275.00.**

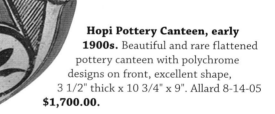

Hopi Pottery Canteen, early 1900s. Beautiful and rare flattened pottery canteen with polychrome designs on front, excellent shape, 3 1/2" thick x 10 3/4" x 9". Allard 8-14-05 **$1,700.00.**

Three Southwest Blackware Bowls.

Left: San Ildefonso, Maria Poveka, 20th C., 3" high x 3 3/4" diameter. Skinner 9-10-05 **$881.25.**

Center: Santa Clara, signed "Betty Naranjo, Santa Clara" deeply carved Avanu pattern, 4 3/4" high x 5 1/2" diameter. Skinner 9-10-05 **$352.50.**

Right: San Ildefonso, Maria and Santana, 20th C. feather devices on neck, 2 1/8" high x 4" diameter. Skinner 9-10-05 **$587.50.**

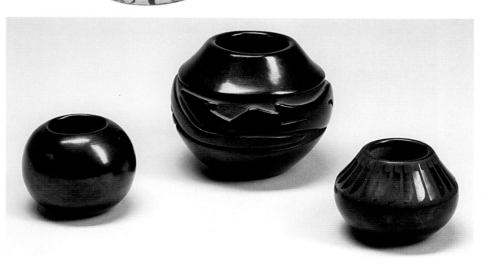

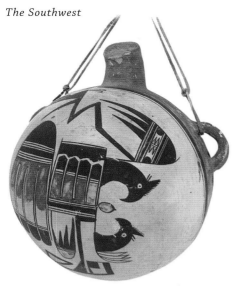

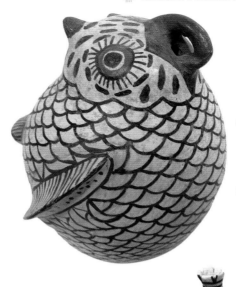

Acoma Pottery Owl, circa 1930. Superb black and red-on-white pottery owl with ears, nose, and wings in excellent condition, 7" x 6". Allard 8-13-05 **$700.00.**

Hopi Canteen, circa 1940s. Polychrome with traditional bird designs, intact lugs shows wear from use, 6 3/4" x 9 1/4" x 8". Allard 8-13-05 **$9,000.00.**

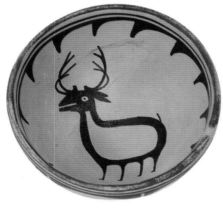

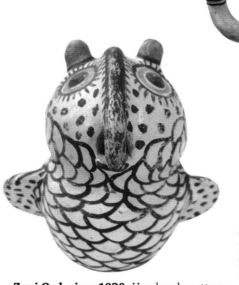

Cochiti Figure, late 1900s. Handmade pottery figure, no damage or restoration, 14 1/2" tall. Allard 8-13-05 **$600.00.**

Santo Domingo Deer Figure Pottery, mid/late 1900s. Dough or chili bowl in polychrome with traditional motifs and deer design, 5" high x 9" diameter. Allard 3-12-05 **$325.00.**

Zuni Owl, circa 1920. Handmade pottery owl attributed to Nellie Bica, 6 1/2" x 7". Allard 8-13-05 **$275.00.**

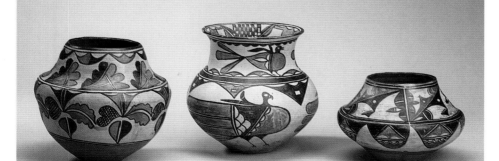

Three Southwest Pottery Examples.
 Left: San Ildefonso, circa 1900 olla in polychrome, 10" high x 10 1/2" diameter. Skinner 1-29-05 **$4,994.00.**
 Center: San Ildefonso, early 20th C. olla with concave base as the first one, some surface pitting, 10 1/2" high x 10 1/4" diameter. Skinner 1-29-05 **$7,050.00.**
 Right: San Ildefonso early 20th C. pottery jar, 7 1/4" x 9 3/4". Skinner 1-29-05 **$5,875.00.**

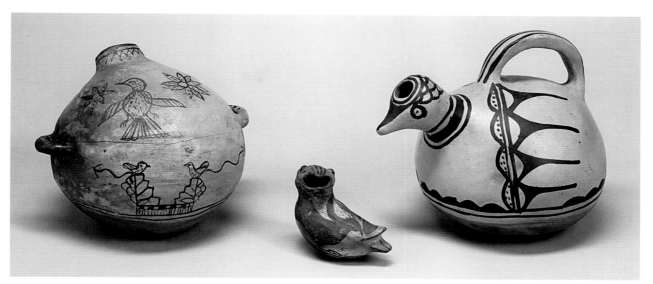

Three Southwestern Pottery Vessels.

Left: Flat-bottomed canteen with two lugs and spout, floral, bird, and tablita imagery, broken and repaired with some surface loss, widest is 8". Skinner 9-10-05 **$822.50.**

Center: Acoma (?) circa 1900 pottery bird painted with two birds and a foliate device, 4" long. Skinner 9-10-05 **$822.50.**

Right: Cochiti, circa 1900, pottery vessel in shape of bird effigy, black on cream abstract decoration with red stripe near bottom, 7 1/2" high x 8" long. Provenance: Wistariahurst Museum. Skinner 9-10-05 **$735.00.**

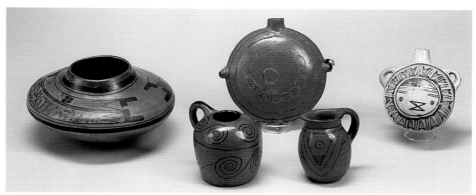

Five Southwestern Pottery Vessels.

Left: Polychrome seed jar, Hopi, late 19th C. 5 1/4" high x 9 1/4" diameter. Skinner 9-10-05 **$980.00.**

Central: Three Items: Mojave, late 19th C. canteen, jug and small pitcher, canteen is 7 1/2". Skinner 9-10-05 **$470.00.**

Right: Hopi, 20th C. Polychrome canteen, belly is painted in a stylized Kachina face, cream-orange slip, 5 1/2". Skinner 9-10-05 **$1,175.00.**

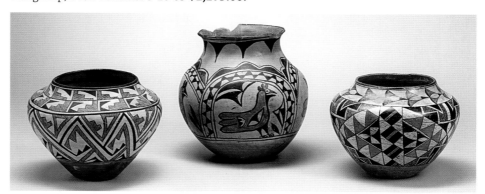

Three Southwestern Pottery Vessels.

Left: Acoma pottery olla, circa 1920s, 8" high x 10 1/2" diameter. Skinner 9-10-05 **$1,645.00.**

Center: Santo Domingo, pottery olla circa early 20th C. Four black and orange/red birds framed in arches, some damage and loss, 11" high x 10" diameter. Skinner 9-10-05 **$1,057.50.**

Right: Acoma pottery olla, circa 1930s, some wear at neck, geometric motifs on a cream colored ground, 7 1/2" high x 9 3/4" diameter. Skinner 9-10-05 **$1,527.50.**

Prehistoric Items

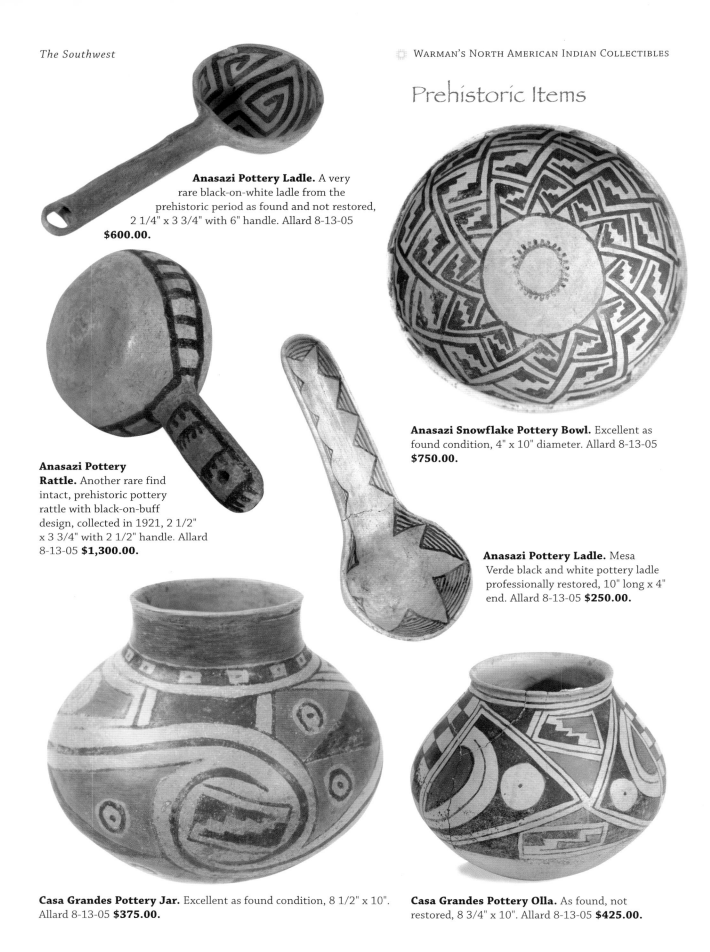

Anasazi Pottery Ladle. A very rare black-on-white ladle from the prehistoric period as found and not restored, 2 1/4" x 3 3/4" with 6" handle. Allard 8-13-05 **$600.00.**

Anasazi Pottery Rattle. Another rare find intact, prehistoric pottery rattle with black-on-buff design, collected in 1921, 2 1/2" x 3 3/4" with 2 1/2" handle. Allard 8-13-05 **$1,300.00.**

Anasazi Snowflake Pottery Bowl. Excellent as found condition, 4" x 10" diameter. Allard 8-13-05 **$750.00.**

Anasazi Pottery Ladle. Mesa Verde black and white pottery ladle professionally restored, 10" long x 4" end. Allard 8-13-05 **$250.00.**

Casa Grandes Pottery Jar. Excellent as found condition, 8 1/2" x 10". Allard 8-13-05 **$375.00.**

Casa Grandes Pottery Olla. As found, not restored, 8 3/4" x 10". Allard 8-13-05 **$425.00.**

Woven Materials

One cannot possibly think of the Southwest without the image of a great Navajo blanket coming to mind. In addition to rugs per se, additional woven throws were also made throughout the Southwest and are collectible. Examples of this beautiful artwork are shown following, and the form is a great example of a cultural adaptation using the wool introduced by the Europeans to develop an indigenous tradition now seen as one of the most significant material cultural traits of the region.

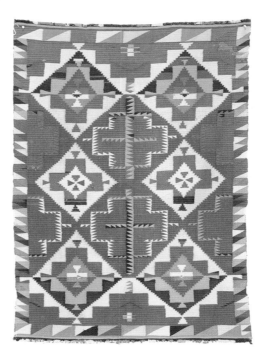

Navajo Weaving, late 1800s. Fine tapestry grade weaving of classic red, gold, brown, green, etc., 45" x 30". Allard 8-13-05 **$2,250.00.**

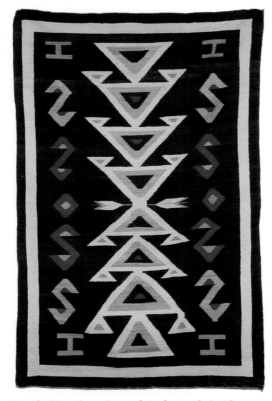

Navajo Weaving, Crystal Style, early/mid-1900s. Dark background rug with interesting figures, 67" x 43". Allard 8-13-05 **$1,200.00.**

Navajo Weaving, circa 1986. Award winning Two Gray Hills rug with ribbon, 92" x 58". Allard 8-13-05 **$4,750.00.**

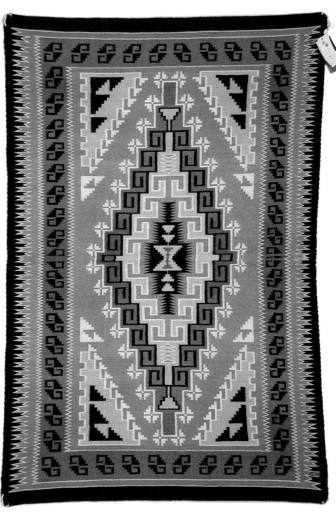

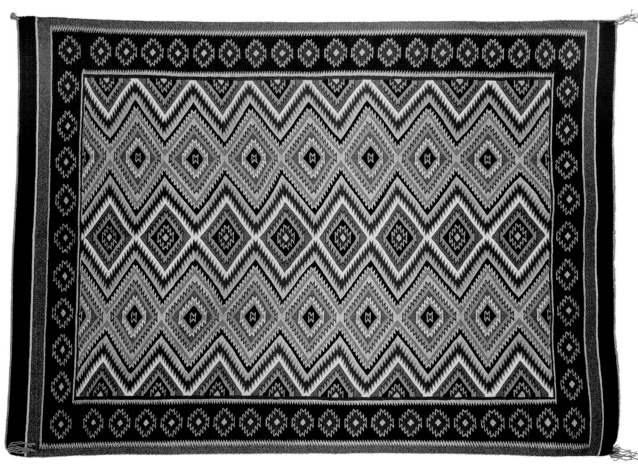

Navajo Weaving, mid/late 1900s. Serrated chevron pattern on gray/black base, 58" x 43". Allard 8-13-05 **$4,000.00.**

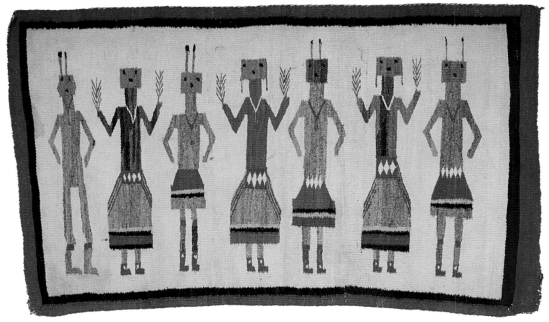

Navajo Pictorial Weaving, second quarter 20th C. Made of natural and commercially dyed homespun yarns showing seven Yei figures, some old repairs, 34 1/2" x 59". Skinner 9-10-05 **$1,410.00.**

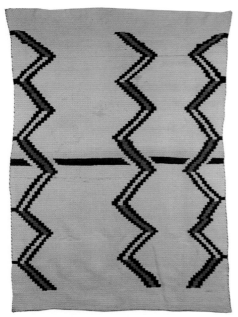

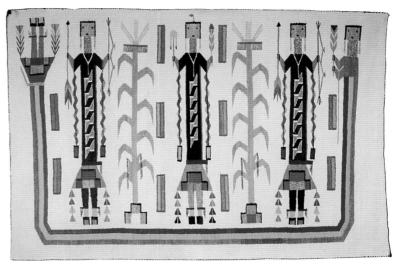

Southwest Pictorial Weaving, 1939. Four multicolored Yei figures and two cornstalks on a cream-colored background. 61" x 41". Provenance: First prize winner, Inter-Tribal Ceremonial, Gallop, New Mexico, 1939, with ribbon and letter from trader to first owner, letter dated 1943. Skinner 9-10-05 **$1,410. 00.**

Southwest Transitional Period Blanket, Navajo, last quarter 19th C. Woven in hand-spun Merino wool with a vertical lightning pattern in aniline red and natural dark brown with minor stains, 74" x 50". Skinner 9-10-05 **$3,407.50.**

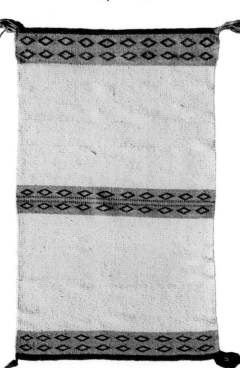

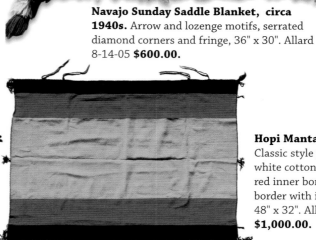

Navajo Sunday Saddle Blanket, circa 1940s. Arrow and lozenge motifs, serrated diamond corners and fringe, 36" x 30". Allard 8-14-05 **$600.00.**

Navajo Double Saddle Blanket, circa 1940s. Natural homespun wool with stripes and diamond motifs, 52" x 31". Allard 8-14-05 **$1,200.00.**

Hopi Manta, circa 1940. Classic style plain weave white cotton manta with red inner border and black border with indigo cording, 48" x 32". Allard 8-14-05 **$1,000.00.**

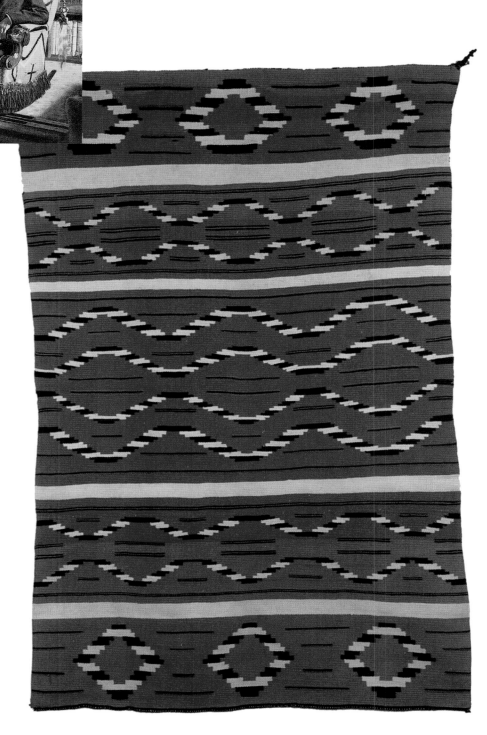

Navajo Late Classic Period Wearing Blanket, circa last quarter 19th C. Tightly woven banded pattern with background in raveled cochineal-dyed red and aniline-dyed light red, separated by ivory stripes, overlaid with deep indigo blue and ivory zigzag and stepped motifs with indigo blue and blue-green stripes, minor wool loss, 70 1/2" x 46". Provenance: Edward Everett Ayer, one of the founders and the first president, and then trustee, of the Field Museum of Natural History in Chicago. This item descended through the family and was personally collected by him prior to his death (1841-1927). Skinner 9-10-05 **$35,250.00.**

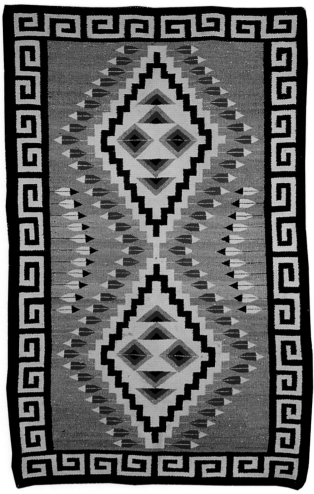

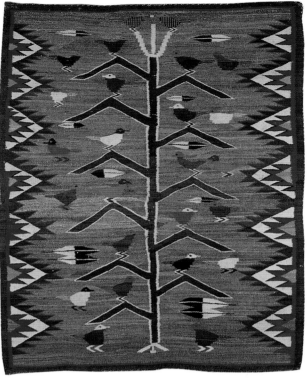

Navajo Woven Rug, second quarter of 20th C. 43" x 53", made of natural and commercially dyed homespun wool with a central cornstalk and various colored birds and feathers, two old repairs. Skinner 9-10-05 **$2,115.00.**

Navajo Woven Rug, first quarter of 20th C. 68" x 41", made of natural and commercially dyed homespun wool. Skinner 9-10-05 **$2,820.00.**

Navajo Rug, early 20th C. Specific origin unknown as it is a typical "reservation style" pattern. Woven with handspun yarn in black and white with dyes, 126" long x 45" wide. Julia 10-05 **$2,012.50.**

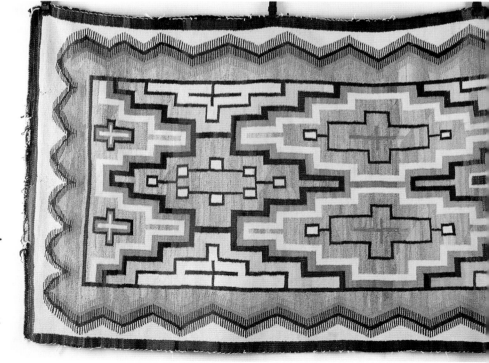

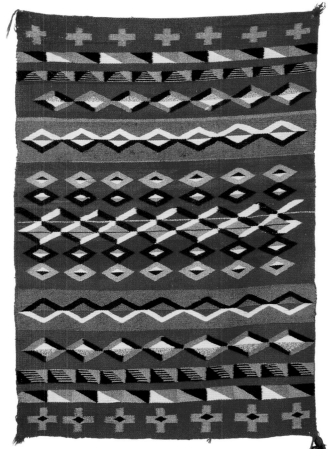

Navajo Rug, circa 1940. Banded weaving on red ground with crosses and other designs, 54" x 36". Allard 3-11-05 **$1,200.00.**

Navajo Rug, circa third quarter 20th C., pictorial rug with truck, sheep, eagles, humans, horses, goats, etc., 52" x 31". Allard 3-11-05 **$650.00.**

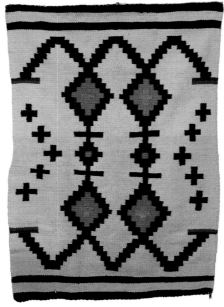

Navajo Rug, mid-1900s. Classic design, light background transitional weaving with black geometric designs, accented with orange, 52" x 35". Allard 3-11-05 **$325.00.**

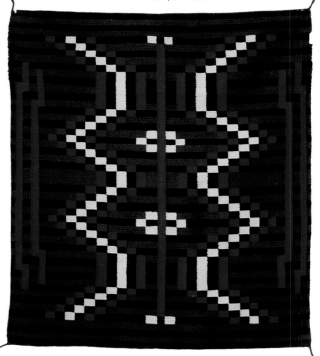

Navajo Rug, circa 1980s. Moki style blanket with black, navy, red and white geometric designs, 45 1/2" x 39". Allard 3-11-05 **$375.00.**

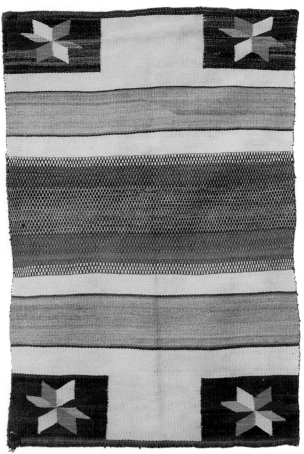

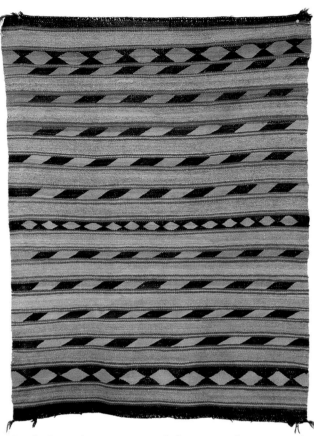

Navajo Rug, circa 1940s. Design weaving with a modified checkerboard center and Valero stars in the corners, 51" x 31". Allard 3-11-05 **$425.00.**

Navajo Rug, circa 1940s. Banded transitional weaving with rhomboids, diamonds and other designs, 50" x 36". Allard 3-11-05 **$600.00.**

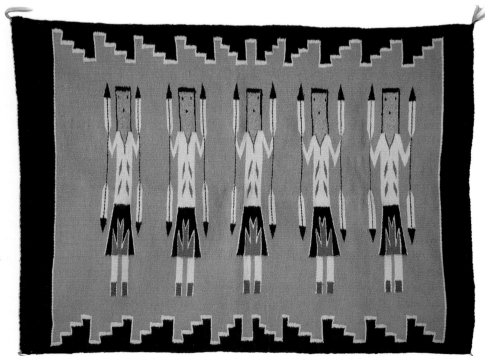

Navajo Rug, circa 1970s. Fine weave vegetal dyes with repeating Yei figure in earth tone colors, 1974 award winner from the Museum of Northern Arizona by Alice Yazzie, 40" x 29 1/2". Allard 3-11-05 **$400.00.**

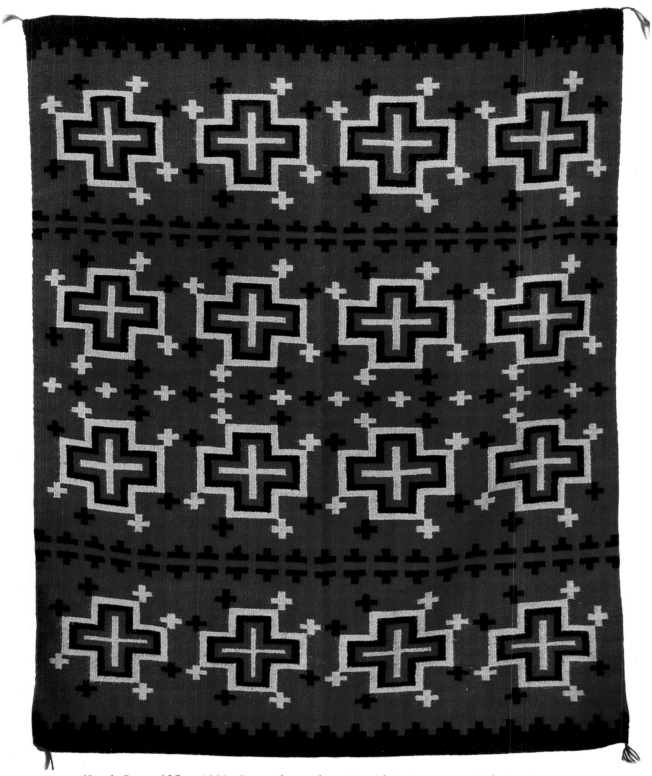

Navajo Rug, mid/late 1900s. Deep red ground weaving with intricate geometric designs in black and gray, 60" x 46". Allard 3-11-05 **$2,000.00.**

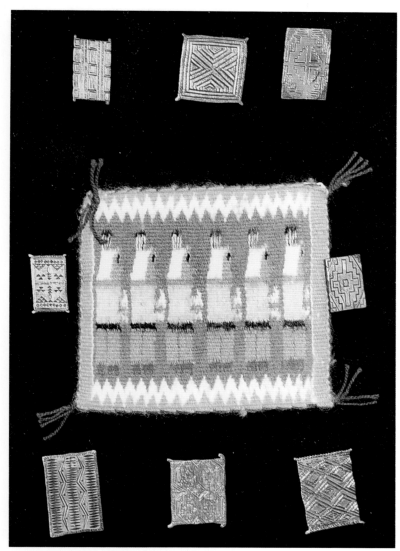

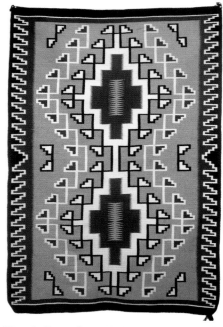

Navajo Rug, circa 1970. Fine weave rug by Sadie Benally, from the Notah Begay Trading Post, 64" x 42". Allard 8-13-05 **$850.00.**

Navajo Rug, circa 1980s. Superfine miniature Yei figural weaving, framed and surrounded by eight sterling Navajo rug jewelry pins, 12" x 8". Allard 3-11-05 **$100.00.**

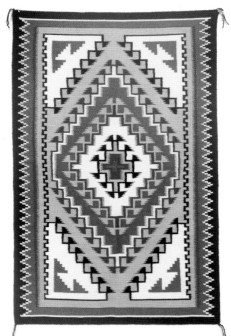

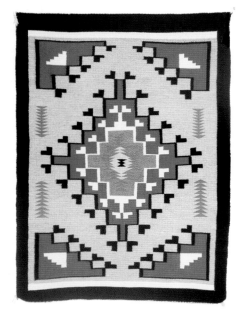

Navajo Rug, late 1900s. Fine weave rug with blue, gray and white geometric designs, 50" x 36". Allard 8-13-05 **$325.00.**

Navajo Rug, late 1900s. Fine weave in stunning colors by Mollie Mitchell, 59" x 37". Allard 8-13-05 **$1,500.00.**

Navajo Rug, late 1900s. Unique combination of traditional and non-traditional designs of native figures and symbols, 47" x 37". Allard 8-13-05 **$375.00.**

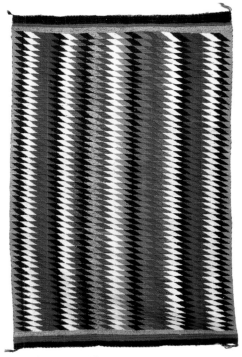

Navajo Rug, mid-1900s. Heavier weave in classic patterns with traditional rows of black, white, red, tan, gray and other serrated diamonds, 82 1/2" x 50 1/2". Allard 3-12-05 **$600.00.**

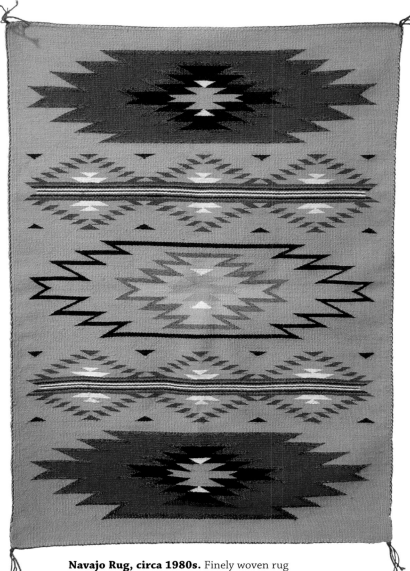

Navajo Rug, circa 1980s. Finely woven rug with serrated geometric designs on a gray/brown background, 38" x 26". Allard 3-12-05 **$400.00.**

Navajo Rug, circa 1940.
Heavy weave black and
white rug with large
chevron designs, 48" x 37".
Allard 3-12-05 **$475.00.**

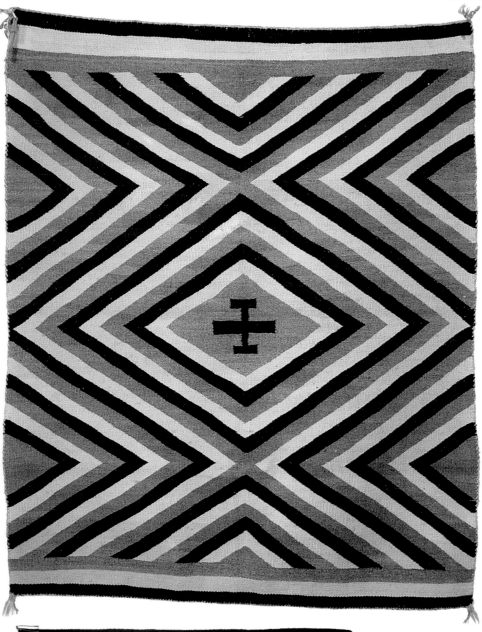

Navajo Rug, late 1900s. Figural rug with different colored Yei
figures and green corn stalks, 53" x 31". Allard 8-13-05 **$400.00.**

4

The South-Eastern Woodlands

 n writing this book, I was somewhat surprised to see the relatively small number of Southeastern artifacts sold at auction in 2005. But, then again, I understood the reasons for it, which are really two-fold: (1) early contact by Europeans and settlers, which accounted for material cultural alteration and disintegration within the region; and, (2) high humidity in the entire region, which is contrary to preservation of materials made from wood, cloth, and other fragile items. This is discussed again in the Northeastern Woodlands and Great Lakes chapters, but cannot be stressed enough.

Collector interest seems higher according to the prices garnered for Southeastern items than for Northeastern or Great Lakes items, but there simply were not a large number of items offered for sale due to their scarcity.

As with many other regions in this book, I would have loved more examples, but I just did not have them. All items shown were offered for sale in 2005 and I thought it important to show current values by only including recent items, so my choices were limited by the year's offerings at auction. However, I believe the items included show a good representation of material cultural items from the indigenous peoples of the Southeastern United States.

Materials were primarily cane, wood, cloth, and pottery. Items of interest include basketry, clothing, carvings, and pottery items, among others. Major cultural names that immediately come to mind include the Cherokee, Chickasaw, Choctaw, Creek, and Seminole, as well as smaller groups such as the Yuchi and Chitimacha.

Artistic Items

Creek Carving, mid-1900s. Hand-carved stylized fox head carved by Joe Johns Caryoni, signed, 32 1/2" long x 7 1/2" wide. Provenance: Formerly of Peabody Museum. Allard 3-13-05 **$70.00.**

Two Jerome Tiger Original Gouache Paintings. This is our personal favorite Native American painter, as we have his #1420/1500 "Observing the Enemy" signed print hanging in our bedroom. Jerome was Creek-Seminole and lived from 1941-1967 and was a superb artist in watercolors and gouache. Our painting was done in his last year of life, 1967 and is so dated. These two paintings depict a male and a female dancing, signed "Tiger 65", some fading at mat edge, unframed, each 6" x 4 3/4". Skinner 1-29-05 **$1,998.00.**

Basketry

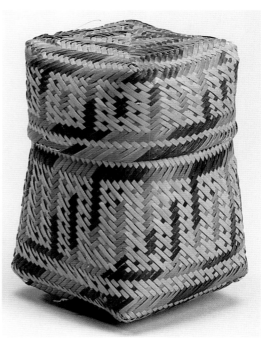

Louisiana Polychrome Twilled Lidded Basket, circa 1900. Chitimacha culture lidded form with damage to three corners, squares and rectangular designs, 5" high. Skinner 1-29-05 **$2,350.00.**

Choctaw Basket, early/mid-1900s. Hand woven storage basket in excellent condition, 12" x 13". Provenance: Thunderbird Museum. Allard 3-12-05 **$550.00.**

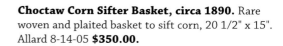

Choctaw Corn Sifter Basket, circa 1890. Rare woven and plaited basket to sift corn, 20 1/2" x 15". Allard 8-14-05 **$350.00.**

Cherokee Basketry, early 1900s. Polychrome woven cane basket with bentwood handle, 10" x 14" x 15". Allard 3-13-05 **$300.00.**

Ceremonial and Utilitarian Items

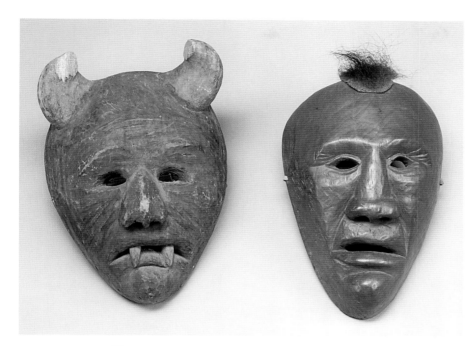

Two Cherokee Carved Wooden Masks, 20th C.
Left: Signed on inside "Will West Long", great horned figural mask with traces of red and black pigments, 12" high. Skinner 9-10-05 **$705.00.**

Right: Attributed to Will West Long, collaborator to ethnographer Frank G. Speck, hollowed mask with animal fur on top of head, 11 3/4" high, shiny patina. Literature: Pictured in *North American Indian Art*, Furst and Furst, Rizzoli, 1982. Skinner 9-10-05 **$4,112.50.**

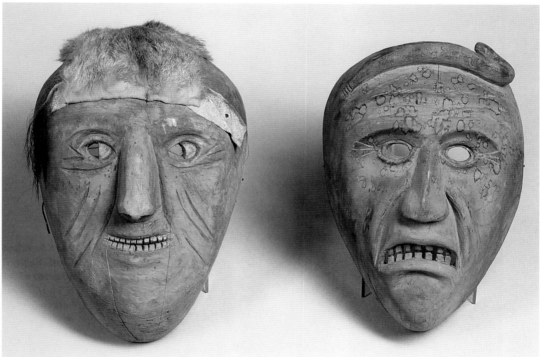

Two Cherokee Carved Wooden Masks, both by Will West Long, 20th C.
Left: Animal hair atop head, incised teeth, traces of pigments and some cracking, 10 1/2" high. Provenance: collected in South Carolina. Skinner 9-10-05 **$1,175.00.**

Right: 10" high mask with carved snake atop head and incised teeth with some traces of pigmentation. Provenance: Purchased directly from carver at Ravensford, North Carolina in 1941. Skinner 9-10-05 **$2,232.50.**

Clothing

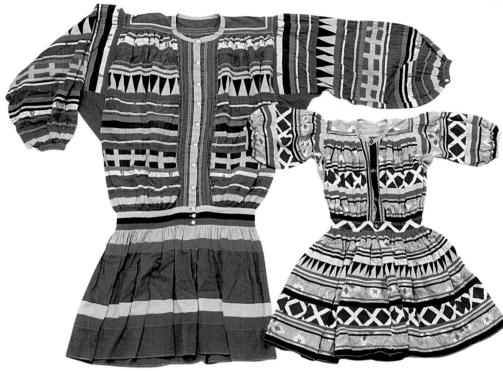

Southeastern Man's and Boy's Patchwork Long Shirts, Seminole, circa 1920s.
 Left: Man's shirt with pearl shell buttons, 41" long. Literature: "Patchwork Clothing of the Florida Indians," D. Downs, *American Indian Art Magazine*, Vol. 4, No. 3. Skinner 9-10-05 **$1,410.00.**
 Right: Boy's shirt with printed cotton stripes, 27" long. Skinner 9-10-05 **$940.00.**

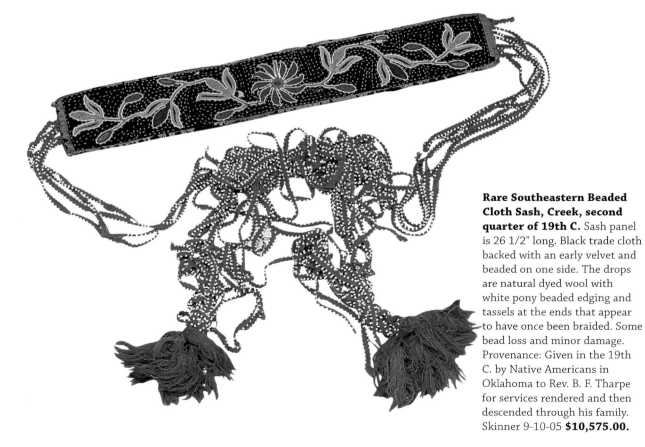

Rare Southeastern Beaded Cloth Sash, Creek, second quarter of 19th C. Sash panel is 26 1/2" long. Black trade cloth backed with an early velvet and beaded on one side. The drops are natural dyed wool with white pony beaded edging and tassels at the ends that appear to have once been braided. Some bead loss and minor damage. Provenance: Given in the 19th C. by Native Americans in Oklahoma to Rev. B. F. Tharpe for services rendered and then descended through his family. Skinner 9-10-05 **$10,575.00.**

Southeastern Woman's Dress and Handbag, Seminole, circa 1920. Traditional Seminole patterns and colors made of brightly colored traditional cloth skirt and cape, applique and Seminole patchwork on cotton and rayon and a multicolored patchwork handbag, skirt length 30". Literature: "Patchwork Clothing of the Florida Indians," D. Downs, *American Indian Art Magazine*, Vol. 4, No. 3. Skinner 9-10-05 **$1,292.50.**

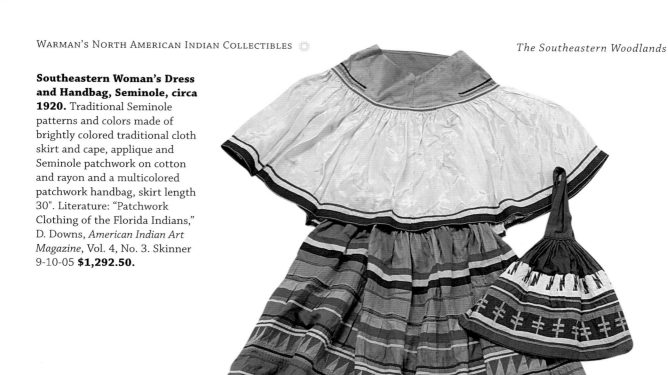

Prehistoric Items

Three Prehistoric Items from Georgia.

Left: Two prehistoric carved stone discoids, the larger one is 5 1/4" and has an old tag reading Etowah River, Bartow Co. Georgia. Provenance: Wistariahurst Museum, Sherman Collection. Skinner 9-10-05 **$11,162.50.**

Right: Carved shell gorget from Georgia, concave 4 1/8" diameter with two holes for suspension with incised and open work representing a rattlesnake. Provenance: Wistariahurst Museum, Sherman Collection. Skinner 9-10-05 **$8,225.00.**

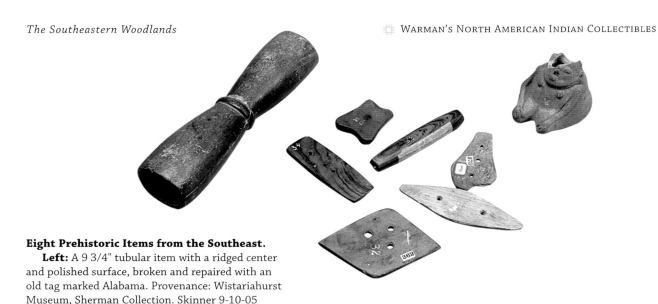

Eight Prehistoric Items from the Southeast.

Left: A 9 3/4" tubular item with a ridged center and polished surface, broken and repaired with an old tag marked Alabama. Provenance: Wistariahurst Museum, Sherman Collection. Skinner 9-10-05 **$2,350.00.**

Center: Six prehistoric gorgets all in slate, one with early label, largest is 4 3/4", Southeast. Provenance: Wistariahurst Museum, Sherman Collection. Skinner 9-10-05 **$1,410.00.**

Right: Prehistoric effigy vessel, Floyd County, Georgia, some clay loss, 3 1/2" high. Provenance: Wistariahurst Museum. Skinner 9-10-05 **$1,527.50.**

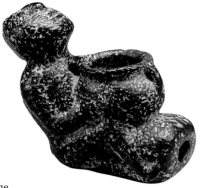

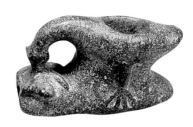

Two Prehistoric Stone Effigy Pipes, both Southeastern.

Left: 6 1/2" pipe in form of human holding a large container with two handles. Provenance: Wistariahurst Museum, Sherman Collection. Skinner 9-10-05 **$11,162.50.**

Right: 5 1/2" effigy pipe in the form of a bird eating a frog. Provenance: Wistariahurst Museum, Sherman Collection. Skinner 9-10-05 **$3,818.75.**

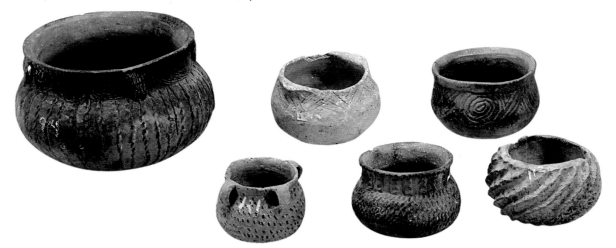

Six Prehistoric Pottery Bowls from the Southeast.

Left: Smith County, Tennessee, prehistoric cooking bowl, broken and reassembled, 5 1/4" high, 7 1/2" diameter. Provenance: Wistariahurst Museum, Sherman Collection. Skinner 9-10-05 **$3,055.00.**

Right: Five prehistoric pottery bowls from Georgia, grayware, some with old tags, some damage, largest diameter is 4". Provenance: Wistariahurst Museum. Skinner 9-10-05 **$2,467.50.**

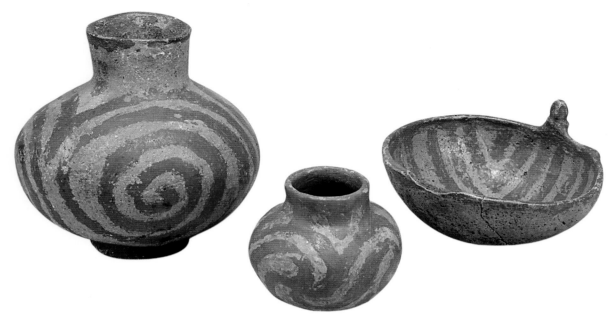

Three Prehistoric Painted Pottery Items from Smith County, Tennessee. Two jars with swirling red designs and a bowl with a human head effigy (broken and reassembled), largest is 8 1/4" high. Provenance: Wistariahurst Museum; Sherman Collection. Skinner 9-10-05 **$1,997.50.**

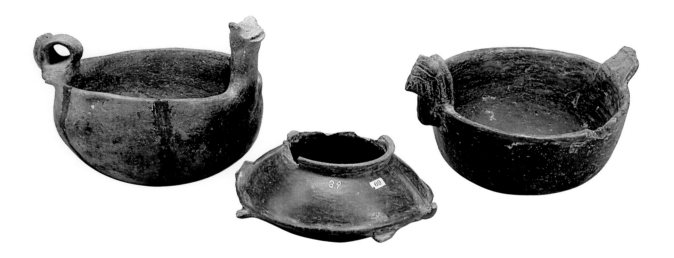

Three Prehistoric Effigy Vessels in Grayware. Two are in forms of animals and one is a turtle (some damage), largest diameter is 9". Provenance: Wistariahurst Museum; Sherman Collection. Skinner 9-10-05 **$705.00.**

5

The North-Eastern Woodlands

As previously indicated, I have divided the Eastern Woodlands into two groups, as the northern and southern regions do exhibit some major differences culturally and because most auction houses also recognize this distinction. Clearly this region was discovered early, and both northern and southern areas were similarly integrated and disintegrated culturally by our European ancestors. Many of the original Native American cultural items are so much a part of our American existence that they are not recognized by most as "Indian," and others were quickly replaced by European cultural materials. For example, most flint items were exchanged for iron and steel. Many of the items shown in the next chapter on the Great Lakes could easily be placed in this region as well, as the material cultural traits are very similar and, of course, the Ojibwa extended into both regions, as did the Huron.

The Woodlands region also suffers from the high humidity harmful to artifacts, so not as many are here for us to collect. Also, early cultural disintegration left fewer items behind than did the more recent cultural explosions, such as the Plains cultures of the 1700s-1800s. I also think the large numbers of some items and the fact that the cultural traditions making them

have changed very little for centuries has harmed collector interest in the items, e.g. Woodlands basketry is a classic example.

Woodlands basketry is beautiful but far from rare, as are examples of basketry from the Pomo or Yurok of California. I have fish creels made by both Woodlands and Great Lakes Native Americans, our wastebasket in our bedroom (that we use) is a 1960s Potawatomi example, our home has at least three Ojibwa Treasure Baskets, and other examples could be found if I add in our ice fishing decoy collection that includes many Native American examples. I only mention this thought concerning "familiarity" with these items, as I was shocked by the low prices for some of the basketry from this region, and the Great Lakes for that matter as well.

Cultures from this region are numerous and not all are included with samples sold during 2005. However, the inclusions should give the reader a fine idea of what is available to collect and the styles and materials used in the Northeast. Important materials are, of course, birch bark, willow, some pottery, ash, cloth, beads, buckskin, and wood in general. Groups included all of the Iroquois Nation members, Micmac, Passamaquoddy, Huron, and others.

> The Woodlands region also suffers from the high humidity harmful to artifacts, so not as many are here for us to collect.

Basketry

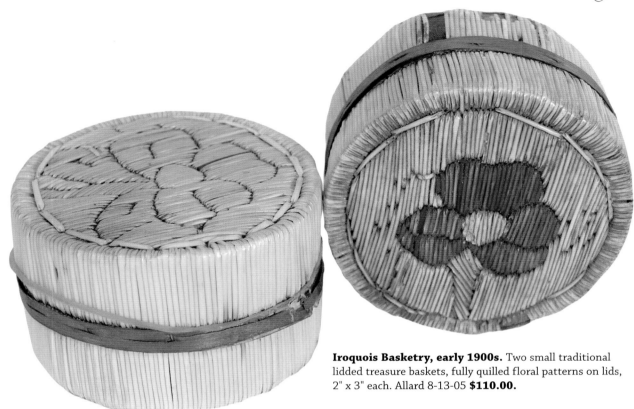

Iroquois Basketry, early 1900s. Two small traditional lidded treasure baskets, fully quilled floral patterns on lids, 2" x 3" each. Allard 8-13-05 **$110.00.**

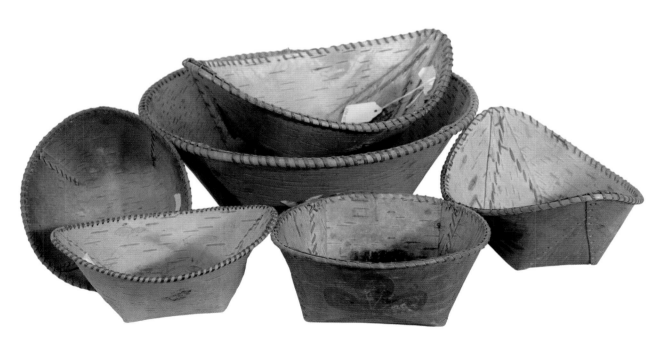

Iroquois Basketry, circa early/mid-1900s. Six examples of Iroquois baskets, five with incised designs and the largest one with porcupine quill accents, 2 1/2" to 5" tall and 6" to 13" wide. Allard 8-13-05 **$275.00.**

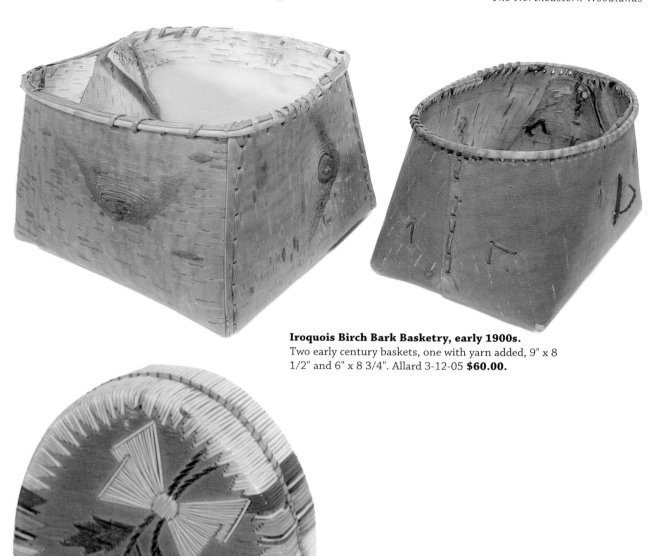

Iroquois Birch Bark Basketry, early 1900s.
Two early century baskets, one with yarn added, 9" x 8
1/2" and 6" x 8 3/4". Allard 3-12-05 **$60.00.**

Iroquois Birch Baskets, early 1900s. Pair
of oval lidded baskets of birch bark, quilled
with color floral motifs on each top, 2" x 4" x
6" each. Allard 8-13-05 **$300.00.**

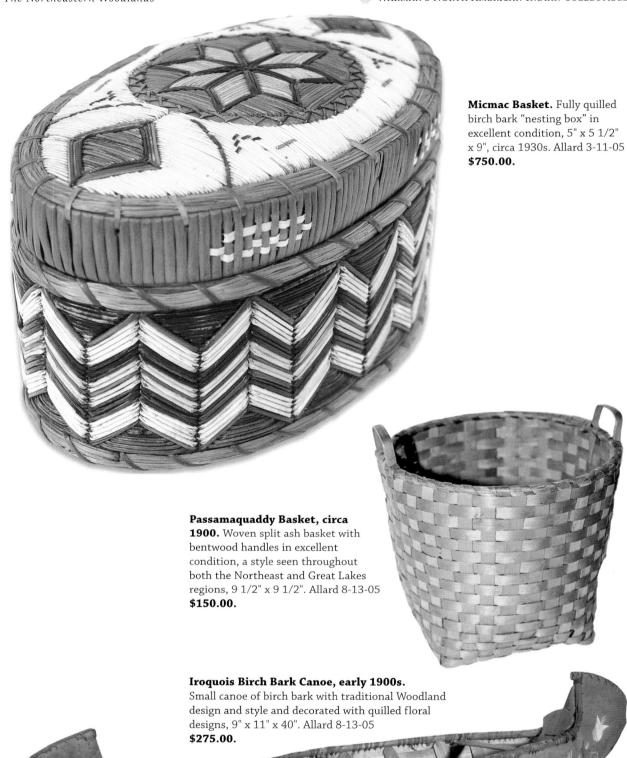

Micmac Basket. Fully quilled birch bark "nesting box" in excellent condition, 5" x 5 1/2" x 9", circa 1930s. Allard 3-11-05 **$750.00.**

Passamaquaddy Basket, circa 1900. Woven split ash basket with bentwood handles in excellent condition, a style seen throughout both the Northeast and Great Lakes regions, 9 1/2" x 9 1/2". Allard 8-13-05 **$150.00.**

Iroquois Birch Bark Canoe, early 1900s. Small canoe of birch bark with traditional Woodland design and style and decorated with quilled floral designs, 9" x 11" x 40". Allard 8-13-05 **$275.00.**

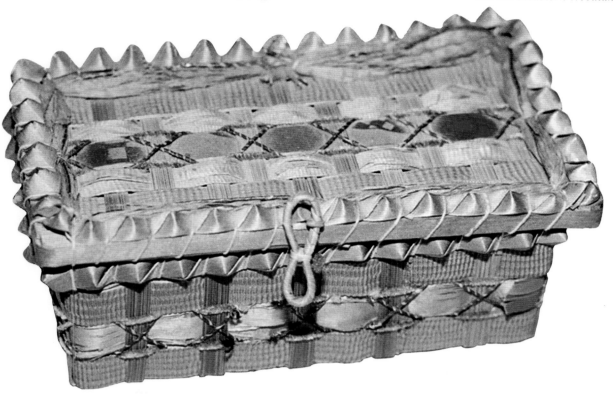

Woodlands Treasure Basket, early 1900s. Finely woven Northeastern Woodlands basket with lid and latch, museum quality, 2" x 3" x 5 1/2". Allard 3-13-05 **$250.00.**

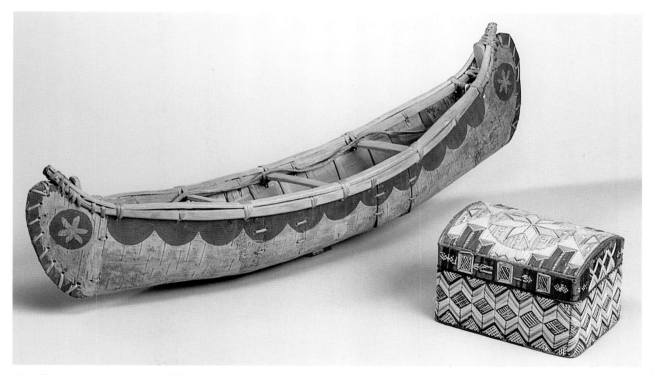

Woodlands Model Canoe and Micmac Box.
 Left: Woodlands canoe made of wood and birch bark, 20th C., 31" long. Skinner 1-29-05 **$323.00.**
 Right: Micmac, circa mid-19th C. dome lid bark box, some quill loss and damage, 5" high x 7 1/2" long. Skinner 1-29-05 **$1,175.00.**

Ceremonial and Utilitarian Items

Two Woodlands Carved Wooden Canes. Length to 43". Skinner 1-29-05 **$646.00.**

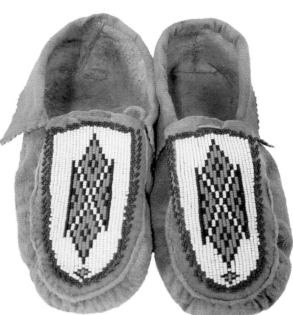

Woodlands Moccasins, mid-1900s. Classic woodland design moosehide moccasins with puckered seams and fully beaded vamps, 10 1/2" long. Allard 3-11-05 **$60.00.**

Woodlands (?) Toy Canoe, late 1800s. Hand-carved canoe with interesting blue and red (barely visible) symbols, 16 1/4" long. Allard 8-13-05 **$110.00.**

Woodlands Net, early to mid-1900s. Hand tied and knotted net made of rawhide lacing, 38" x 39". Allard 8-13-05 **$225.00.**

Woodlands Burl Wood Bowl, early 1900s. Hardwood bowl used for mixing and mashing, 11" x 10 1/2". Allard 3-13-05 **$160.00.**

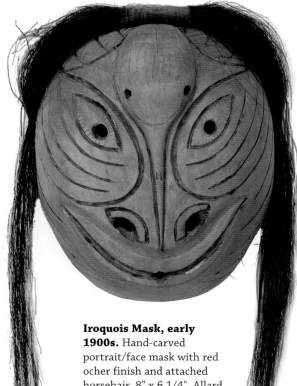

Iroquois Mask, early 1900s. Hand-carved portrait/face mask with red ocher finish and attached horsehair, 8" x 6 1/4". Allard 3-11-05 **$200.00.**

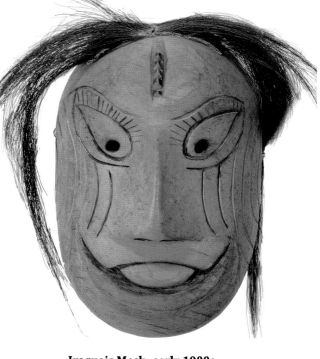

Iroquois Mask, early 1900s. Hand-carved portrait/face mask with yellow ocher finish and horsehair, marked "Storyteller", 8 3/4" x 6". Allard 3-11-05 **$275.00.**

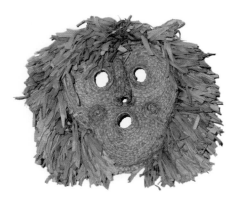

Iroquois Mask, early 1900s. Hand-carved fully hand woven cornhusk mask with protruding nose and cheek details, very good condition, 10" x 12" x 4". Allard 8-13-05 **$350.00.**

Iroquois Mask, early 1900s. Hand-carved portrait/face mask with green natural ocher finish and horsehair, marked "Owl", 8 1/2" x 6". Allard 3-11-05 **$275.00.**

Clothing

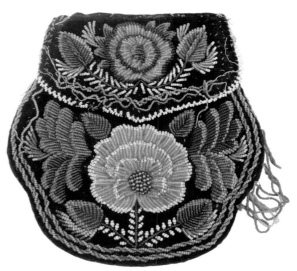

Iroquois Bag, early 1900s. Finely detailed two-sided flap pouch with floral design in small beads on brown velvet, some beads missing, 6 1/4" x 6". Allard 8-13-05 **$250.00.**

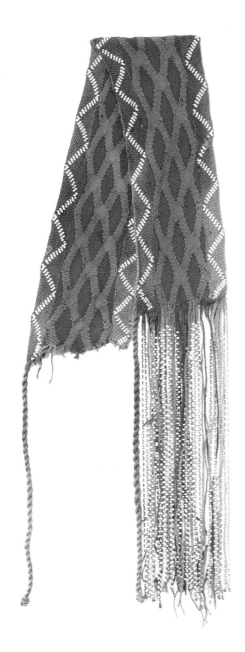

Woodlands Sash, early 1900s. Hand woven dance sash in purple, green and red designs with woven in and hanging pony bead accents, 31 1/4" long x 4 1/4" wide plus fringe. Allard 3-13-05 **$250.00.**

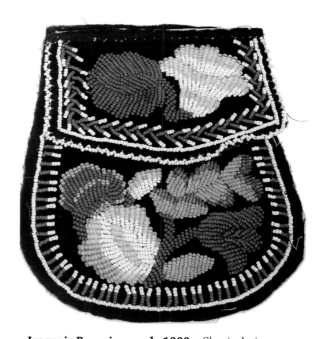

Iroquois Bag, circa early 1900s. Classic design two-sided brown velvet flap bag with colorful matching floral motifs on both sides, two pieces, 7 1/4" x 6 1/4". Allard 8-13-05 **$130.00.**

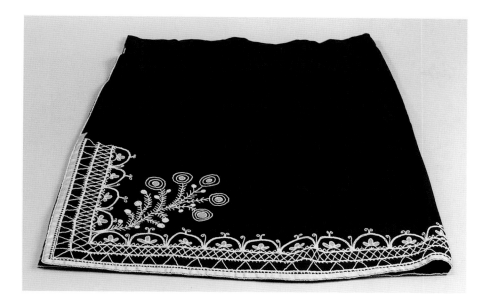

Iroquois Beaded Cloth Skirt, circa early 20th C. Black wool trimmed along the bottom with ribbon, geometric designs and commercial buttons, 29" long. Provenance: The Charles and Blanche Derby collection. Skinner 1-29-05 **$382.00.**

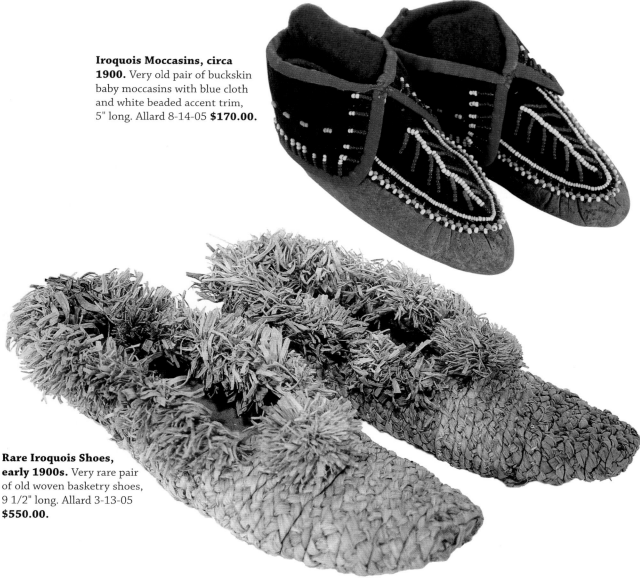

Iroquois Moccasins, circa 1900. Very old pair of buckskin baby moccasins with blue cloth and white beaded accent trim, 5" long. Allard 8-14-05 **$170.00.**

Rare Iroquois Shoes, early 1900s. Very rare pair of old woven basketry shoes, 9 1/2" long. Allard 3-13-05 **$550.00.**

Recreational

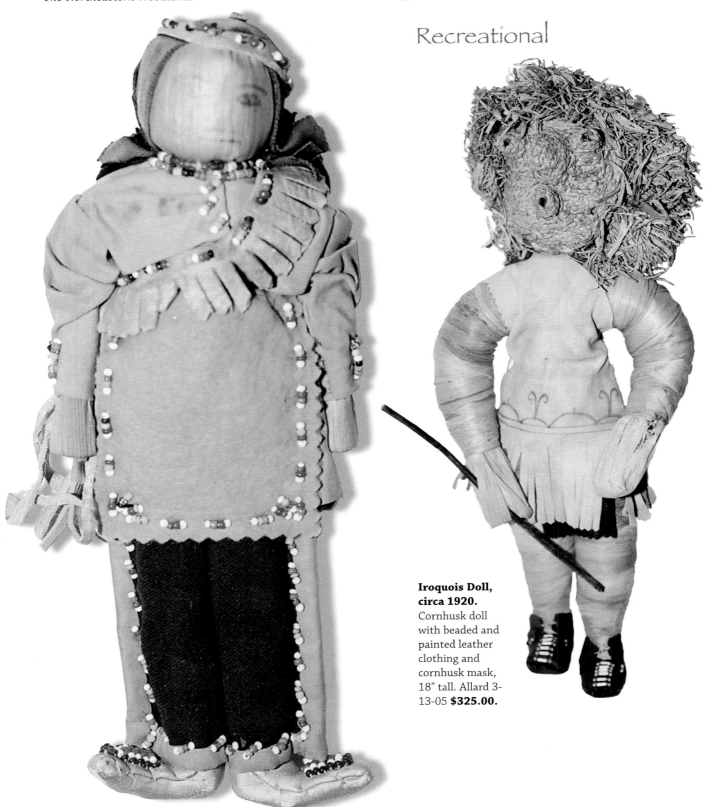

Iroquois Doll, circa 1920. Cornhusk doll with beaded and painted leather clothing and cornhusk mask, 18" tall. Allard 3-13-05 **$325.00.**

Woodlands Cornhusk Doll, early 1900s. Traditional style cornhusk doll found throughout both the Woodlands and the Great Lakes regions. This Eastern Woodlands doll has full dress and all over beadwork trim and is 9" tall. Allard 8-13-05 **$110.00.**

Weaponry

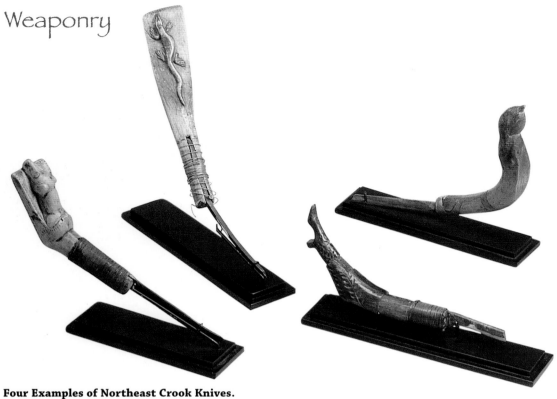

Four Examples of Northeast Crook Knives.
Knives vary from 8" to 10 3/4".
Upper Left: Skinner 1-29-05 **$529.00.**
Upper Right: withdrawn or no sale.
Lower Left: Skinner 1-29-05 **$823.00.**
Lower Right: Skinner 1-29-05 **$235.00.**

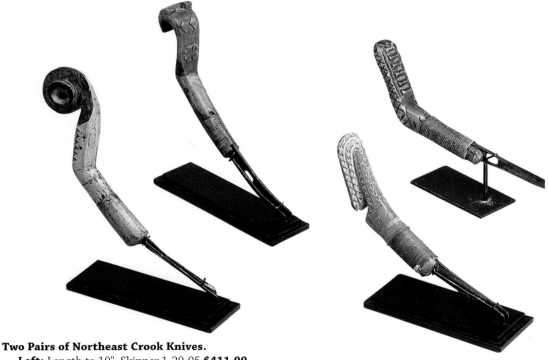

Two Pairs of Northeast Crook Knives.
Left: Length to 10". Skinner 1-29-05 **$411.00.**
Right: Length to 9 1/2". Skinner 1-29-05 **$294.00.**

6

The Great Lakes

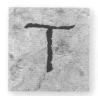 his region is obviously vast and includes groups that could also be placed in other regions, and partly were located in other regions, such as the Ojibwa. The Ojibwa extended over one of the largest geographical areas of North America in what is today both Canada and the United States. However, their "cultural home" was the Great Lakes, and it is for that reason that I have placed the culture here. Other groups included the Huron, Menominee, Ottawa (Odawa), Potawatomi, Winnebago (though primarily a Prairie group), Miami, and others that are also found on the Prairie.

Many of the items found throughout the Great Lakes region have not survived in the numbers found in the more arid regions of the Plains and the Southwest due to the materials from which they were made, primarily wood, cloth, and basketry. Our climate here in the Great Lakes is one of high humidity, causing rapid deterioration of these fragile items if not properly stored.

Also, due to early cultural contact, many of the earlier artifacts disappeared forever. My excavations of a Miami Village destroyed Christmas Eve of 1812 is a great example to show how much integration had already occurred at the material cultural level between Native Americans and the French, English, and American societies. Most of the over 10,000 items excavated were European trade goods and no longer solely Native material culture. However, there were still many cultural traits typical of the Miami that did show up in the material cultural remains.

The items shown below are not in as large of numbers as I would prefer, but it is for the reasons stated above and also because the three areas that seem to generate the greatest collector interest are the Plains, Northwest Pacific Coastal, and Southwest regions. As I have used only items with known values from recent sales in 2005, it has limited the number of artifacts from some regions, such as the Great Lakes.

Winnebago Basketry, early/mid-1900s. Woven ash basket with bentwood swing handle. Allard 3-13-05 **$25.00.**

Basketry

Artistic Items

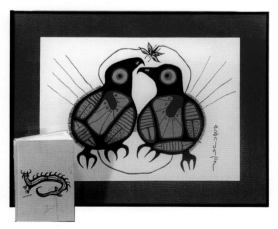

Norval Morriseau (b. 1931) Original Gouache. Signed, image of two birds by this Ojibwa "Legends" artist, includes his book. Painting 16 1/2" x 22", frame 22 1/4" x 28 1/4". Allard 8-13-05 **$1,100.00.**

Ojibwa Basket, circa early/mid 1900s. Fine quilled birch bark basket, quilled on all sides, 5" x 6". Allard 3-11-05 **$250.00.**

Ceremonial and Utilitarian Items

Burled Bowl, 19th C. Eastern Woodlands bowl with patina, 3 1/2" high x 6" diameter. Allard 3-11-05 **$275.00.**

Great Lakes Wooden Ladle, 19th C. Burled wooden ladle with an eagle head carved on the handle's end, 4 1/2" x 12 1/2" long. Allard 3-11-05 **$110.00.**

Ojibwa Hide Grainer, early 1900s. Flat curved tool used to tan hides, see *Ojibway Indians Observed* by Fred Blessing, page 18, plate 11, 18" x 1 3/4" wide. Allard 3-13-05 **$15.00.**

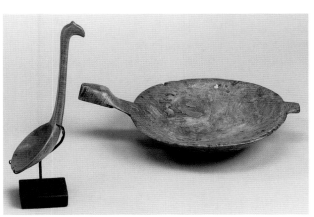

Bowl and Spoon.

Left: Woodlands carved wood spoon, 19th C. Bird effigy handle, 9" long, crack. Skinner 1-29-05 **$323.00.**

Right: Great Lakes turtle effigy carved bowl. Likely early 19th C. wooden bowl in form of turtle, holes in burl surface had been filled with wood putty and recently filled with lead, 13 1/2" long. Provenance: Formerly of Caster Line collection. Skinner 1-29-05 **$1,116.00.**

Two Ojibwa Spoons, circa 1870s. Two small carved spoons found in medicine bundles, 6" x 4 1/2". Allard 3-13-05 **$225.00.**

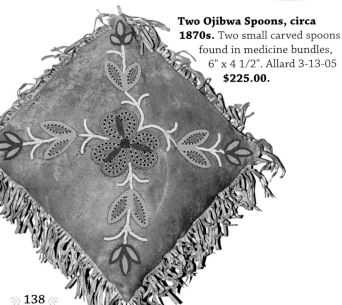

Ojibwa Pillow, circa 1900. Beaded and fringed pillow made of buckskin, 15" x 15". Provenance: Thunderbird Museum, Hatfield, Wisconsin. Allard 3-12-05 **$90.00.**

Clothing

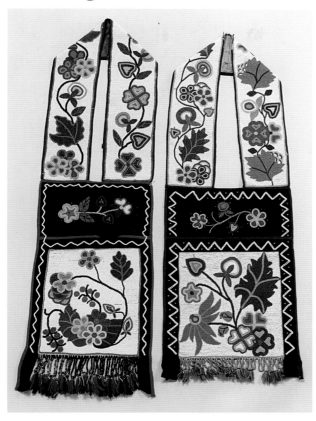

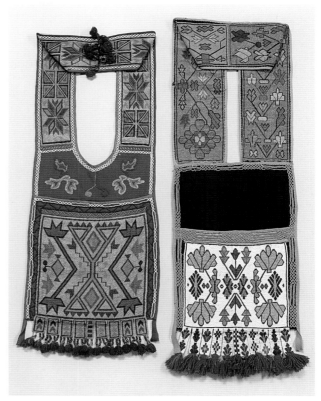

Two Great Lakes Beaded Cloth Bandolier Bags, both Ojibwa, circa 1900.
 Left: 47" long backed with commercial cloth, multicolored floral motifs using bugle beads and yarn danglers. Skinner 9-10-05 **$1,762.50.**
 Right: 43" long backed with commercial cloth decorated in the same fashion. Skinner 9-10-05 **$1,837.50.**

Two Great Lakes Bandolier Bags.
 Left: Ojibwa, circa late 19th C. similar to ones above, 35" long. Skinner 9-10-05 **$2,817.50.**
 Right: Menominee, circa last quarter 19th C., commercial cloth, 40" long. Skinner 9-10-05 **$2,467.50.**

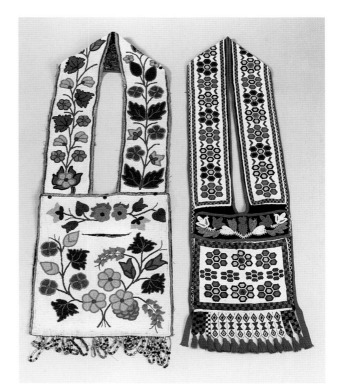

Two Ojibwa Beaded Cloth Bandolier Bags
 Left: Ojibwa beaded cloth bandolier bag, circa 1900. Made of commercial cloth with remnant bugle bead swags with some damage, 35" long. Skinner 1-29-05 **$1,410.00.**
 Right: Ojibwa beaded cloth bandolier bag, commercial cloth, display case included, 35" long. Skinner 1-29-05 **$1,998.00.**

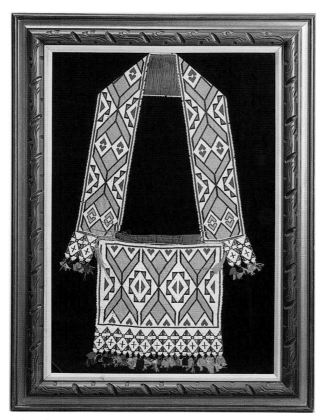

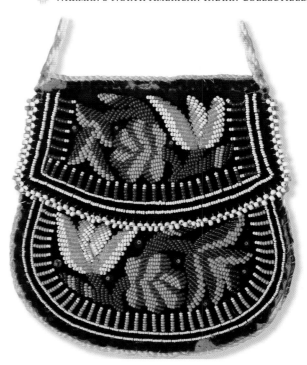

Great Lakes Beaded Pouch, circa early 1900s. Very fine Great Lakes pony beaded pouch, beaded on both sides, 7" x 7". Allard 3-11-05 **$130.00.**

Winnebago Loom Beaded Bandolier Bag, circa last quarter 19th C. Tabs have remnant silk ribbons, framed, some bead loss, 33" long. Skinner 1-29-05 **$3,055.00.**

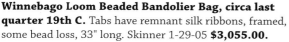

Great Lakes Feathered Cape, mid-19th C. Cloth cape in crescent shape with two long tabs down the front trimmed with domestic bird feathers, it has some feather loss, 26" long. Skinner 9-10-05 **$2,115.00.**

Ojibwa Moccasins, circa 1900. Classic old pair of puckered toe moccasins with beaded floral motifs on the vamp and ankle flaps, 9" long. Allard 8-14-05 **$275.00.**

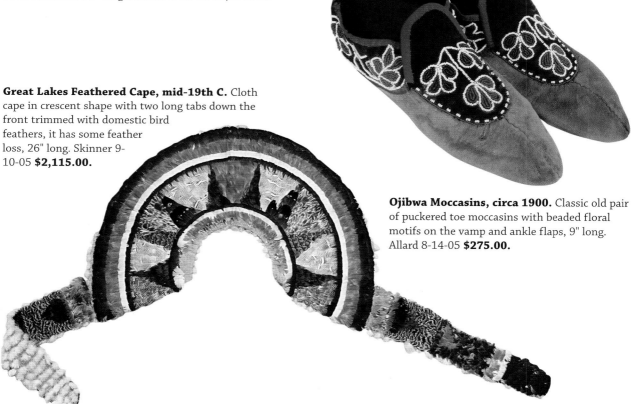

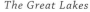

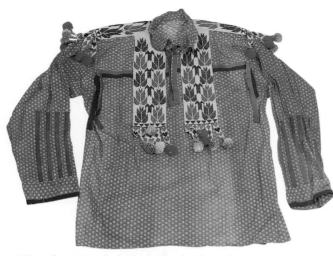

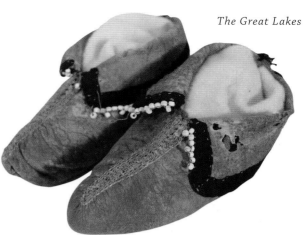

Huron Moccasins, circa 1900. Small, early pair of buckskin child's moccasins with pinched toe, embroidered vamp and beaded ankle flap trim, 4 1/2" long. Allard 8-14-05 **$160.00.**

Winnebago Beaded Cloth Man's Shirt, late 19th C. Calico pullover with wool tape ribbons, loom beaded panels on shoulders and bib, leaf pattern, tabs decorated with trade beads and wood tassels, some minor damage, 29" long. Skinner 1-29-05 **$2,233.00.**

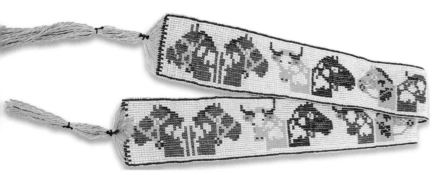

Great Lakes Belt Strip, mid-1900s. Loom beaded belt strip with horse and cow motif, ends unfinished, 29 1/2" x 2" wide. Allard 3-13-05 **$400.00.**

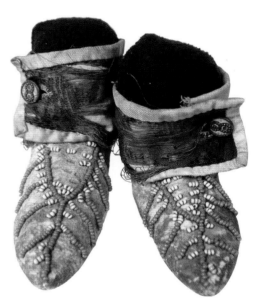

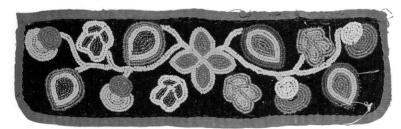

Very Rare and Early Huron Baby Moccasins, circa 1780-1810. Excellent and original condition, 5" long. Allard 8-14-05 **$2,500.00.**

Menominee Beadwork, circa 1890. French velvet panel with floral beadwork, 3 1/2" x 11". Provenance: Old tag reads "from Neopit, Wisconsin". Allard 3-13-05 **$60.00.**

Ojibwa Sash, circa 1890. Loom beaded with acorn and maple leaf designs and long yarn fringes, 8' 6" x 4 1/2". Provenance: Pohrt collection. Allard 3-12-05 **$400.00.**

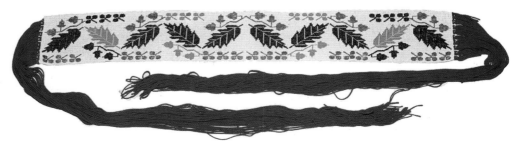

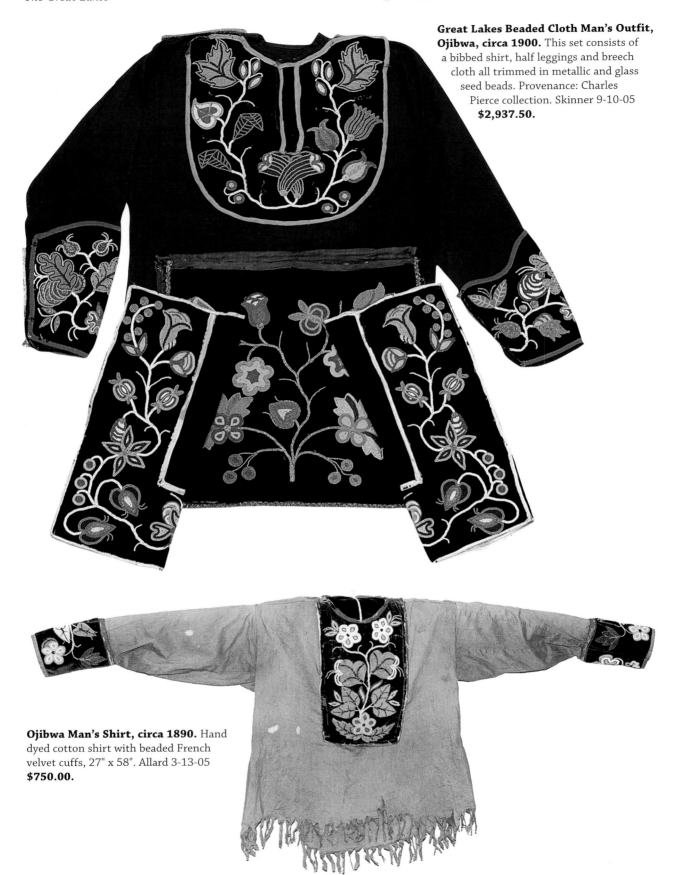

Great Lakes Beaded Cloth Man's Outfit, Ojibwa, circa 1900. This set consists of a bibbed shirt, half leggings and breech cloth all trimmed in metallic and glass seed beads. Provenance: Charles Pierce collection. Skinner 9-10-05 **$2,937.50.**

Ojibwa Man's Shirt, circa 1890. Hand dyed cotton shirt with beaded French velvet cuffs, 27" x 58". Allard 3-13-05 **$750.00.**

Prehistoric Items

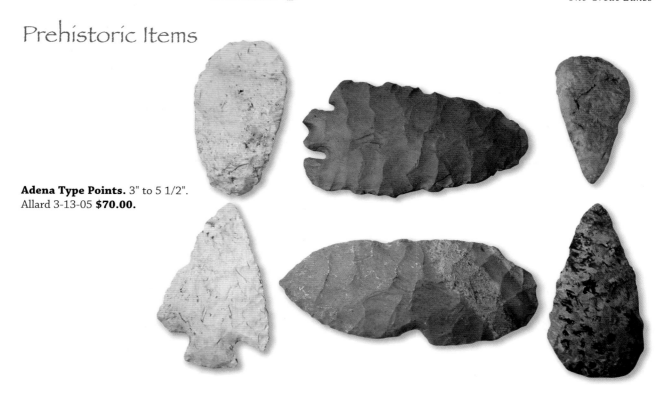

Adena Type Points. 3" to 5 1/2".
Allard 3-13-05 **$70.00.**

Ohio River Valley Point Examples. Collected in the 1920s, 23 chert and flint arrow and spear points, 1" to 4" each. Allard
3-13-05 **$100.00.**

Seven Hopewellian Points. Various sizes and shapes, flint points from Hopewell period, 3 1/2" to 4 1/2" each. Provenance: Thunderbird Museum, Hatfield, Wisconsin. Allard 8-14-05 **$325.00.**

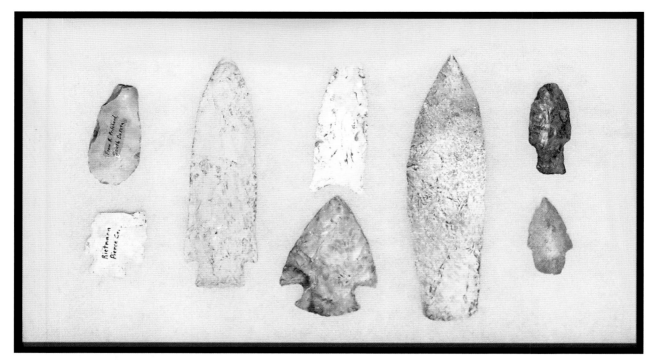

Eight Hopewellian Points. Various sizes and shapes, 1 1/2" to 6" long. Provenance: Thunderbird Museum, Hatfield, Wisconsin. Allard 8-14-05 **$325.00.**

Eight Hopewellian Points. Hopewellian points formerly of the Thunderbird Museum collection, Hatfield, Wisconsin, 2" to 5". Allard 3-12-05 **$375.00.**

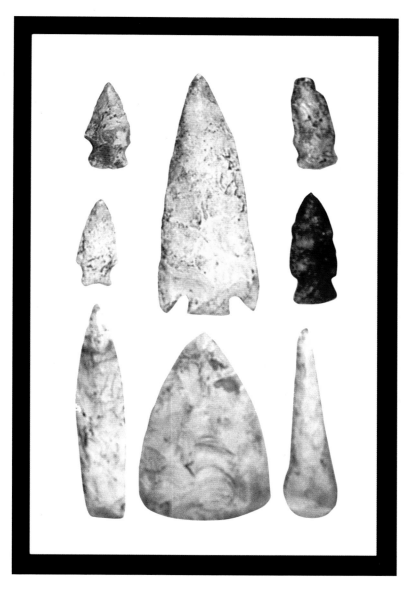

Mound Builder Pipe. Prehistoric effigy pipe associated with the Hopewellian cultures of the Ohio River Valley and the Great Lakes, 7" long. Provenance: James Fowler collection. Allard 3-13-05 **$500.00.**

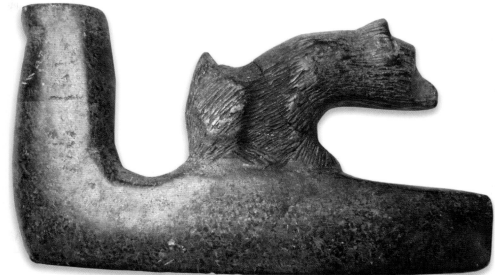

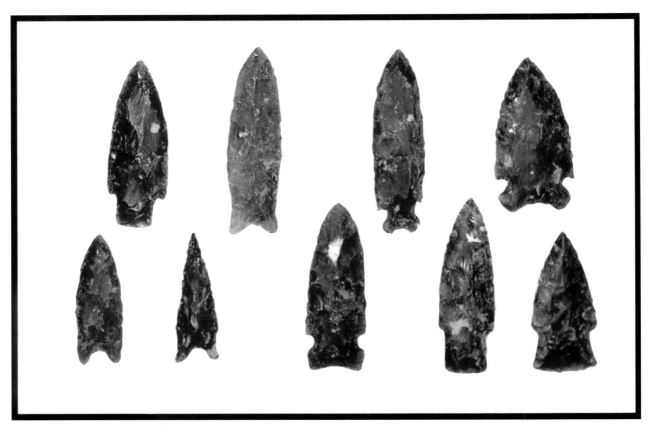

Nine Knife River Hopewellian Points. Hopewellian points from 2 1/2" to 3 1/2" long. Provenance: Thunderbird Museum, Hatfield, Wisconsin. Allard 8-14-05 **$550.00.**

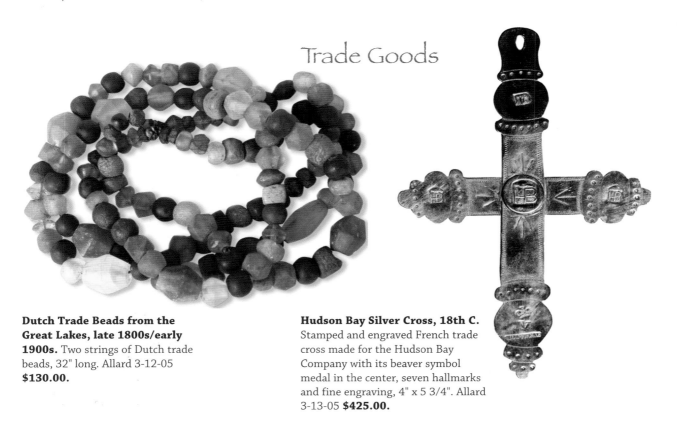

Trade Goods

Dutch Trade Beads from the Great Lakes, late 1800s/early 1900s. Two strings of Dutch trade beads, 32" long. Allard 3-12-05 **$130.00.**

Hudson Bay Silver Cross, 18th C. Stamped and engraved French trade cross made for the Hudson Bay Company with its beaver symbol medal in the center, seven hallmarks and fine engraving, 4" x 5 3/4". Allard 3-13-05 **$425.00.**

Weaponry

Ball Headed War Club, Eastern Great Lakes, 19th C. Carved of hardwood, this is actually an example of a club that would have been carried denoting the bearer was on "men's business" and not a war club. However, the design of the war clubs was similar with ball end clubs being favored in the Great Lakes and the Northeastern Woodlands. Julia 10-05 **$1,725.00.**

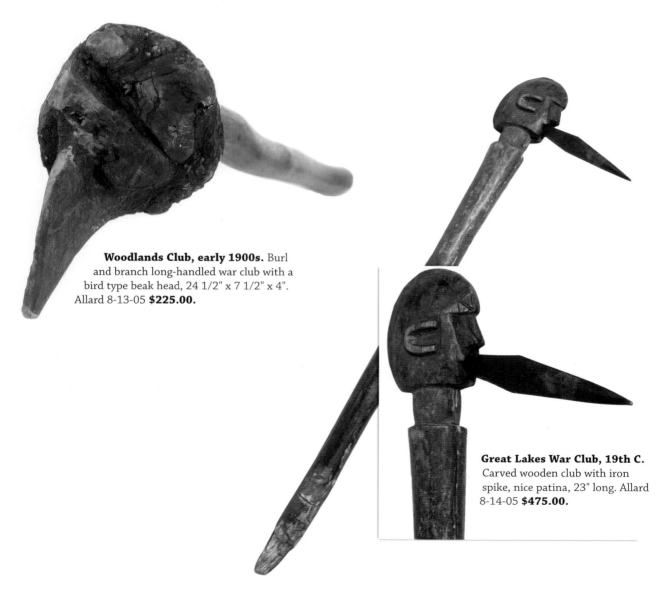

Woodlands Club, early 1900s. Burl and branch long-handled war club with a bird type beak head, 24 1/2" x 7 1/2" x 4". Allard 8-13-05 **$225.00.**

Great Lakes War Club, 19th C. Carved wooden club with iron spike, nice patina, 23" long. Allard 8-14-05 **$475.00.**

7

The
Prairies

The Prairie peoples are, of course, the original Plains cultures, in many instances moving from a more sedentary agrarian lifestyle along the Missouri or its tributaries onto the high plains with the advent of the gun, the horse, and the invading non-indigenous populations. Some eventual Plains peoples also had roots in the woodlands of the Great Lakes, such as certain Sioux groups.

Many of the indigenous populations on the Prairies saw total or near-total extinction due to smallpox and other diseases brought with first or early contact. Other groups managed to survive culturally but made drastic societal and material cultural changes when moving onto the high plains and becoming more nomadic hunters. These groups included the Winnebago, Sauk, Fox, Potawatomi, Ioway, and Otoe, among others.

Many Michigan natives do not realize that our original land in the southwestern part of the state was a natural prairie, which extended westward to the beginning of the high plains. It is difficult for us to conceive of the native bison roaming on what would now be the interchange of Interstates 196 and 94 and leading west down Interstates 80 and 90 as well. This is natural prairie, nonetheless, and the Potawatomi were among its early residents. The Winnebago could be included as well in the Great Lakes region, and some of the items have been included above for that reason.

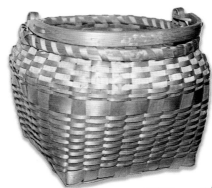

Winnebago Basket, early 1900s. Woven split ash swing handle basket with golden patina, 11" x 14". Allard 8-13-05 **$120.00.**

Basketry

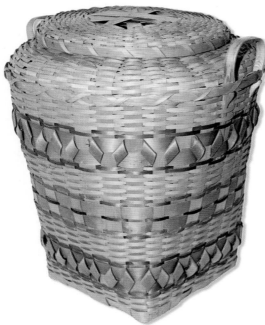

Winnebago Basket, circa 1900. Huge lidded splint polychrome basket with ribbon curls and bent ash handles, excellent condition, 19" x 20". Allard 8-14-05 **no sale/withdrawn**.

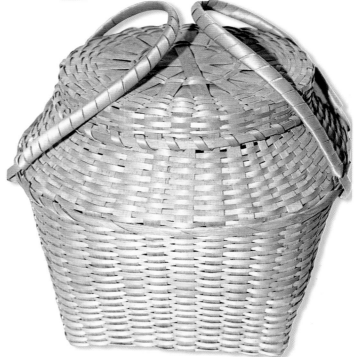

Winnebago Basket, circa 1900. Split ash basket with handles and lid and some faint colors still visible, excellent condition. Allard 8-14-05 **no sale/withdrawn**.

Ceremonial and Utilitarian Items

Osage Dice Game, 19th C. Six dice and one rabbit figure with incised markings and dyed blue and red, as shown in the "Art of the Osage, Saint Louis Art Museum", objects are approximately 1" diameter. Allard 8-13-05 **$375.00.**

Clothing

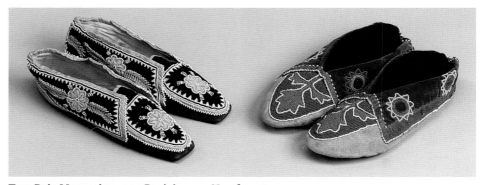

Two Pair Moccasins, one Prairie, one Northeast.
 Left: Northeast, Seneca, circa mid-19th C. moccasins of commercial leather forms with hard soles, silk edging, 9 1/2" long. Skinner 1-29-05 **$2,938.00.**
 Right: Prairie, Delaware, circa last quarter of 19th C., moccasins with soft sole forms on beaded vamps with abstract floral designs on a "pony trader" blue ground, brown cloth cuffs edged with silk and partially beaded celestial motifs, some wear, 9 3/4" long. Skinner 1-29-05 **$1,763.00.**

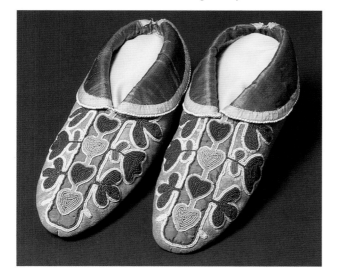

Pair of Delaware Moccasins, circa second quarter 19th C. Soft soles with beaded vamps using small seed beads with green silk striped backing on the vamp, edge beaded two color silk cuffs, 8 1/4" long. Provenance: The Charles and Blanche Derby collection and by repute previously of the Mary Bremmen of Lancaster, Pennsylvania, collection and brought back from Ohawa, Kansas in 1867. Literature: *Eye of the Angel, 1990,* White Star Press, plate 10, *Turkey River, Native American Art of the Ohio Country,* edited by Theodor J. Brasser, 2003, Canton Museum of Art, p. 27. Exhibitions: George Walter Vincent Smith Art Museum, Springfield, Massachusetts, October 27, 1991-January 5, 1992; Canton Museum of Art, Canton, Ohio, August 22-October 26, 2003. Skinner 1-29-05 **$23,500.00.**

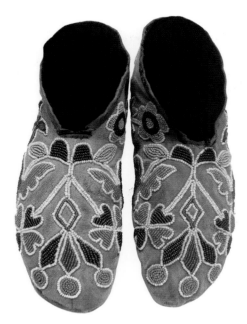

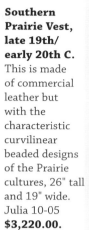

Southern Prairie Vest, late 19th/ early 20th C. This is made of commercial leather but with the characteristic curvilinear beaded designs of the Prairie cultures, 26" tall and 19" wide. Julia 10-05 **$3,220.00.**

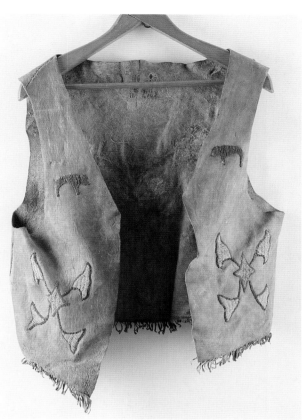

Sauk Fox/Otoe Beaded Moccasins, early 1900s. Rare and in very fine condition, 10 1/2" long. Provenance: Richard Pohrt, Sr. Collection. Allard 3-12-05 **$3,000.00.**

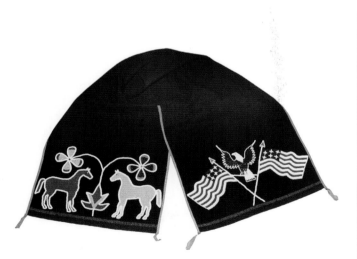

Otoe Breech Cloth, circa 1910. Selvage edged trade wool with flag, eagle, and horse pictorials, 16" x 5'8" long. Provenance: Pohrt and Norm Feder collections. Allard 3-12-05 **$3,250.00.**

Prairie Silk Applique Blue Man's Leggings, circa early 20th C. 31" long each. Skinner 1-29-05 **$470.00.**

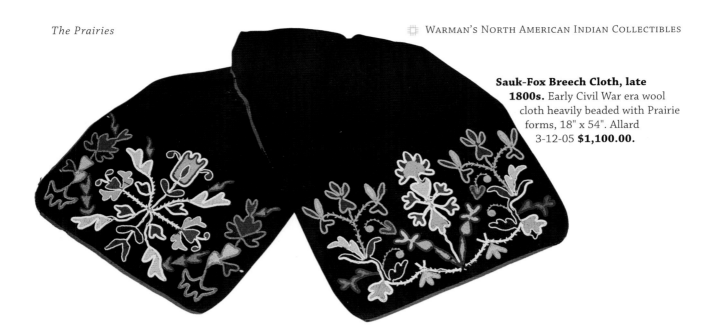

Sauk-Fox Breech Cloth, late 1800s. Early Civil War era wool cloth heavily beaded with Prairie forms, 18" x 54". Allard 3-12-05 **$1,100.00.**

Mesquakie Sash, circa 1890s. Finger woven yarn and pony bead sash with yarn and bead fringe, excellent condition, 6' 10" x 6" wide. Provenance: Pohrt collection. Allard 3-12-05 **$425.00.**

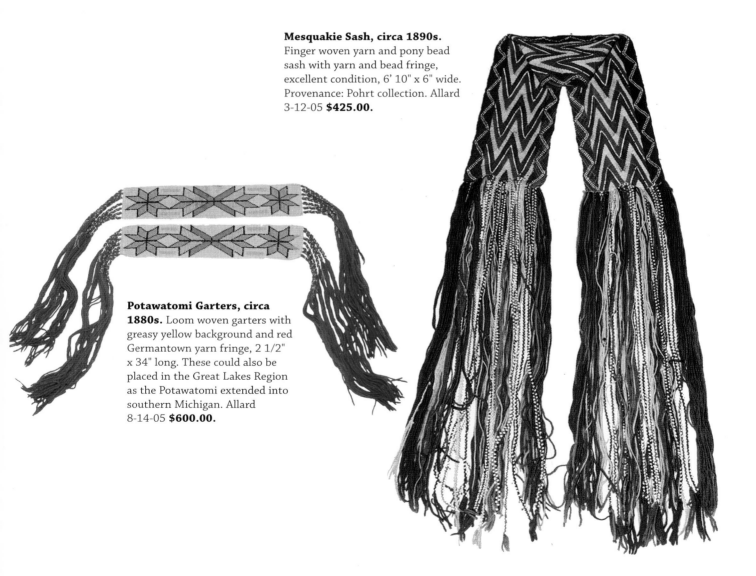

Potawatomi Garters, circa 1880s. Loom woven garters with greasy yellow background and red Germantown yarn fringe, 2 1/2" x 34" long. These could also be placed in the Great Lakes Region as the Potawatomi extended into southern Michigan. Allard 8-14-05 **$600.00.**

Recreational

Osage Gaming Pieces, late 1800s. Seven carved and painted bone dice used in gambling, 1" diameter. Allard 3-12-05 **$110.00.**

8

The Plains

here is no way an American can think of indigenous Native American culture more often than as a Northern or Southern Plains Indian. Hollywood has permanently embedded visions of Plains peoples in the minds of not only most Americans but numerous Europeans as well. Add to the mix the genre of early dime novels and the "Wild West" shows and it is no wonder that the crown heads of Europe and most Americans envisioned a plains area covered with buffalo and natives on horseback.

There are far too many errors and myths with this portrayal for me to defeat in a book on collecting. However, suffice it to say that the most interesting thing to an anthropologist about Plains culture is that it truly sprang from the loins of two European contributions to the geographical region, the horse arriving from the Southern Plains and the rifle coming in from the Northern Plains.

These two innovations allowed the indigenous cultures to seek the buffalo in new ways and larger numbers than before. The Plains people were in essence agrarian, supplementing their diets with hunting, until the horse and the gun allowed them to become far more nomadic, relying on the buffalo and other game animals for sustenance. The use of the buffalo from hide to horn is legendary and well documented among certain groups.

However, the ancestors to these Plains groups were far more dependent upon agriculture and were similar to many Eastern Woodland groups at one time. But only a complete book on ethnography of Plains culture would allow for a full discussion of this fascinating history, and this is, after all, a book on identification and collecting material cultural items.

Be that as it may, it is with some certainty that our fascination with the Plains is related to the time when horse, man, and gun became one, and the way of life of these cultures was changed forever. Most of the artifacts being traded that are attributed to one or more of the Plains cultures are from this and not the earlier period of agricultural communities along the Missouri or Mississippi or some other river bottom land. This is clearly exemplified in great works of bronze sculpture by such artists as Remington or in the paintings by Russell. To these artifacts, we now turn our attention.

This region could easily be divided into the Northern, Central, and Southern Plains, which was my first intention, but I believe the region flows smoothly as one general area and many auction houses so treat it. As to specific cultures included, there is some dispute, of course, between auction houses and historians alike. I have placed some artifacts of the Cree and Crow in the Plateau as well, due to historical links to that region. Also, some other groups were not solely Plains dwelling, such as the Apache with its clear cultural roots in the Southwest. So, I have attempted to place artifacts in whatever region made the greatest sense to me concerning the artifact type and cultural attributes it demonstrated, e.g. a Crow item showing clear Plateau designs of elk and floral motifs may be placed in the Plateau region instead of the Plains.

The problem is somewhat similar to the Ojibwa issue discussed under the Great Lakes region inasmuch as some groups covered a vast geographical area. Whereas the Ojibwa went from the eastern shores of the Great Lakes to the furthest reaches of the western shores, some groups such as the Cree had an immense north-to-south geographical area, placing them at times in the Plains, Plateau, and even the Subarctic.

> **This region could easily be divided into the Northern, Central, and Southern Plains, which was my first intention, but I believe the region flows smoothly as one general area and many auction houses so treat it.**

The Assiniboine, Cheyenne, Crow, and Sioux also had wide distributions, and ethnographers have broken them into many sub-groups not necessarily followed by commercial auction houses or the format of this book.

Again, it is not that I do not recognize these subtle distinctions as an anthropologist, but it is impossible to satisfy the needs of a general audience by being overly technical. Also, some items are not exactly traceable to a particular group in all instances, but are still clearly Plains items due to style and technique used in construction or colors or design or materials.

If the reader finds items from a Plains group in another area, it is because I decided it was a better cultural fit to that region for this particular group and/or type of item.

Artistic Items

Although I could have placed these in some other categories, I believed this separate category necessary for this region especially. Many items included in other categories following are clearly of an artistic nature as well, but the items in this grouping are solely artistic or historical cultural representations.

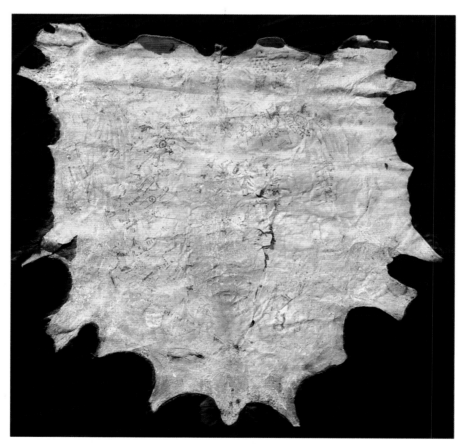

Painted Buffalo Robe, Northern Cheyenne, circa 1880. Provenance to survivors of the Little Big Horn and owned until sale by descendants of the original 1876 Cheyenne artist. The consignor stated it was passed on to him through his family lineage and traces back to a Cheyenne named Wolf and his wife Magpie, descendants of the consignor. The cavalry figures were overpainted by the consignor's grandfather in an attempt to preserve the images. This beautiful piece measures 8' tall x 8' 4" wide and is a wealth of information about Cheyenne culture and very likely the Battle of the Little Big Horn. Apparently, provenance was strong enough to bring healthy bidding at auction. Julia 10-05 **$14,950.00.**

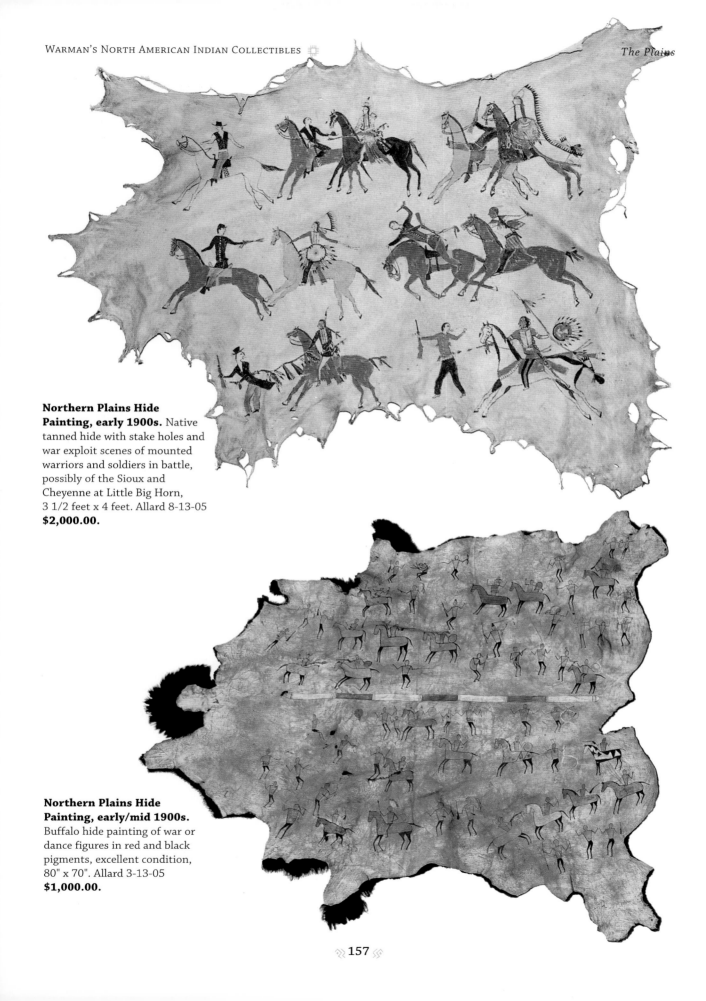

Northern Plains Hide Painting, early 1900s. Native tanned hide with stake holes and war exploit scenes of mounted warriors and soldiers in battle, possibly of the Sioux and Cheyenne at Little Big Horn, 3 1/2 feet x 4 feet. Allard 8-13-05 **$2,000.00.**

Northern Plains Hide Painting, early/mid 1900s. Buffalo hide painting of war or dance figures in red and black pigments, excellent condition, 80" x 70". Allard 3-13-05 **$1,000.00.**

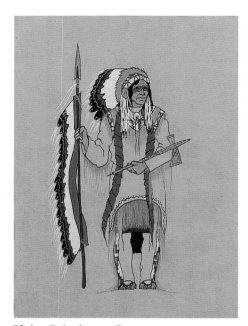

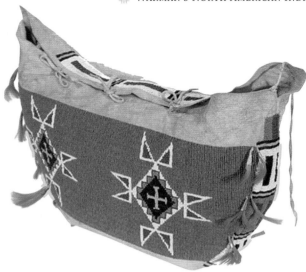

Plains Possible Bag. Sinew sewn hide bag with traditional motifs and blue background, lazy stitch beadwork, 11" x 18 1/2" x 6". Allard 8-14-05 **$3,500.00.**

Plains Painting on Paper, second quarter 20th C. Gouache on paper, backing marked "A Cheyenne Chief drawn by Mr. W. Richard West, Wah-pah-nay-yah", frame 13 1/2" x 10 1/4". Skinner 9-10-05 **$440.63.**

Curtis Photogravure of Cheyenne, 1914. Nicely framed and matted photo entitled "Cutting the Centre Pole-Cheyenne". Image is 8" x 5 1/2" and it is 18 1/4" x 14 1/4" framed. Allard 8-14-05 **$80.00.**

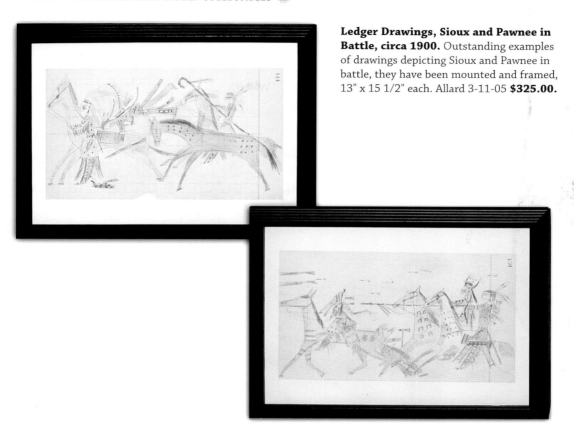

Ledger Drawings, Sioux and Pawnee in Battle, circa 1900. Outstanding examples of drawings depicting Sioux and Pawnee in battle, they have been mounted and framed, 13" x 15 1/2" each. Allard 3-11-05 **$325.00.**

Ceremonial and Utilitarian Items

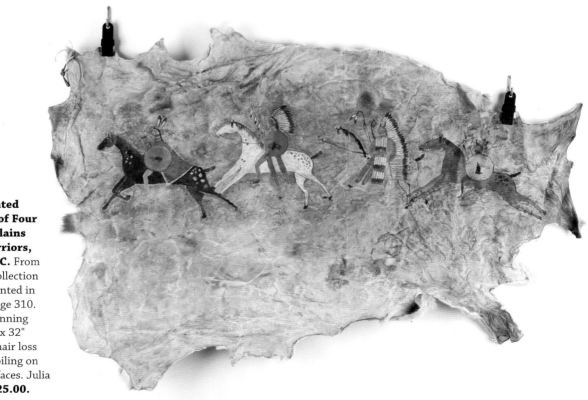

Plains Painted Deer Hide of Four Mounted Plains Indian Warriors, early 20th C. From the Moon collection and documented in Driebe at page 310. This is a stunning piece at 49" x 32" with slight hair loss and some soiling on painted surfaces. Julia 10-05 **$6,325.00.**

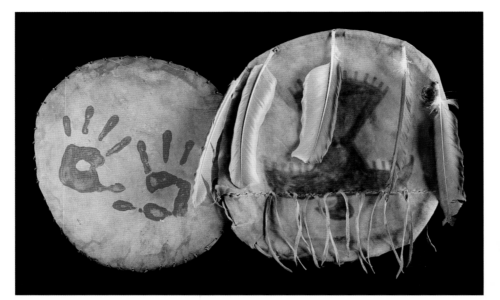

Plains Shield and Shield Cover, late 19th C. These items were also shown from the Moon collection in Driebe's book on page 329 and are made with rawhide, tanned hides and turkey vulture buzzard feathers. Diameter of the cover is 17 1/2" and of the shield itself 16 1/4". Julia10-05 **$2,875.00.**

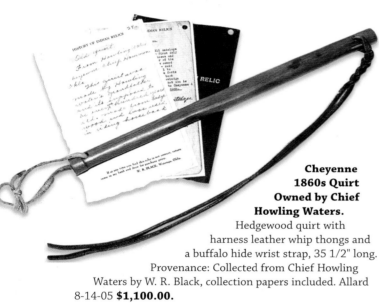

Cheyenne 1860s Quirt Owned by Chief Howling Waters. Hedgewood quirt with harness leather whip thongs and a buffalo hide wrist strap, 35 1/2" long. Provenance: Collected from Chief Howling Waters by W. R. Black, collection papers included. Allard 8-14-05 **$1,100.00.**

Three Central Plains Pipes, Lakota Sioux, circa 1900. The first has a catlinite faceted stem with seated person bowl. The second has a painted and carved wooden stem depicting a snake, and a damaged catlinite bowl. The third is a small catlinite bowl in acorn form. The longest is 19 1/2". Skinner 9-10-05 **$2,232.50.**

Hide Shield, Apache, late 19th C. Carl Moon collection. Documented in Driebe at page 236, this 16 1/2" diameter rawhide shield could have been used for both ceremonial and war purposes, an ermine pelt hangs from the bottom of the shield. Julia10-05 **$2,875.00.**

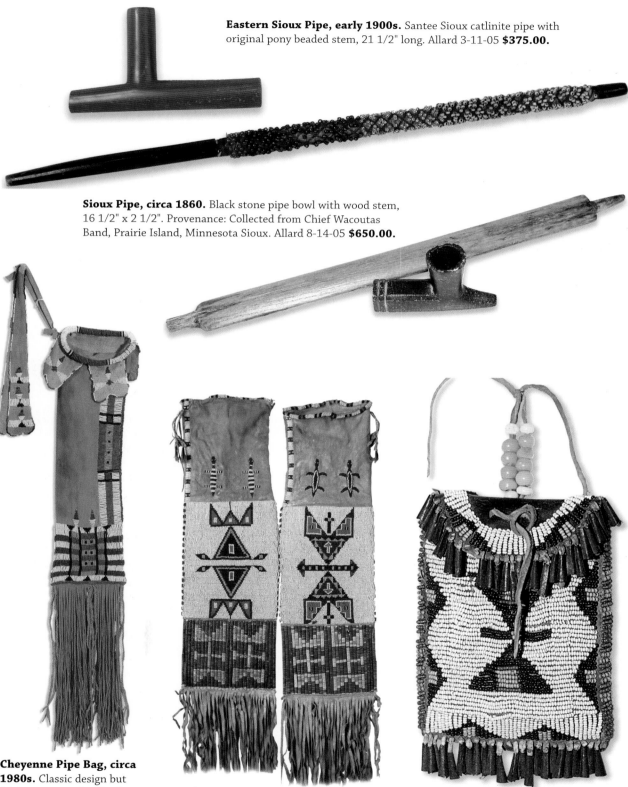

Eastern Sioux Pipe, early 1900s. Santee Sioux catlinite pipe with original pony beaded stem, 21 1/2" long. Allard 3-11-05 **$375.00.**

Sioux Pipe, circa 1860. Black stone pipe bowl with wood stem, 16 1/2" x 2 1/2". Provenance: Collected from Chief Wacoutas Band, Prairie Island, Minnesota Sioux. Allard 8-14-05 **$650.00.**

Cheyenne Pipe Bag, circa 1980s. Classic design but fairly recent made of soft buckskin with lazy stitch beaded panels and accents, top tab flaps and long fringe, 21" x 6". Allard 8-13-05 **$950.00.**

Arapaho Pipe Bag, circa 1890. Sinew sewn buckskin pipebag with lizards beaded on top, terminated with quilled slats and fringe, all original, 8" x 32" long. Allard 3-11-05 **$4,000.00.**

Sioux Strike-a-Lite, circa 1870s. Full beaded harness leather case containing original iron striker, 5 1/2" x 4". Provenance: Old tag reads "Brule Sioux, Cody, NE". Allard 8-14-05 **$1,100.00.**

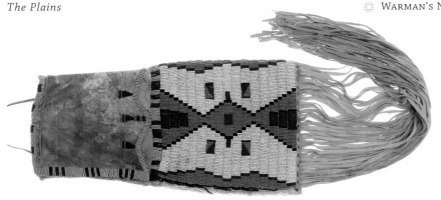

Sioux Pipe Bag, early 20th C. Native tanned, beaded upper portion, and commercially tanned fringes, 37" long. Julia 10-05 **$2,012.50.**

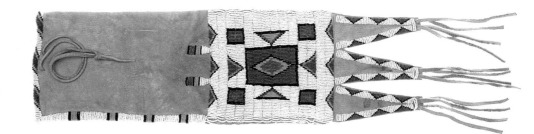

Sioux Pipe Bag, 20th C. Native tanned leather (deer hide), 27" long x 6 1/2" wide, typical Sioux motifs in large seed beads. This item is shown in Driebe's 1997 book on Moon on page 308. Julia 10-05 **$1,782.50.**

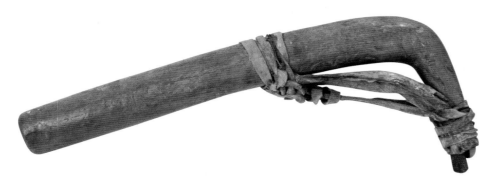

Plains Hide Scraper, circa 1870. 5" x 12". Provenance: Pawnee Bill Museum. Allard 8-14-05 **$475.00.**

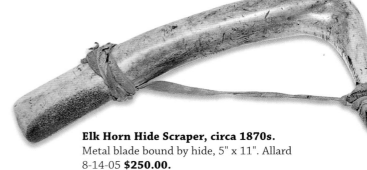

Elk Horn Hide Scraper, circa 1870s. Metal blade bound by hide, 5" x 11". Allard 8-14-05 **$250.00.**

Cheyenne Buffalo Horn Ladle. Carved buffalo horn with quilled drops, 9" x 3". Provenance: Collected from Cheyenne Bone Road by W. R. Black, Watanga, Oklahoma, includes documentation. Allard 8-13-05 **$275.00.**

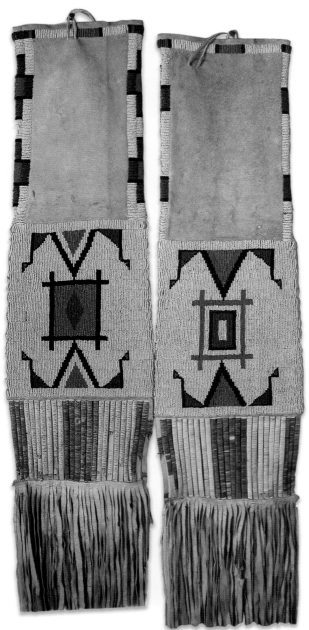

Sioux Pipe Bag, circa late 1800s/early 1900s. All original sinew sewn native tanned buffalo hide with quilled slats and fringe, 7" x 35". Allard 3-12-05 **$2,750.00.**

Plains Pipestone and Bone Objects.
 Left: Two Plains red pipestone pipe bowls, left is a mid-19th C. locomotive-type bowl and right is a T-bowl, late 19th C. with snake motif, 5 3/4" long. Skinner 9-10-05 **$528.75.**
 Center: Carved red pipestone object, likely Plains, purpose unknown, 4". Skinner 9-10-05 **$411.25.**
 Right: Plains carved bone roach spreader in shape of hand with traces of red pigment, 4 3/4" high. Skinner 9-10-05 **$2,820.00.**

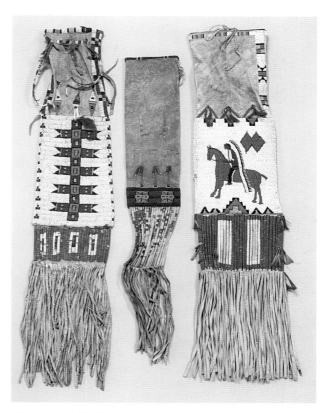

Three Beaded Hide Pipe Bags
 Left: Lakota Sioux late 19th C. beaded and quilled hide pipe bag, 33" long. Skinner 9-10-05 **$4,406.25.**
 Center: Central Plains beaded and quilled buffalo hide pipe bag, circa last quarter of 19th C., 30 1/2" long. Skinner 9-10-05 **$3,430.00.**
 Right: Lakota Sioux beaded hide pictorial pipe bag, circa 1900. Provenance: collected by Joel Crowe from Chief White Rabbit, Pine Ridge Reservation, circa 1890-1905, history of item included. Bag has a commercially made leather "white rabbit" glued to one side. Skinner 9-10-05 **$7,637.50.**

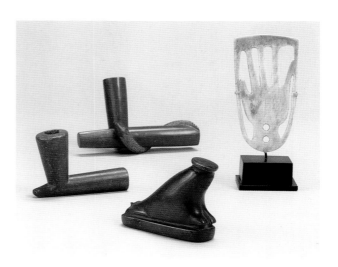

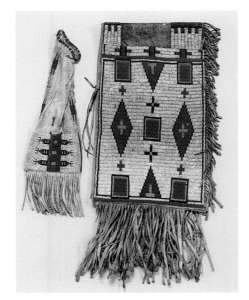

Two Central Plains Beaded Items, Saddle Bags and Pipe Bag.

Left: Pipe bag with pattern similar to saddle bags, heavily damaged.

Right: Large double saddle bags, 64" long, beaded panels on buffalo hide with canvas backing and heavily fringed. Printed in the top is "Presented to ? by the Apache Indians in open court, December 18, 1855" (ink stain and hide loss). Skinner 9-10-05 **$7,050.00.**

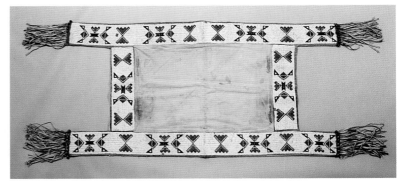

Lakota Sioux Beaded Hide and Cloth Saddle Blanket, late 19th C. Central panel is canvas, and bead work is on recycled buffalo hide with cowhide fringe trim. Beads include metallic and glass seed beads and also used are brass hawk bells. Skinner 9-10-05 **$2,585.00.**

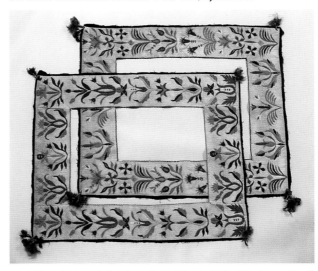

Two Northern Plains Beaded Hide Saddle Blankets, both circa late 19th C., Possibly Dakota, both examples are buffalo hide beaded with glass and metal seed beads with tin cones and purple-dyed feather trim and were likely intended to have a central panel.

Lower: 32" x 26 1/2" Skinner 9-10-05 **$2,467.50.**
Upper: 31 1/2" x 28" Skinner 9-10-05 **$2,350.00.**

Cheyenne Peyote Bag & Drum, early 1900s. Iron kettledrum and classic fringed and beaded Peyote bag, drum is 9" diameter and bag is 2" diameter and 5" long. Allard 8-13-05 **$350.00.**

Large Northern Plains Hide Double Saddle Blanket, 19th C. This 57 1/2" x 50" example of a Northern Plains buffalo hide blanket has beaded strips at one end forming the finger pattern with translucent bead detail, the blanket has some water and insect damage. Provenance: Wistariahurst Museum. Skinner 9-10-05 **$2,115.00.**

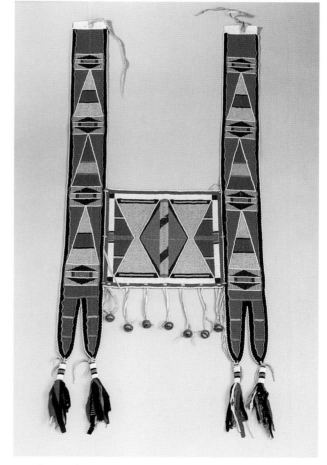

Kiowa/Apache Peyote Bag, circa 1890s.
An example of the early Peyote culture
expandable pouch with beaded rosettes
on each side and beaded balls on the
drawstrings representing Peyote
buttons, 2 1/2" x 5". Allard
8-13-05 **$475.00.**

Cheyenne Tipi Liner Panel, early 1900s. Collected in
Oklahoma, this classic bar design pattern has beadwork
using greasy yellow and red beads, 3' x 7' long. Allard 8-13-05
$650.00.

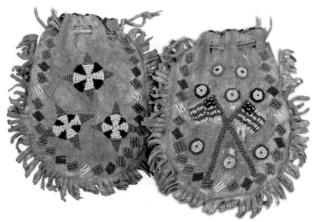

Sioux Medal Pouch, early 1900s. Finely detailed sinew
beaded buckskin bag with modified morning stars on one
side and American flag on the other, 6" x 5". Allard 8-13-05
$375.00.

**Northern Plains Beaded Cloth and Hide Martingale,
Crow, circa 1900.** Muslin backed with red and dark blue
trade cloth inserts, roll-beaded cloth danglers, classic Crow
geometric patterns, central panel has hide fringe and hawk
bells, 42" long. Skinner 1-29-05 **$8,225.00.**

Apache Ceremonial Mask, circa late 19th C., Carl Moon collection. Driebe shows this at page 326. Made of deer spike antlers, pelvic bone, fur, and cow and horse hair. Julia 10-05 **$1,782.50.**

Rare Indian Horse Mask, Cheyenne, late 19th C. These masks were used for ceremonial purposes and horse parades by Northern Plains and Plateau cultures. This intricate mask was made of buffalo robe, cow buffalo horns and feathers, with buckskin fringe trim. Provenance indicates it is of Cheyenne origin. Julia 10-05 **$23,000.00.**

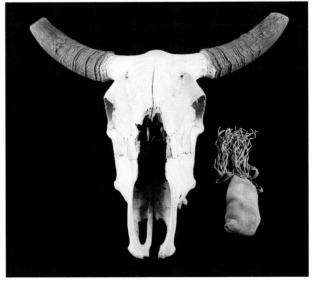

Plains Buffalo "Medicine" Bull Skull, circa 1880. Provenance from Moon collection indicates it may have belonged to a Chief Thunderbird, circa 1880. The green dots represent hail stones to call on the might of the Thunderbird. Julia 10-05 **$4,600.00.**

Medicine Pouch and Cow Skull, circa later 19th C. Provenance to Geronimo via Moon Family collection. This is pictured in two of Carl Moon's photographs; both entitled "The Medicine Man." Julia 10-05 **$2,817.50.**

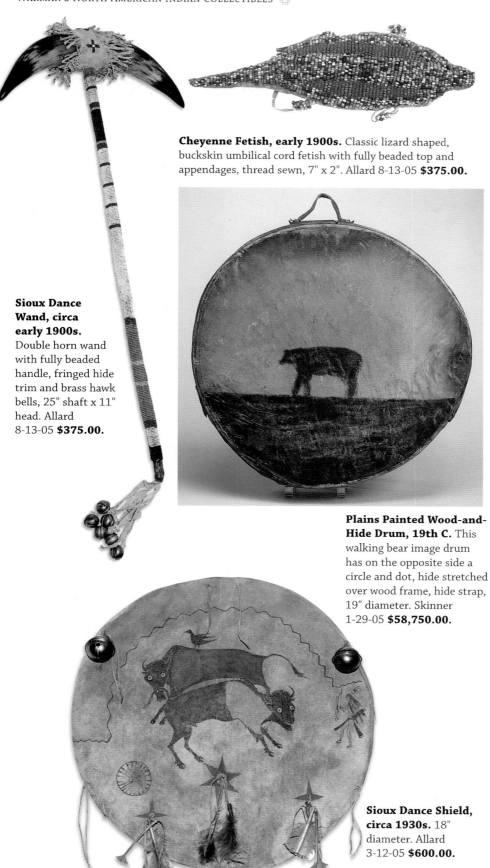

Cheyenne Fetish, early 1900s. Classic lizard shaped, buckskin umbilical cord fetish with fully beaded top and appendages, thread sewn, 7" x 2". Allard 8-13-05 **$375.00.**

Sioux Dance Wand, circa early 1900s. Double horn wand with fully beaded handle, fringed hide trim and brass hawk bells, 25" shaft x 11" head. Allard 8-13-05 **$375.00.**

Plains Painted Wood-and-Hide Drum, 19th C. This walking bear image drum has on the opposite side a circle and dot, hide stretched over wood frame, hide strap, 19" diameter. Skinner 1-29-05 **$58,750.00.**

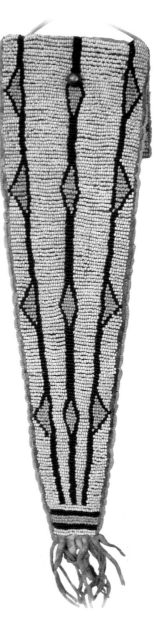

Ute Tail Bag, circa 1870. Beaded tail bag with sinew sewn beadwork on buffalo hide, an early example, 3 1/2" x 13" long. Allard 8-14-05 **$1,500.00.**

Sioux Dance Shield, circa 1930s. 18" diameter. Allard 3-12-05 **$600.00.**

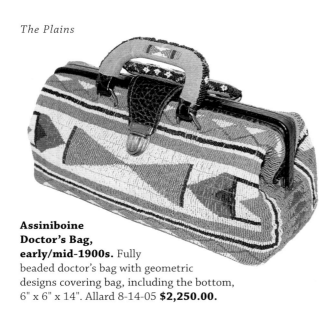

Assiniboine Doctor's Bag, early/mid-1900s. Fully beaded doctor's bag with geometric designs covering bag, including the bottom, 6" x 6" x 14". Allard 8-14-05 **$2,250.00.**

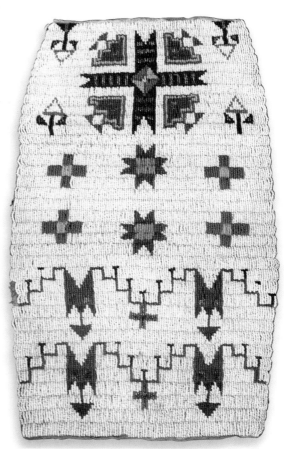

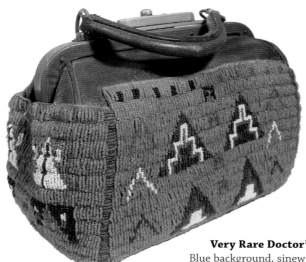

Sioux Bag Panel, early 1900s. Lazy stitched and sinew sewn doctor's bag panel done in white background, 3-panel design, 16 1/4" x 9". Allard 8-13-05 **$1,500.00.**

Very Rare Doctor's Bag, Sioux, early 1900s. Blue background, sinew sewn and lazy stitch beaded buckskin bag, 7 1/2" x 11" x 6". Allard 8-13-05 **$2,000.00.**

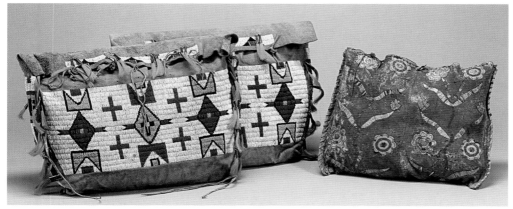

Three Plains Possible Bags.
Left: Two Lakota buffalo hide possible bags (tipi bags), last quarter 19th C. trimmed with yellow dyed horsehair and tin cone danglers, 18" long. Skinner 9-10-05 **$15,275.00.**
Right: Late 19th C. Plains possible bag stained red with quilling on one side, remnants of red trade cloth on sides, some quill loss, 13". Provenance: Wistariahurst Museum; C. H. Strawbridge. Skinner 9-10-05 **$705.00.**

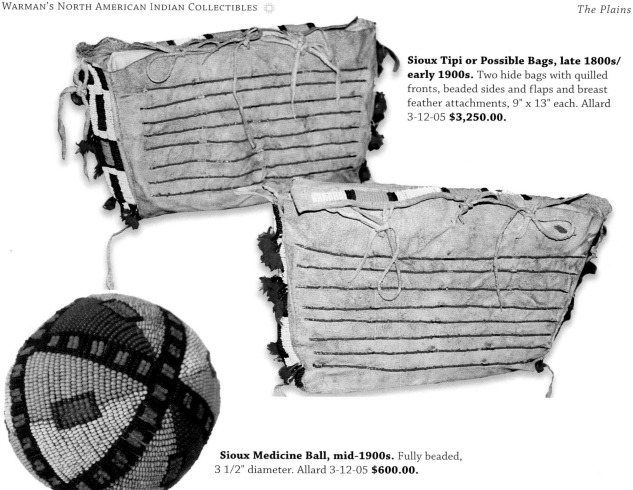

Sioux Tipi or Possible Bags, late 1800s/ early 1900s. Two hide bags with quilled fronts, beaded sides and flaps and breast feather attachments, 9" x 13" each. Allard 3-12-05 **$3,250.00.**

Sioux Medicine Ball, mid-1900s. Fully beaded, 3 1/2" diameter. Allard 3-12-05 **$600.00.**

Sioux Possible Bag, various ages. Original older buckskin tipi bag with some original sinew sewn work plus more recent additions of a pictorial front panel and in need of some beadwork, 12" x 15". Allard 8-14-05 **$3,000.00.**

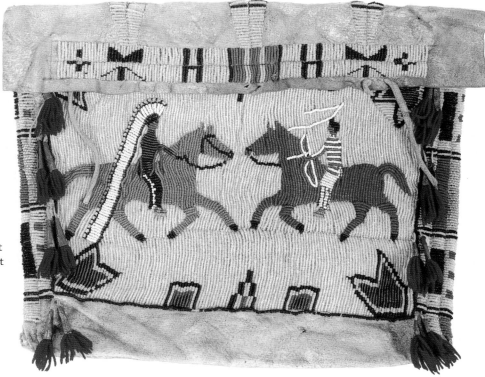

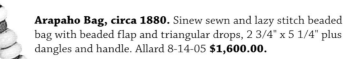

Arapaho Bag, circa 1880. Sinew sewn and lazy stitch beaded bag with beaded flap and triangular drops, 2 3/4" x 5 1/4" plus dangles and handle. Allard 8-14-05 **$1,600.00.**

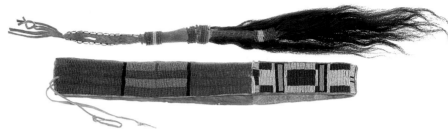

Asperger, early 20th C. Plains, specific tribe unknown. These items were used to apply water to rocks in sweat lodges and for healing ceremonies by brushing the individual. This one is made of American bison, buffalo, tail sewn around a stick and decorated with beads, and is 21" long. Sold in the same lot was a child's belt made of two ends of a possible bag, a storage bag also known as a tipi bag, 28" long. Julia 10-05 **$575.00.**

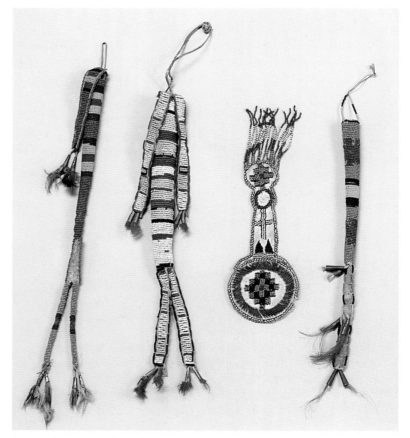

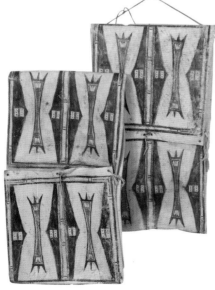

Plains Pair of Parfleches, early 1900s. Red and green designs, rawhide containers, approximately 24" x 14" each. Allard 8-13-05 **$950.00.**

Lakota Beaded Hide Awl Cases, circa late 19th C. Decorated with multicolored glass and faceted brass beads and tin cone danglers, 16" long. Lakota, circa 1900, awl case, 13" long. Provenance: donated by Douglas and Jane Deihl to benefit American Indian College Fund. The two beaded items on the right consist of a beaded Apache pocket watch holder and another awl case from the Plains, circa 1900. Provenance: Wistariahurst Museum, sold to benefit the American Indian College Fund. Skinner 9-10-05

Left awl case: $528.75; Center awl case: $214.38; and, Two items together on right: $440.63.

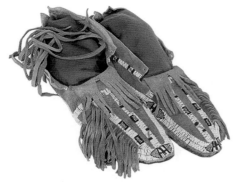

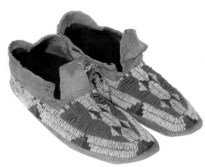

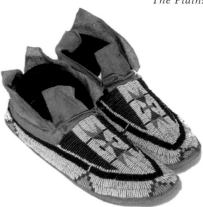

Southern Plains Moccasins, early 1900s. Sinew sewn and lazy stitch beaded with tiny beads and stained with red ocher, side fringe, 11" long. Allard 8-14-05 **$1,900.00.**

Sioux Moccasins, circa 1900. Fully beaded hard-soled moccasins with sinew sewn lazy stitch beadwork, 11". Allard 8-14-05 **$1,100.00.**

Sioux Moccasins, circa 1900. 10". Allard 8-14-05 **$1,600.00.**

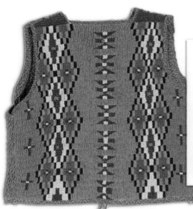

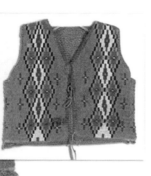

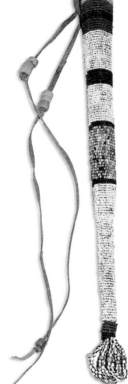

Sioux Awl Case, circa 1930s. Fully beaded tapered case with beaded drops and thongs, 11" long. Allard 8-13-05 **$300.00.**

Plains Child's Vest, early 1900s. Fully lazy stitch beaded child's vest beaded on both sides in traditional motif on a blue background, 12 1/4" at chest, 11" long. Allard 8-14-05 **$2,750.00.**

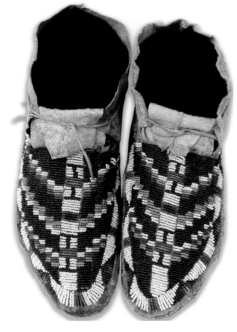

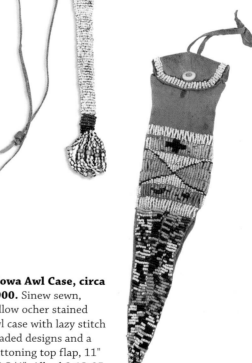

Sioux Moccasins, circa late 1800s. Sinew sewn moccasins of buffalo hide, classic patterns, 10 1/2" long. Allard 3-12-05 **$900.00.**

Kiowa Awl Case, circa 1900. Sinew sewn, yellow ocher stained awl case with lazy stitch beaded designs and a buttoning top flap, 11" x 2 3/4". Allard 8-13-05 **$700.00.**

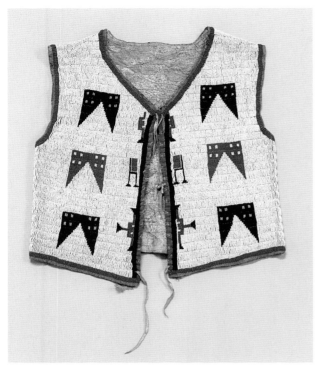

Clothing

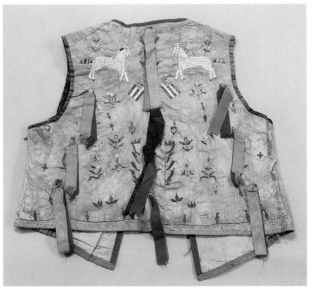

Lakota Sioux Beaded Hide Boy's Vest, last quarter 19th C., 19" long. Provenance: Wistariahurst Museum; C. H. Strawbridge. Skinner 9-10-05 **$2,115.00.**

Lakota Sioux Quilled Pictorial Cloth and Hide Vest, circa late 19th C., 22" long, decorated with American flags, horses and floral motifs, item has some quill loss. Skinner 9-10-05 **$1,762.50.**

Plains Breastplate, Possibly Sioux, late 19th C. This item could have also been placed in Weaponry as it was worn in war but indigenous peoples are also seen wearing them for photographic sessions and possibly for ceremonies. Made of 4 1/2" pipes, glass, and brass trade beads and harness leather, 9" wide x 17" long. Julia 10-05 **$862.50.**

Infant Vest, Plains, circa late 19th C. Tiny beads and tanned leather, 8 1/2" wide x 5 1/2" high. Julia 10-05 **$780.00.**

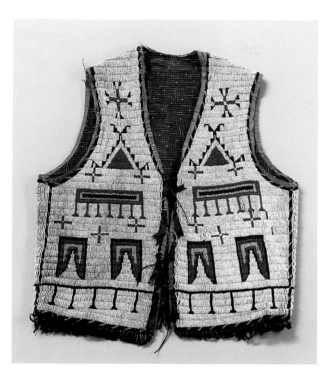
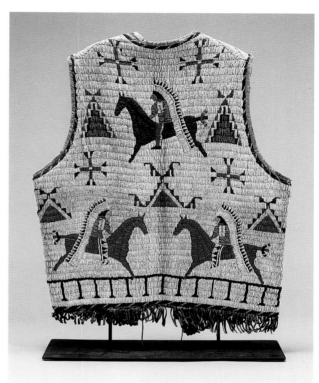

Lakota Sioux Men's Vest, Beaded Hide, circa late 19th C. This has calico lining and ribbon trim, geometric designs, horses and riders, fringed on bottom, some damage to silk ribbon edging, 22" high. The custom-made stand shown was included in the lot. Skinner 9-10-05 **$14,100.00.**

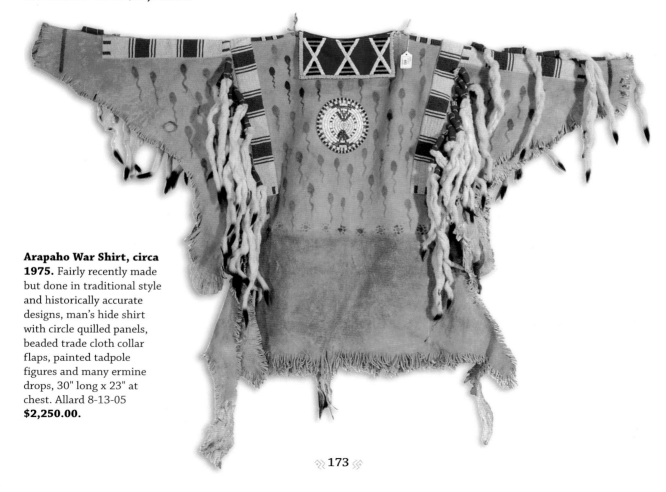

Arapaho War Shirt, circa 1975. Fairly recently made but done in traditional style and historically accurate designs, man's hide shirt with circle quilled panels, beaded trade cloth collar flaps, painted tadpole figures and many ermine drops, 30" long x 23" at chest. Allard 8-13-05 **$2,250.00.**

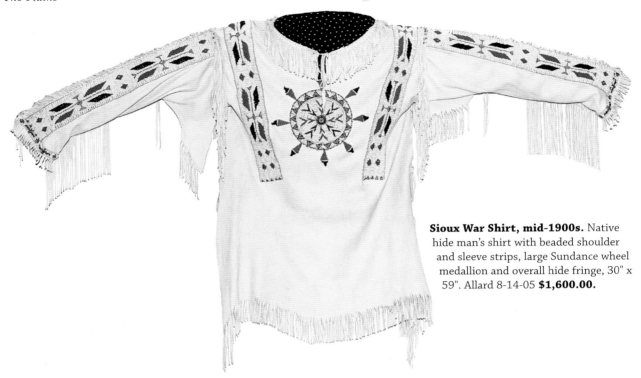

Sioux War Shirt, mid-1900s. Native hide man's shirt with beaded shoulder and sleeve strips, large Sundance wheel medallion and overall hide fringe, 30" x 59". Allard 8-14-05 **$1,600.00.**

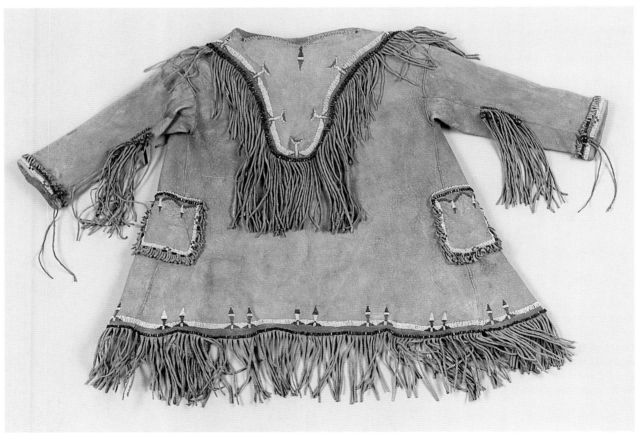

Southern Plains Beaded Hide Coat, last quarter 19th C. This yellow stained with red details coat with fringe also has black faceted and mescal beads, 20" long. Provenance: Collected during the 1889 Oklahoma Land Rush by Fred H. Reed and descended in his family. Skinner 1-29-05 **$19,975.00.**

Central Plains Beaded Hide Trousers, circa last quarter of 19th C. Unknown tribal origin but possibly Dakota, 44" long. Skinner 9-10-05 **$1,347.50.**

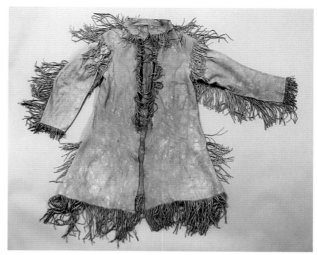

Plains Fringed Hide Coat, circa 19th C., 44". Skinner 9-10-05 **$2,820.00.**

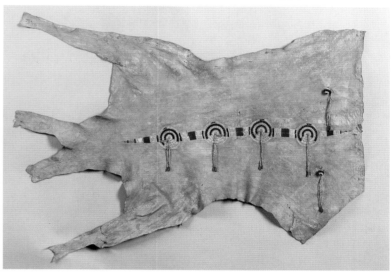

Very Rare Northern Plains Beaded-Hide Child's Robe, third quarter 19th C. Yellow pigmentation with a strip beaded directly to the hide, rondels with quill wrapped hide suspensions and tin cone danglers, also two bead covered spheres with quill wrapped suspensions, 39" long. Skinner 1-29-05 **$23,500.00.**

Southern Cheyenne Leggings, 1870s. Sinew sewn beadwork on green and yellow ocher stained elk hide, trimmed with brass shoe buttons, 12" x 30". Provenance: Richard Pohrt, Sr. collection. Allard 8-14-05 **$3,250.00.**

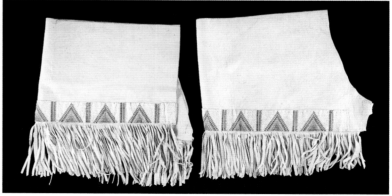

Sioux Man's Leggings, circa 1940s. Commercial hide, unpainted, 30" long x 11 1/2" wide. Julia 10-05 **$517.50.**

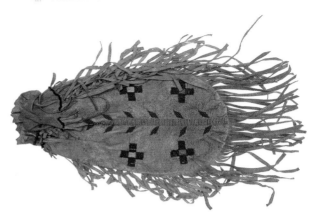

Sioux Pouch, late 19th C. Constructed of native tanned cowhide and painted overall with yellow ocher, 15" long. Julia 10-05 **$1,207.50.**

Plains Beaded Strips, late 1800s, early 1900s. Beaded legging or shirt strips, one is Sioux and is white, lazy stitched and sinew sewn on buffalo hide, the other is Blackfoot and is older, blue and flat beaded and thread sewn on buckskin, 30" x 2 1/2" each. Allard 8-14-05 **$700.00.**

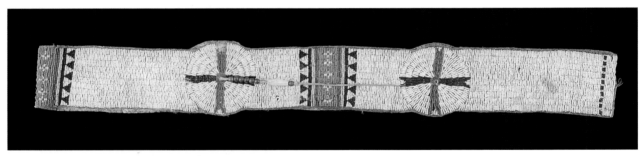

Blanket Strip, Sioux, 19th C. These were used to adorn blankets or robes worn by an individual, 55" long x 3 1/2" wide. Julia 10-05 **$2,012.50.**

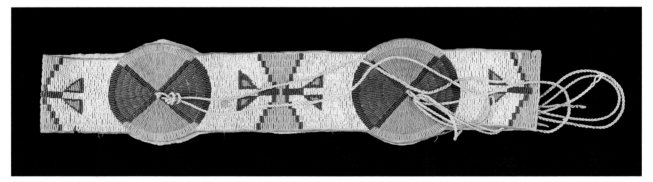

Blanket Strip, Sioux, circa 1870s. 49" long x 5 1/2" wide. Julia 10-05 **$5,980.00.**

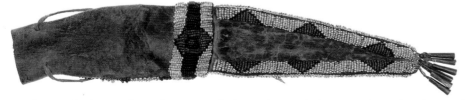

Arapaho Pouch, late 19th C. This is typical of Arapaho pouch designs and matches those collected by the anthropologist Alfred Kroeber now belonging to the American Museum of Natural History in New York City. Note the long triangular tab at the bottom. Julia 10-05 **$1,955.00.**

Plains Ladies' Slat Bag, circa 1940s. Fully quilled square ladies' bag done on white buckskin with beaded handle, 8 1/2" x 9" plus handle. Allard 8-13-05 **$425.00.**

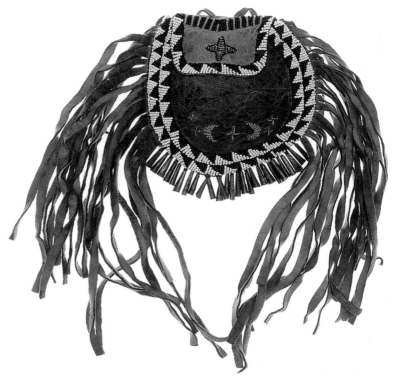

Apache Pouch, late 19th C. 13" x 5 1/2". Julia 10-05 **$1,035.00.**

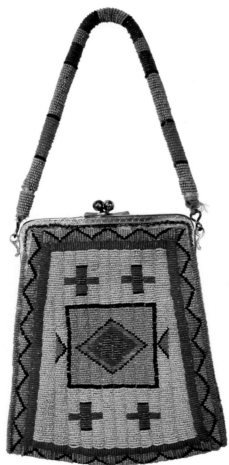

Sioux Purse, circa 1900. Fully beaded with tiny #16 seed beads, 6" x 4 1/2". Allard 8-14-05 **$1,600.00.**

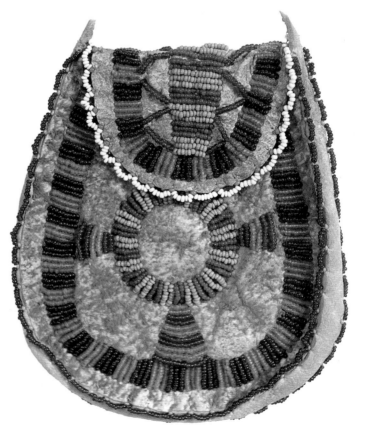

Plains Pouch, circa 1930s. Yellow ocher stained, sinew sewn buckskin pouch with beaded decorations done in lazy stitch technique, 5" x 4 1/4". Allard 8-13-05 **$300.00.**

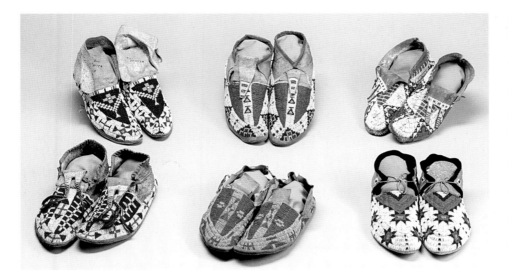

Six Pairs of Lakota Indian Moccasins, late 19th C. The two center pair show the "Buffalo Track" pattern on the top of the moccasins in a solid colored bead pattern (e.g. looks like the bottom of a buffalo hoof). These vary from 10" to 11 1/2" long. Provenance includes Wistariahurst Museum; C. H. Strawbridge and the Charles Pierce collections. Skinner 9-10-05. **Top Left: $940.00; Top Center: $998.75; Top Right: $735.00; Bottom Left: $1,997.50; Bottom Center: $1,410.00; Bottom Right: $940.00**

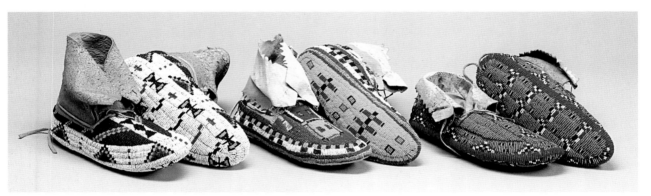

Three Pair of Lakota Moccasins, late 19th C. Provenance for center pair: descended through family of Ned Cook, former scout for the U.S. Army. These vary from 9" to 10" long. Skinner 9-10-05. **Left: $3,818.75; Center: $22,325.00; Right: $2,937.50**

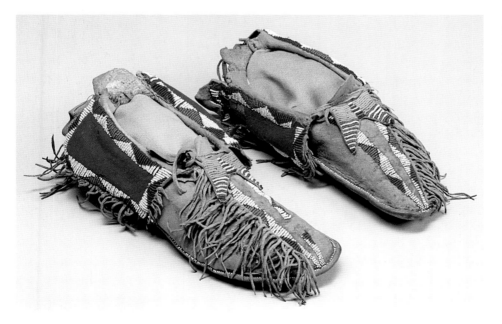

Southern Plains, Kiowa, Hard Sole Buffalo Hide Moccasins, circa 1870s. Partially beaded and trimmed with red trade cloth. Skinner 9-10-05 **$15,275.00.**

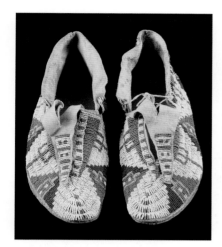

Sioux Moccasins, late 19th C.
10 1/4" long. Julia 10-05 **$1,380.00.**

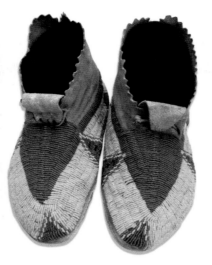

Southern Plains Ute/Apache Moccasins, circa 1880. Fully beaded sinew sewn buffalo hide moccasins, museum quality, 10 1/2". Allard 8-14-05 **$3,500.00.**

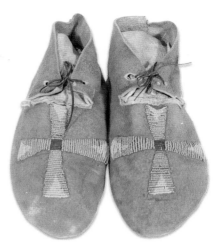

Plains Moccasins, early 1900s. Sinew sewn on buffalo or elk hide with hard soles and classic cross design in lazy stitch beadwork, 10 1/2". Allard 8-14-05 **$375.00.**

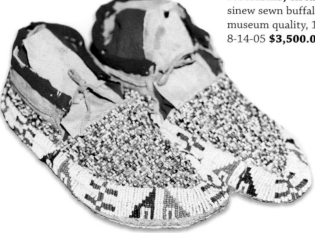

Sioux Moccasins, circa 1880s. Sinew sewn fully beaded on buffalo hide with red trade cloth trimmed cuffs, 9". Allard 3-11-05 **$475.00.**

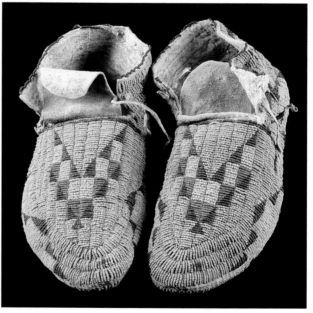

Sioux Ceremonial Moccasins, circa 1880s. Likely Lakota from the time of when the Western Sioux decorated many surfaces with beads, including the soles of some shoes. Beads are worn at both ball and heel indicating, the beads on the bottom were worn from actual use and not just ceremonial or burial purposes as some previously thought, 9 1/2" long. Julia 10-05 **$1,667.50.**

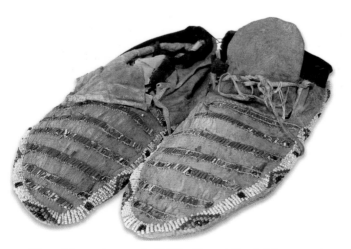

Sioux Moccasins, early 1900s. Very old buckskin moccasins with hard rawhide soles, quilled tops and lazy stitch bead edging, 11" long. Allard 3-12-05 **$225.00.**

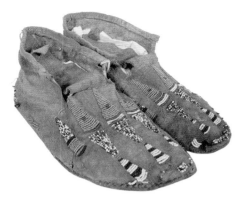

Sioux Moccasins, early 1900s. Sinew sewn on buffalo hide with lazy stitch beadwork and later added commercial soles, some bead loss, 11 1/4" long. Allard 8-14-05 **$475.00.**

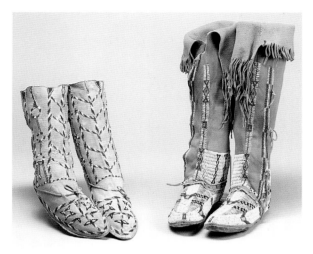

Two Pairs of Moccasins
 Left: Apache girl's moccasins with buckskin uppers and rawhide soles, circa 1900. 12" high and 9" long sole. Skinner 9-10-05 **$1,997.50**
 Right: Southern Plains Arapaho beaded hide woman's high top moccasins, circa late 19th C., stained yellow, German silver buttons at cuffs, 18", sole 9 1/2" long. Skinner 9-10-05 **$4,112.50.**

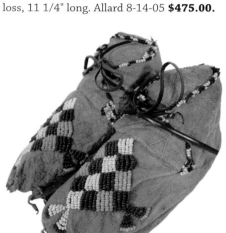

Sioux Moccasins, circa 1900. Soft-soled sinew sewn buckskin moccasins with lazy stitch beadwork, child's size, 6" long. Allard 8-14-05 **$110.00.**

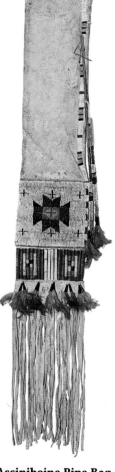

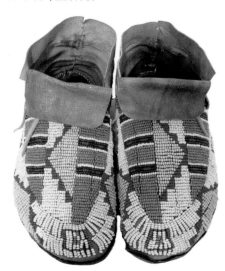

Arapaho Moccasins, mid-1900s. Heavy saddle leather soles and pony beaded tops and sides, 11" long. Allard 3-12-05 **$650.00.**

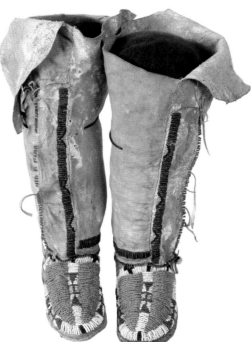

Rare Arapaho Child's Moccasins, circa 1880. High top child's moccasins, sinew sewn beadwork on yellow ocher stained antelope hide, museum mounted, 5 1/2" long x 10" high. Allard 8-14-05 **$3,250.00.**

Assiniboine Pipe Bag, circa 1890s. Beaded and quilled sections, native hide pipebag with many tin cone and feather drops and danglers, old tag reads "Ft. Union North Dakota", 34" x 5" wide. Allard 8-14-05 **$2,750.00.**

Jewelry

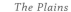

Sioux Necklace, circa 1900. Unusual old rawhide horse figure cutout with a beaded mane, twisted fringes added to tail, and three medicine packs attached, 12" x 9". Allard 3-11-05 **$325.00.**

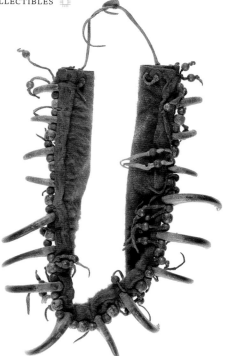

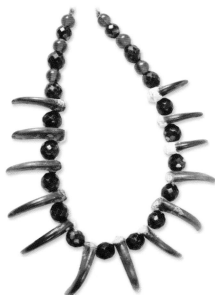

Apache Bear Claw Necklace, late 19th C. Provenance: Moon collection. Consists of nine grizzly claws and eight black bear claws attached to buffalo hide and edged with red felt similar to that used for the backing on buffalo lap robes. The metallic and blue beads used as spacers are of an unknown origin. Driebe shows this at page 322 in his book on Moon. Julia 10-05 **$3,450.00.**

Plains Bear Claw Necklace, circa early 1900s. Northern Plains necklace re-strung with trade beads from 19th C., 22" long. Allard 8-14-05 **$32500.**

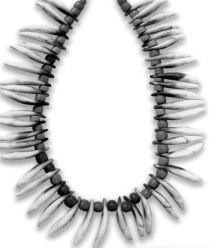

Dog Tooth Warrior's Necklace, circa early 1900s. Strung with 44 canine teeth and re-strung with 19th C. trade beads, 23" long. Allard 8-14-05 **$325.00.**

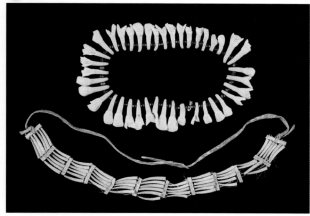

Plains Dentalia Choker Necklace and String of Teeth (Buffalo), late 19th C. The dentalia choker is typical of Plains tribes such as the Sioux, Cheyenne and Arapaho. The dentalia used by Plains groups most likely came from European traders and not the NW Pacific Coast. The choker is 15 1/2" long. The teeth are likely buffalo teeth and are strung with Bohemian ruby glass beads, the string is 11 1/2" long. Julia 10-05 **$747.50.**

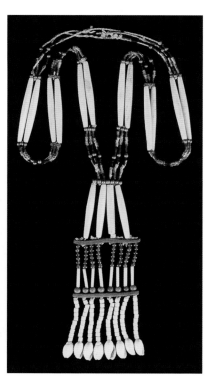

Plains Woman's Necklace, late 19th C. 34" long. Made of bone, glass beads including what are known as basket beads, bugle beads, tile beads and imitation dentalium shells. Julia 10-05 **$402.50.**

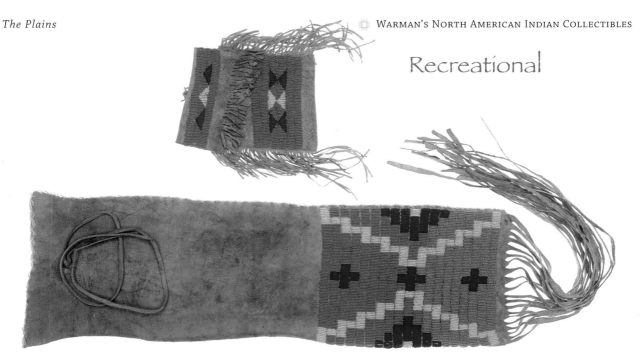

Recreational

Plains Pipe Bag and Strike-A-Lite Pouch, Possibly Sioux, circa 1900.
Both items are native tanned cowhide and painted with dark yellow ocher.
Pipe bag is 36" long and the pouch is 4 3/4" long x 4 1/2" wide. Julia 10-05
$1,035.00.

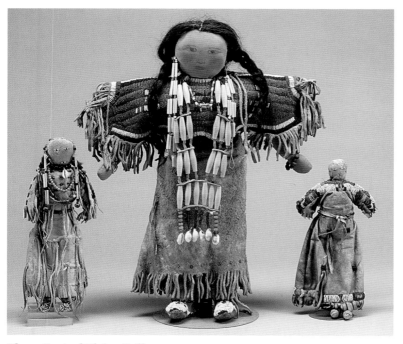

Three Central Plains Dolls.
 Left: Late 19th C. doll wearing multiple strands of trade beads, 11 1/2"
high, stand included. Skinner 9-10-05 **$3,407.50.**
 Center: Lakota Sioux early 20th C. cloth female doll, 20" high. Skinner
9-10-05 **$3,525.00.**
 Right: Lakota Sioux last quarter 19th C. beaded yoke and hemline, 10 1/2"
doll. Skinner 9-10-05 **$4,112.50.**

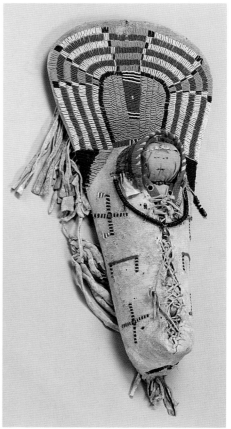

**Central Plains, Ute, Beaded Hide and
Wood Cradle and Cloth Doll, circa last
quarter 19th C.** some cloth and bead loss,
21" high. Skinner 9-10-05 **$8,812.50.**

Central Plains Pictorial Miniature Wood and Hide Tipi, Lakota Sioux, circa last quarter 19th C. 20 1/2" high x 14" diameter, this item could be recreational for children or ceremonial or historical only. Provenance: collected by General Mott Hooton in the 19th C. and from the Wistariahurst Museum collection. Skinner 9-10-05 **$8,812.50.**

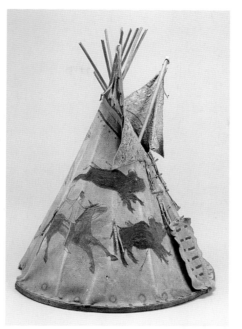
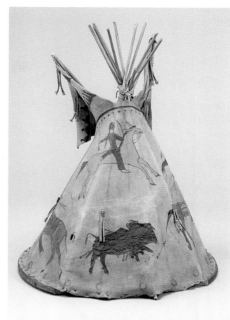
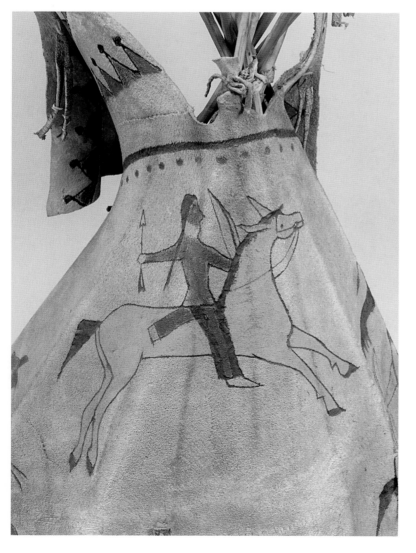
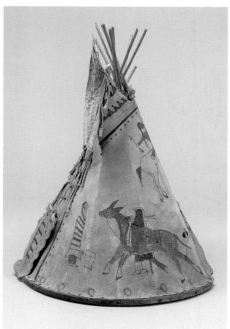

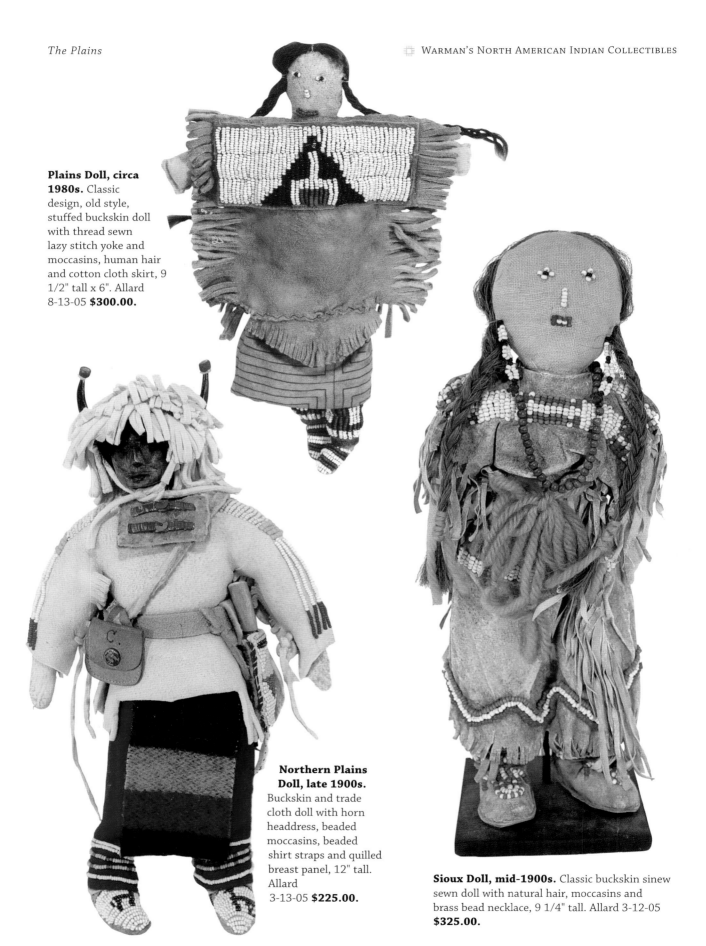

Plains Doll, circa 1980s. Classic design, old style, stuffed buckskin doll with thread sewn lazy stitch yoke and moccasins, human hair and cotton cloth skirt, 9 1/2" tall x 6". Allard 8-13-05 **$300.00.**

Northern Plains Doll, late 1900s. Buckskin and trade cloth doll with horn headdress, beaded moccasins, beaded shirt straps and quilled breast panel, 12" tall. Allard 3-13-05 **$225.00.**

Sioux Doll, mid-1900s. Classic buckskin sinew sewn doll with natural hair, moccasins and brass bead necklace, 9 1/4" tall. Allard 3-12-05 **$325.00.**

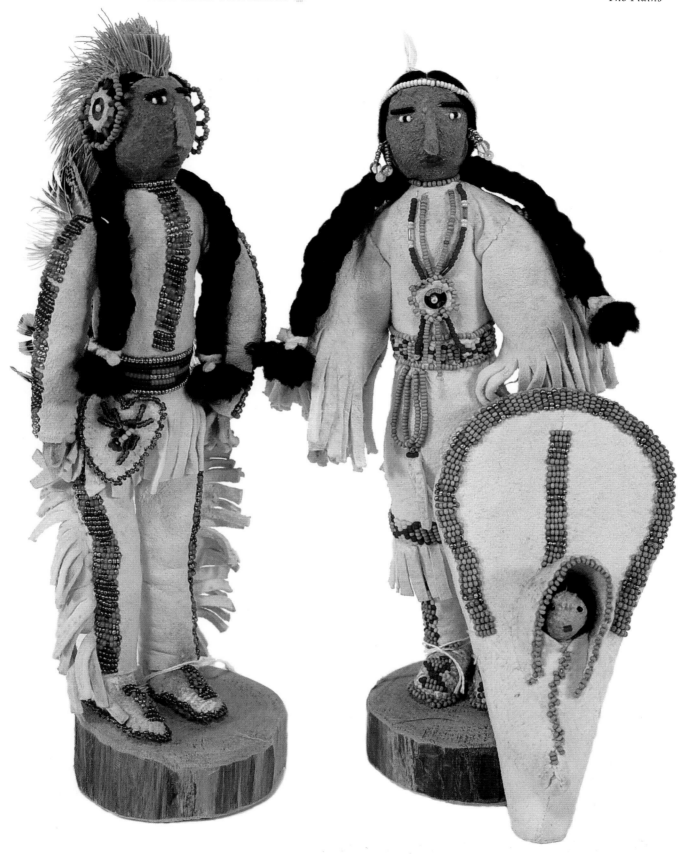

Sioux Doll Set, circa 1960s. Fully costumed family of three, approximately 11" tall. Allard 3-13-05 **$450.00.**

Trade Goods

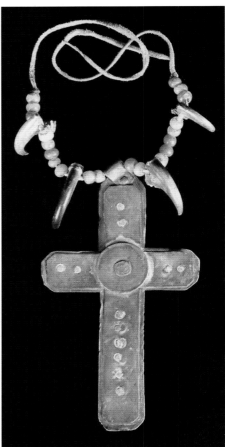

Indian Rosary from Camp Apache. Geronimo provenance according to the Moon family records. The rosary is engraved "Missionarie School" and "Camp Apache," with the small cross being original to the item and the larger cross later added. It is 27 1/2" long and the larger metal cross is 3 5/8" x 2 7/8". Julia 10-05 **$2,100.00.**

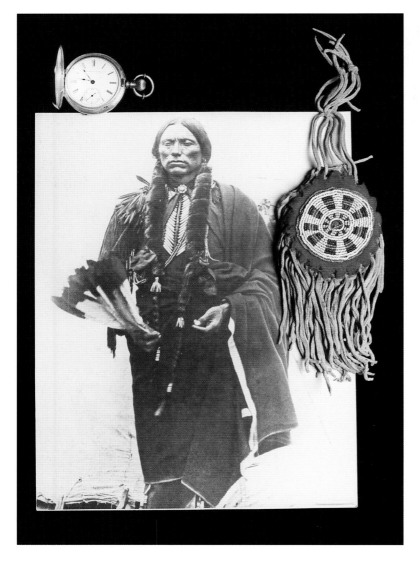

Plains Indians Trade Cross Necklace, late 19th C. Pendant is made of two pieces of copper, with a penny superimposed on the cross dated 1832. The leather thong is strung with glass beads and four black bear claws. Cross is 7 1/8" long x 4" wide and entire pendant is 19". Julia 10-05 **$460.00.**

Quanah Parker's Watch and Beaded Carrying Pouch. This silver pocket watch manufactured by Elgin in 1882-1883 is engraved on the reverse "Comanche Chief Quanah Parker", serial number of watch is 1112639. The beaded holder is in typical Comanche motifs. The photo is a reproduction, modern copy, of a historic circa 1900 photograph. Julia 10-05 **$5,750.00.**

Box and Photograph Belonging to Geronimo. Provenance from the Moon family. The signed photograph of Geronimo was taken at Ft. Sill and hung in his cabin until his death. Then Al-che-say acquired it and later gave it to the photographer Moon. The color photograph is a contemporary print. The set brought more than $3,500 due to its provenance. It does lend some credence to the possibility of the weapons in the next section also being his but it does not, of course, prove it. Julia 10-05 **$3,737.50**.

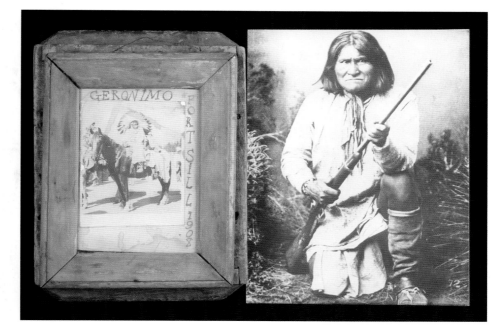

Plains Trade Axe, mid-19th C. Old fur trade axe with a long haft and leather grip at the end and nice patina, hallmarked P.C. Allard 3-11-05 **$275.00**.

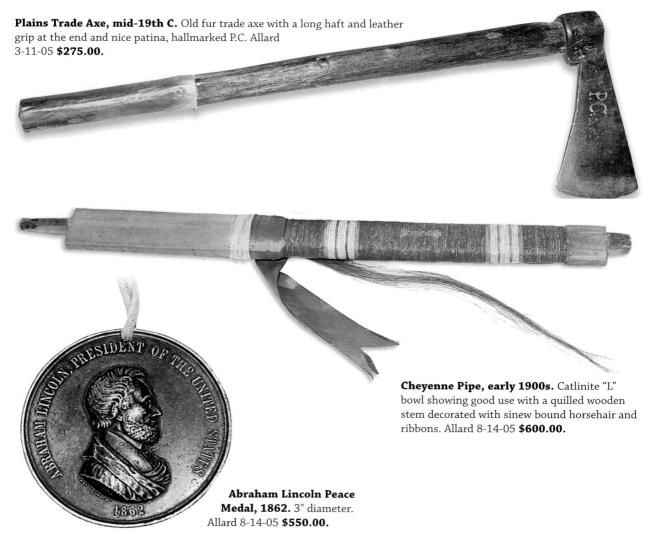

Cheyenne Pipe, early 1900s. Catlinite "L" bowl showing good use with a quilled wooden stem decorated with sinew bound horsehair and ribbons. Allard 8-14-05 **$600.00**.

Abraham Lincoln Peace Medal, 1862. 3" diameter. Allard 8-14-05 **$550.00**.

Weaponry

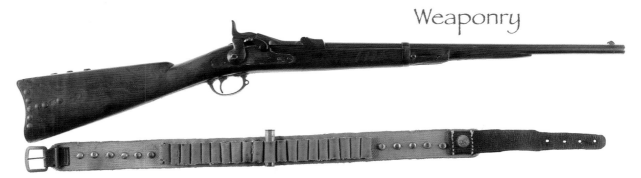

Indian-Decorated Modified Springfield Trapdoor Bored Out to 20 Gauge. This is purported to be related to Geronimo of the Southern Plains but the provenance is weak in my opinion. However, it is typical of the modifications and decorative motifs made by Plains cultures and similar to many others shown in this book. Julia 10-05 **$3,737.50.**

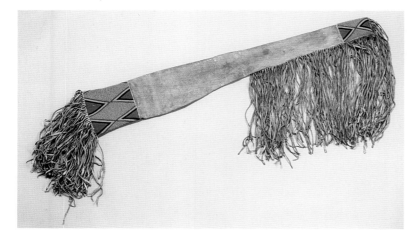

Northern Plains Beaded Buffalo Hide Rifle Case, circa last quarter of 19th C. 44" long. Skinner 9-10-05 **$12,925.00.**

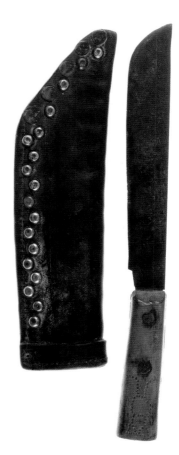

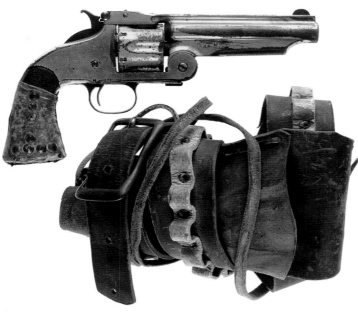

Indian-Decorated Smith & Wesson 44 Caliber Revolver. As with the gun above and the knife below, claims were made of Geronimo ownership but no provenance was offered. However, X-rays did confirm tacks placed in the grips of the gun similar to those used for other gun decorations. Julia 10-05 **$2,587.50.**

Small Butcher Knife, 8 1/4" blade. As with the guns above, this item was purported to be Geronimo's due to the symbols used to decorate it but the provenance was weak although the symbols were apparently similar if not identical to the ones used by Geronimo. Julia 10-05 **$1,500.00.**

Bow Case, Quiver, and Bow, Southern Plains, Possibly Apache, late 19th C. Some provenance from the Moon family indicates these may also have been Geronimo's possessions and the four grooves filed on the edge of the bow are similar to those found on the Springfield Trapdoor. These are constructed of commercial leather and wool felt. The bow case is 30 1/2" long x 3 1/2" wide and the quiver is 26 3/4" long x 5 1/2" wide. The bow is made of ash and backed by sinew. Julia 10-05 **$3,450.00.**

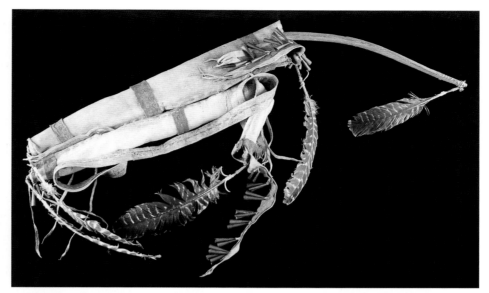

Southern Plains Bow, Bow Case and Quiver, late 19th C. Southern Plains tribes such as the Southern Arapaho, Southern Cheyenne, Kiowa, Comanche, and Kiowa-Apache sometimes made ornate items such as these from black and white domestic cow hide with the hair left on. The quiver still has its stiffening rod present to support the quiver. Canvas repairs have been made to some areas. The quiver is 28 3/4" long and the case is 34" long. The hand-carved Osage orange (bois d'arc) heartwood bow has a double nock at each end and is 47 1/2" long. Julia 10-05 **$1,955.00.**

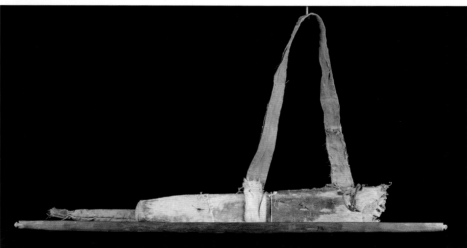

Frontier Knives, various ages. Seven different old knives used by pioneers and Native Americans, the smallest one appears to be a more modern "hoof pick" as we use on our horses, 8" to 18" long. Allard 8-14-05 **$400.00.**

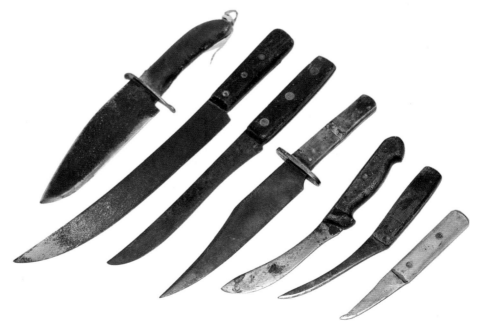

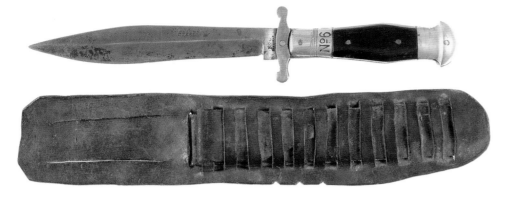

Indian-Used Sheffield #6 Knife, 7" Single Edged Blade. This same knife was shown on page 351 of the Moon book. Julia 10-05 **$402.50.**

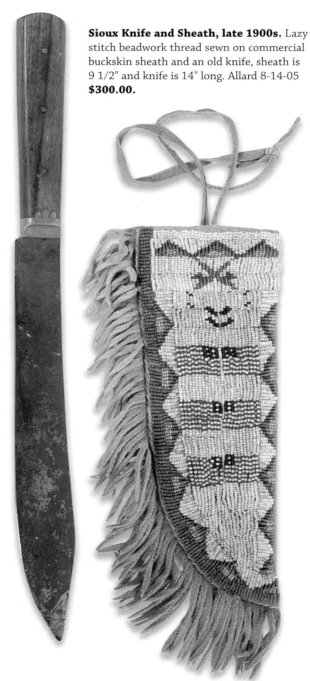

Sioux Knife and Sheath, late 1900s. Lazy stitch beadwork thread sewn on commercial buckskin sheath and an old knife, sheath is 9 1/2" and knife is 14" long. Allard 8-14-05 **$300.00.**

Small Plains Knife and Sheath, mid-1900s. Ladies/child's sinew sewn lazy stitch beaded sheath with small antique knife, sheath is 6" and knife is 8" long. Allard 8-14-05 **$150.00.**

Sioux Knife and Sheath, late 1800s/early 1900s. Sinew sewn on buffalo hide with Sundance pattern, old knife and neckstrap, 2 1/2" x 7" sheath. Allard 3-11-05 **$400.00.**

Sioux Knife Case and Knife, late 19th C. Typical patterns of Hunkpapa or Yanktonai Sioux. Knife is a handmade butcher knife. The case is 7" long and the knife is 13 3/4" long. Julia 10-05 **$1,437.50.**

Sioux Knife Case, circa late 19th C., 12" long. Typical patterns and colors of Lakota groups with top motif likely the Morning Star. Julia 10-05 **$1,150.00.**

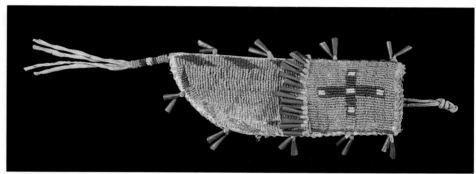

Sioux Knife Case, circa late 19th C. Typical patterns and colors of Lakota groups, 12 1/2" long. Julia 10-05 **$805.00.**

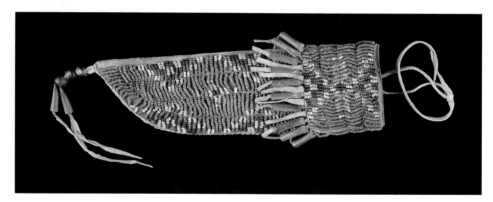

Plains Tomahawk, circa third quarter 19th C. Handle has typical Plains adornment of tacks, original beaded drop has been repaired and a newer piece added to the buffalo hide original, head is forged, it is 23 1/2" long. Skinner 9-10-05 **$10,575.00.**

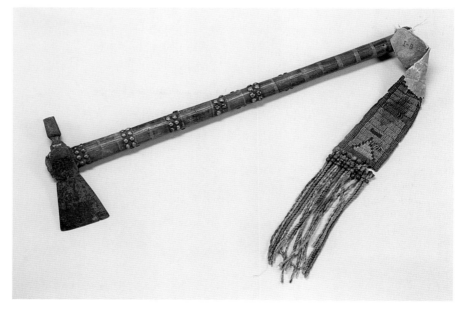

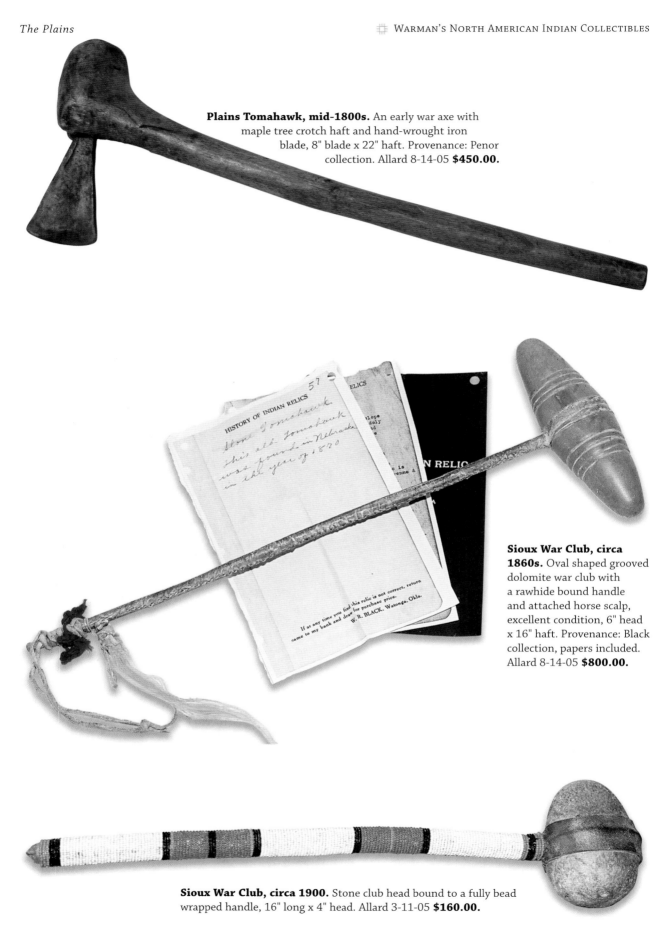

Plains Tomahawk, mid-1800s. An early war axe with maple tree crotch haft and hand-wrought iron blade, 8" blade x 22" haft. Provenance: Penor collection. Allard 8-14-05 **$450.00.**

Sioux War Club, circa 1860s. Oval shaped grooved dolomite war club with a rawhide bound handle and attached horse scalp, excellent condition, 6" head x 16" haft. Provenance: Black collection, papers included. Allard 8-14-05 **$800.00.**

Sioux War Club, circa 1900. Stone club head bound to a fully bead wrapped handle, 16" long x 4" head. Allard 3-11-05 **$160.00.**

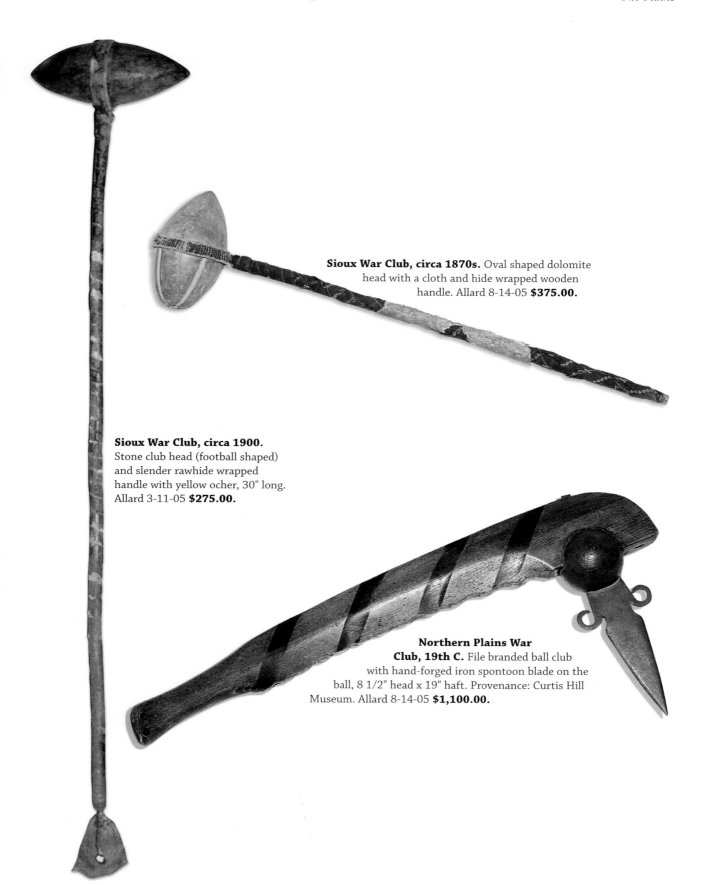

Sioux War Club, circa 1870s. Oval shaped dolomite head with a cloth and hide wrapped wooden handle. Allard 8-14-05 **$375.00.**

Sioux War Club, circa 1900. Stone club head (football shaped) and slender rawhide wrapped handle with yellow ocher, 30" long. Allard 3-11-05 **$275.00.**

Northern Plains War Club, 19th C. File branded ball club with hand-forged iron spontoon blade on the ball, 8 1/2" head x 19" haft. Provenance: Curtis Hill Museum. Allard 8-14-05 **$1,100.00.**

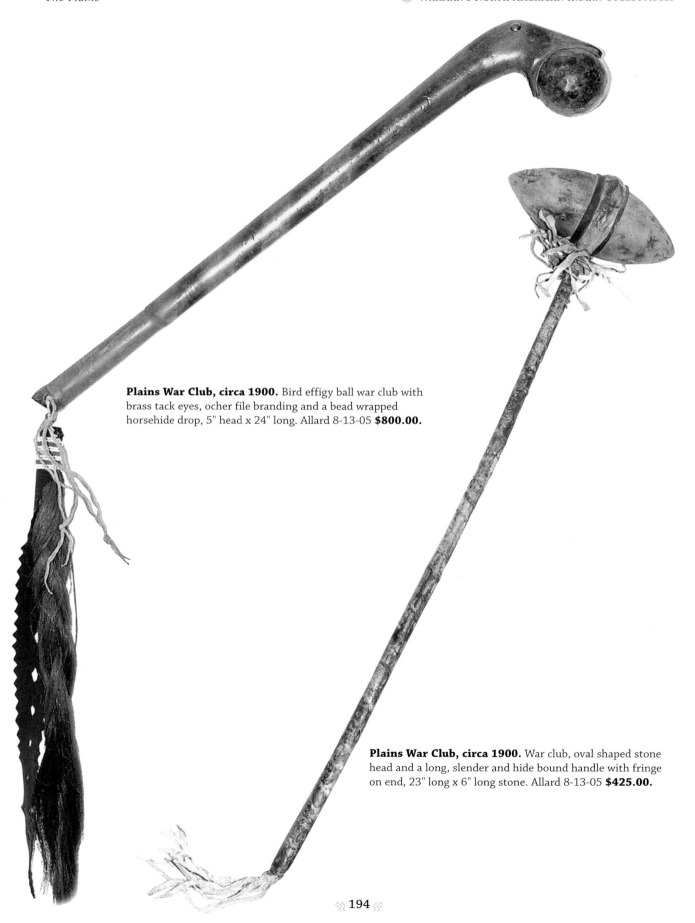

Plains War Club, circa 1900. Bird effigy ball war club with brass tack eyes, ocher file branding and a bead wrapped horsehide drop, 5" head x 24" long. Allard 8-13-05 **$800.00.**

Plains War Club, circa 1900. War club, oval shaped stone head and a long, slender and hide bound handle with fringe on end, 23" long x 6" long stone. Allard 8-13-05 **$425.00.**

War Club, late 19th C. Possibly Sioux, slightly flexed head and covered with beadwork of geometric designs, 22 3/4" long. Julia 10-05 **$517.50.**

War Club. Attributed to Geronimo and the Apache by Moon and family, circa late 19th C, 30" long. Julia 10-05 **$2,070.00.**

Two War Clubs, Plains, Possibly Sioux, late 19th C. The smaller one may be an example of ones made for trading with European (American) traders, 14" long. The larger 27" version is of typical Plains design with a double pointed stone head, beads, leather and rawhide on a wooden shaft. Julia 10-05 **$920.00.**

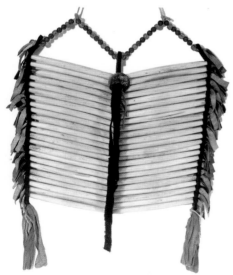

Crow Breastplate, mid-1900s. Hairpipe bone and bead breastplate with fringed edges and ribbon suspensions, 11" x 11" plus tie and fringe. Allard 8-13-05 **$150.00.**

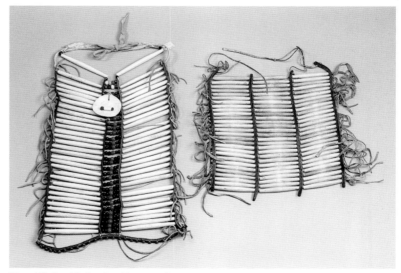

Two Plains Hairpipe Breastplates.

Left: Late 19th C. made with commercial leather strips and hide-strung hairpipes and multicolored trade beads with a trade bead and shell disc pendant, 19". Skinner 1-29-05 **$1,058.00.**

Right: Last quarter 19th C. example with three sections of hairpipes strung on red-stained hide with commercial leather spacers, 21 1/2". Skinner 1-29-05 **$1,645.00.**

9

The Plateau Region
(Intermountain)

his cultural region is between the Plains and the Coastal regions to the west of the mountains. Both scholars and auction houses also refer to the region as the Intermountain. Many of the cultures actually did spend time on the Plains on the eastern side of the Intermountain region, and some cultures migrated further west on the western side of the region. Thus, it is a difficult region to pin down as to specific cultural attributes, as it was truly a corridor in many ways, likely being most famous for the corridor that Lewis and Clark traveled on their famed explorations.

Cultures normally associated with this region include the Nez Perce, Sarsi, Black-foot in Canada and the United States (Piegan), Assiniboine, and Gros Ventres, among others. Collectors normally consider the Crow to be people of the Plains, but indeed they often migrated into this region as well, and many of their historical cultural attributes and styles are closer to the Plateau styles. I have placed Crow artifacts in both regions for this reason.

The Apache, originally from the Southwest, often migrated into both the Southern Plains and the Southern area of the Intermountain West or Plateau. As mentioned in Chapter Three, I have placed Apache artifacts in both the Southwestern and Plains areas depending, to a large extent, on the time period.

Artistic Items

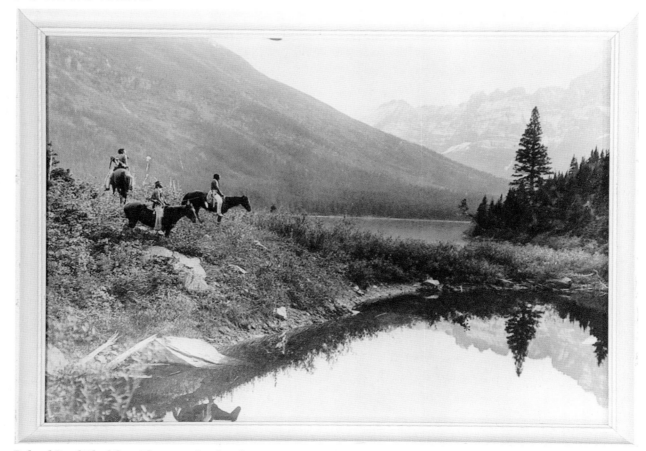

Roland Reed Blackfoot Photograph, circa late 1800s. Signed original photo of Blackfoot Indians in Glacier Park, 14 3/4" x 18 1/2" image, framed 16 1/2" x 20 3/4". Allard 8-14-05 **$2,250.00.**

Ceremonial and Utilitarian Items

Blackfoot Leggings, circa 1880. Calico-backed leggings with beaded panels, 13" x 13". Allard 8-14-05 **$1,300.00.**

Deer Antler Headdress, Likely Plateau, circa 1900. Beautiful example of a ceremonial headdress typical of the Plateau (and some Plains) groups. It is about 43" overall. Julia 10-05 **$2,587.50.**

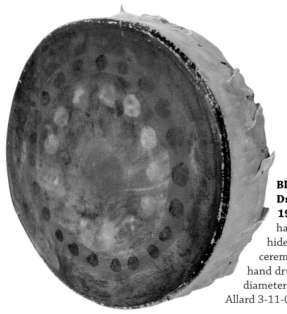

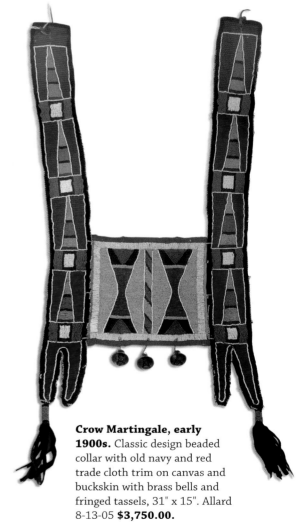

Blackfoot Drum, circa 1900. Old hand-carved, hide-covered ceremonial hand drum, 9 3/4" diameter, 3" thick. Allard 3-11-05 **$130.00.**

Crow Martingale, early 1900s. Classic design beaded collar with old navy and red trade cloth trim on canvas and buckskin with brass bells and fringed tassels, 31" x 15". Allard 8-13-05 **$3,750.00.**

Beaded Trapping, Likely Plateau, early to mid-1900s. Unusual loom and wrap beaded horse decoration done on recycled and other leather, with elk-hide fringe, 30" x 9". Allard 3-11-05 **$300.00.**

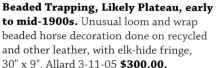

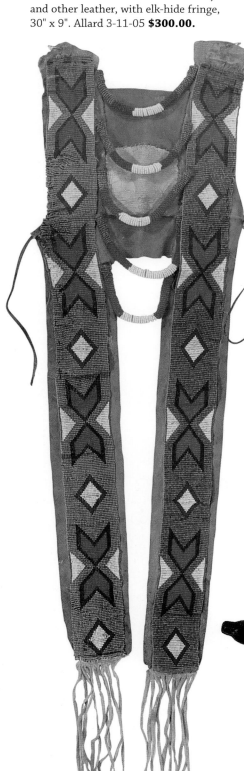

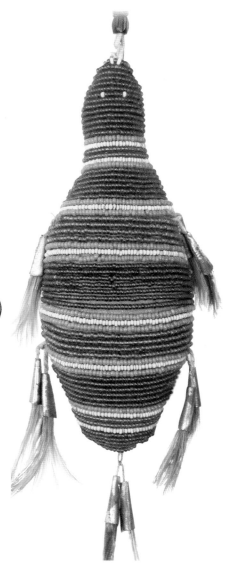

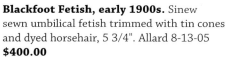

Blackfoot Fetish, early 1900s. Sinew sewn umbilical fetish trimmed with tin cones and dyed horsehair, 5 3/4". Allard 8-13-05 **$400.00**

Blackfoot Pipe Bag, circa 1910. Hide bag with geometric design and dog ear flaps and fringe, 32" x 7 1/2". Allard 3-12-05 **$1,600.00.**

Blackfoot Pipe, circa 1920s. Bead-wrapped ash stem with a pewter inlaid black stone bowl, 20" long x 4" high. Allard 3-11-05 **$200.00.**

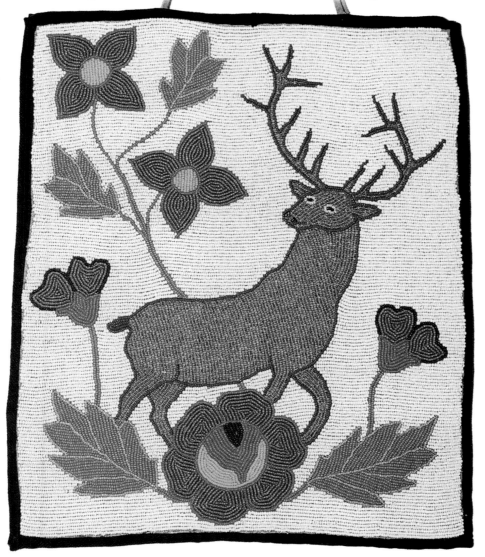

Nez Perce Beaded Flat Bag, circa 1900. Classic Plateau designs with an elk and floral patterns, 11" x 13". Allard 8-14-05 **$650.00.**

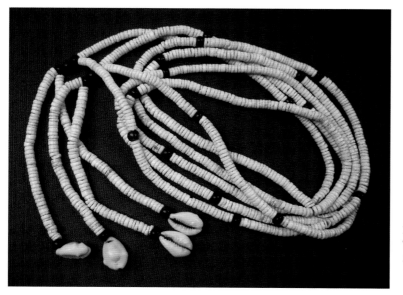

Piegan Pipe Bag, circa 1870. Buffalo hide bag beaded on both sides with beaded bottom fringe, 5 1/2" x 21". Allard 8-14-05 **$1,600.00.**

Nez Perce Clamshell Wampum, mid-1900s. Two strands restrung, each 48" long. Allard 3-12-05 **$275.00.**

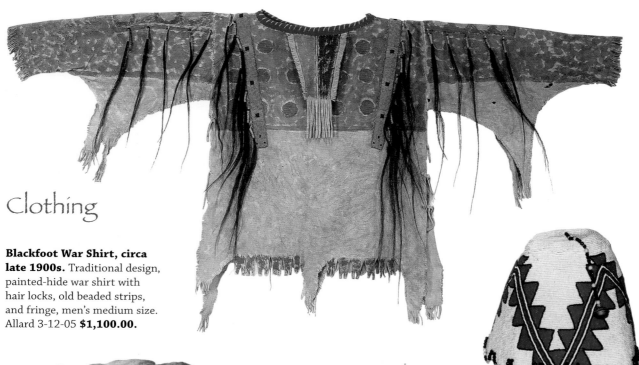

Clothing

Blackfoot War Shirt, circa late 1900s. Traditional design, painted-hide war shirt with hair locks, old beaded strips, and fringe, men's medium size. Allard 3-12-05 **$1,100.00.**

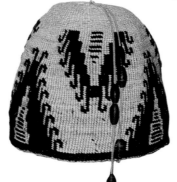

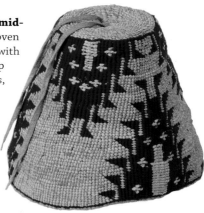

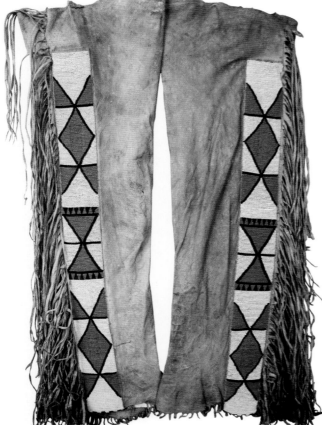

Nez Perce Fez, early/mid-1900s. Traditional Nez Perce style, fully beaded hat with red, white, blue, and black geometric patterns in step design, 8" x 8". Allard 8-14-05 **$1,500.00.**

Nez Perce Fez, early/mid-1900s. Classic hand woven cornhusk basketry hat with intricate black wool "top knot" and other designs, 8" x 8". Allard 8-14-05 **$900.00.**

Nez Perce Fez, mid/late-1900s. Classic woven cornhusk hat with rare red yarn designs, quail top knots, and crosses in chevron form, 6 1/2" x 8". Allard 3-12-05 **$1,000.00.**

Blackfoot Leggings, circa 1880. Mountain sheep hide leggings with beaded strips and long fringe, 30" long x 9" wide. Provenance: Richard Pohrt, Sr. collection. Allard 8-14-05 **$3,250.00.**

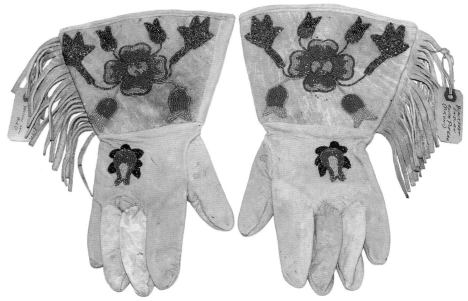

Blackfoot Gauntlets, circa early 1900s. Collected from Whitewater, Montana, 13" x 8". Allard 8-14-05 **$275.00.**

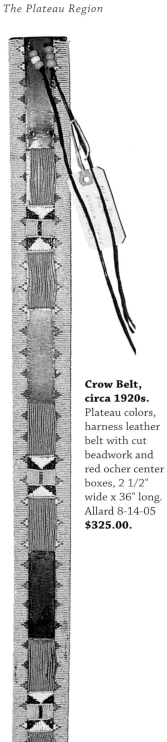

Crow Belt, circa 1920s. Plateau colors, harness leather belt with cut beadwork and red ocher center boxes, 2 1/2" wide x 36" long. Allard 8-14-05 **$325.00.**

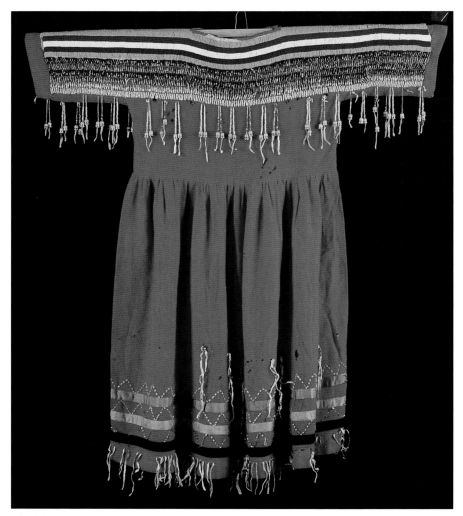

Blackfoot Dress, late 19th C. Made of red trade cloth and decorated heavily with seed beads and pink basket beads. 51" tall and 45" wide. Julia 10-05 **$2,587.50.**

**Plateau Gauntlets
(Gloves), mid-1900s.**
Classic design of fancy
buckskin gloves with fully
beaded uppers, each fringed
and containing a rose,
14 1/4" long x 8". Allard
8-13-05 **$450.00.**

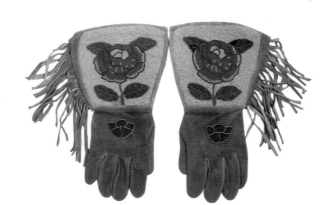

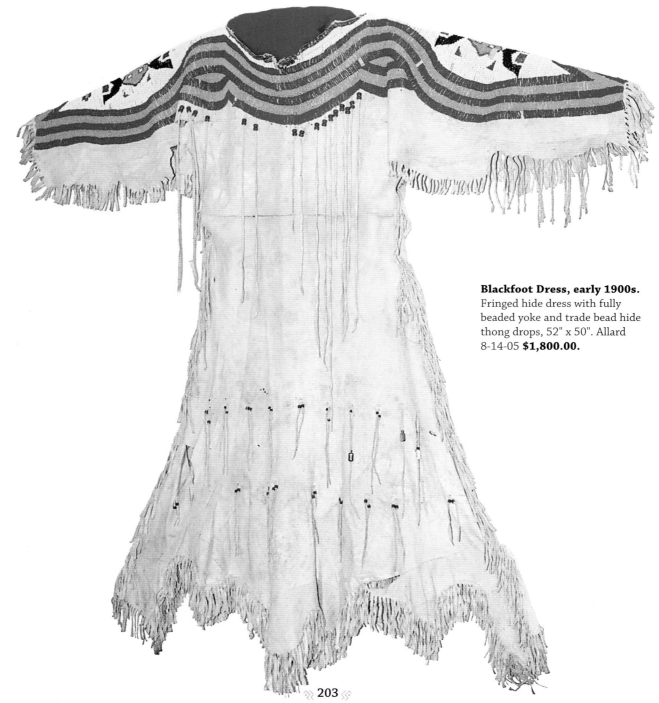

Blackfoot Dress, early 1900s.
Fringed hide dress with fully
beaded yoke and trade bead hide
thong drops, 52" x 50". Allard
8-14-05 **$1,800.00.**

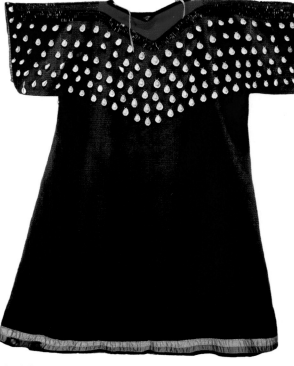

Flathead Skirt, early 1900s. Older thread sewn black/navy trade cloth skirt with large floral designs and trim done with glass tube beads, 36" waist and 32" long. Allard 8-13-05 **$1,000.00.**

Blackfoot Dress, early 1900s. An example of a Cowry decorated dress from the Plateau made from purple and red trade cloth and decorated with satin ribbon, ladies' medium. Allard 3-13-05 **$400.00.**

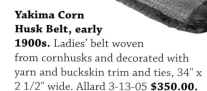

Yakima Corn Husk Belt, early 1900s. Ladies' belt woven from cornhusks and decorated with yarn and buckskin trim and ties, 34" x 2 1/2" wide. Allard 3-13-05 **$350.00.**

Cree Moccasins, early/mid-1900s. High top buckskin moccasins with traditional floral motifs typical of the entire Plateau region and felt/trade cloth tops, 10" x 15" high. Allard 3-12-05 **$300.00.**

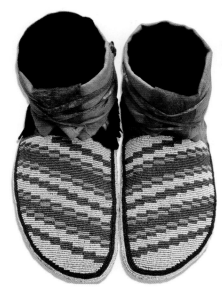

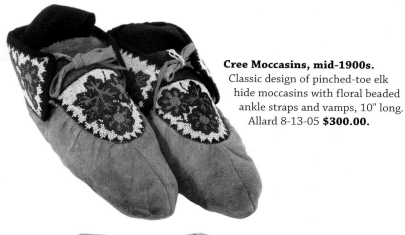

Cree Moccasins, mid-1900s.
Classic design of pinched-toe elk
hide moccasins with floral beaded
ankle straps and vamps, 10" long.
Allard 8-13-05 **$300.00.**

Blackfoot Moccasins, circa 1880. 11",
provenance: Richard Pohrt collection. Allard
8-14-05 **$1,600.00.**

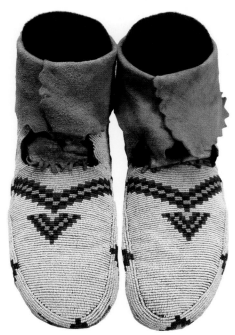

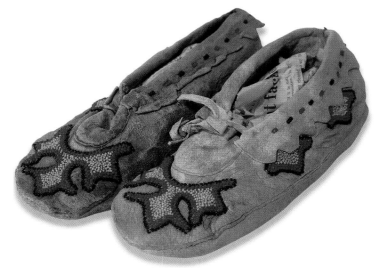

**Crow Moccasins, circa
1890.** Buffalo hide soles,
false vamps, partially beaded
moccasins, museum quality,
10 1/2". Provenance:
Honnen collection. Allard
8-14-05 **$1,900.00.**

Blackfoot Moccasins, circa 1880.
Beaded buffalo hide moccasins in excellent
shape, fully beaded, 11" long. Provenance:
Richard Pohrt, Sr. collection. Allard 8-14-05
$2,000.00.

Cree Moccasins, early 1900s. Buckskin and beaded moccasins with red,
yellow, and black designs, 9" long. Allard 3-12-05 **$100.00.**

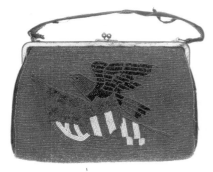

Plateau Purse, circa 1930. Typical of many Plateau cultures were purse type bags, many shown here in this section. This clasp model had an eagle and flag motif with both faceted and unfaceted seed beads decorating it. 9 3/4" long and 7" wide. Julia 10-05 **$402.50.**

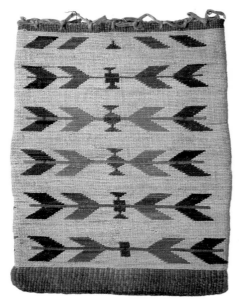

Nez Perce Bag, early/mid 1900s. Large cornhusk bag in pristine condition, no fading or damage, 12" x 16". Allard 3-11-05 **$900.00.**

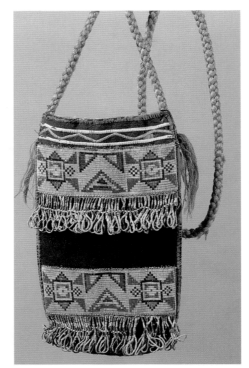

Quilled Cloth Bag, Cree, first half 19th C. Made of blue trade cloth with silk applique details, decorated with tightly loomed geometric quillwork with quill wrapped hide loops and white seed bead spacers below the panels. It has a braided cloth strap and is lined with cloth ticking. An old paper label says "This Indian bag was made by squaws and used by Titian Peale during Longs Rocky Mountain Expedition in 1819-1820". The reverse of the paper says "Holmesberg Feb. 4, 1876". The bag has some minor loss and is 10 3/4" long. Provenance: Supposedly purchased from the direct descendants of the Peale family by Wesley Crozier of Red Bank, New Jersey. Exhibitions: Monmouth (NJ) County Library. Skinner 9-10-05 **$94,000.00.**

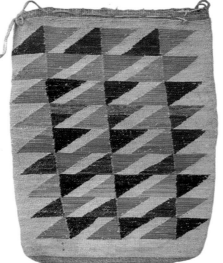

Nez Perce Cornhusk Bag, circa 1900. 13" x 18 1/2". Allard 8-14-05 **$1,200.00.**

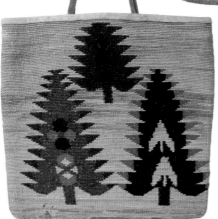

Nez Perce Bag, circa 1860. Rare figured cornhusk bag with pine trees, flowers, and arrowheads, 11" x 11". Allard 8-13-05 **$700.00.**

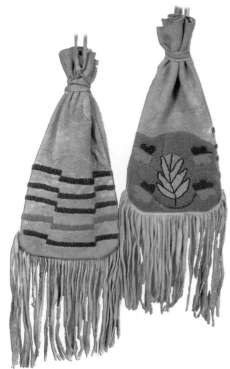

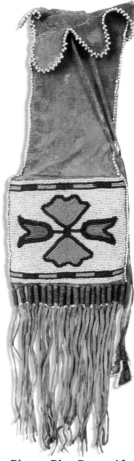

Plateau Beaded Bag, early 1900s. Fully beaded bag, sinew sewn, one sided bag in floral design on greasy blue background, 10" x 8". Allard 8-13-05 **$225.00.**

Plateau Bag, mid-1900s. Elk hide, ladies' drawstring bag with fully front beaded panel and long fringe, 14" x 6" plus fringe. Allard 8-13-05 **$375.00.**

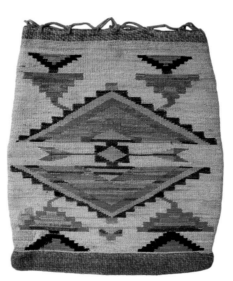

Nez Perce Bag, circa 1900. All cornhusk polychrome flat bag, 14" x 17". Allard 8-13-05 **$800.00.**

Piegan Pipe Bag, mid-19th C. Rare and early tab-top Piegan pipebag, sinew and thread sewn on mountain sheep hide with pony bead trim terminated with ocher stained fringe wrapped with coiled brass wire, 5" x 21" long. Allard 8-13-05 **$3,250.00.**

Crow Parfleche, circa 1860. Early mineral painted elk hide parfleche, 11" x 18". Allard 8-14-05 **$550.00.**

Yakima Flat Bag, circa 1920s. Typical Plateau motifs of floral designs and elk, 14" x 14". Allard 8-14-05 **$550.00.**

Jewelry

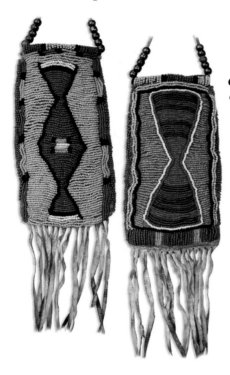

Crow Fire Bag, circa 1870. Rare sinew sewn fully beaded firebag, complete with striker and flint, 3 1/2" x 6 1/4". Provenance: formerly of the Honnen Collection. Allard 8-13-05 **$2,000.00.**

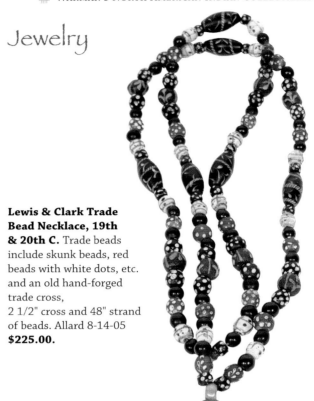

Lewis & Clark Trade Bead Necklace, 19th & 20th C. Trade beads include skunk beads, red beads with white dots, etc. and an old hand-forged trade cross, 2 1/2" cross and 48" strand of beads. Allard 8-14-05 **$225.00.**

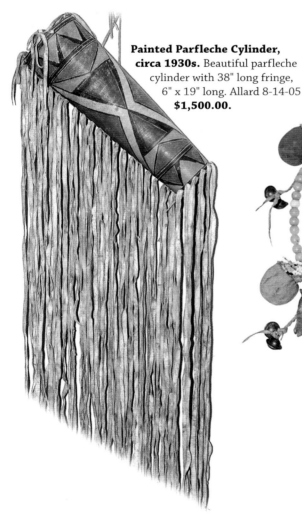

Painted Parfleche Cylinder, circa 1930s. Beautiful parfleche cylinder with 38" long fringe, 6" x 19" long. Allard 8-14-05 **$1,500.00.**

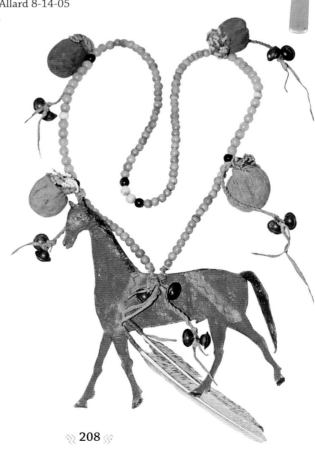

Plateau Necklace, early 1900s. Trade bead necklace with medicine packs added and a rawhide horse cutout, regalia worn by military society members, 7" horse x 18" strand. Allard 8-14-05 **$425.00.**

Recreational Items

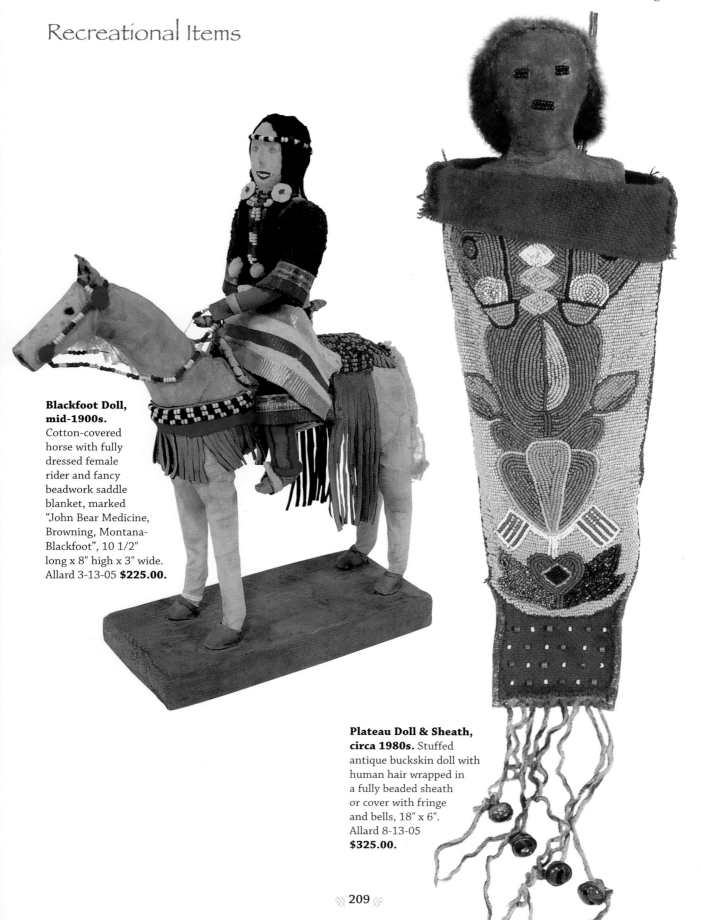

Blackfoot Doll, mid-1900s. Cotton-covered horse with fully dressed female rider and fancy beadwork saddle blanket, marked "John Bear Medicine, Browning, Montana-Blackfoot", 10 1/2" long x 8" high x 3" wide. Allard 3-13-05 **$225.00.**

Plateau Doll & Sheath, circa 1980s. Stuffed antique buckskin doll with human hair wrapped in a fully beaded sheath or cover with fringe and bells, 18" x 6". Allard 8-13-05 **$325.00.**

10

California

This region seems self-defined by today's geographical map and one of our greatest states. However, as one who has lived in California on two occasions and traveled it from one corner to the other, I can assure the reader it is a vast and geographically—and thus culturally—varied area from its arid southern regions to its more moderate regions of the north. Thus, it is hard to lump all cultures into one area such as this, but again, it is well-defined in the literature and also clearly isolated by the geographical barriers of mountains, deserts, and large rivers in the north.

Most of the artifacts in this region are related to very fragile materials that survived due to the arid or semi-arid climates of most of California. Examples include mainly basketry with very few items from other categories discussed in Chapter Two. The basketry examples are divided into cultural regions—northern and southern California—and into time periods such as the Mission Period.

California is a vast and geographically—and thus culturally—varied area from its arid southern regions to its more moderate regions of the north. Thus, it is hard to lump all cultures into one area such as this...

Basketry

Four Northern California Twined Baskets and Bowls.
 Left: Circa late 19th C. cooking basket with chevron motif, patina from use, 14" high x 8" diameter. Skinner 9-10-05 **$822.50.**
 Front Center: Northern California twined basketry bowl with natural triangular design on dark brown background, 3" high x 6 3/4" diameter. Skinner 9-10-05 **$264.38.**
 Front Rear: Circa 1900 Northern California mush bowl, 3 1/4" x 7 1/4". Skinner 9-10-05 **no sale/ withdrawn.**
 Right: Circa 1900 Northern California twined basketry bowl, tapered ovoid form with dark brown stacked triangles on top of houses or lodges, 5 1/2" x 8". Skinner 9-10-05 **$822.50.**

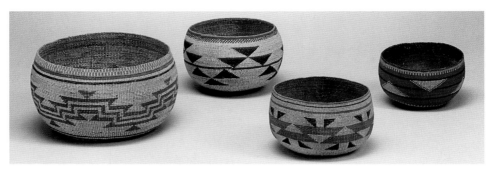

Four Northern California Twined Basketry Bowls.
 Left: Polychrome bowl, circa 1900, flat-bottomed globular form with dark and medium brown geometric designs, 5 3/4" high x 9 1/2" diameter. Skinner 9-10-05 **$940.00.**
 Rear Center: Polychrome bowl, circa 1900, globular form with triangle designs, 5" high x 7" diameter. Skinner 9-10-05 **$705.00.**
 Front Center: Polychrome bowl, circa 1900, triangular designs in dark and medium browns, 3 3/4" high x 6 1/2" diameter. Skinner 9-10-05 **$587.50.**
 Right: Twined basketry bowl, globular form with dark and natural geometric designs on medium brown background, 3 3/4" high x 5 3/4" diameter. Skinner 9-10-05 **$440.63.**

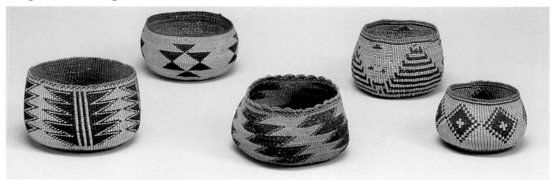

Five Northern California Twined Basketry Bowls.
 Left: Early 20th C. twined basketry bowl with stacked triangles, 3 3/4" high x 5 1/4" diameter. Skinner 9-10-05 **$822.50.**
 Left Rear: Early 20th C. twined basketry bowl with dark brown triangles on natural background, 2 3/4" high x 5 1/4" diameter. Skinner 9-10-05 **$367.50.**
 Center Front: Circa 1900 scalloped rim bowl with stacked diagonals, 3" high x 5 1/2" diameter. Skinner 9-10-05 **$398.13**.
 Right Rear and Right Front: Two circa 1900 bowls both with dark brown rim and bottom and geometric designs, largest is 3 1/2" high x 4 1/2" diameter. Skinner 9-10-05 **$881.25.**

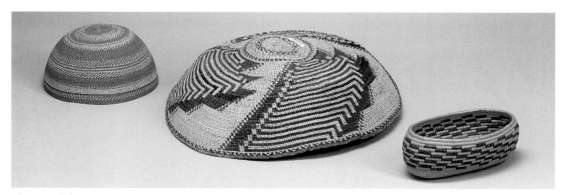

Three California Basket Items. Left: Circa 1900 Hupa hat and **Center:** circa 1900 Hupa gambling tray, 14 1/2" diameter, pair sold together. Provenance: Wistariahurst Museum; C. H. Strawbridge. Skinner 9-10-05 **$1,527.50.**
 Right: Early 20th C. California, Pomo culture, flat bottom ovular bowl with diagonal designs, old sticker inside reads "made by Lina Iditi --? sale price $5.00", 2 1/2" high, 7" long. Skinner 9-10-05 **$705.00.**

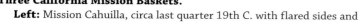

Three California Mission Baskets.

Left: Mission Cahuilla, circa last quarter 19th C. with flared sides and some stitch loss, 3" high x 15 1/2" diameter. Skinner 9-10-05 **$1,645.00.**

Right: Two late 19th C. mission coiled baskets, an ovoid bowl and a tray with some stitch loss, bowl is 2 3/4" high x 9" long and the tray is 2" high x 12 3/4" diameter. Skinner 9-10-05 **$1,175.00.**

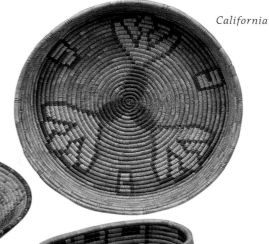

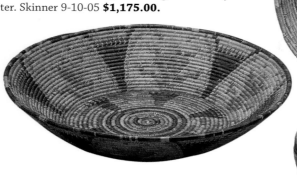

Three California Coiled Basketry Bowls.

Left: Late 19th C. flat-bottomed bowl with flared top and diagonal patterns and some stitch loss, 8 1/2" high x 18 1/2" diameter. Skinner 9-10-05 **$2,115.00.**

Front Right: Circa 1900 bowl with dark red triangular devices and minor rim damage, 5' high x 12 1/2" diameter. Skinner 9-10-05 **$1,057.50.**

Rear Right: Circa 1900 flared bowl with geometric designs, 7 1/2" high x 16 1/2 diameter. Skinner 9-10-05 **$1,292.50.**

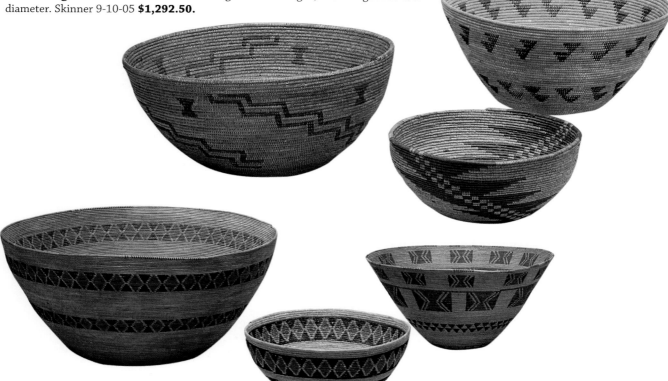

Three California Polychrome Coiled Basketry Bowls, All Yokuts.

Left: Late 19th C. large polychrome bowl, flared with rattlesnake pattern, minor stitch loss and small break at rim, 10 1/2" high x 21 1/2" diameter. Skinner 9-10-05 **$5,581.25.**

Center: First quarter 20th C. flared bowl with six-point star and rattlesnake designs, made by "Katie Garcia Wukchumne", no size listed, Provenance: Wistariahurst Museum. Skinner 9-10-05 **$1527.50.**

Right: Circa late 19th C. tightly woven with flared sides and two bands of concentric hourglass motifs, some stitch loss at rim, 7 1/2" high x 15" diameter. Provenance: Wistariahurst Museum. Skinner 9-10-05 **$3,818.75.**

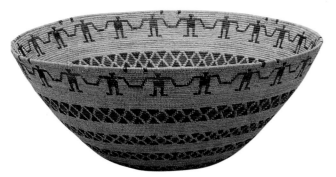

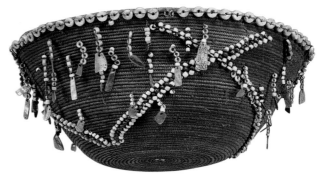

Pictorial Coiled Basketry Bowl, Yokuts, circa late 19th C. Flared form pictorial bowl with four rows of two color rattlesnake design and a top row of humans holding hands in alternating colors, some restoration done to this piece, 7 1/2" high x 17 1/4" diameter. Skinner 9-10-05 **$14,100.00.**

Early California Coiled Basketry Bowl, Pomo, 19th C. Tightly woven flat-bottomed with flared sides and the outside of the bowl decorated with shells at the rim, shell and glass pony beaded grid pattern, and abalone and pony bead danglers. The bowl has splits at rim and some bead loss, 4" high x 10" diameter. Skinner 9-10-05 **$6,462.50.**

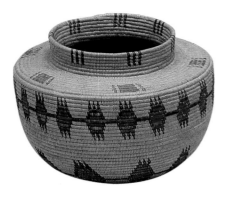

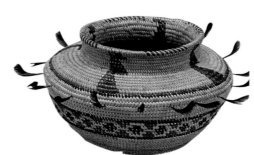

Two California Polychrome Basketry Jars.

Left: Kern culture circa 1900 tightly woven bottleneck form, 4 1/2" high x 6 1/4" diameter. Skinner 9-10-05 **$5,287.50.**

Right: Yokuts first quarter 20th C. bottleneck form with geometric and rattlesnake designs and decorated with feathers, 3 1/2" high x 5 1/2" diameter. Provenance: Wistariahurst Museum. Skinner 9-10-05 **$2,702.50.**

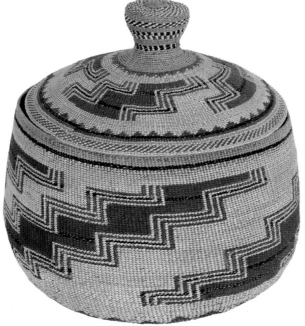

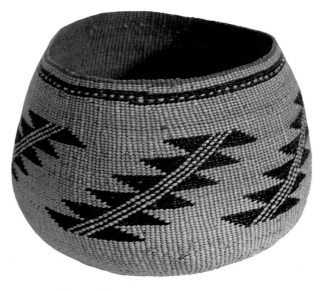

Hupa Lidded Basket, early 1900s. Rare fine-weave lidded basket with excellent black and red designs and top knot handle on lid, 10" high x 9 1/2" diameter. Allard 8-13-05 **$2,000.00.**

Hupa Basket, early 1900s. Fine weave mush bowl with exterior rhomboid designs, 4 3/4" high x 6 3/4" diameter. Allard 8-13-05 **$425.00.**

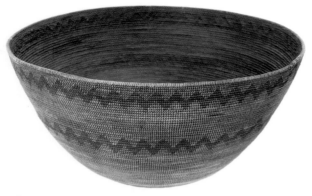

Yokuts Basket, early 1900s. Huge old woven basketry vessel with two rows of zigzag figures and well used blackened interior, 7 1/4" x 15 1/4". Allard 3-11-05 **$1,100.00.**

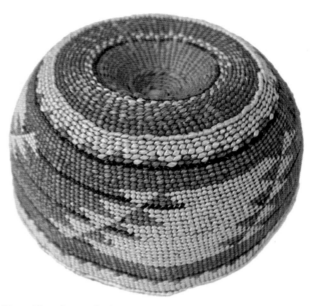

Hupa/Yurok Bowl, circa 1900. 6" diameter. Allard 8-14-05 **$475.00.**

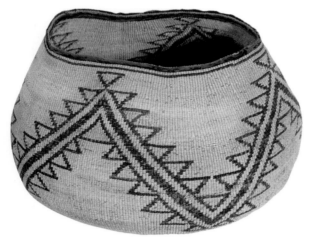

Yana Basketry, early 1900s. Huge and rare northern California (possibly Pitt River) bulbous storage basket, geometric designs, some professional restoration to piece, visually stunning, 10 1/2" high x 18" diameter. Allard 8-13-05 **$3,250.00.**

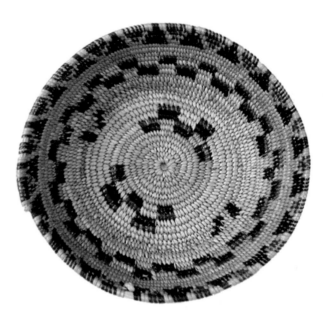

Miniature Mission Basket, circa 1900. Polychrome basket with rattlesnake design, excellent, 5 1/4" diameter. Allard 8-14-05 **$325.00.**

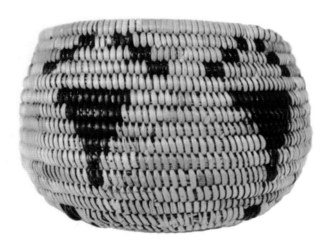

Miniature Mission Basket, circa 1900. Polychrome basket with arrowhead design, excellent, 3 1/4". Allard 8-14-05 **$325.00.**

Karok Basketry Hat, circa 1900. 6" diameter.
Allard 8-14-05 **$400.00.**

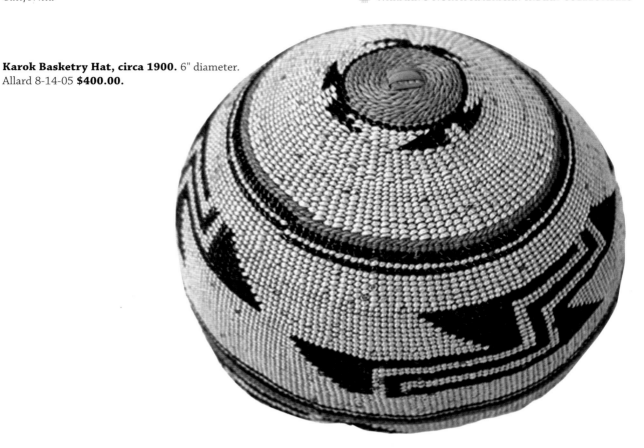

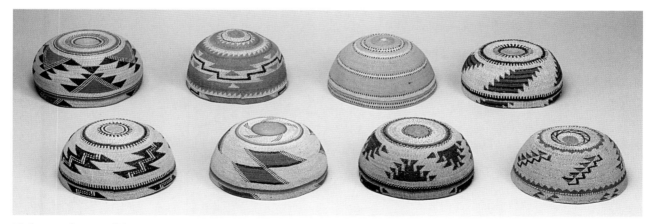

Eight Northern California Polychrome Twined Basketry Hats, all circa 1900.
 Top Left: Triangular designs, some damage, 3 1/2" high x 7 1/4" diameter. Skinner 9-10-05 **$881.25.**
 Top Second: Multicolored hat with 1" split, 4 1/4" high x 7" diameter. Skinner 9-10-05 **$588.13.**
 Top Third: Three-band pattern, slight edge loss, 3 1/2" high x 7 1/2" diameter. Skinner 9-10-05 **$705.00.**
 Top Right: Barred diagonal pattern, 3 1/4" high x 6 3/4" diameter. Skinner 9-10-05 **$763.75.**
 Bottom Left: Yellow quilled geometric motif, 3 1/2" high x 7 1/4" diameter. Skinner 9-10-05 **$998.75.**
 Bottom Second: Geometric designs, 3" high x 7" diameter. Skinner 9-10-05 **$940.00.**
 Bottom Third: Quail feather designs, 3 1/4" high x 7 1/4" diameter. Skinner 9-10-05 **$735.00.**
 Bottom Right: Geometric designs on tightly woven hat, 3 1/8" high x 7 1/4" diameter. Skinner 9-10-05 **$587.50.**

Clothing

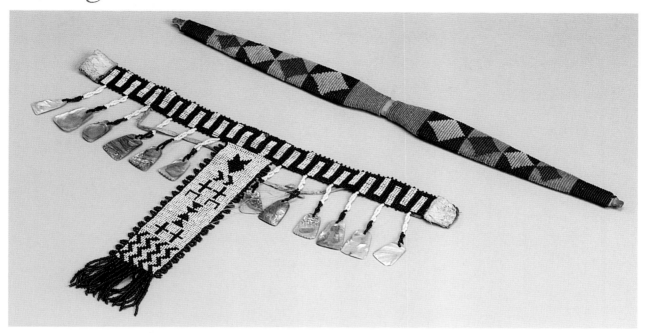

Beaded Choker and Beaded Bow.

Left: Northern California beaded choker, possibly Pitt River, circa 1900. Dark blue and bottle green geometric designs on a white background, with beaded fringe and abalone pendants, minor loss, 15" long. Skinner 1-29-05 **$940.00.**

Right: California beaded bow, minor bead loss, 18 1/2" long. Skinner 1-29-05 **$353.00.**

Prehistoric Items

Chumash Beads, prehistoric. A rare long string of Chumash stone and shell beads from the Channel Islands, California, 60" long. Allard 8-14-05 **$180.**

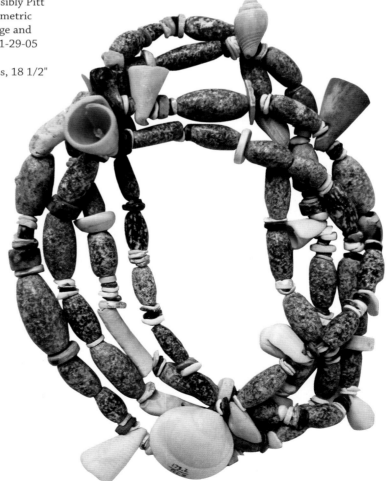

11

Northwest Pacific Coastal

This is a cultural region that has fascinated not only anthropologists, but economists as well, because of the role of reciprocity and the Potlatch Ceremony. Historians also show keen interest because of the cultural contact with both Russian and Western European traders. In addition, it piques the interest of most Americans who have ever seen native woodcarvings from the Northwest Pacific Coast. The high-priced item in this catalog is a mask from this area, evidencing this interest among collectors as well.

To say that the woodworking capabilities of the indigenous populations was stunning is a gross understatement. The region has one of the most storied histories of any cultural region regarding the art of making masks and is rivaled only by some African nations regarding both the strength of this tradition and collector interest in the artifacts.

In addition to the smaller-scale mask making, the region is also famous for its large totemic carvings known to Americans as "totem poles." Many of these were indeed monumental in scale, but some were of a much smaller, portable size.

Materials used included cedar and other native woods and a number of trade goods from an early date. Abalone, shell, and other items from the sea were also important material cultural elements of this region. Basketry was well developed and replaced pottery for the most part. Other items included stone such as slate, obsidian from the Plateau region, bone, and copper.

Cultures included the Kwakiutl, Tlingit, Haida, Nootka, Tsimshian, Makah, Salish, Cowlitz, Skokomish, Wasco, Wishram, Sitka, and others. Examples from all of these societies are shown in this section.

Major items of collector interest include all of the art forms related to carving masks, totems, or other items. Also, basketry examples from this region are comparable to those from other regions with high collector interest. Other items of high interest related to this area are the early trade items exchanged with these cultures by Western European, Russian, and American traders and explorers, including Lewis & Clark trade beads.

The cultural region extended from the southern Oregon coast to well into what is today Canada but south of the Aleutians. It extended east to the mountains along the entire north-south corridor. Some of the cultures in eastern Oregon and Washington could also properly be called Plateau, considering some of their cultural traits and affiliations. The "classic" NW Coastal cultures have dozens of examples shown following, and the traits of this area can be quickly learned by any observer of their material culture.

This region has one of the most storied histories of any cultural region regarding the art of making masks and is rivaled only by some African nations regarding both the strength of this tradition and collector interest in the artifacts.

Artistic Items

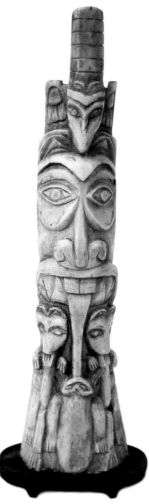

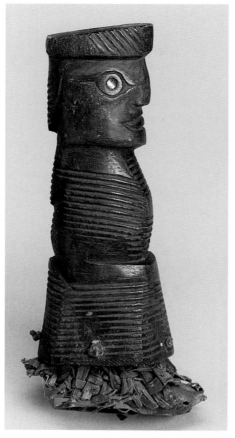

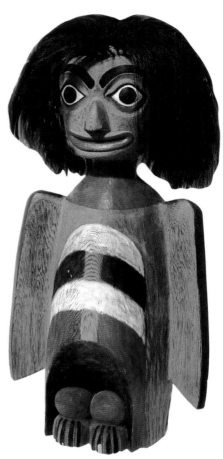

Nootka (?) Carved Bone Figure, 19th C.
Possibly to be used as a handle, bone carving in human figure with one remaining abalone eye and cedar bark and hide pegged to the bottom, 7" high. Skinner 1-29-05 **$2,703.00.**

Haida Carving, mid-1900s. Hand-carved totem pole showing a frog, wolves, beaver, seahawk, and potlatch symbol, 9 1/2" tall, see the print of Haida Slate Carvings. Allard 8-13-05 **$170.00.**

NW Coastal Figure, circa late 1900s. Attributed to Ivan Otterlifter (Coyote), this hand-carved figure of a winged man shows many of the classic NW Coastal stylistic traits, 26" tall x 12 1/2". Allard 8-13-05 **$375.00**

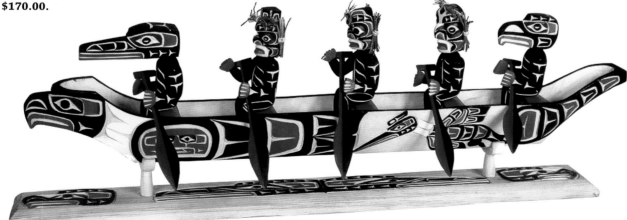

Kwakiutl Canoe and Five Paddlers, late 1900s. Native hand-carved war canoe with five masked paddlers, great example of traditional carvings and art form, as well as Kwakiutl masks on the warriors, 36" long. Allard 8-14-05 **$1,100.00.**

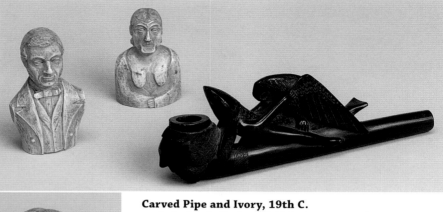

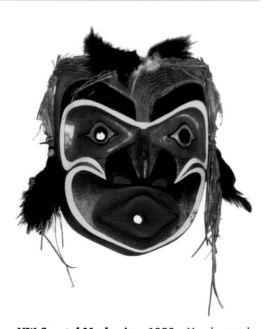

Carved Pipe and Ivory, 19th C.
 Left: Likely Haida mid-19th C. carvings of a European male and a Native female wearing a lip labret, both nicely incised, to 3 3/4" high. Skinner 1-29-05 **$4,113.00.**
 Right: Haida 19th C. carved Argillite pipe with avian figure straddling a half fish/half human form, pipe has been repaired, 8 1/2" long. Skinner 1-29-05 **$4,700.00.**

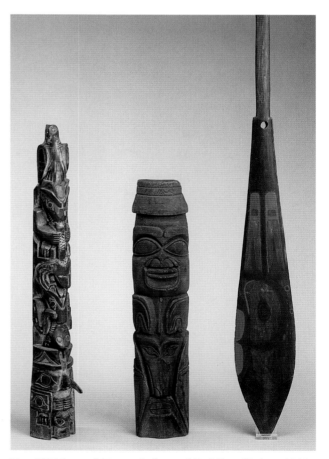

NW Coastal Mask, circa 1980s. Hand-carved and painted cedar mask with woven cedar bark "hair" signed by "Fred Peters", 17" x 16" x 10". This mask is clearly in the traditions shown following under Ceremonial Items. Allard 8-13-05 **$300.00.**

Two NW Coastal Totem Poles and Paddle, all circa 1900.
 Left: 24 1/2" totem pole with stylized animal figures. Skinner 1-29-05 **$1,998.00.**
 Center: Cedar hollow backed version with human and animal form, 20" high. Skinner 1-29-05 **$1,058.00.**
 Right: Polychrome wooden paddle with incised blade with animal figures, 38" long. Skinner 1-29-05 **$558.00.**

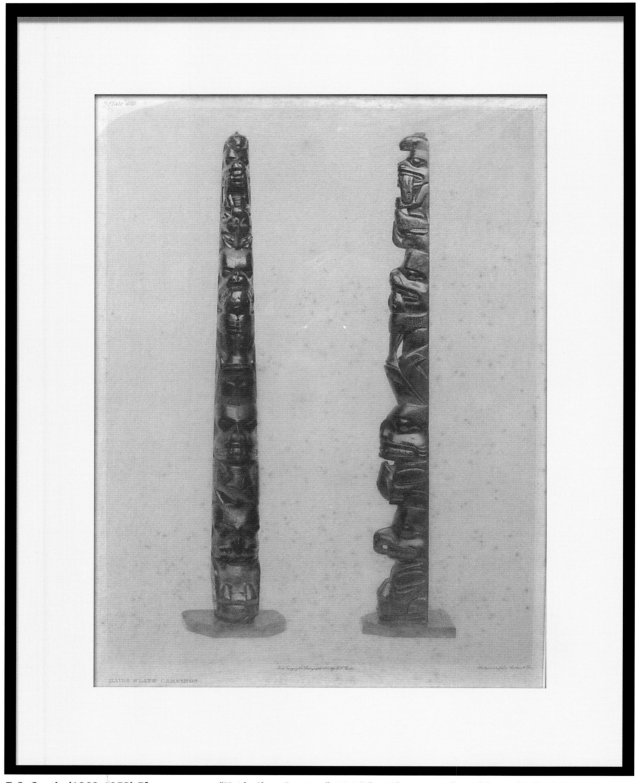

E.S. Curtis (1868-1952) Photogravure. "Haida Slate Carvings", 16 1/2" x 12" image, 22" x 18" framed. Allard 3-11-05 **$300.00.**

Basketry

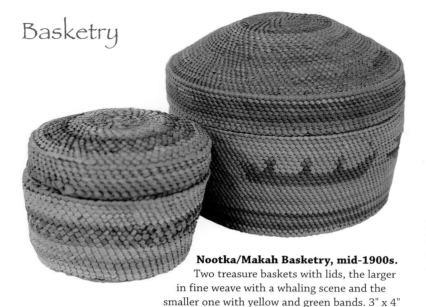

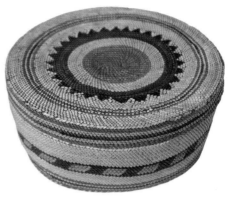

Nootka/Makah Basketry, mid-1900s.
Two treasure baskets with lids, the larger
in fine weave with a whaling scene and the
smaller one with yellow and green bands. 3" x 4"
and 2" x 2 1/2". Allard 3-11-05 **$250.00.**

**Nootka Lidded Polychrome Basket, early
1900s.** Stunning small basket with lid in
excellent condition, 3" high x 7" diameter.
Allard 3-11-05 **$300.00.**

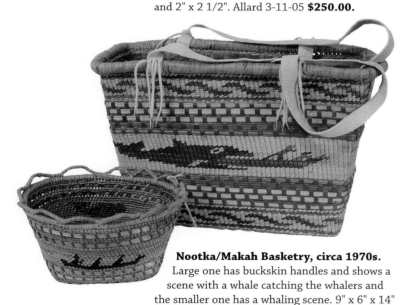

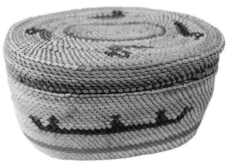

Nootka/Makah Basketry, circa 1970s.
Large one has buckskin handles and shows a
scene with a whale catching the whalers and
the smaller one has a whaling scene. 9" x 6" x 14"
and 3 1/2" x 7". Allard 3-11-05 **$425.00.**

Nootka Lidded Basket, circa 1910.
Whaler and bird designs, polychrome, 2" high
x 4" diameter. Allard 8-13-05 **$225.00.**

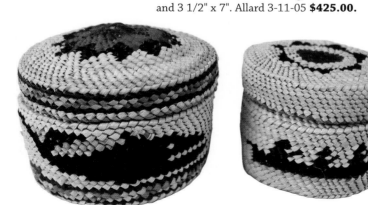

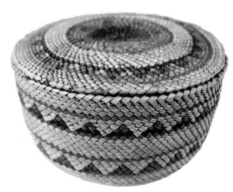

Nootka Basketry Examples, mid-20th C. Two lidded treasure baskets,
polychrome with whale and whaler designs, largest is 2 1/4" x 3". Allard
8-13-05 **$130.00.**

Nootka Lidded Basket, circa 1910.
Polychrome with star and wave designs, 4"
diameter. Allard 8-13-05 **$110.00.**

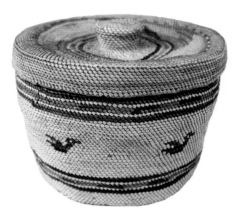

Nootka Basket, circa 1910. Polychrome lidded treasure basket, bird motif, excellent condition, 6" high x 6 1/2" diameter. Allard 8-14-05 **$350.00.**

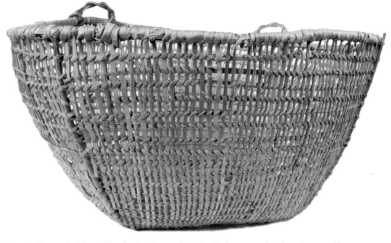

Puget Sound Clam Basket, circa 1880. Cedar root basket in excellent condition and a rare example, 16" x 22". Allard 8-14-05 **$650.00.**

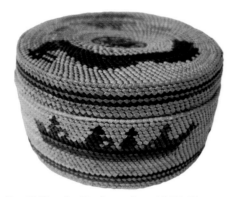

Small Nootka Basket, circa 1900. Fine-weave treasure basket with lid in polychrome depicting a sea serpent, whalers, and eagle, 2" high x 3 1/2" diameter. Allard 8-14-05 **$170.00.**

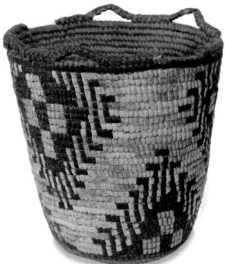

Cowlitz Basket, early 1900s. Classic upright basketry vessel with intricate exterior designs, some of the rim loops are missing, 7 1/2" x 7 1/2". Allard 3-11-05

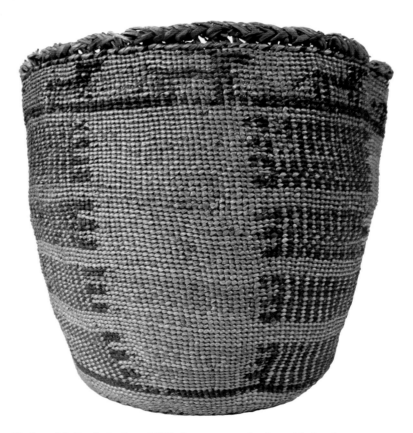

Skokomish Basket, circa 1900. Large storage basket with dog figures encircling the rim, excellent shape, 13" x 13". Allard 8-14-05 **$3,000.00.**

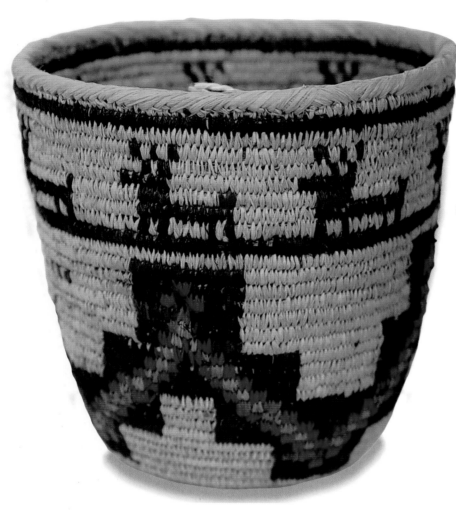

Richard Cultee Basket, Skoskomish, circa 1970. Wonderful contemporary example of a fine-weave miniature traditional basket with dog figures, 3 1/2" x 3 1/4". Allard 3-11-05 **$275.00.**

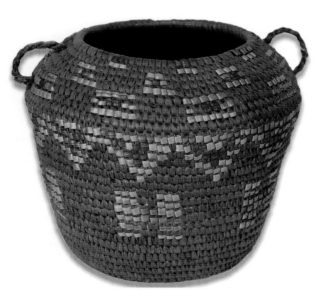

Early Salish Basketry, circa 1900s. Closed top design with polychrome exterior and woven cedar lugs, 7 1/4" x 9". Allard 3-11-05 **$180.00.**

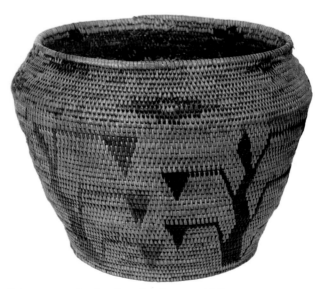

Polychrome Basket in Olla Shape, mid/late 1900s. Flat-bottomed semi-olla shape with polychrome floral and geometric motifs, 12 1/2" high x 17" diameter. Allard 3-11-05 **$475.00.**

Ceremonial and Utilitarian Items

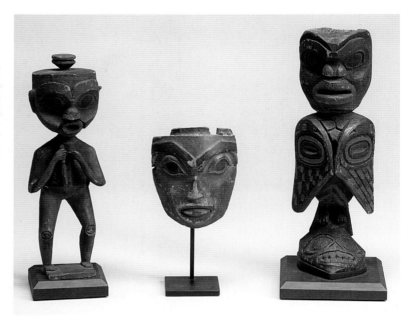

Three NW Coastal Carved Figures.

Left: Tlingit 19th C. standing figure, wearing a European waistcoat, one arm has been reglued and loss to base. Skinner 9-10-05 **$9,400.00.**

Center: Tlingit 19th C. hollowed wood maskette with some traces of pigmentation and some wood loss and wear, 4 3/4" high x 3 3/4" wide. Skinner 9-10-05 **$18,800.00.**

Right: NW Coast carved figure, 19th C. The front form is in an avian motif with human head, and the rear is an owl with stylized animal heads on the wings and a human face on the abdomen, red and black painted detailing, and a dark patina with a crack repaired at base, 11 1/2" high. Skinner 9-10-05 **$2,350.00.**

Northwest Coastal Carved Wooden Figure, 19th C. Tlingit culture, 11", Julia 10-05 **$5,462.50.**

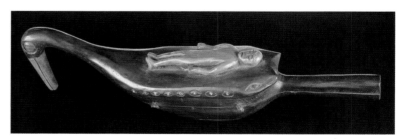

Raven Rattle, early 20th C., 16 1/2" long. Julia 10-05 **$3,300.00.**

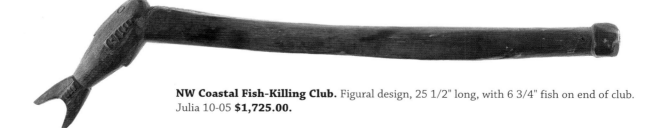

NW Coastal Fish-Killing Club. Figural design, 25 1/2" long, with 6 3/4" fish on end of club. Julia 10-05 **$1,725.00.**

Kwakiutl Mask, circa late 1900s. Hand-carved raven moon mask by master carver Jimmy Joseph of Alert Bay, British Columbia, 24". Allard 3-11-05 **$425.00.**

Kwakiutl Mask, circa late 1900s. Native carved Moon mask depicting a human and eagles, 24" diameter. Allard 8-13-05 **$425.00.**

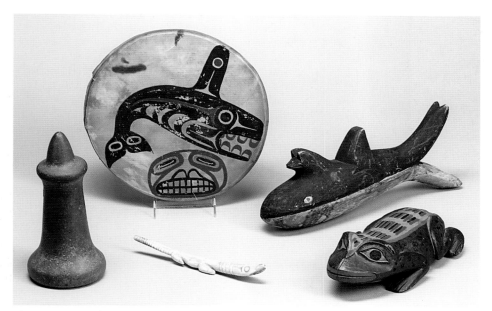

Five NW Coastal Items.

Left: Stone hand maul, Salish culture. Flat bottom with tapered shaft and a ridged top. Old sticker indicates "Wash.", height 8 1/4". Skinner 9-10-05 **$1,645.00.**

Top Left: Painted wood and rawhide drum, circa 1900. One-sided drum with a black and red killer whale motif, some splits on skin, diameter 9 3/4", depth 1 1/4". Skinner 9-10-05 **$646.25.**

Bottom Center: Tlingit culture Shaman's charm in form of otter, later 19th C., 7 3/4" long. Skinner 9-10-05 **$1,880.00.**

Top Right: Wooden rattle, carved and painted, circa first part 20th C., two pieces carved and glued together in whale form with black, white, and red pigments, 12 1/4" long. Skinner 9-10-05 **$411.25.**

Bottom Right: Sitka carved wooden polychrome frog figure, circa 1875. A detached label reads "Carved by the 'Sitka' Indians in 1875 for Robert Breck Tunicliffe", crack in wood, 8 3/4" long. Skinner 9-10-05 **$2,350.00.**

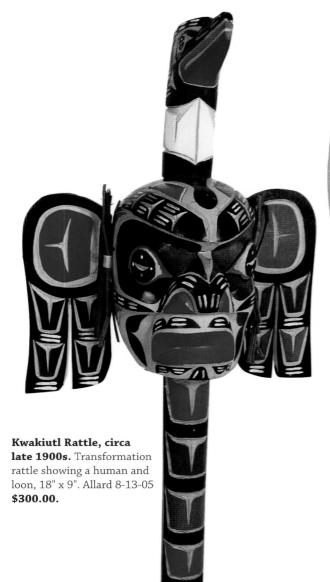

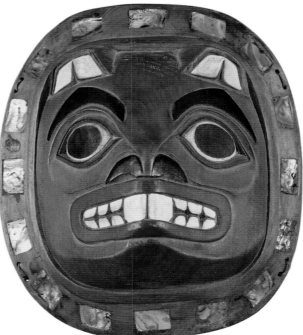

Beaver Face Carving, late 19th C. 7" x 6", painted highlights and inset with abalone. Julia 10-05 **$2,700.00.**

Kwakiutl Rattle, circa late 1900s. Transformation rattle showing a human and loon, 18" x 9". Allard 8-13-05 **$300.00.**

NW Coastal Painted and Carved Wood Mask, Tsimshian, second half 19th C. This item was the high of the 9-10-05 Skinner Auction at $259,000.00, as apparently the provenance was solid and the age of the mask important, as well as the articulating mouth. The mask is a cedar form with both an articulated lower jaw and articulated eyes, part of the articulation device remains on the mask. It is in a form with both human and bird features, it has red lips and nostrils over a graphite-like black pigment. The outer edge of the mask is decorated with cedar bark bundles nailed to the edge, patina on mask from use, 14" high. Provenance: Collected by Garnet West in 1952 from Rev. Shearman, Kitkatla Reserve, Prince Rupert, British Columbia. Note: "Over 200 years old, worn by Chief Gum-I-gum, meaning 'Brave Man'". Skinner 9-10-05 **$259,000.00.**

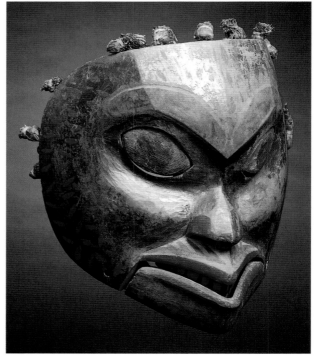

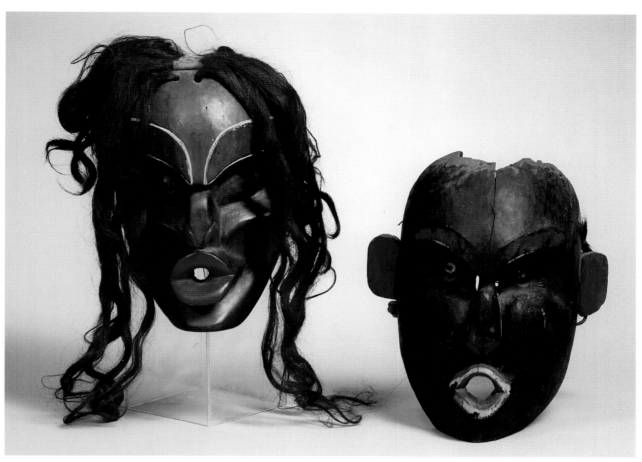

Two NW Coastal Carved Masks.

Left: NW Coast carved and painted wood mask, Tsimshian culture, first quarter of 20th C. Mask with pronounced pierced mouth and cheeks, replugged eye sockets, pronounced brow, long hair from atop, black surface with red and white details, 11 1/2" high. Provenance: Collected by Garnet West from R. Scott, Alert Bay, 52, "Singing Woman". Skinner 9-10-05 **$4,700.00.**

Right: NW Coastal carved and painted mask, Kwakiutl, Tsonoqua image, circa late 19th C. This unusual two-piece carved mask from cedar has a projecting mouth, sunken round eyes, pronounced brow line and cheeks and attached ears, hair, and moustache. It also has very slight holes near nose. Black background with red and white details, some cracks and wood loss, 12" high. Provenance: Collected by Garnet West in Alert Bay from R. Scott, British Columbia Packers Ltd., 9, 4, 40, "...Mr. Newcombe says it is quite old and rather a freak. May have been made to show the family were not in good standing in the society, it is unusual to find one made in more than one piece...Tsonoqua wanders through the woods making a 'Hoo-hoo' sound attracting little children that she ate..." Skinner 9-10-05 **$8,225.00.**

Nootka Mask, late 1900s. Native carved red cedar articulating Raven mask, 24" long. Allard 8-13-05 **$275.00.**

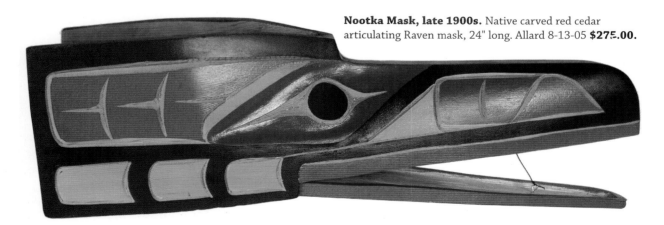

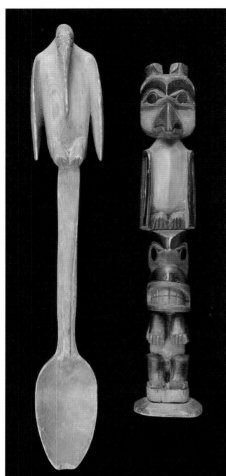

NW Coastal Totem Pole and Carved Wooden Spoon.
Small totem pole, 9 3/4" high with bird and human effigies,
and 12 1/2" carved wooden spoon with a bird effigy handle.
Julia 10-05 **$460.00.**

**NW Coastal Polychrome Wood Mask, Kwakiutl, circa
last quarter 19th C.** Large cedar mask with perforated
round nostrils and articulated fins at top representing a killer
whale with an articulated lower jaw and side fins representing
ravens. Pigmentation includes red, white, black, and green
pigment remnants, along with remnants of the string and
toggles for the articulating parts and a remnant head cloth.
Some damage, old repairs, and the hinges have been replaced
on the side fins. The mask is 26" high and 41" wide with both
side fins extended. Provenance: Collected by Garnet West in
1941, from R. Scott at Alert Bay, "Probably the Killer Whale
mask, good example I believe." Skinner 9-10-05 **$88,125.00.**

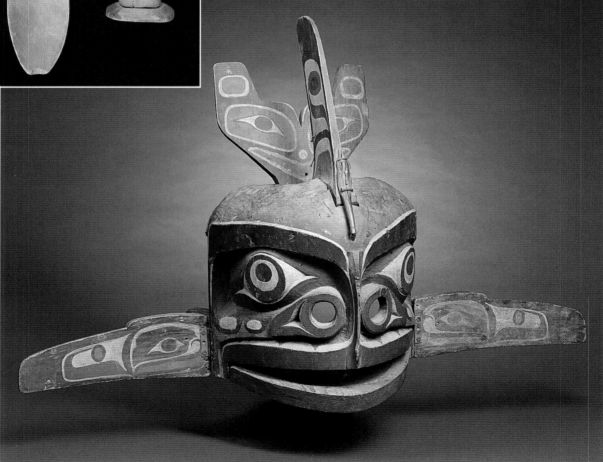

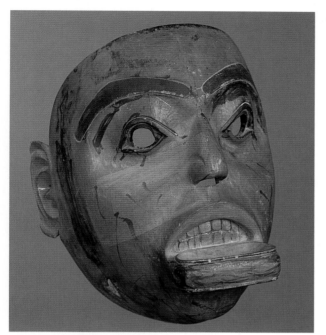

NW Coastal Carved Wooden Mask, Likely Haida, pre-1850. Portrait of a woman wearing a large labret in lower lip, incised eye details and pierced for vision, detailed incising of face, traces of black and green pigments that may have been added later, remnant paper label on the inside, patina from use, some wood loss, 8 1/2" high. Literature: For similar masks see *The Far North*, Indiana University Press, 1977, pp. 236-237 and *Gifts of the Spirit*, Peabody Essex Museum, 1996, pp. 28-30, 121. Skinner 1-29-05 **$76,375.00.**

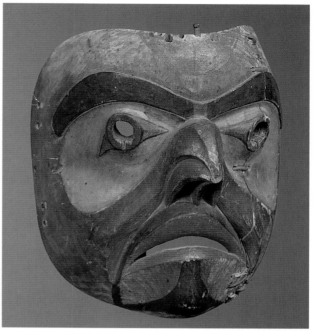

Bella Bella Painted Wood Mask, circa 19th C. Hollowed ovular form with details carved and painted of this stylized avian form, the mask has repairs on one side and a square nail protruding from top edge, 8" high. Skinner 1-29-05 **$82,250.00.**

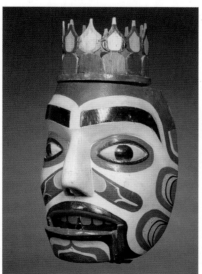

NW Coastal Polychrome Carved Wooden Mask, Nootka, circa late 19th C. Stunning colors on this articulated jaw carved cedar mask make it stand out among others. Portions of the inner headband and cloth and cedar bark strips remain, mask has some cracking, 20 1/2" high. Provenance: "...gotten from Indian agent, Mr. P. B. Ashbridge, Port Alberni, B.C. 4,20,40... It was a mask used by the chief of the Nootka tribe at ceremonial dances and is approximately 70 years old. The crown is the mark of a king or chief. Worn by the chief and this particular one was owned by the late Chief 'Maguinna'...," (from a letter by P. B. Ashbridge). Skinner 9-10-05 **$17,625.00.**

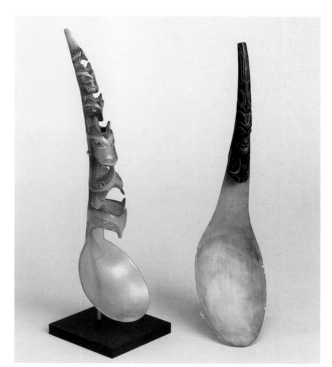

Two NW Coastal Carved Horn Spoons.
 Left: Beautifully carved totemic type animals on handle with abalone eyes, spoon has been reglued and has cracks, 12" long. Skinner 1-29-05 **$1,116.00.**
 Right: The black horn handle also has stylized animal carvings, 12 1/2" long. Skinner 1-29-05 **$441.00.**

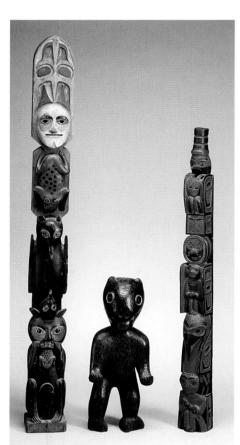

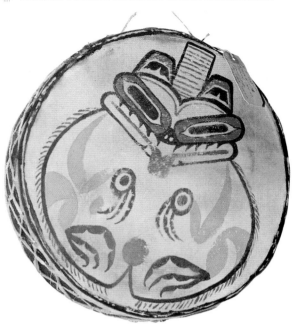

Kwakiutl Drum, circa 1930s. Double-headed hide drum with painted images on each side. An old tag reads "Goose Bay Fitz Hugh Sound B.C. Canada", 13" diameter. Allard 8-13-05 **$250.00.**

Two NW Coast Totems and Carved Bear.

Left: NW Coast carved and painted 59" totem pole, circa 1900. Variety of totemic animals carved and painted on a flat backed totem pole with a human-like face beneath abstract forms at the top. Skinner 9-10-05 **$8,225.00.**

Center: Carved wooden bear, circa 19th C., 23 1/2" high. This carved and painted bear has remnant black and brown-red pigment overall and white traces around the eyes with some wood loss. Skinner 9-10-05 **$4,700.00.**

Right: NW Coast polychrome wood totem pole, circa late 19th C. This 45 3/4" high totem has a hollowed back, both animal and human figures with the top figure wearing two potlatch rings. Skinner 9-10-05 **$11,162.50.**

Haida Totem Pole, 1890. Very detailed old hand-carved totem pole with six figures, concave back and covered in a reddish paint or stain, 16 1/2" high. Allard 3-11-05 **$1,000.00.**

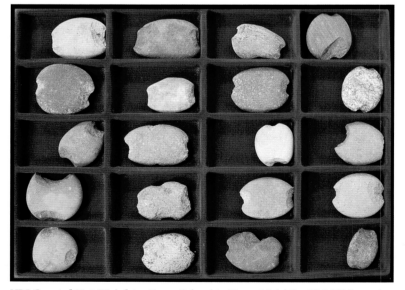

NW Coastal Net Weights. From Columbia River, 15 1/4" x 12 1/4" framed. Allard 3-13-05 **$30.00.**

Clothing

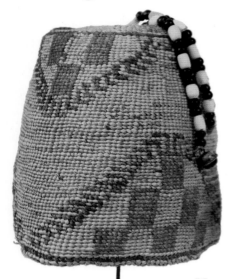

Rare Wasco Bag, 19th C. Loomed octopus bandolier bag with sinew and thread sewn pony beads. Skeletal figures on both sides with shell wampum and abalone drops, 7 1/2" x 39", very rare piece. Allard 8-13-05 **$10,000.00.**

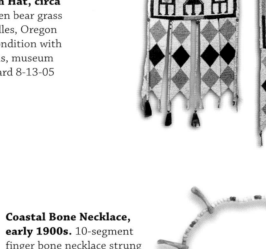

Wasco/Wishram Hat, circa 1900. Early woven bear grass hat from The Dalles, Oregon area, excellent condition with some water stains, museum mounted, 6". Allard 8-13-05 **$550.00.**

Jewelry

Coastal Bone Necklace, early 1900s. 10-segment finger bone necklace strung with mission and cobalt trade beads. Allard 8-13-05 **$200.00.**

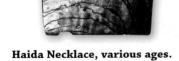

Haida Necklace, various ages. Made of Pacific dentalium and abalone, a chief's necklace was re-strung with early 19th C. Hudson Bay trade beads, 50" long. Allard 8-13-05 **$190.00.**

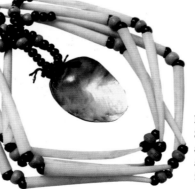

Haida Chieftain's Necklace, mid-1900s. Strung from long matched Pacific Dentalia and 19th C. Hudson Bay trade beads with an abalone pendant, 32" long. Allard 3-11-05 **$120.00.**

Trade Items

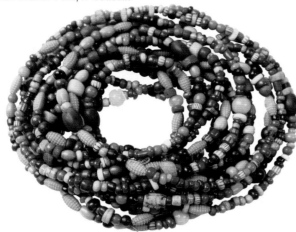

Early Trade Beads, early 19th C. The Dalles Site, Columbia River. Lewis & Clark trade beads, five strings, 30" long. Allard 3-11-05 **$325.00.**

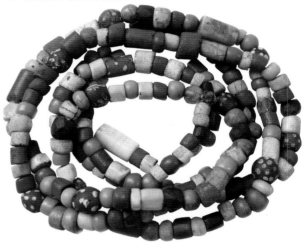

Early Trade Beads, early 19th C. John Day Site, Columbia River. Lewis & Clark trade beads, two strings, 30" long. Allard 3-11-05 **$190.00**

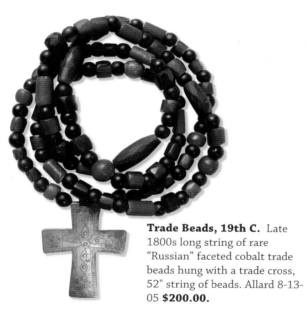

Trade Beads, 19th C. Late 1800s long string of rare "Russian" faceted cobalt trade beads hung with a trade cross, 52" string of beads. Allard 8-13-05 **$200.00.**

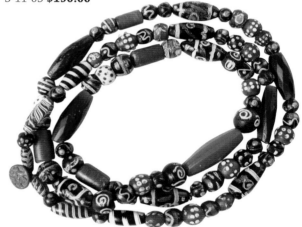

Trade Beads, mid-1800s. A long string of rare, mixed fancy Venetian polychrome beads, Lewis & Clark type, found at various sites along the Columbia River, 44" long. Provenance: Hall Collection, Yakima, Washington. Allard 8-14-05 **$750.00.**

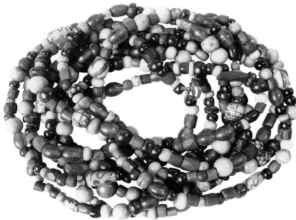

Trade Beads, mid-1800s. Lewis & Clark trade beads, three strings of 19th C. Columbia River beads from Celilo Falls site, 28" long. Allard 8-13-05 **$375.00.**

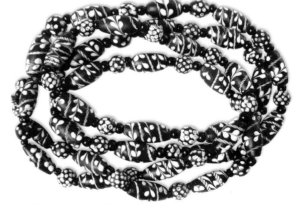

Trade Beads, mid-1800s. Two long strands of Lewis & Clark "Ambassador" beads, very rare, 30" each. Allard 8-14-05 **$450.00.**

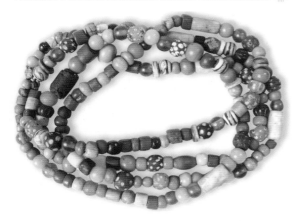

Trade Beads, mid-1800s. Two strings of Lewis & Clark trade beads from the Memaloose Island site along the Columbia River, 28" long. Allard 8-13-05 **$550.00.**

Weaponry

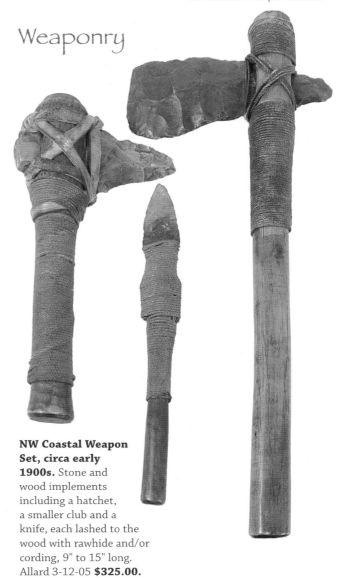

NW Coastal Weapon Set, circa early 1900s. Stone and wood implements including a hatchet, a smaller club and a knife, each lashed to the wood with rawhide and/or cording, 9" to 15" long. Allard 3-12-05 **$325.00.**

Trade Beads, mid-1800s. Three strings of Lewis & Clark trade beads from the Vantage site along the Columbia River, 28" long. Allard 8-13-05 **$550.00.**

Woven Items

Northwest Coast Button Blanket, 20th C. This example of a blanket is not technically "woven" but fits best here to compare it to Southwestern styles. The "weaving" is with the buttons and mother of pearl and not the cloth, 69" x 39". Skinner 1-29-05 **$764.00.**

12

The Subarctic

This region is one of the hardest to pin down for collectors, as it really was so broad and in many cases had traits of the Northern Woodlands interspersed with traits of the Arctic. The first culture an anthropologist usually thinks of within this region is the Athapascan following the Caribou herds across vast territories for their sustenance. Their territory was actually even a bit larger than that of the Ojibwa.

The Athapascan indeed are typical of the region, but one could easily argue that the Cree were also part of this region, as well as the Northern Plains and Plateau regions. Add to that the Northern Ojibwa north of Lake Superior and even some Algonquin groups in the Northeast and it is easy to see how many regions overlap at times.

On the west coast, some of the NW Pacific Coastal groups at times extended into this area, and the Aleut of the Aleutian Islands are truly between the harsh Arctic climates and the more temperate NW Coastal climates and should be added to this region as well.

Another difficulty placing items in this category for this book is the fact that many Aleut items are often listed simply as Eskimo, more properly Inuit, when indeed they are Aleut items instead. Inuit and Aleut shared many material cultural traits, and it is difficult to identify many of the items as to origin if not found with correct provenance and documentation.

Of course, the final difficulty for placing items in this category is the scarcity of items offered for sale in any one year, such as 2005.

This region is one of the hardest to pin down for collectors, as it really was so broad and in many cases had traits of the Northern Woodlands interspersed with traits of the Arctic.

Basketry

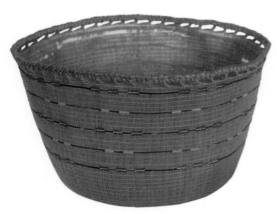

Aleutian Basket, circa early 1900s. Very fine weave openwork basket with banded red and blue yarn designs, in good condition with some repairs and some missing stitches, 6 1/2" x 10 1/2". Allard 8-13-05 **$425.00.**

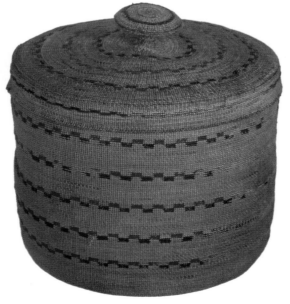

Aleutian Basket, circa 1900. Extremely finely woven lidded treasure basket with checks done in blue and red yarns, 5 1/4" x 6 1/2". Allard 8-13-05 **$550.00.**

Clothing

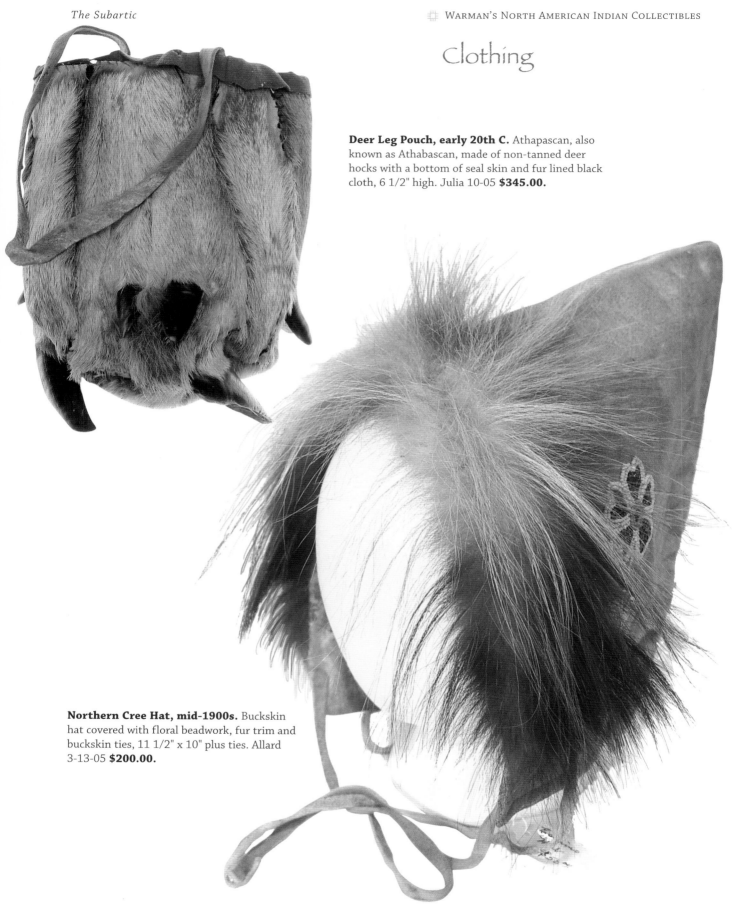

Deer Leg Pouch, early 20th C. Athapascan, also known as Athabascan, made of non-tanned deer hocks with a bottom of seal skin and fur lined black cloth, 6 1/2" high. Julia 10-05 **$345.00.**

Northern Cree Hat, mid-1900s. Buckskin hat covered with floral beadwork, fur trim and buckskin ties, 11 1/2" x 10" plus ties. Allard 3-13-05 **$200.00.**

Trade Goods

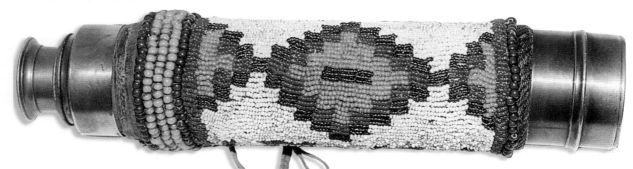

Blackfoot Telescope, 19th C. Brass telescope covered with beadwork. An old tag reads "Blackfeet Indian Spy Glass, Arrowwood, Alberta, Canada", 2" x 9". Allard 8-13-05 **$500.00.**

Weaponry

Cree Sword Case, circa 1920s. Smoked moosehide case with foliate beadwork and hide fringe on both sides, 39" x 7". The Cree extended into the Subarctic and could also easily be placed in the Northern Plains and the Plateau at times, some Cree items are found placed in those regions in this book. Allard 8-13-05 **$800.00.**

13

The Arctic

T his region is vast, to say the least, and is larger than even the Ojibwa or the Athapaskan cultural regions, but parts of it were uninhabited due to the harshness. One normally thinks of the Inuit, also known to lay persons as the Eskimo, inhabiting primarily the coastal regions of the Arctic and subsisting on various creatures from the seas and land, such as seal, walrus, caribou, and bear. Of course, many smaller creatures were also hunted, including various birds. Fish was always an important part of the diet as well.

Today, Alaska and Greenland form the geographical boundaries normally thought of as Inuit homelands, although the inner regions of Canada also were native to this interesting culture that was actually a rather recent arrival to North America compared to other indigenous populations.

As with many other regions discussed earlier in this book, fewer items come up for sale in any given time period than from the Plains, NW Coast, or Southwest, but a number of items are shown in this chapter that are typical of the Arctic region. When the Inuit come to mind, one normally thinks of soapstone carvings, harpoons, ivory, sealskin clothing, and kayaks. The artifacts below give a good idea of the value and identification of these items.

In addition, the Inuit have developed a fairly extensive modern trade network with the rest of us to supply us with "tourist" items, and some of those items are also of value. As an example, I used to collect chess sets and still have a pottery chess set made by a Canadian Inuit artist in the form of native figures, dogs, igloos, and other motifs common to this cultural region. Each piece is signed and I know it would garner hundreds of dollars if for sale, which it is not. There are numerous similar examples that have returned to "the lower 48" since the beginning of Alaskan tourism decades ago.

Artistic Items

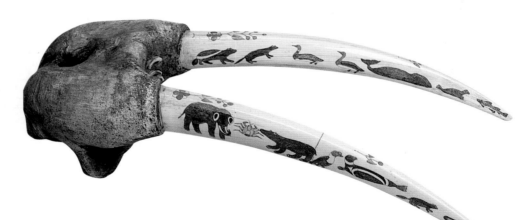

Inuit Engraved Walrus Skull, circa 1900. Profusely decorated tusks with images of birds, a hunter and bear, elephant, insects, crab, etc., one tusk reglued, 27" long. Provenance: The Charles and Blanche Derby collection. Skinner 1-29-05 **$2,350.00.**

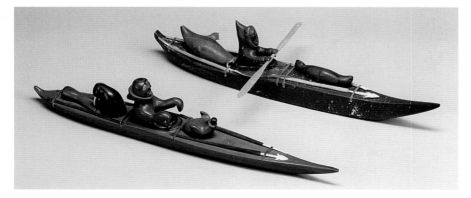

Two Inuit Soapstone Carvings.
 Left: Kayak, paddler, and walrus head, part of a seal and harpoon attachments, signed piece, 21" long. Skinner 9-10-05 **$763.75.**
 Right: Kayak, paddler, his catch, wooden paddle, and wood and bone implements, signed on bottom, mid-20th C., 20" long. Skinner 9-10-05 **$1,292.50.**

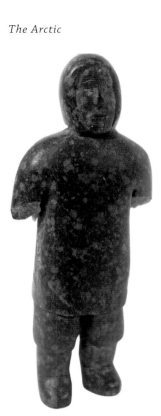

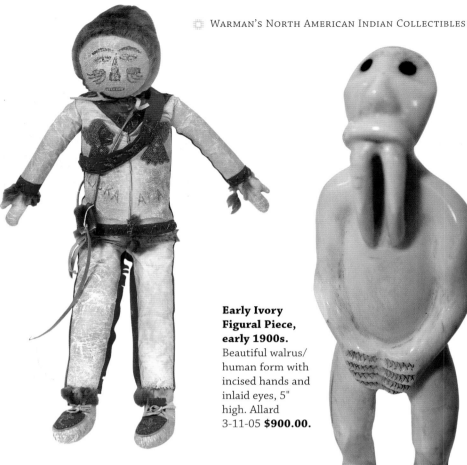

Early Ivory Figural Piece, early 1900s. Beautiful walrus/human form with incised hands and inlaid eyes, 5" high. Allard 3-11-05 **$900.00.**

Eskimo Carved Soapstone Figure, late 1800s. Hand-carved mottled soapstone human figure with parka, hood, and boots, arms are missing, 3 3/4" tall. Allard 8-13-05 **$225.00.**

Eskimo Doll, circa 1930s. Handmade sealskin doll made in Juneau in 1938, painted facial features and "Alaska" on the jacket, 26" tall. Allard 8-13-05 **$275.00.**

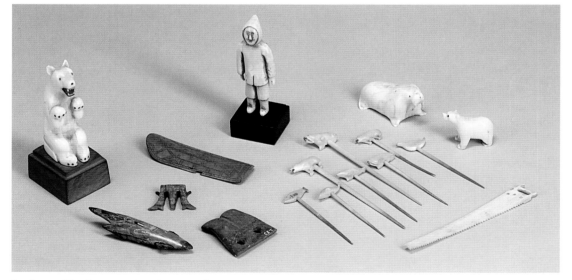

Variety of Inuit Ivory Carvings, prehistoric and historic periods.
 Left: Early 20th C. carved bear, 3 1/2" high. Skinner 9-10-05 **$470.00.**
 Lower Left: Lot of four prehistoric carved ivory objects, wrist guard, and harpoon point with original stone points from Bering Sea culture, largest item is 3 3/4" long. Skinner 9-10-05 **$1,997.50.**
 Upper Center: Inuit carved ivory standing male figure on stand, circa 1900, 3 3/4" high. Provenance: Beasley collection. Skinner 9-10-05 **$881.25.**
 Right: Lot of Inuit carvings, circa early 20th C. includes a walrus, bear, miniature saw, and eight picks in the form of animals, length of walrus is 2 1/2". Skinner 9-10-05 **$940.00.**

Basketry

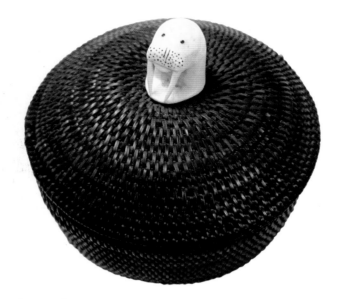

Inuit Basketry, circa 1900. Very rare lidded baleen basket tipped with a carved walrus head, 3 1/2" x 4 1/2". Allard 8-14-05 **$1,000.00.**

Ceremonial and Utilitarian Items

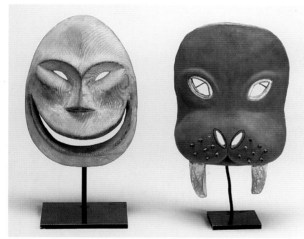

Two Inuit Polychrome Carved Masks, early 20th C.
 Left: Hollowed oval form, traces of red pigment at the mouth, overall white pigment, label on back reads "Eskimo, St. Michaels, Kuskokwim Alaska", 8" high. Skinner 9-10-05 **$3,055.00.**

 Right: Walrus form with wooden whiskers painted with brick red pigment and black and white kaolin details, collection label on back reads "Nonivagmiut, Nunivak Island, Alaska, 9" high. Skinner 9-10-05 **$1,762.50.**

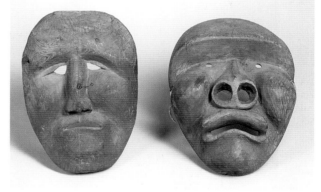

Two Inuit Carved Wood Masks, 20th C.
 Left: High cheekbones piercing at mouth, nostrils and lips, 10 1/2" high. Skinner 9-10-05 **$1,470.00.**
 Right: Protruding upper lip, enlarged facial features, pierced nostrils enlarged, 10" high. Skinner 9-10-05 **$1,410.00.**

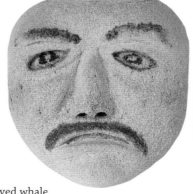

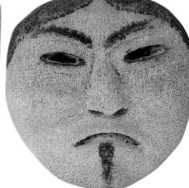

Two Inuit Masks, early/mid-1900s. Hand-carved whale bone flat masks, one each of a man and a woman, 7" x 6 1/4". Allard 3-13-05 **$325.00.**

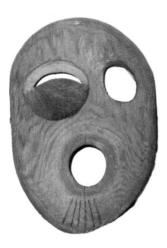

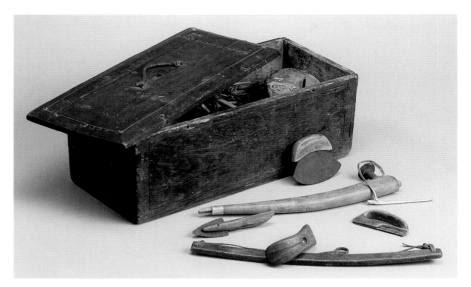

Eskimo Mask, circa 1970s-80s. Hand-carved flat cedar mask with white/gray ocher, 10" x 7" x 7". Allard 8-13-05 **$600.00.**

Inuit Wooden Utility Box and Contents, circa late 19th C. A rare find of numerous early Inuit items from the late 19th C. Box includes five early trade beads inlaid on the lid, contents include ulus, a saw, a pipe, wood bow drill, animal teeth, kayak cleats, a miniature pair of mukluks, and other items, box is 7" high x 17" long. Skinner 1-29-05 **$10,575.00.**

Ivory Snow Knife, early/mid-1900s. Highly polished snow knife made of ivory, 28" long. Allard 3-13-05 **$425.00.**

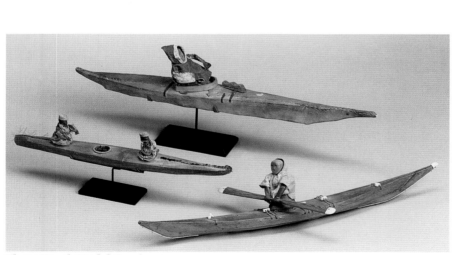

Three Kayak Model Carvings.

Top: No sale/withdrawn from sale.

Center: Inuit hide and wood kayak model, Aleutian Islands, 19th C. Three-seat sealskin over wood form with two remaining highly detailed paddlers, custom stand included. Some loss and insect damage, 15" long. Skinner 1-29-05 **$705.00.**

Bottom: Inuit hide and wood kayak with paddler, 19th C. Sealskin over wood form with bone rigging details, a wooden figure with a cloth parka and bone-tipped paddle, a tear to one hand, 20 1/2" long. Skinner 1-29-05 **$294.00.**

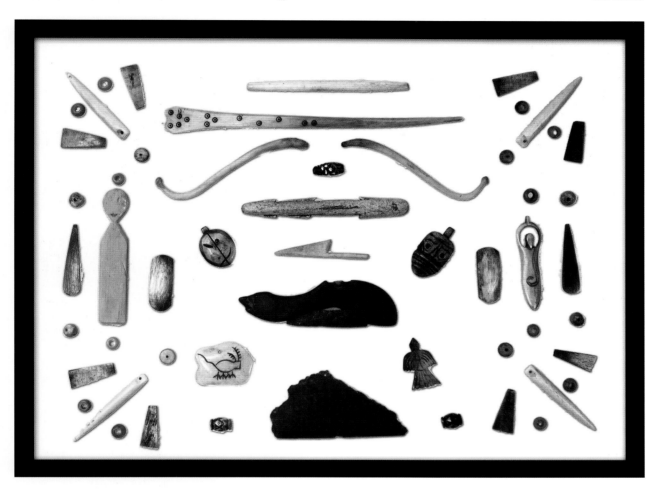

Eskimo Artifacts, Framed Collection. St. Lawrence Island items including slate scrapers, a fishing tool, bone harpoons, awls, beads, and effigies. Allard 3-13-05 **$200.00.**

Clothing

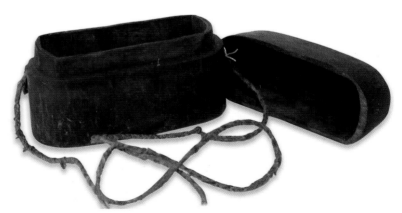

Inuit Moccasins, early 1900s. Rare pair of hard-soled seal skin child's boots, 4" x 5" x 2 1/2". Allard 3-12-05 **$70.00.**

Inuit Hand-Carved Carrying Case. Two piece with woven hair and root lanyard, 7" x 4 1/2" x 2 1/2". Allard 3-12-05 **$110.00.**

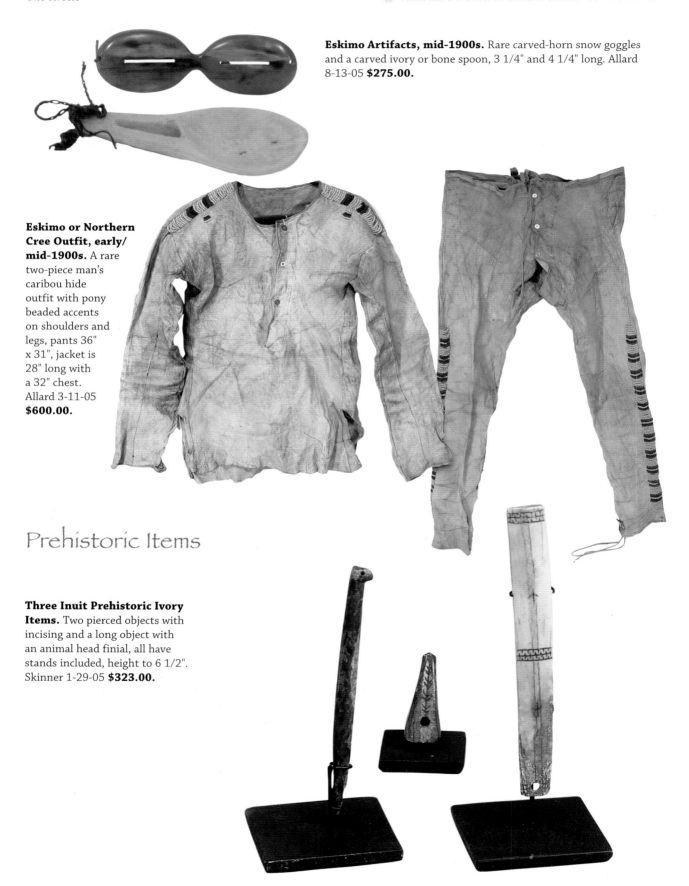

Eskimo Artifacts, mid-1900s. Rare carved-horn snow goggles and a carved ivory or bone spoon, 3 1/4" and 4 1/4" long. Allard 8-13-05 **$275.00.**

Eskimo or Northern Cree Outfit, early/ mid-1900s. A rare two-piece man's caribou hide outfit with pony beaded accents on shoulders and legs, pants 36" x 31", jacket is 28" long with a 32" chest. Allard 3-11-05 **$600.00.**

Prehistoric Items

Three Inuit Prehistoric Ivory Items. Two pierced objects with incising and a long object with an animal head finial, all have stands included, height to 6 1/2". Skinner 1-29-05 **$323.00.**

Trade Goods

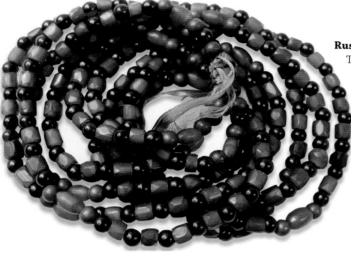

Russian Trade Beads, late 1800s. Three strings of large and rare faceted Russian trade beads of cobalt interspersed with Hudson Bay trade beads, from Nome, Alaska, 35" long. Allard 3-11-05 **$150.00.**

Antique Trade Beads, circa late 1800s. Three strands of Hudson Bay, Peking type trade beads from Nome, Alaska area, 26" long. Allard 3-13-05 **$70.00.**

Hudson Bay Trade Beads, late 1800s. 19th C. Hudson Bay cobalt "chief's" beads interspersed with yellow center Corneline d' Allepo trade beads, from Alaska, 32" long. Allard 3-13-05 **$90.00.**

Trade Beads, Chief Type, mid-1800s. Hudson Bay Company "chief" beads and yellow center Cornaline D' Allepo trade beads, 42" long strand. Provenance: Hall collection, Yakima, Washington. Allard 8-14-05 **$325.00.**

Antique Russian Trade Beads, late 1800s. Two strings of 19th C. red and cobalt "Russian" faceted trade beads from Alaska, 32" long. Allard 3-13-05 **$100.00.**

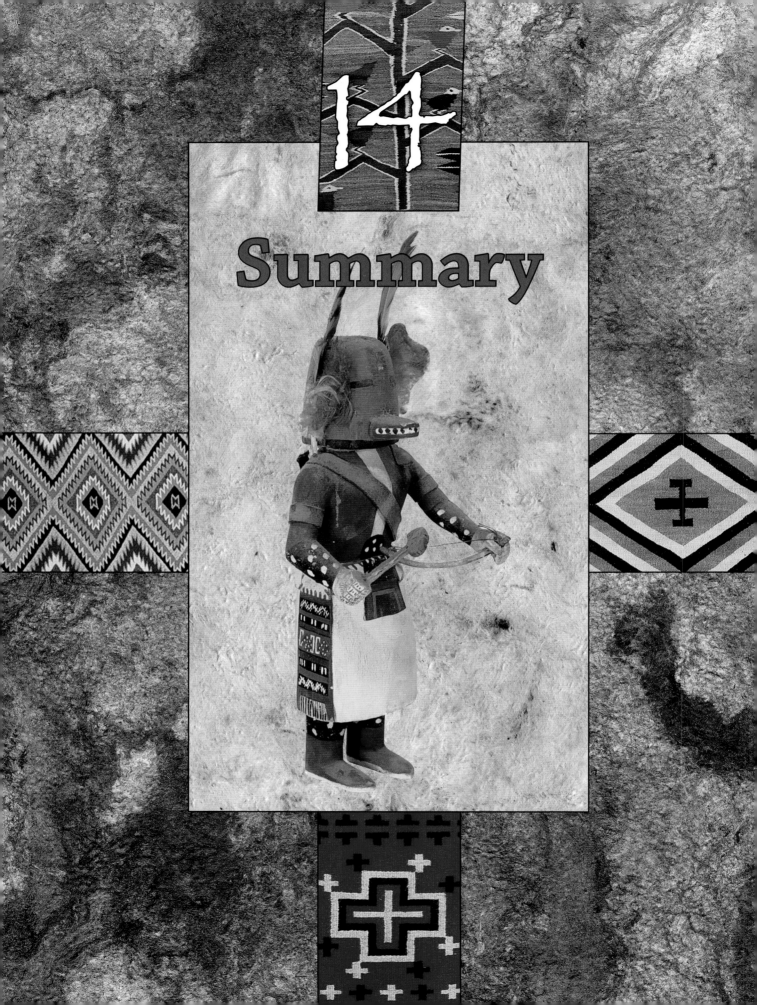

14

Summary

his chapter could extend for hundreds of pages or just a few, as there is still so much to say. However, editorial constraints always make me quit hitting the keyboard before I am done, and this is no exception. Seldom have I had as much fun as when writing this book. It is the first time in years that I could forget about law books and law lectures for a while to go back to my professional roots as an anthropologist to write about something so dear to my heart.

I realize this is not a traditional scholarly treatment of Native Americans according to many. However, I would argue that for years our academic community has been deprived of seeing in one location the major material items from each cultural region that have survived into our time period. Thus, I would say that though this book was originally intended for the collector market, it could also serve as an excellent auxiliary text in any ethnography or history of Native Americans course in a college curriculum, or high school for that matter.

I believe I have done justice to the items and placed them within a rational framework understood by most collectors and anthropologists alike. Some may disagree with the placement of an item or two; however, I believe most are correctly placed. I must end on an issue that still bothers me to this date, nearly 37 years after it happened. The issue is the economic value of an item. Anthropologists always will be quick to say we are only interested in the "inherent value" of an item for what it can tell us and add to the body of knowledge known as archaeology and/or anthropology. They will always claim that the dollar value is not important and should not even be asked.

After 37 years as both an anthropologist and a collector, I must take issue with this premise. I agree that when doing an excavation we are after information and only information. However, digs are often funded by the artifacts that will be contributed to some major institution or museum, so even this is a false premise. Do you think the current work in Central America could continue if the items being displayed by major museums did not have an economic impact on the revenues of said museums? If so, I would argue that you do not understand the major theories of economics and the concept of value assigned to any particular good or service.

I shall never forget the first time a student asked me: "How much is that worth?" and I responded in the same pompous fashion as did my professors when I asked the same question. I explained to the student that the item did not have a value other than for learning. Well, I was wrong then and I would be wrong now for not pointing out the value of Native American artifacts for collectors and museums and anyone interested in possibly owning a part of our wonderful human history.

As I clearly indicated in the Preface to this book, I do not condone, now or ever, destroying a site for monetary gains. However, I believe that I have matured to a level to understand that once an item is in legitimate avenues of trade that it indeed does have a value and that we all have a right to know what it is. If my ancestors from Wales or Scotland would have brought over an item still in the family nearly 400 years later, I would certainly want to know its dollar value in addition to the familial, and maybe at times sacred, value.

I believe this is also true of Native American artifacts. I respect all cultures to control the destiny of their own possessions and respect any ownership rights claimed by indigenous populations to their sites. However, I also am a firm believer in the free market system and also believe we all have a right to know the answer to the student's question: "How much is that worth?" when an item is in the legitimate marketplace. Hopefully, you have learned both something about our native peoples and also how much an item may be worth if you are lucky enough to own one or find one in your many searches for that right item to add to your collection.

Annotated Bibliography

Adair, John. *The Navajo and Pueblo Silversmiths.* Norman OK: University of Oklahoma Press, 1944 (numerous later printings).

Anson, Bert. *The Miami Indians.* Norman OK: University of Oklahoma Press, 1970. An excellent resource combined with my own archaeological reference noted below to gain in-depth insight into one Great Lakes culture.

Brose, David S., James A. Brown and David W. Penney, *Ancient Art of the American Woodland Indians.* New York: Harry Abrams, 1985.

Catlin, George. *Letters and Notes on the Manners, Customs and Conditions of North American Indians.* New York: Dover Publications, 1973 (first published in London in 1844). A fine source of some early observations made concerning Native American societies, especially Plains and Prairie cultures.

Colton, Harold S. *Hopi Kachina Dolls.* Albuquerque, NM: University of New Mexico Press, 1959.

Davis, Robert T. *Native Arts of the Pacific Northwest.* Stanford, CA: Stanford University Press, 1949.

Douglas, F.H. *Indian Culture Areas in the United States,* Denver, CO: Denver Art Museum, 1950.

Driebe, Tom. *In Search of the Wild Indian Photographs and Life Works by Carl and Grace Moon.* Moscow, PA: Maurose Publishing, 1997.

Driver, Harold E. *Indians of North America.* Chicago, IL: University of Chicago Press, 1961. A classic anthropological text.

Garbarino, Merwyn, S. and Robert F. Sasso. *Native American Heritage,* 3rd Edition. Long Grove, IL: Waveland Press, Inc., 1994. A great beginning text that uses a similar regional cultural format to this book in delineating the cultural history of Native Americans.

Hothem, Lar. *North American Indian Artifacts.* Florence, AL: Books Americana, 1994. A good popular source for an introduction to projectile points and related artifacts.

Hoxie, Frederick E., editor. *Encyclopedia of North American Indians.* New York: Houghton Mifflin Company, 1996. This also has a fantastic Internet site at http://college.hmco.com/history/readerscomp/naind/html/na_000101_publicationd.htm. This site contains an alphabetical reference to all major groups, culture areas, and various maps at different times in history. It also contains specific references to artworks and forms of Native Americans. This is a great resource for the beginning or advanced student of American Indian cultures.

Hunter, David E. and Phillip Whitten, editors. *Encyclopedia of Anthropology.* New York: Harper & Row, 1976. An excellent source on the study of culture, including specific references to material cultural artifacts of Native American and other societies.

James, George Wharton. *Indian Basketry.* New York: Dover Publications, 1972.

Josephy, Alvin M., Jr. *The American Indian Heritage of America.* New York: Alfred A. Knopf, 1968. One of my favorite references when teaching American Indian anthropology at the college level. The late Mr. Josephy passed away in October 2005 and was one of the leading authors on the history and culture of Native Americans. His works also included books on recent events such as the Red Power Movement (see Means entry below).

Kidwell, Clara Sue and Richard W. Hill, Sr. *Treasures of the National Museum of the American Indian.* New York: Abbeyville Press, 1996.

Kroeber, A.L. *Handbook of the Indians of California.* New York: Dover Publications, 1976. A great historical reference by one of the founders of modern anthropology and one of the leading experts on California Native Americans.

Kroeber, Theodora. *Ishi in Two Worlds: A Biography of the Last Wild Indian in North America.* Berkeley: University California Press, 1963.

A touching and well-documented example of radical culture change experienced by one Native American in California in the late 1800s and early 1900s.

La Farge, Oliver. *A Pictorial History of the American Indian*. New York: Crown Publishers, 1956. Out of print but worth the find for a nice general photographic overview of Native American cultures.

Laws related to historic preservation: National Historic Preservation Act of 1966, 16 U.S.C. Section 470 and its amendments. American Folklife Preservation Act, 20 U.S.C. Section 2170 and its amendments.

Lewis, Russell E. "Amerindians, Archaeologists, Artifacts and Lawyers: An Essay on the Legal Protection of Our Cultural Heritage." Unpublished manuscript discussing legal issues related to historic preservation, 1984.

———. *The 1976 Excavation of a Miami House Site*. Copyright 1977 by Ball State University and the author, 14 Ball St. U. Archaeological Reports 300. Scholarly text on the recovery of over 10,000 artifacts found in a Miami house destroyed December 24, 1812, near Marion, Indiana. (See also Anson, Bert. *The Miami Indians.*)

Lowie, Robert H. *Indians of the Plains*. New York: McGraw-Hill, 1957.

Mason, Otis Tufton. *American Indian Basketry*. New York: Dover Publications, 1988.

Means, Russell with Marvin J. Wolf. *Where White Men Fear to Tread: The Autobiography of Russell Means*. New York: St. Martin's Press, 1997. Means is without doubt one of the most influential individuals in the Red Power Movement and a modern leader of Native Americans. This is a must read concerning the reawakening of political power among Native Americans.

Penney, David W. *Art of the American Indian Frontier*. Seattle, WA: University of Washington Press, 1992.

Quimby, George Irving. *Indian Culture and European Trade Goods*. Madison, WI: University of Wisconsin Press, 1966. This source is excellent for learning the various trade goods of European origin and the trade patterns that developed in various American Indian cultures.

Roe, Frank Gilbert. *The Indian and the Horse*. Norman, OK: University of Oklahoma Press, 1955.

Shuman, John A. III. *Warman's Native American Collectibles*. Iola, WI: Krause Publications, 1998. Predecessor to this book, with many additional photographs of trade goods and Native American collectible items held in museums and private collections. The book has a useful glossary of common terms and a bibliography with additional resources on specific art forms.

Spicer, Edward H., editor. *Perspectives in American Indian Culture Change*. Chicago, IL: University of Chicago Press, 1961. A classic text dealing with the important anthropological concept of culture change.

Stirling, Matthew W. *Indians of the Americas*. Washington, D.C.: The National Geographic Society, 1961. Stirling was chief of the Smithsonian Institutions Bureau of American Ethnology from 1928 until 1957 and brought this experience to his writing of this classic reference.

Tanner, Clara Lee. *Indian Baskets of the Southwest*. Tucson, AZ: University of Arizona Press, 1983.

Tschopik, Harry Jr. *Indians of North America*. New York: American Museum of Natural History, 1952.

Underhill, Ruth. *Red Man's America*. Chicago, IL: University of Chicago Press, 1956 (revised 1971).

Wissler, Clark. *Indians of the United States*. New York: Doubleday and Company, 1949 (revised 1967).

Index

photogravures, 22, 158, 222

Piegan, 200, 207

pillow, 138

Pima, 28, 74-77

pin, 41, 89-90

pipe, 122, 145, 160-161, 163, 187, 199, 221

pitcher, 53, 103

Pitt River, 215, 217

Plains, 29, 30-31, 32-40, 45, 47, 58, 63-64, 154-195, 198

plate, 51, 76

Plateau (Intermountain West), 34-37, 40, 166, 196-209

points, 54-57, 143-145

Pomo, 25-26, 212, 214

Popovi, Maria, 50

Potawatomi, 152

pouch, 36-38, 44, 140, 164, 176-177, 182, 186, 238

Prairie, 148-153

Pueblo, 43, 59, 71, 84, 86, 92, 98, 100

purse, 177, 206

Q

Quah Ah (Tonita Pena), 71

quirt, 160

quiver, 189

Quotskuyva, Dextra, 49

R

rake, meal, 29

rasp, 83

rattle, 29, 31, 81, 83, 104, 226-228

Reed, Roland, 197

Remington, Frederick, 21

revolver, 188

ring, 89

roach, 29

robe, 156, 175

rosary, 186

rug, 109-115

S

Salish, 225, 227

San Ildefonso, 50-51, 71, 96, 98, 101-102

sash, 49, 120, 132, 141, 152,

Sauk Fox, 151-152

scabbard, rifle

scoop, 53

scraper, 32, 162

Seminole, 117, 120-121

Seneca, 150

sheath, knife, 38, 63, 190-191

Shelton, Henry, 80

shield, 160, 167

shield cover, 160

shirt, 120, 141-142, 173-174, 201

shoes, 133

Shoshone, 35

silkscreen, 20, 71, 73

Sioux, 22, 32, 38-40, 47, 59, 64, 157, 159-165, 167-185, 190-193, 195

Sitka, 227

skirt, 84, 133, 204

Skokomish, 224-225

skull, 166, 241

Southeast Coastal region

Southeastern Woodlands, 116-123

Southwest, 24, 27, 36, 38, 42, 48, 58, 68-115

spoon, 138, 230-231, 246

spurs, Crockett, 40

stereoptic cards, 23-24

strike-a-lite, 161, 182

strips, 176

Subarctic, 45, 236-239

Surber, Paul, 18

T

tabletta, 82

telescope, 239

Tennessee, 122-123

tie, bolo, 41

ties, hair, 40

Tiger, Jerome, 117

tipi, 183

Tlingit, 226-227

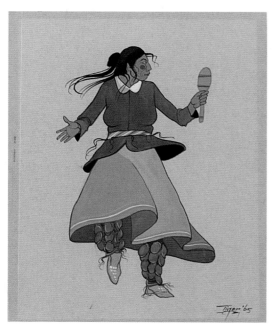

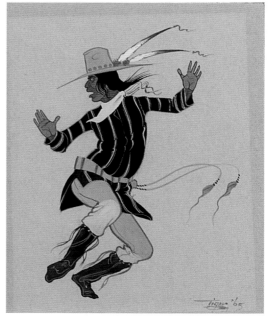